# CALLED

# TO

# WAR

## How Life's Battles Transform Us

## for God's Purposes

Dawn Amsden Stark

Called to War: How Life's Battles Transform Us for God's Purposes/Dawn Amsden Stark

Copyright @2021 by Dawn Marie Stark

Published in the United States of America

Library of Congress Control Number: 2021916785

Editing by Leanne Wickham of Red Pencil Proofreading & Editing
Typesetting by Sally Hanan of Inksnatcher.com
Cover design by Jessica Salas of Alas Creative Design
Original cover and chapter art by Isabelle Stark

Identifiers: ISBN: 978-1-7374916-0-6 (paperback) | ISBN 978-1-7374916-1-3 (hardback) | ISBN 978-1-7374916-2-0 (e-book)

*For Tim*
*One of us is always pushing to go faster.*
*One of us is always pulling to slow down.*
*Together, we are always right on time.*
*Thank you for always jumping into the trenches with me.*

# TABLE OF CONTENTS

*O God, you have taught me from my earliest childhood,*
*and I constantly tell others about the wonderful things*
*you do. Now that I am old and gray, do not abandon me,*
*O God. Let me proclaim your power to this new generation,*
*your mighty miracles to all who come after me.*
*—Psalm 71 NLT*

# DEDICATION

My Grandpa Jimmie Lybarger was not eligible to fight in WWII due to a spot on his lung. During an era of intense nationalism and militaristic fervor, Jimmie was unable to join his brothers and friends in the South Pacific or Europe. There was nothing he wanted more than to enlist and fight in the raging world war. He tried multiple times and in every branch of the service, even lying to recruiters so that he could possibly find a way into the US Army, Air Force, or Navy. But every single time he was stopped because of that darn X-ray.

Make no mistake this was a defining moment in my grandfather's life. In fact, he and I talked about it the week he left this earth. I honestly believe it was one of his greatest regrets, not being able to participate in such a worldwide effort to fight darkness. He was motivated by the euphoric reaction of patriotism that was never balanced by the harsh realities of war. All Grandpa knew was what he was denied; he did not understand it was not time for his war. His war wasn't held in the 1940s; he wasn't destined to fight fascism.

My grandpa was a warrior, but he was not a natural warrior. He was meant to take a backseat to physical war and to prepare for multigenerational spiritual war. That spot on an X-ray, which toward the end of life he would find out was nothing but a spot, saved his physical life to serve his actual destiny. He was supposed to remain faithful in marriage to my grandmother, raise a family, become a skilled tradesman, fall in love with his Savior, and spend his twilight years freeing captives for the eternal King.

My grandpa ministered to prisoners until a few months before he died at ninety years of age. He led countless convicts—many undeserving of society's grace—to the cross. He opened pathways to redemption through the basic understanding that all men fall short of the glory of God, while at the same time, opening pathways for our family to serve those needing social justice.

I dedicate this book to all those who make war, whether it be physical or spiritual. All are worthy of our honor, respect, and admiration.

# PREFACE

Although it will tell my story, *Called to War* is not a how-to guide for infertility treatment or a treatise on adoption. This is also not a Christian self-help book. This is a book about faith and transformation, about becoming someone new entirely while facing a lifelong battle or difficulty. This book is also about how the very thing you might run from in the beginning becomes the very thing you embrace, because a journey with God transforms your eyes, your heart, and your walk. Finally, this is a book about surrender of self while learning to sacrifice for others.

I want to recognize and salute our military and veterans who have given their lives, energy, time, and dedication in the service of our country. The comparisons to a personal war on infertility and adoption are in no way meant to minimize the actual horrors of combat or to diminish the personal price millions of Americans have paid for our nation's freedom. This is a literary comparison of my personal journey which required pressing forward into battles I never knew existed and ones that terrified my soul.

Although I've done my best to stay truthful with military terms, this is a book written by a civilian. Please excuse any terminology that has not been appropriately applied and instead consider the message being conveyed beyond the words. I did not pick one branch of the service as my frame of reference, but there may be times when I might employ a phrase that is only used by one branch of the military. Also, my use of job roles (recruit, spy, general) is again for literary purposes and does not necessarily correspond with the actual method of advancement or promotion of rank within today's military. I recognize that starting as a drafted or an enlisted man may not produce the same levels of advancement portrayed in this material. The terms "recruit" and "solider" are often applied in a broad sense.

None of my material was meant to define any one particular journey or capture all the possible exceptions and multilayered complexities of the modern military. This material is meant to honor, but it is primarily meant to draw spiritual parallels. For any infraction of the military code or specific areas of conduct or duty, please forgive me.

# INTRODUCTION

How did I get here? I did not enlist for this fight. I never even consciously knew this war existed. My innocence is quickly stripped away, and in its place, I find only overwhelming fear. I must learn to fight, how to save myself and my dreams in this terrifying battle.

My grief becomes my encouragement; my emptiness is my drive. After stumbling around in the war zone for years, I develop a strategy and head for the front. Doctors, expensive medications, and painful surgeries become my weapons. Forging on through this long season, I keep attempting to structure a peace treaty, but instead I am pulled deeper into the fight. This is crazy. Is what I want such an impossible request? I carry the flag in this army, waving it before my Commander-in-Chief screaming, "Can't you see my desires; don't you care about me?"

As the years wage on, I am convinced this conflict will never subside. I feel so alone in this fight. My hope and longings turn to despair, anger, rage and ultimately depression. How can I make peace with my enemy? How can I live defeated and ever find life? How can I forgive God for the destiny he chose for me? Will I die in the process and never find fulfillment in this life?

I begin to run out of ammunition and drive. The funds to support my private war are depleted; the source has dried up. Ultimately, the last struggle concludes and the fog from the cannon fire slowly begins to fade away. The battle is over. I survey the carnage around me; the broken pieces of my life litter the ground. I wave the white flag of surrender and make a peace treaty with my Lord and the terms of surrender are written.

Out of unconditional surrender comes an entirely different life. I am transformed into someone new. Now I freely embrace a life that is called to war.

# PART I

# BEFORE WAR

Open your eyes and look at the fields! They are ripe for harvest.

—John 4:35

# 1 My Conscription Notice

## Confessions of a Twelve-Year-Old Girl

*To expect the same service from raw and undisciplined recruits, as from veteran soldiers, is to expect what never did and perhaps never will happen. Men, who are familiarized to danger, meet it without shrinking; whereas troops unused to service often apprehend danger where no danger is.*
—George Washington, General of the Armies

I grew up in church. The first church I remember attending was called Eastfork Baptist located in West Frankfort, IL. This church was set up on a hill, out in the country, surrounded by a cemetery. I'm fairly certain the reason this church stands out in my memory is because it didn't have inside plumbing. As a young child I was forced to use an outhouse and that terrified me! I can still see the spiders in the corners of that antiquated wooden structure, not to mention the fear of other beasts that might have been lurking below. The term "holding it" took on a whole new meaning when faced with using this facility in the extreme cold of a Midwestern winter. The raw combination of the surrounding cemetery and the outhouse seared that early church deep into my memory.

My parents become devout followers of Christ in their midtwenties when I was about five years old. After their conversion, they both actively pursued a relationship with Jesus. My mom studied the Bible constantly; I remember swimming with my younger brother while she

2

tanned and read her Bible. She was and still is passionately in love with her Savior. It was this woman who led our family in a quest for doctrinal truth. Her search and discovery of faith resulted in getting our family kicked out of both the Methodist and Baptist denominations, until we found our place among the growing charismatic movement of the late seventies.

When I say I was raised in the church, that's what I mean. We attended Sunday morning, Sunday night, and usually midweek services. My mom led women's Bible study groups and my dad led worship and various service projects. I remember playing on the giant rock pile while my dad helped Eastfork Baptist leave the Dark Ages and build a new church complete with inside bathrooms. My memories are filled with the sound of Dad's voice coming across the microphone leading hymns and the sound of my mom's voice praying and teaching God's Word. I also recall the laughter of friends in Sunday school rooms and youth services.

In August 1979, I turned twelve years old. It was in this month two major events occurred in my life: I made the cheerleading squad, and my dad started Son Life Church. You may be scratching your head at this odd combination of the secular and the sacred, but for me these were both defining moments.

I had been "in training" for years to become a cheerleader in the seventh grade. In my town, the junior high school cheerleading coach was also the elementary school's PE teacher. Her name was Eileen Westfall, and she was my favorite teacher of all time. Mrs. Westfall taught us gymnastics as part of PE and offered after school and summer programs to help us master our skills. Essentially, she prepared her girls for cheerleading years before they were even eligible to try out for a squad. My mom will tell you that I spent my childhood upside down with my feet in the air. I practiced, and practiced, and practiced for years to be ready for tryouts. Competition was tough with so many young girls technically qualified for the role. To say becoming a cheerleader was my long-term goal during the middle school years is probably the biggest understatement of all times.

During these same years, my parents had also been preparing for their new role as pastors. They had served in nearly every imaginable capacity in the churches we'd attended. It was in their early thirties that they relinquished a successful personal business and accepted a call to full-time ministry, a decision not made lightly as parents of five children. Doors opened wide and pieces fell quickly into place for the birth of a work called Son Life Fellowship in Collinsville, IL. Initially we were only a fellowship of people who joined together for the charismatic worship experience; later, we transitioned into a church of committed saints who believed in building the kingdom for future generations.

I was busy living out my childhood dreams, and my parents were busy building the church. Every single moment of my life was occupied between these two spheres of life—well, those and my three new baby siblings, but that's another story of my parents' busyness all together! Somewhere in the midst of all of this activity, I read a book about missions that pierced my heart. I don't remember the title of the book, but it was a love story of life on a mission field wrapped in the biblical concept of the fields being ripe for harvest (John 4:35–37).

Although my heart was filled with this all-important role of being a cheerleader for the Troy Trojans, I couldn't deny the emotional tug that this newly planted mission seed had created. I read the book several times and wept over the heaviness of personal sacrifice and fulfilling love these characters experienced by giving their all for others. Somewhere in the middle of my twelfth year, I remember surrendering to a mission's call and dedicating myself to the world's disenfranchised and lost.

Acting on my interest, my parents connected me with missionaries who shared their inspirational stories and testimonies with me. I remember going out to lunch alone with a missionary friend of the family. Aside from the awkwardness of being a preteen alone with an adult female I barely knew, it was cool to listen to her stories about life on the mission field. The more I learned, the more I was intrigued. At some point, my parents decided it would be a good idea for me to go on a mission trip. Dad had connections in Mexico and before I knew

it, we were heading to Galveston, Texas and crossing the border for some real hands-on missionary work.

Wait—*what?* Everything about this trip was very different from the scenario my mind had painted about mission work. This wasn't romantic; it was work! Sitting in church services and listening to the messages twice because of the translation process bored me to death! Everything was dirty and the people were poor and it did not interest me at all. I did not feel compassion or even pity. The whole experience was a total disconnect. Apart from my first experience with nachos, the food was gross. I just wanted to get out of Mexico and on to Padre Island, my one-day beach reward on the other side of the trip. And I wanted my mom. I missed her and just wanted to get home and put all this nonsense behind me.

It's a funny thing when fantasy meets reality and perspectives are adjusted. I quickly figured out that life as a missionary was going to cost me something—lots of things. My twelve-year-old brain could not see beyond the physical comfort and the normal by which I defined life. All the compassion that I had felt for people in foreign lands quickly evaporated once I put my feet on their soil. I didn't yet have eyes to comprehend mercies in the process or ears to hear the cries of the fatherless. In my heart, I closed (actually slammed) the chapter titled "missions" while I was still in Mexico on my very first trip.

Thirty years of hindsight later I believe the actual conversation in the heavenly realm was recorded something like this:

**Me**: "No, thank you, God, I'm pulling back that vow I made to life as a missionary I blindly made a few months ago. I'm going to be a cheerleader. I'm going to be normal and popular and just like everyone else I know. I might even be an Olympic gymnast. I'm not interested in Destiny Door #1. I'm an American who can be anything I want to be, and I don't want to be this. I'll go to church and all, but I won't be doing things for others. I'm choosing to refuse a life of surrender and sacrifice. Pick someone else."

**God**: "It's okay, daughter, you can be a cheerleader today. But my seed's been planted and your draft notice into my army has been issued. My fields are ripe for harvest, but not in the way you understand

it today. The world is filled with sons and daughters just like you who need a family and need to be loved. I will work in your life and place an unquenchable compassion and understanding of sacrifice. You will dream my dream in due season, and it will be the delight of your heart."

# 2 My Reporting Orders

# A Location Change

*Why did these men fight? The answer to this question is simple. We are ordinary people, molded into Marines. We came from different backgrounds; however, we became a team, moving and fighting as if we had known each other all of our lives.*
—George Krug, a corporal with Fox Company of the 5<sup>th</sup> Marines, Korean War

I married Tim Stark when I was eighteen years old. Actually, I turned eighteen on a Tuesday and we married that same weekend. I was— *shall we all just agree right now*—in a hurry to begin the only adult life I recognized.

Okay, now that you've had a minute to absorb that shocking fact, let's all pick up our jaws and move on. Here's some important backstory to put the whole married-at-eighteen-thing into more context. During my junior year of high school, my parents decided to move closer to church and the new Christian school which had opened a few years after our church began in 1979. It all went down something like this: I went away to cheerleading camp in July with my varsity squad and my parents put our home up for sale, which sold in a matter of days. Mom found a home she loved that didn't appear to be for sale, but when Dad knocked on the door to inquire, he learned the owner was just about to put the sale sign in the yard so my parents bought said dream home in Collinsville. I returned home from a week away at camp to a fresh "sold" sign in our yard.

7

I could probably elaborate more about this "miraculous" house sale, and my ensuing reaction, but suffice it to say that once again at sixteen years of age, my sacred and secular worlds collided. This time, pieces of my parents' world came together while huge chunks of my world suddenly shattered.

Our move from Troy to Collinsville was only a distance of five miles, but it might as well have been on the other side of the planet. Not only were we moving, but I was also being enrolled in the Christian school along with my other siblings. My parents' decision forced me to give up every place I found value: cheerleading, swing choir, student council, German Club, not to mention all of friends and everything I'd ever known. This move might have been a dream come true for them, but it meant a huge loss for me.

I was mad, sad, furious, depressed, and unhappy—did I mention mad? Well, I was mad, and everyone around me knew it, too. God bless the teachers and fellow students who had to put up with my better-than-you-attitude throughout my junior year of high school. I couldn't believe that my parents, much less God, had forced this new life upon me. Just like the trip to Mexico a few years before, I was all "no, thank you very much" to the future being forced on me.

All I could see or hear was what this relocation had cost me, not what I was gaining in the transition. I didn't understand the Christian scripture that explains often we have to lose our life to find it. I mean, it's repeated over and over in the Gospels for goodness' sake, so we should clearly see this sort of thing coming:

> "Whoever finds their life will lose it, and whoever loses their life for my sake will find it."
> —Matthew 10:39

> "Whoever wants to save their life will lose it, but whoever loses their life for me will find it."
> —Matthew 16:25

"Whoever wants to save their life will lose it, but whoever loses their life for me and for the gospel will save it."
—Mark 8:35

"Whoever wants to save their life will lose it, but whoever loses their life for me will save it."
—Luke 9:24

"Whoever tries to keep their life will lose it, and whoever loses their life will preserve it."
—Luke 17:33

"Anyone who loves their life will lose it, while anyone who hates their life in this world will keep it for eternal life."
—John 12:25

You can say it six ways from Sunday, but it all means the same thing: when you lay down your plans and hopes for life, you find that God has something altogether more rewarding than the life you envisioned. Oddly enough, this new life often encompasses many of the same characteristics and passions but is fashioned in a different shape than we imagined. It's all part of the upside-down thinking that is required by followers of Christ. All the disciples (eventually) grasped this truth when they walked the earth with Jesus. They all experienced the shift and realignment of an earthly reality when they embraced a heavenly truth.

But, at this stage of my Christian development, I could barely function to obey my parents, much less comprehend what it meant to voluntarily lay my life down. I left nail marks on the door to my past, clinging onto my old life with all the strength left inside me. Always a prolific dreamer, this season of my youth was marked with dream after dream that I was dying. My soul was echoing the reality of my external life. The months that followed our world-rocking move were the closest I ever came to rebellion. I felt it grab hold inside my heart, but thankfully I had enough Christian character at the time to resist outward expressions of my pain. (Ok, it was probably not Christian

character as much as it was fear of my parents and of my God! And also, there was grace, lots and lots of grace.)

I didn't understand what a journey with God looked like or felt like when I was sixteen. Looking back, I can see how this physical move was a huge jump-start to my unfolding story. I was stupid and young with messed up priorities (I still hadn't shaken my all-important cheerleader status), but God was gracious and patient, never failing to miss an opportunity to mold into my life his eternal perspective. As a good architect, he knew exactly how much pressure and shift my structure could endure. And yet, his limitless perspective also knew that night seasons are necessary for true joy to come in the morning (Ps. 30:5).

The pressure and shift of those days was simply all about getting my feet on the right path. This was not the season for me to develop skills of patience; that process would mark my twenties and thirties. I didn't have to wait long for answers to be revealed and to see the new path rising up to meet me. Concurrent with my realignment process, my new path was also being realigned by a move. After a few years attending Bible school in Oklahoma, Tim Stark was moving back home to begin his ministry as a youth leader…in my church.

Tim was handsome, outwardly confident, perfectly styled and drove a red convertible, traveled with a national ministry, and seemed to have his life together. We'd known each other for several years, but our five-year age difference kept us separated in different worlds. When Tim moved back home to step into full-time ministry, we suddenly noticed each other in a different way. We each told our friends about the "older guy" and the "younger girl" situation before we'd even spoken to each other about our feelings. I can't explain the internal knowing we both experienced, separately and yet concurrently—it was like we both knew "he was the one" and "she was the one."

Tim was home from college trying to find his next life step; I was pulled out of high school trying to find my next life step. Although we were most definitely in different stages of life, in hindsight I can clearly see how our common storyline naturally led us toward a relationship. He started hanging out in my circles, which initiated a real friendship,

which eventually turned us into a couple. Ours wasn't an arranged marriage, nor was it a courtship. We were just two people in the midst of "location change" whose paths intersected at, what I'm certain was, a predestined moment in time. For us, the age difference became part of our love story and was the first barrier that we learned to navigate as a couple.

I'm fairly certain that being pulled away from the typical high school mentality jump-started my adult journey. I graduated from high school early and held a retail management job that I adored. Although I was an honor's student, there was not an obvious career path calling my name or leading me toward college. In short, I was in love with someone five years older and uncertain of what I wanted to do with the rest of my life.

As the oldest of five siblings, I knew being a wife and mommy were the only real-life goals I could define. I was the pastor's oldest daughter, and Tim was the energetic youth leader. In our universe, we were the "it" couple with a romantic start and a bright future in ministry. Other than my uncle, who was more than a little displeased that I was not going to college, everyone else in our world was excited about our plans to marry. While opportunities for women were opening wide in the 1980s, early marriage was still very common. I was excited about spending the rest of my life with my best friend, being a real "grown-up," and finally possessing the ability to make my own choices.

Tim bought our first starter home and worked tirelessly to get it ready for us to occupy after the honeymoon. Our August wedding was enormous with five hundred guests, thanks to the booming size of my parents' church and Tim's youth pastor role. After the wedding, we took a two-week dream honeymoon to Hawaii and kicked off our lives in true exotic fashion. I might not have known what I wanted to do with the rest of my life, but I was dead set on the honeymoon in paradise part. In fact, Tim might even say that one of my terms for marriage was the Hawaiian honeymoon! It was the picture-perfect start for the picture-perfect couple.

You may be thinking right now, well, that's an interesting and cute love story—thanks for sharing. Or you might still be picking your jaw up from the opening of this chapter and what you feel is a ludicrous defense of a child bride, and I'm not saying you're wrong! Regardless of your assessment, I want to be sure you understood why I shared this narrative and how it folds into *Called to War.*

1) If my symbolic "conscription notice" was issued when I was twelve years old and gave my heart to missions, then it follows similar reasoning that my "reporting orders" were issued when I was sixteen years old and my family moved.

2) Finding my spouse was God's unique "mercy in the process" during my relocation/ alignment period. Not only was Tim receiving his own set of relocation orders, but he was also God's gift to me as a friend. He was a new (and unforeseen) beginning when I was jolted from the pathway I was traveling.

3) My marriage was also key to my future processes. This story is the perfect example of how one season transitions and flows into the next, with each season delivering unique highs and lows.

# PART II

# INFERTILITY WARS

For nothing will be impossible with God.
—Luke 1:37 (ESV)

# 3 My Boot Camp

## The Barren Season Begins

*Normal people can't do the things warriors are asked to do.*
*They can't imagine it and shouldn't be forced to. But there*
*are those that do. For these people though, there must be a*
*transition from 'civilian' to 'warrior.' Boot camp is the*
*means of that evolution, and every part of it is necessary.*
*—Jon Davis, Marine Sergeant, Iraq vet*

Somewhere in between the "getting to know each other" and the "falling head over heels in love" phase, Tim confided in me that he was born with a birth defect called hypospadias.[1] I can still remember how afraid he was to open up his soul and reveal this part of himself to me. I'm fairly certain it was this conversation that actually sealed our future together instead of breaking us apart. He had spent his entire life hiding this secret, a heavy weight that he had carried around all alone. Even today, I wasn't sure how to write about our infertility without uncovering this fact. But it's really true that time heals all wounds, or at least time gives you a new perspective to frame the problem differently. In our journey through life together, this has also become my birth defect and in many ways, I've shared this problem with him.

A hypospadias is a common congenital birth defect occurring in one out of 150 baby boys, which typically requires two corrective surgeries during the toddler years. But Tim was born in 1961, before the necessary microsurgery techniques were developed. Growing up, he endured nearly a dozen surgeries as his doctors attempted to repair

14

the problem (being ahead of the medical curve is something we would face again in the early 1990s). As you might imagine, this was a deeply personal and private matter that affected his life in numerous ways growing up. For example, while most kids spent Easter break goofing off with friends and playing ball, Tim spent Easter break in the hospital trying to hide the surgery from his peers.

His doctors were concerned that fertility might be an issue later in life, so his parents had raised him to believe that he would probably not be able to have children. As Tim's future bride, I of course needed to know this private and personal story. Both Tim and his parents honestly and transparently shared all of this information with me. Looking back on this time in our lives, with the truth so obviously staring us in the face, all I can say is that we must have been blinded. Well, obviously we were stupid, but blinded is a much easier word to swallow. We had all this (alarmingly vital) data, but instead of acknowledging the potential roadblocks with eyes wide open, we evaluated the information more like this:

We were in love (the past was behind us).

Ours was a picture-perfect story (everything will turn out fine).

We were the "it" couple (together we were unstoppable).

Love would overcome all (ah, the fallacy of our modern world).

Faith overcomes all negative reports (an oversimplistic doctrinal position).

Doctor concerns were outdated (we never even bothered to check).

I honestly never, *not even for one single moment*, had any concern that his birth defect would be a problem for us. Never. We were so in denial that I took oral birth control for the first year that we were married. We ceremoniously stopped taking birth control on our first anniversary; August 23, 1986, was the day we officially started trying to build our family. I remember deciding that "even though we weren't quite ready to have a family," we would stop trying to prevent it "just in case" it took us a bit longer to conceive because of the birth defect.

I still can't believe we wasted money on the pill for twelve months. It's hard to imagine we ever thought for even one moment that we would have any control over our fertility.

We were young, naïve recruits who showed up to boot camp on our first anniversary in August of 1986. Our blind and innocent honeymoon was over. War was on the horizon and it was going to be long, painful, and bloody, and it would cost more than we knew how to give in the quest to build a family.

I've explained my backstory in the hope that the introductory chapters would provide the framework for the core of this book. Naive immaturity would probably be a fair description of how I hit the "boot camp" phase of my life. Even for those who've willingly given their life over to military service, the boot camp process is fraught with difficulties and unexpected challenges. But, for those of us conscripted, who are unwillingly forced into service, boot camp is an unwelcome and intolerable interruption of life. In other words, for those prepared for what's ahead, it's incredibly difficult; for those unprepared, there are no words.

Boot camp is a season that separates recruits from everyone and everything in life that brings comfort for the purpose of transitioning men and women into soldiers. Everything normal about life is tossed upside down, including language, comfort, sleep schedules, food, exercise, personal space, relationships, etc. in order to systematically dismantle basic life routines and alter the recruit's old nature. I interviewed one soldier who reported he was required to change his handedness preferences (left to right) so that he could be the same as the rest of his unit.[2]

Although I've never personally been to boot camp, anything you read and everyone you talk to can attest to this systematic entry into the military. Teaching blind and unwavering obedience is necessary for the safety of the unit. Jon Davis, Marine Sergeant and Iraq vet says, "The most important single thing to know about boot camp is that it

is 100 percent designed to reprogram children and civilians into warriors."[3]

While military life and boot camp are altogether life changing, there are a few themes that seemed to emerge over and over in my research: being disoriented, being denied, and losing control. These areas therefore provide an excellent starting point to explain my introduction into our infertility journey and how being refashioned for a new purpose must begin with a de-creation process.

## Disoriented

Let's look first at the concept of disorientation, or being disoriented, which literally means "to cause to lose bearings; displace from normal position or relationship; to cause to lose the sense of time, place, or identity."[4] In essence, it is a confused state that doesn't fit within how life is defined as normal and impacts identity. Disorientation even has a medical application because it can be a condition affecting both the physical and mental spheres of a person. There is not a sense of how to proceed because the pathway is not defined; a form of culture shock occurs as the new environment sets in.

Normally when arriving at a new destination, school, or job, you go through an orderly process called orientation. But the converse is true when you begin life in the military. Instead of orientation, new recruits are submitted to a disorientation process. New recruits at boot camp explain that being stripped of all individual identity and existing only by your last name and a number contributes to the disorienting nature of the process. This is because the old identity of an individual must be transformed into the new identity of a soldier, which is necessary for the safety of the person, the unit, and ultimately the nation.

Recruits must stop viewing life, work, and quite possibly most importantly, liberty though the lens of "what's best for me" and put on a new set of glasses that see "what's best for my unit. "The Marine values of "God, Country, and Corps" indicate the hierarchical set of lenses that are applied to a recruit. Noticeably, "being true to oneself" is not in that list; in the military, "self" is sacrificed early in the transformation of becoming a soldier. Being willing to die for a higher

17

cause—a greater glory—despite one's personal feelings or needs is the ultimate purpose of disorientation.

By comparison, my early days of the barren season were eerily familiar to some of these situations reported by those who've experienced boot camp. I didn't understand what was happening or how to retain any sense of normal. Sadly, I had no idea I was a recruit. I felt more like a captive who was wild, wide-eyed, lost, and full of fear. I only saw one role for my life: motherhood. I knew of no other identity. Frankly, I wanted no other identity. Yes, at nineteen years old I knew exactly who I was and what I wanted to be for the rest of my earthly life.

A key part in the definition of disoriented that jumps out related to our infertility topic is *to lose identity*. Infertility is a condition of intangible loss that alters the normal state of self—or let's say it this way—the normal and expected progression of life. There is a very natural sense of identity that expects to participate in the human cycle of procreation. It's been hardwired into us spiritually, via the mandate in Genesis 1:28 to "Prosper! Reproduce! Fill Earth! Take charge!" (MSG); it's been hardwired in us physically, through passion and the sexual exchange that embodies love and results in reproduction; and it's hardwired into us culturally, expressed through all manner of traditions and customs. Who hasn't danced around a playground teasing classmates with the timeless song that affirms this normal progression of life:

Tim and Dawn

Sitting in a tree,

K-I-S-S-I-N-G!

First comes love

Then comes marriage

Then comes baby

In a baby carriage!

Honestly, I was so clueless at this point of my process I didn't even really know that infertility was a thing. Sure, I knew my dad's mother,

my Grandma Amsden, adopted my dad after parenting a string of foster children. Although I didn't yet understand the magnitude of the problem, I'd heard the tales and was familiar with my dad's empty pain. I knew that he carried a deep longing for his birth mother and that we never really knew the history of our lineage. Somewhere, deep down in the hidden places where fear lives, I'm sure I knew that she couldn't have children, or that so-and-so didn't have children for whatever reason, but it didn't quite click.

*I was not only an unwilling recruit; I was a blind and deaf recruit.*

Recruits don't know the language of the military; that's part of the indoctrination process of boot camp. I didn't have a cognitive awareness of infertility, so clearly, I didn't know the language. Heck, I didn't even totally understand the biology! Have sex, get pregnant, birth baby. This was my vast understanding of reproduction. Well, maybe my understanding was not that simplistic, but the point remains that I was completely unschooled about the science, (dare I say) industry, terminology, support systems, emotional pain, or lifelong baggage associated with infertility.

Not to go all old school on you with an *"I had to walk to school both ways, uphill, barefoot in the snow"* comparison, but the simple truth is that a majority of my infertility journey was completed pre-internet. This all began back in the days before the internet and social media transformed our lives, simplified research, and connected groups of people by circumstances and events. In the late eighties, a diagnosis of infertility was largely a long, lonely, and disorienting road.

I'd compare it to the first time you land in a foreign country with only your passport in hand, jetlag messing up your internal body clock, and masses of indigenous locals surrounding the airport exits shouting out greetings in a foreign language. You just stand there with a blank look on your face and endless questions overloading your out-of-control senses: Which way do I go? What did they say? What is that smell? Stop touching my luggage!

Instead of standing still, catching our breath, and rationally processing the temporary disorientation, humans naturally and instinctively give into the physiological fight or flight response.

Externally threatened by changes in our world, internally we scream, "I just want to go home. Please take me back to 'normal' as quickly as possible please!"

## Denied

Denied. Boom! The word falls so flat. So final. It's a powerful word we avoid like the plague. Denied, a past tense form of deny, has a few meanings: "to state that (something declared or believed to be true) is not true; to refuse to agree; to withhold the possession, use, or enjoyment of; to withhold something from, or refuse to grant a request of; to refuse to acknowledge; disown; disavow; to withhold (someone from accessibility to a visitor); to refuse to take or accept."[5]

First off, do you notice the use of refusal over and over in the definition? No matter how you want to slice it, denied is the dressed-up, grown-up, and polished version of *out-of-control, you can't live life as you used to when you are in the military. No, you can't have a baby when you are drafted by God into a transformation process. No, these terms aren't negotiable in any sense of the word.* No simply means no. DENIED!

During my research for this book, I conducted several informal surveys of military personnel. One of these surveys was designed to help me learn more about the boot camp experience. In this survey I asked respondents, "What were you denied at boot camp, and how did that make you feel?" Overwhelmingly, the responses were about being denied some form of freedom and self-expression: denied communication; denied time spent with loved ones; or denied a voice. One recruit said, "Freedom to have any personal time. Freedom to eat whenever you get hungry; freedom to call those you rely on for support." Almost everyone reported being denied sleep on a regular basis, lending to one of the most disorienting aspects of this new environment. Another recruit explained feeling denied the "freedom to make your own choices about what you do, eat, when you sleep. I just surrendered to it, but it sure made me appreciate that freedom when I had it again."

Although I personally have no experience with actual boot camp, it seems to me that boot camp is a structured, artificial environment

meant to use the powerful forces of denial to produce a new sense of resilience and character development in a new recruit *for the purposes of transformation*! In the case of the military, the environment is conditioned for the purposes of transforming civilians into warriors. In keeping with the symbolism of this book, being denied a baby was my induction into a spiritual boot camp, also for the purposes of transformation (or probably and more importantly, for sanctification!).

Okay, let's slow down here a little bit and take a closer look at the transformation process:

Transformation—or a metamorphosis—from one state to another does not simply occur on its own. It always happens because there is some form of an agent or a catalyst such as pressure, heat, or pain. Even hormones can be a catalyst! Although I majored in political science, I am clearly not a scientist. So, I'm not even going to try and use scientific language to defend this concept. Instead, let me illustrate the concept of transformation with some simple examples we can all understand and follow:

A piece of black, worthless coal can be transformed into a beautiful and priceless diamond through the catalyst of both pressure and heat.

The transformation of a caterpillar into a butterfly is gruesome, involving digestive enzymes triggered by hormones to activate the transformation process.[6]

Children grow into adults through the catalyst of hormones, fueled by food, rest, and love—yes, especially love. Endless studies exist to prove that when children are denied **any** of these key ingredients, they fail to thrive and grow properly.

The phrase "no pain, no gain" is a common exercise motto that proves physical transformation costs something. We all know the pain of too many squats or sprints about twenty-four hours after a hard workout. While we all want our eighteen-year-old bodies back, few are willing to endure the pain of transformation to achieve the goal.

Let's look at transformation through the daily activity of cooking. I love to cook, bake, and create in my kitchen. My mama taught me, and her mama taught her. One of my most favorite things to cook is a big

'ole pot of homemade soup. I don't even care which kind; I love to cook them all—from chicken noodle, to chili, to squash soup, to Italian-style soups—you name it, I'll make it! No matter which type of soup you make, there is always a raw base from which you begin. For me, it's usually a little butter, a little olive oil, and some onion, carrots, celery and a few spices. Oh, the ways you can expand from this small little beginning of raw materials! Regardless of the ingredients combined in a recipe, nothing brings a soup together like the catalyst of heat. Ingredients sit in a pot together, literally stewing. A bunch of individual parts come together, get reduced and transformed, to make something entirely new—and hopefully delicious. I always marvel when I make soups. I take pictures of the before and after and think about how purposeful and wonderful the process of transformation is in creating something delightful and unique all in my own kitchen.

Being denied something, whatever that X is in your life, is a powerful force. There is nothing quite like the experience of wanting something and not being able to have it that makes you want it that much more! There is a difference between being denied and living in a state of denial, which is equally as powerful and is covered in the next chapter. But right now, let's consider an example that many of us can relate to about being denied something: say you're on a diet, but every commercial on TV is about food. And not just any food, but gooey, cheese-dripping-pizza! Although you know it's not actually possible, you can practically smell that darn pizza! It seems that everywhere you look, there is imagery or aromas of savory foods you can no longer have, and all you can think about is what is being denied. Instead of remembering why you gave up pizza in the first place (to lose weight and presumably be healthier), you focus on the "what" you can no longer have.

While this is a lightweight example of denial compared to military conscription or infertility, the point I want to make is that we humans become fixated on what we can't have and lose sight of the bigger picture. Denial, in all of its forms, is a powerful force. Remember Adam and Eve? Placed in the opulent Garden of Eden, cared for by the Creator, masters of the entire earth, but deceived because of the one thing they were denied—the Tree of Knowledge. Yes, we all know

the story, and history now lives out the eternal results of one single act of refusing to live denied. When Adam and Eve focused on the forbidden fruit, they lost sight of their much bigger purpose and plan.

The real trick about denial is attempting to find a great purpose or a higher plan associated with the denial. Once you can align your vision to the plan, then you find a key to navigating the process.

Military recruits are being transformed into warriors. But the question facing me in my early twenties was this: what kind of transformation was a barren season for?

## Losing Control

I'm going to come clean with y'all right now: **I am a control freak.** It's true. I am top to bottom and inside out your stereotypical firstborn Type A perfectionist. Every word of this section is so difficult to write because it's like standing up at some sort of an addiction anonymous meeting and finding the strength to say for the first time: "Hi, I'm Dawn" (.... group murmurs "Hi, Dawn") "I'm a *control*-aholic. It's been like twenty minutes since I tried to control something."

Turns out after you wade through "disoriented," and trudge through "denied," you hit the rock bottom deal of "control." It's like teaching a Siberian Husky puppy to submit to a leash. Let me just say right now, you better buy a lot of leashes because I've personally lost count on how many of them will be chomped through in the submission process. At this stage of the training, someone's got to give up control and follow. (I think you might be able to tell by now that control issues might have been a major factor in my prolonged boot camp process.)

Control is defined as "to direct the behavior of (a person or animal); to cause (a person or animal) to do what you want; to have power over (something); to direct the actions or function of (something); to cause (something) to act or function in a certain way."[7]

Control works two ways: you are either the one controlling or the one being controlled. It is a result of applied hierarchy and power of some sort. Ah, those pesky issues of hierarchy and power that are

expressed in many different ways throughout life, whether that is governmentally, professionally, relationally, or spiritually. Someone or something is always leading and directing. We are always—in every conceivable situation—either the leader or the follower. You've heard the phrase, "no man is an island"? Well, it's true. None of us stand alone; everyone and everything surrenders under some system of control. Like it or not, man is not autonomous (can we say original sin?).

Think about it; where can you outrun control? As much as human beings may want to cast off restraints of society, economics, faith, morality, or family, there are limits to outrunning every system and every form of control. You'd be hard pressed to run away from every form of government on the planet. For example, let's say you ran to the rainforest in Brazil. Deep into the Amazon you might be able to hide out from the government and maybe people, but you would not be able to run from a system of control called the weather! Nope, it will rain there no matter how tired you get of rain. That's because man cannot control the weather! Consider the literal and physical control that gravity holds over you. I suppose you could become an astronaut and leave the planet, to avoid gravity and the weather (but not government or economics, as you would require one of those systems to arrange your ride to outer space). However, this is not a way to avoid control because now you have to face the effects of antigravity. This is not good news for all of us control freaks. Turns out, most of the time, control is simply an illusion.

At some point in each of our lives, we will face a situation that requires us to surrender. Recruits surrender to sergeants; children surrender to parents; parents surrender to each other; adults surrender to employers; employers surrender to customers; citizens surrender to government; governments ultimately surrender to each other; people surrender to death. And everyone in one of these entities—in some expression, in this life or next—surrenders to the Sovereign of the universe. Yes, even governments. Scripture is very clear that God raises up and lowers kings and governments (Dan. 2:21; Rom. 13:1). Like it or not, deny it or not, we are living in the created order; therefore,

everything and everyone surrenders control to the Creator. Unavoidable. Unarguable. Unexplainable. Unconditional.

The sovereignty of God is a lifelong study that would fill volumes and still not crack the deepest mysteries of the Eternal. For anyone growing up in a post-Christian, democratic, humanistic, liberal society, the sovereign nature of God is unthinkable control over what we believe to be an autonomous life. Even for me, raised in a practicing Christian home, it made no sense. Looking back, I can see a twenty-something-year-old who was unwillingly dragged into service by a sovereign God. The sad truth about my story is, I didn't know my God or His ways. God summoned me to active duty. He decided it was time for me to be introduced to His sovereignty, in all of its mystery, marvel, and majesty. But I missed the memo announcing this change. I just knew our world was shifting and, in the shift, we lost control. And we were being denied. I didn't understand that those He loves, He matures. Whether that is through a pit, a prison, or empty arms as it was for Hannah.

Turning now to Scripture we need look no further than Hannah to find a pattern for the barren season. If you are unfamiliar with Hannah's story, take a few minutes to read through it to get caught up before moving on with me:

> Now there was a certain man of Ramathaimzophim, of mount Ephraim, and his name was Elkanah the son of Jeroham, the son of Elihu, the son of Tohu, the son of Zuph, an Ephrathite:
>
> And he had two wives; the name of the one was Hannah, and the name of the other Peninnah: and Peninnah had children, but Hannah had no children.
>
> And this man went up out of his city yearly to worship and to sacrifice unto the Lord of hosts in Shiloh. And the two sons of Eli, Hophni and Phinehas, the priests of the Lord, were there.

And when the time was that Elkanah offered, he gave to Peninnah his wife, and to all her sons and her daughters, portions:

But unto Hannah he gave a worthy portion; for he loved Hannah: but the Lord had shut up her womb.

And her adversary also *provoked her sore,* for to *make her fret,* because the Lord had shut up her womb.

And as he did so year by year, when she went up to the house of the Lord, so she *provoked her; therefore she wept,* and *did not eat.*

Then said Elkanah her husband to her, Hannah, why *weepest* thou? and why *eatest thou not?* and why is thy *heart grieved?* am not I better to thee than ten sons?

So Hannah rose up after they had eaten in Shiloh, and after they had drunk. Now Eli the priest sat upon a seat by a post of the temple of the Lord.

And she was in *bitterness of soul,* and prayed unto the Lord, and *wept sore.*

And she vowed a vow, and said, O Lord of hosts, if thou wilt indeed look on the *affliction* of thine handmaid, and remember me, and not forget thine handmaid, but wilt give unto thine handmaid a man child, then I will give him unto the Lord all the days of his life, and there shall no razor come upon his head.

And it came to pass, as she continued praying before the Lord, that Eli marked her mouth.

Now Hannah, she spake in her heart; only her lips moved, but her voice was not heard: therefore Eli thought she had been drunken.

And Eli said unto her, How long wilt thou be drunken? Put away thy wine from thee.

And Hannah answered and said, No, my lord, I am a woman of a *sorrowful spirit*: I have drunk neither wine nor strong drink, but have *poured out my soul before the Lord*.

Count not thine handmaid for a daughter of Belial: for out of the *abundance of my complaint and grief* have I spoken hitherto.

—1 Samuel 1:1–16 (KJV, emphasis mine)

Clearly, Hannah experienced being disoriented and being denied, and she had lost all control—emotionally, relationally, reproductively, and spiritually. She is the Bible's poster child for barrenness, or in today's vernacular: infertility. Hannah was dearly loved by her husband, Elkanah, who favored her despite her inability to bear him children (vv. 2–5). But to all of us who've experienced infertility, and as I mentioned in the previous section on denial, it's really hard to shift your focus away from the **X** you are being denied. In Hannah's case— and in my case—that **X** is the ability to conceive and to have a child, the reproductive phase of life that so many people take for granted. Even Hannah's husband didn't get the magnitude of the problem. How many wives struggling with infertility can relate to this concept? It's so hard to grasp the loss of such an intimate rite of passage, the loss of being a mother. I still struggle to find the proper words to describe the ache, the loss, the prolonged loss, the monthly loss, the intangible but very personal loss of motherhood.

Hannah's sister wife, Peninnah, didn't make life easier for Hannah either. She taunted her for being unable to conceive. She is called her "adversary" (literally, *vexar*, rival wife[8]) who "provoked her sore" and "made her fret" (vs. 6). Now, while I didn't have a baby-factory-sister wife to contend with during my infertility, I did face the taunting societal norms that are constantly thrown in your face. After a few years of marriage, the questions just naturally start. "When are you going to start your family?" As time progresses, and as your friends all begin having babies, the pressure from well-meaning, yet clueless,

acquaintances begin to grow. Duck and cover, dodge and avoid, becomes the strategy at holiday gatherings, weddings, and (God forbid) baby showers. I've endured my share of vexing too, being the brunt of many jokes that begin with phrases such as "Let me show you how it's done!" and "What are you doing wrong?" Yep, come to think of it, anyone who lives in the land of the infertile for any time at all must learn to face the unrelenting nature of torturous comments, even from people who are supposed to love you and know better.

Nowhere in Scripture is the picture of when empty arms become a heavy burden[9] better portrayed than right here in 1 Samuel 1. Unfolding like a journey through the grief cycle, Hannah experiences denial, anger, bargaining, depression, and acceptance.[10] The terminology used to describe Hannah in this chapter is so vivid and strong. I've italicized for you all the terms in this short passage that speak to the emotional pain Hannah experienced. By my count there are fourteen references in sixteen verses! The physical description is of someone distraught, depressed, and desperate; she was a woman who pleaded unceasingly before the Lord for a son. She struggled with "bitterness of soul" and "wept sore" (vs. 10). To this day, it pains me to read this section of Samuel because my identification with Hannah is so deep. Has your heart ever been so grieved that you have wept sore? I have. I can tell you exactly where I was in those moments of time when I constructed and attended to an altar of tears. These moments leave scars, invisible to everyone else in your world, yet forever etched into the soul of the brokenhearted one.

But, as a new recruit in an infertility war, the part of this story I have struggled with the most is the statement that "the Lord closed her womb" (vs. 5). In case you think this is a typo of some sort, or an ancient mistake by the author, it's repeated again in verse 6! This implies that God took action to deny Hannah "year by year" (vs. 7) though she wept bitterly. Hannah, favored by her husband, was quite clearly denied a son by a sovereign Creator. Sometimes, God just says no and, in that place, we must come to terms with His sovereign nature. This is the hard and painful truth of maturing and submitting and becoming; all the tears, depression, and bitterness of soul don't alter the process that's ahead.

# 4 Life as a Soldier

# The Process of Transformation

*The truth of the matter is that you always know the right thing to do. The hard part is doing it.*
—*General Norman Schwarzkopf*

After boot camp, I entered a long period of time that involved figuring out the landscape of our new reality, grasping hold of the treatment options for infertile couples, and sorting out what came next in our journey. You must know that each of my actual phases lasted much longer than any militaristic system of being drafted or basic training. I would have been that soldier who was always trying to find a way out of this new environment I found myself facing. I was the worst soldier ever. I wanted the wide path, the easy way, children arriving on my schedule, a large home decorated top to bottom, an upgrade on my diamond every five years, annual vacations to the beach, and so forth. I wasn't asking for much really, just the picture-perfect family living out the complete American dream—all while attending church, of course. I could not hear or understand the words of either sacrifice or service. God was leading me on toward a richer life, filled with direction and purpose, but all I heard was the mumble of *denied*.

In hindsight, my personal maturity and small perspective of the world contributed to some of the problems with the post boot camp phase of my infertility journey. **I just didn't know enough about everything to have a grasp on anything.** Remember the child bride narrative in Chapter One? Tim had lived away for a few years and traveled the US during his time in Bible school; I had vacationed in a

29

few places, namely Florida, been to Mexico, and of course, had the aforementioned honeymoon in Hawaii. But we both viewed life small and narrow. Suddenly thrust into a larger box, we didn't know how to function; we couldn't touch the walls on either side or reach the top and bottom. Not only did we not fully understand the problem of infertility or the available fixes, but we also didn't see the bigger purpose associated with the trials and tests that God sent our way.

After boot camp, soldiers advance into the specialized training for the position they will occupy. Each branch of the US Armed Services has a slightly different system for this portion of a soldier's training; many times, this route is predetermined prior to boot camp. This process also varies greatly for officers, whom I might add still must attend schools and training, but along a different set of development tracks. For the purposes of brevity, let's examine what happens to a Marine after boot camp:

After your Marine has graduated boot camp, they will need to complete their next phase of training at the School of Infantry (SOI), where all Marines attend 'every Marine a rifleman.' Then they will move to their MOS training (Military Occupational Specialty) where they will attend their job specific school. Each school differs in length, location and requirements and once the training is complete, your Marine will be assigned to a Permanent Duty Station where they will begin their career.[1]

As we can see, training and education for a Marine requires several steps beyond boot camp. It's this secondary phase that makes a Marine combat ready. All Marines attend the School of Infantry, where there are two different directions a Marine will take: they will either proceed to Marine Combat Training (MCT) or Infantry Training Battalion (ITB). Generally speaking, after completing the SOI, Marines continue training for their particular career course known as MOS. The training for MOS is unique to the career the Marine is being prepared for; therefore, there is no standardized time or location for this phase of education.

Like growing up or attending college, training to become a Marine doesn't happen overnight, in a few weeks, or even in a few months. Depending on the position you are training for, this entire process can take well over a year. There is a process to becoming a soldier in today's military. But, somewhere in the middle of this training is where the good stuff happens. It's right about here that transformation begins to become evident externally! In this phase you begin to form a new family, speak a new language, and build unit camaraderie. A sense of belonging and identity is established over time and through the exertion of blood, sweat, and tears. It's here in this place, in the learning phase, that identity is reshaped, refocused, and refined. It's where vision is expanded and boundaries are enlarged. Oorah!

Here's a new analogy. Have you ever put together a puzzle? I'm talking a 1,000-piece monster puzzle that gets dumped out onto a table in a zealous "let's have fun" moment. First of all, let me just tell you that's insane! There is no planning or strategy in that dumping action. It may be fun in that moment, but it doesn't take long to know you are in trouble. A large puzzle simply cannot be worked in one sitting. Sooner than you think, all the pieces start looking exactly the same. If, *for the love*, you dump said puzzle out onto the only table you own, I can tell you right from the start that you are in jeopardy of failure!

Here's what I've learned about puzzles: first off, pick one that has separate and distinct images. If your 1,000-piece puzzle image is a herd of zebras drinking water in lake that mirrors their reflection, then stop right there. Put that puzzle back or buy another table! I'd also recommend skipping the 3-D and the non-interlocking varieties. These bring me to the edge of sanity, which is the polar opposite of the plan to "have fun." When you'd rather be outside picking weeds from an overgrown garden or cleaning out a refrigerator, you may be in too deep water with your "toy."

I'll also add—*and this here is free advice, so you're welcome*— never buy a puzzle from a thrift store or yard sale. Nope, just move on past the temptation of the low prices and walk yourself into a store to purchase

a wrapped puzzle from a retail outlet. Trust me, you will thank me at the end when you are actually able to place the final piece instead of coming up short. (Have I mentioned my OCD tendencies yet?)

Keeping in mind these exceptions about picking a puzzle, the next step is preparing to work it. After dumping out the pieces, the first thing I do is display the box top in a central point on the table for quick reference. This gives me my color and graphic pattern to follow. Then, I sort outside pieces from inside pieces. This is a relatively quick step that I am convinced saves hours of frustration. My plan is to build the frame first, then add on from there. After the frame is built, the project hits the tedious phase. Man, it's hard here. None of it makes any sense. Nothing you try fits together. Everyone who started this puzzle with you has already left the table. However, there you sit shoving random edges together, trying to force the picture to come to life. It shouldn't be this hard! I just wanted to have fun! It's at this phase when you want to gather up all the pieces and shove them in the box again.

But, if you push through the frustration and the disconnected parts, if you allow your eyes to focus on each particular piece, something begins to change. Suddenly, two pieces fit together, then another one fits, and then another locks in place. It's not that you still don't go down frustrating paths that are annoying and difficult, but it's not as bad as it was in the beginning. You are learning to lean into the tedious process of putting together the puzzle. And to your quiet surprise, you find joy with each and every piece that does come together. This is the point where you start to identify patterns and build the story, to slowly begin to pull together the restored image from the scattered pieces.

It all gets exciting, and oddly fulfilling, when you discover how a whole bunch of these odd and random pieces come together in the picture that made no sense to you a little further back in the process. The process moves from piece-by-piece building to chunk-by-chunk building. This is the part of the process where it gets good! You gain confidence, and you start feeling happy and accomplished heading into the finish line of this activity. There is such a sense of satisfaction when the picture is nearly complete and there are only a few dozen pieces to place. It's right in this space that I always have someone who wants to

step in and "help" me finish the puzzle. But it's okay because I know this is my puzzle. I showed this puzzle who was boss. I've moved through this messy process all the way to the other side. The picture is no longer scattered all over the table, and possibly the floor, as it was during the painstaking and slow beginning. It's coming together and is almost done. I can exhale. I can relax. I can start "having fun." I'm making it through this as a piece-by-piece journey and watching a complete picture emerge out of 1,000 small pieces.

I think my puzzle analogy is like both a military career and infertility. In the beginning, it's all just messy hard. It seems impossible, fragmented. During boot camp, a new recruit can't see through the lack of sleep or the loss of identity and control. Infertile couples can't see through the loss of control in reproductivity or bear the empty arms. The difference of course between these examples and a puzzle is that in life, we don't get the benefit of seeing the bigger picture. We don't get that neatly wrapped puzzle box with a picture that guides our progress and leads to the desired outcome. We only get one piece at a time from which to frame our story. We can only try one piece with another in a laborious exercise of trying to find the perfect fit.

At this point in my story, we just had a few pieces to our life story puzzle: we loved the Lord; we loved each other; we were called to ministry; we had jobs; we had a home; and we wanted a family. It seems so clear that all of these normal and natural things should fit together to form the picture of the outcome we'd dreamed of. But we also had this new piece called infertility. It was such an ugly piece. It didn't fit with the rest of the picture. I hid it at first, not even wanting to look at its random jagged edges that didn't fit with our clean straight lines. We kept arranging the easy pieces to fit, forcing them together, but we were always left with this one piece that prevented our picture-perfect puzzle from coming together. But there comes a point in every puzzle process where you have no choice but to figure out what to do with the piece in your hand.

Each and every month, right on cue, I watched my dreams vanish and hopes shatter. After a few years of this loss cycle, it was obvious we needed to seek out answers and ask for help. This was a hard step. Just picking up a book on infertility caused me such shame and embarrassment; I didn't even want a nameless, faceless clerk at the bookstore or library to know I couldn't get pregnant! Oh, how much easier some of this would've been if the internet could've been my nameless, faceless clerk! As anyone who's worked through the grief cycle will tell you, acceptance is really tough to admit. But living in denial has its limits, and we finally hit that place when moving ahead in truth seemed better than ignoring the problem.

Knowing Tim's birth defect might be a problem, we turned to medicine. Prior to the internet and the advent of Web MD, people used the phone book as a starting point. I got my hands on the St. Louis Yellow Pages and started calling every doctor who claimed to specialize in infertility. I will never forget that the first doctor I visited with on the subject, when I was only twenty-one years old, who told us that we would never have children. This man, who had only done one exam on me and just by hearing about Tim's birth defect, pronounced a death sentence on my dream to have children. I remember needing to find my mom so desperately at that moment. To this day, I can tell you where she was standing when I finally found her and shared the dreadful pronouncement I'd just been given. Thankfully, my mother was not nearly as defeated by the doctor who gave us an entire thirty minutes of his attention and expertise.

Based on the advice we'd been given from medical professionals and friends who'd walked this road before us, we proceeded to each find a doctor who would help us get pregnant. I endured a string of useless procedures and tests to check my fertility, which is absolutely astounding to me in retrospect because of my age and the fact that we knew there was a male factor involved. Anyway, I digress here. After the first doctor made his prognosis, I moved on to another "infertility specialist" who decided he needed to perform a laparoscopy to "find out what was going on in there." This procedure found one (yes, only one) cell of endometriosis in my abdomen. While I understand this was maybe an indicator of a potential problem in the future, this single

adhesion was not even located in my uterus, fallopian tubes, or ovaries. It shouldn't have been treated, in my humble-infertility-survivor-expert-opinion!

After the discovery of this single cell, I was put through a six-month course of treatment on a male hormone called Danocrine to treat my "endometriosis," which was determined to be the problem for our infertility. Even though I knew it wouldn't fix our problem, I was too young yet to know that you don't necessarily have to do everything a doctor tells you just because he tells you to. I would one day learn to listen to my gut, but back then, I just swallowed the pills. After the six months that seemed like an eternity to me passed, we were given another long period of "trying" followed by several rounds of Clomid. A drug that, I would later learn, is typically prescribed by doctors who don't have a clue about the proper methodologies for diagnosing and treating infertility.

Meanwhile, Tim connected with a group of vascular and plastic surgeons who were trying to piece together his surgical history. Since the doctors of his infancy and childhood had long since stopped practicing medicine, the only records his new doctors had to go by were handwritten notes his parents transcribed twenty-five years earlier. After several consultations, it was determined Tim needed another surgery to finish the repairs on the hypospadias from his birth. Everyone on the team was so confident about this surgery. "It's a routine two surgeries these days for boys born with this condition," and "the surgery you needed wasn't developed yet when you were born." Tim faced a painful skin graft and a full week in the hospital, but after a few months the doctors were hopeful we would be able to conceive.

Except, the surgery was a disaster and utter failure. Our messy situation just got messier! In fact, Tim had to endure a similar surgery the next year just to repair the first one. Somewhere in this period of Tim recovering from one of these surgeries and me taking a male hormone for six months, my mom fell down her basement stairs and shattered both of her arms. Mercifully she lived, but all normalcy was thrown out the window. Our lives were confounded for most of that

year as I moved back home for an extended period of time to help her recover and care for my younger siblings. Medical delays and caring for family took time to work through, not that it really mattered anyway. After going through all of those procedures and drugs, our baby making made no babies. We were discouraged and hopeless, with no other options before us medically.

Sometime during these painfully raw days of infertility, people started to put the pieces together for us: Tim and Dawn were not able to have children. The topic of adoption surfaced now and then, but of this one thing I was sure, adoption was not for me. My dad had been adopted in the 1940s. He was always searching for his missing "real" mother. My "adopted" grandma, Edna, was never enough for my dad. As far back as I remembered, my dad talked about finding his birth mother. In fact, it was during this painful period of our infertility journey that he reunited with his birth mother, Hallie. Although a complete story in itself, she came into our lives miraculously and helped to heal the broken heart my dad had carried for a lifetime.

That scenario played out in my dad's life during the early angst of my infertility and only worked to affirm my fears about adoption. No sir, I would not be a mother to someone who only wanted to find his "real" mother. I decided very early on that I would rather be barren than an adoptive parent. I'd seen the other side and refused to play out the role of villain in anyone's life story. The phrase "talk to the hand" didn't exist back in those days, but I'm tellin' ya, that's exactly what I was doing any time the topic of adoption came up in my presence. Why so many people felt a need to tell me how to solve our problem was baffling!

But where did this leave us? Sex had failed us. Medicine had wounded us. Adoption disappointed us. We questioned God's goodness. Our marriage was pained. The plan, our plan that we'd envisioned for our life was starting to fade more with each passing year. Seriously, at the ages of 22 and 27, respectively, we had hit the wall. Our future was blocked and barren.

What other choice was there for people like us, except to learn to live life one day at a time? Like everyone else who experiences grief,

we had to inhale the next breath and take the next step. Infertility was woven deep into our souls during these years, but there were moments of joy, too. We both experienced job changes during this season of life. Tim's course took him away from ministry and into remodeling management and sales. He became a bi-vocational minister for the first time in his career. Although it took some time to find the right fit, he was slowly building a reputation in an industry that would benefit us for years to come.

During the year of Tim's surgeries, my first experience on hormones, and my mom's accident, I endured the worst professional year of my life. I was working as a customer service representative for a manufacturing company in St. Louis while taking business classes at night. I was too young and naive to understand what was going on then, but I was dealing with sexual harassment in the workplace. I eventually reported the offender to my boss, explaining the unacceptable innuendos that occurred behind closed doors after the manager had put back a few too many cocktails over lunch. But the "boys club" chose to look the other way. With life pressing down so hard on me emotionally that year, I did not have the internal strength to stay at that position very long. I gave my two weeks' notice after only a year and decided to take a little bit of time off work.

We were living in our second house by now. The "little bit of time off work" stretched out to nine months of me being home. I'm too high of an energy person and too goal oriented for that to satisfy for long, so I took to remodeling our little two-bedroom home. I was taking classes at the community college and volunteering at church, still assuming that some time or the other I would be pregnant, and life would pick up as I expected after the hiccup passed. At some point during my self-imposed hiatus, I discovered there was hardwood under the old carpeting in our house. So naturally, I thought, "Hey, we need to restore these hardwood floors!" One day while Tim was at work, I rented a sander and pulled up all the carpeting. I met him in the driveway that night, with all the carpet from inside laying outside in the yard. I expected him to be excited and to pat me on the back for all of my hard work and vision. Instead he simply said, "Dawn, get a job."

Two days later I attended a Trans World Airlines (TWA) group interview for a Reservation Sales Agent position. This was the destiny door that literally changed my life. After attending a month-long technical school to learn the industry language and computer system, I started my airline career that would define the next decade of my life and shape, quite possibly, the rest of my future. I wasn't looking for a destiny or a career; I was just looking for a job. But God had other plans. He wanted me to have wings. TWA would be my long training ground that provided many short-term joys. May 5, 1989 was a pivotal day in my life; it became known from that point forward as 890509 and was my seniority number in an organization that employed roughly 20,000. This new path would enlarge my world exponentially, while also nurturing that seed for the nations silently growing in my heart. But in 1989, it was my ticket to the world and my permission to run away from the pain of infertility.

As the 1990s arrived we were still hurting, but we were growing and changing. The initial shock over our condition wasn't quite as numbing and raw. We still hoped, longed, planned, and talked about our children constantly, though. It was never far from our minds or conversation. I allowed hope to survive in small places, such as completing cross-stitching patterns for a future nursery. Nobody ever knew, as I did this in the secret and safe place of my bedroom. My hope was too little and too small for anyone else to ever have a peek. We bought land and made plans to build our dream home. I made space in that home for the possibility of children, but not so much space that I would be overcome by the emptiness.

When it all got too much or the pain came in too close, we ran away on a jet plane. We'd go anywhere away from our little corner of the world where infertility lived and where my empty arms ached so badly. I learned that getting lost in Europe was soothing to my soul; nobody knew where I was and that brought me more peace than you can imagine. Ever a beach girl, I maximized every system of trading and shift payouts just to get my toes in the sand on a regular basis. Sometimes Tim came along, and sometimes he did not. I could now legitimately run away from life, and I took full advantage of my flight benefits every opportunity I could find. Sometimes I would owe more

on my ticket deductions than I actually earned working. A baby was out of reach, but adventure was not, and I soaked up the adventure like a healing balm.

I'm not sure when I realized it, but TWA was actually God's mercy to me in the process of my infertility. In the middle of waiting, I was living an incredible life! This became a key for me that would help me on the journey that was still ahead. I learned to drink deeply from the wells of provision that God was providing in this season of my life. TWA was a big mercy, but there were small ones too. One day I came to church and found a loaf of banana bread waiting for me on the chair where I normally sat. I remember being so overcome because I had wanted banana bread for some reason, and I just knew that God inspired someone to minister to me in that perfectly small way. God was teaching me patience in those days, but he was also wanting me to see him as a loving Father, who loves us each so uniquely and perfectly. Psalms 94:19 communicates this concept perfectly: "In the multitude of my anxieties within me, Your comforts delight my soul" (NKJV).

We must shift back to Hannah's story now to examine how her mercies in the process actually prepared her for the ultimate sacrifice she was going to make of letting her baby go. Let's jump back into this story beginning in 1 Samuel 1:

> Wherefore it came to pass, when the time was come about after Hannah had conceived, that she bore a son, and called his name Samuel, saying, Because I have asked him of the LORD.
>
> And the man Elkanah, and all his house, went up to offer unto the Lord the yearly sacrifice, and his vow.
>
> But Hannah went not up; for she said unto her husband, I will not go up until the child be weaned, and then I will bring him, that he may appear before the Lord, and there abide for ever.

And Elkanah her husband said unto her, Do what seemeth thee good; tarry until thou have weaned him; only the Lord establish his word. So the woman abode, and gave her son suck until she weaned him.

And when she had weaned him, she took him up with her, with three bullocks, and one ephah of flour, and a bottle of wine, and brought him unto the house of the Lord in Shiloh: and the child was young.

And they slew a bullock, and brought the child to Eli.

And she said, Oh my lord, as thy soul liveth, my lord, I am the woman that stood by thee here, praying unto the Lord.

For this child I prayed; and the Lord hath given me my petition which I asked of him:

Therefore also I have lent him to the Lord as long as he liveth he shall be lent to the Lord And he worshipped the Lord there.

—1 Samuel 1:20–28 (KJV)

It's important to note that if Hannah had not learned how to give up personal control, as we looked at in chapter 3, she would never have given up young Samuel to the Lord! Wow, just think about how thoroughly God prepared Hannah for the entire role she was going to play in this story, all of which was key to the destiny of David and ultimately Jesus. Although we are not able to take that step back and look at a grander picture and higher perspective, God can. And we must let him (*hint—he's going to do it anyway*).

Hannah was always going to have a son. Depending on your perspective it might be argued that Hannah was never really barren; she was only delayed!

## Delayed Is Not the Same Thing as Denied!

Author and Pastor Rick Warren explains the difference between delayed and denied this way: "Contrary to popular book titles, there are no Easy Steps to Maturity or Secrets of Instant Sainthood. When God wants to make a giant oak, he takes a hundred years, but when he wants to make a mushroom, he does it overnight. Great souls are grown through struggles and storms and seasons of suffering. Be patient with the process. James advised, 'Don't try to get out of anything prematurely. Let it do its work so you become mature and well-developed.'"[2]

There are many reasons listed in Scripture of why God might delay a promise. Here's just a few I've come up with:

- Delay makes us people of prayer (Hannah).
- Delay makes us people of faith (Abraham waits for Isaac).
- Delay builds virtuous habits and character (Jacob served for Rachel).
- Delay leads to redemption (Jesus spent three days in the tomb).
- Delay makes a place to display God's glory (Lazarus).
- Delay builds a testimony (Saul transforms to Paul).
- Delay makes a room for sovereignty in our life (Job).
- Delay allows for a time of preparation (Joseph).
- Delay provides a time of testing (children of Israel).
- Delay makes us strong (David).

Process matters! Let's look at a natural process of delay by considering a seed. It's critical to understand that what we see from the surface isn't the whole story! Interestingly, the process of germination appears in the beginning to be one of death. The earth swallows up a seed, burying all the potential and instructions necessary for life. The dirt and pressure of that process cause the seed casing to be cracked so the potential contained inside the seed can be released into the earth. Roots break forth underground, long before any signs of life appear above the soil line.

41

Seeds vary greatly! We need to also consider that it takes certain types of soil and certain conditions for different seeds to grow. As much as I would've enjoyed it my whole life growing up in the Midwest, you can't plant pineapple seeds and expect them to flourish. None of the conditions are adequate, from the soil to the seasons. But plant yourself some corn, or soybeans, or wheat, and you will reap a rich harvest on the plains of Illinois. The situations and conditions matter to a plant, and all of the wishing and dreaming in the world doesn't change this principle.

Farmers have faith in the process because they understand the science of germination. A farmer knows that to bring forth life, you first have to plant and trust in the effect the conditioning process of the soil has on the seed. The dark places (the barren places) have a purpose in the transformation process. This stage is necessary for proper growth of the roots that will sustain the future strength and viability of the plant. To the farmer, planting seeds isn't a death or denial of a harvest. In fact, the expectation of a harvest is built into the seeding principle!

We see this same pattern over and over again in Scripture. The natural realm is often a pattern for the spiritual realm:

> Sow for yourselves righteousness; reap steadfast love; break up your fallow ground, for it is the time to seek the Lord, that he may come and rain righteousness upon you.
> —Hosea 10:12 (ESV)

> I planted, Apollos watered, but God gave the growth. So neither he who plants nor he who waters is anything, but only God who gives the growth.
> —1 Corinthians 3:6–7 (ESV)

> Truly, truly, I say to you, unless a grain of wheat falls into the earth and dies, it remains alone; but if it dies, it bears much fruit.
> —John 12:24 (ESV)

Why is that we expect the seed principle to work with actual soil and seeds but not in our lives? Just as in Hannah's life, God used my infertility to create an environment whereby a seed could be triggered to grow in my life. Did I ask for it? No. Did I see it at the time? No. But God, being the good and excellent Father that He is, was patient. He planted a seed, way, way back when I was a child, and he was slowly helping me through the germination process. For sure, this was my dying stage. However, special mercies in the process watered my soul and helped me endure the night season.

In much the same way the military uses specialized training, God had created the perfect environment for my training in his army. In this phase of my education, I was learning how to reverse depression with worship and how to fight self-pity through finding new purpose. I was drinking from the mercies in the process that he had provided for me, much like one would drink from an oasis in the desert. I was learning to navigate a broader world than I even dreamed possible through my emerging career. God was busy unwrapping all of the potential he had buried in that tiny little seed and supplying all the nutrients it would take for that seed to grow.

# 5 My Commander-in-Chief

# Surrendering to the Sovereign

*I would rather try to persuade a man to go along, because once I have persuaded him, he will stick. If I scare him, he will stay just as long as he is scared, and then he is gone.*
—*General Dwight D. Eisenhower*

Have you seen the movie *The Princess Bride?* Of course you have; it's a classic! Remember the line, "No, there is too much, let me sum up." Well, that sentiment best explains my tension in writing this chapter. This section has been hard going for me, but I think I know why. There are big concepts ahead, ones that I can guarantee you I am not doing theological justice. Words like trust and faith and suffering and sovereignty, and terms such as the fallen nature of man, God's attributes, and the compound names of God find their way into this part of the story. Please hear my heart: I am not attempting to sway you into Calvinist doctrine or speak on end-time theology here. This book does not intend to be a treatise on the fallen nature of man or political theory. I am simply trying to lead you down a path that helps you understand my journey, and in the middle of that journey I came face-to-face with precepts about my Heavenly Father I didn't know before facing infertility. If you don't understand some of these concepts, or if they challenge you in a way you've never considered, I encourage you to start your own research, step into theological studies, and to find your God in a new and deeper way. I certainly do not pretend to have all the answers. In fact, it's probably safe to say that

the more you know about God, the less you realize you actually know about God.

As we have previously explored, a soldier is trained to obey orders. This is primarily for the safety and success of both the soldier and his unit. Individuality and autonomy would be disastrous elements in a fighting corps, where moving together as one unit is of critical importance. However, there is a higher purpose at work behind obedience, and that is one of building trust. It's within the following orders process that a bond of trust begins to be established between soldiers and their commanders. General Ray Odierno, the 38th and current Chief of Staff of the Army affirms this concept; he says, "Our profession is built on trust."[1] It's to this idea of trust where I now want to turn because it applies in the Armed Forces, but it also applies to my journey.

Trust is defined as "assured reliance on the character, ability, strength, or truth of someone or something."[2] Obedience can be achieved through external oppression and can resemble domination. As boot camp demonstrates, obedience is often achieved through a show of power. Though necessary in the early stages of training to facilitate the reprogramming of a civilian into a soldier, this type of subjection is not the long-term goal for the relationship. The idea is to create a character within a soldier of trust for the power and safety that comes through the chain of command. It's a reprogramming process that involves a volitional laying down of self to fulfill a greater mission (sounds a whole lot like Christianity, huh?).

There are two types of trust: horizontal and vertical. In either form, "trust is an attitude that promotes risk-taking."[3] Horizontal trust, or social trust, is a trust in others. Consider driving a vehicle down the highway. Have you ever really thought about the level of trust in play during this scenario? You are trusting fellow humans to obey the established laws and follow the rules of the road, and you're trusting that their vehicles are properly maintained to travel at high speeds. Even more sobering is the fact that some of these "fellow humans" are as young as sixteen! You are also trusting that everyone around is,

in fact, a licensed driver and carries insurance—even though you know there is a chance this is not the case! The fact that we get in two tons of steel every day and career around other humans at 75 miles per hour is proof positive that we recognize and validate a level of social trust in others. In their research on trust, Daniel Eek and Bo Rothstein write, "It is desirable for a society that its citizens have high horizontal trust levels. The reason is that horizontal trust correlates with many positive societal outcomes. For instance, societies characterized by high levels of horizontal trust have larger economic growth, have more well- functioning democratic processes, have happier and healthier citizens."[4]

Vertical trust is a trust in authorities, such as in the political process. I'm not talking about a specific race or election of a president or a local politician. I'm referring to broader political theory based on Hobbes' State of Nature, which explains that society was formed on the basis of a social contract or covenant of a mutual submission to authority for the good of the whole. We may be skeptical of specific forms of government; we may fight against totalitarian regimes; or we may be outspoken critics of the opposite political party, but the majority of mankind—throughout recorded history—surrenders to the hierarchical control and authority of government in our lives.

Within horizontal and vertical trust, there are several dimensions including competence, benevolence, and integrity. All of these components play a part in the process and determine whether or not the outcome of the trust will be successful. In every case, there is a "trustor" and a "trustee." Trust is complicated and layered; it is a process that does not happen overnight. However, people trust in each other because the overall benefits that co-laboring and community produces are often viewed as more beneficial than the risks involved.

Immediately, Mark 12:30–31 comes to mind when I think of this concept of vertical and horizontal relationships. When speaking to the Sadducees about the greatest commandment, Jesus said to "love the Lord your God with all your heart and with all your soul and with all your mind and with all your strength" and to "love your neighbor as yourself." I am not intending to reduce this weighty point that Jesus

was making about the Mosaic Law here, but I do want to extract another principle for us out of this verse that is important to our current topic of trust. (You know you can do that with God's Word, right? It is so rich that sometimes you have to unpack the layers.) In the midst of this statement on the Law, Jesus is also addressing the concept of horizontal and vertical relationships in the kingdom of God. Vertical trust in the Father (heavenly relationship) is the first proper alignment, followed by horizontal trust with neighbors (earthly relationship). It's this idea of as in heaven, so on earth (Matt 6:10).

It's interesting to note that both types of these trust relationships, horizontal and vertical, seem to work together. Eek and Rothstein conducted three experiments to explore the causal relationship between vertical and horizontal trust. Their main hypothesis was that "vertical trust affects horizontal trust."[5] Results from survey data indicate that "people's vertical trust levels correlate positively with their horizontal trust levels"[6] and "that it is more likely that horizontal trust is caused by vertical trust."[7] It is always interesting to me when science confirms a biblical pattern; when we place our trust in God (vertical), our earth is correctly aligned (horizontal).

Here are some additional aspects of trust we need to consider when looking at the issue from either a horizontal or vertical perspective:

## 1. TRUST IS EARNED

In all relationships, trust is earned, whether those relationship are vertical or horizontal. The military also recognizes this fact. The US Army published a white paper entitled "Building Mutual Trust Between Soldiers and Leaders" that explores the importance of trust. The paper states, "Trust occurs when one person willingly makes himself vulnerable to the actions of another based upon a subjective assessment of the other person's competence and character. Trust is both dynamic and contextual. Although people tend to differ in the degree to which they initially trust or distrust new people, it is generally believed that trust emerges over time."[8]

God recognizes that his fallen creation needs help to be able to trust him. Proverbs 3:5 advises us to "trust in the Lord," but this occurs because he graces us to do so! I am firmly persuaded that God makes

a way for his people to come near. Old Testament patterns are constantly affirming that God makes a pathway for us; nowhere is that more clearly seen than when God parted the waters of the Red Sea for the children of Israel fleeing Egypt in Exodus 14. In the New Testament, God sends Jesus and a New Covenant to give us entry into the very throne room![9] The most remarkable thing is that God doesn't have to—or shouldn't have to do this for his creation, but he does! He is faithful to lead us, guide us, and direct us into all truth.[10] Because he is faithful, he earns our trust.

## 2. TRUST GROWS

A second aspect of trust to consider is that it grows! In the white paper previously mentioned, the authors write, "Trust increases as the trustor accepts increasing amounts of risk as long as the trustee continues to meet the trustor's positive expectations."[11] Trust is not static; it is a dynamic process that changes with input. Looking at this statement closely, we see the words "increases" and "continues." What's key here is that trust grows and is cultivated, which demands we allow for the factor of time! Another key is that trust grows when the trustee receives positive expectations. Maria Fors Brandebo, a Swedish researcher who studied trust in a military context, writes, "Trust and distrust is assumed to increase in strength and breadth as a function of frequency, duration and diversity of experiences that confirm positive or negative expectations."[12]

I recognize while typing these words that it's a little ridiculous to consider the premise that our trust in God grows. It shouldn't be that way, but thanks to our fallen nature, that's just the hard truth. We may be redeemed immediately by accepting the Jesus' sacrifice for our sins, but we are not matured in an instantaneous process! It's amazing to me that God actually cares to walk and nurture his saints through a developmental process. Consider Abraham, whom we are introduced to in Genesis 11 when God calls him at the age of seventy-five.

Abraham's story plays out with great drama and detail throughout Genesis. Over the next one hundred years, Abraham takes a journey with God in which he faces all manner of obstacles, as well as all sorts of divine intervention! Through it all, Abraham grew to know and to

trust his God throughout the constant exchanges of positive expectations. Abraham worshipped, and tithed, and did according to the Lord's instruction over and over and over for years and years and years. More importantly than the actual doing, he believed; we are told in Genesis 15:6 that Abraham believed the Lord and it was credited to him as righteousness. He was promised a new land, and he got it! (Canaan). He was promised a son with Sarah in their old age and he got it! (Isaac). When God tested his faith and called him to offer up his promised son as a sacrifice, Abraham knew—because he understood the nature and character of his Commander-in-Chief—that his God would provide a sacrifice for the burnt offering. And he got that, too! The ram was caught in the thicket and Isaac was spared.[13]

### 3. TRUST CAN BE LOST

If trust is earned, then it can be lost. My friends, this is something everyone reading this book already knows to be true. Toxic relationships, power hungry leaders, racial discrimination, sexual biases, and blame shifting are all contributors to a breakdown of trust. Abuse can occur within any relationship, whether that is a military organization, corporation, church or a family. Nowhere is this more clearly observed than infidelity in a marriage, which strikes at the very root of trust.

Ethical leadership is a priority within the US Military. According to Christopher M. Barnes, PhD and Lieutenant Colonel Joseph Doty, PhD, ethical leadership is defined as "the demonstration of appropriate conduct through personal actions and relationships and the promotion of such conduct to subordinates through two-way communication, reinforcement, and decision-making."[14] When these characteristics are absent or abused trust begins to break down. Leaders who are disrespectful, undermine authority, micromanage, withhold information, unduly punish, or are outright deceitful lose the trust of their command.

You know the phrase "climbing your way to the top"? This phrase paints a picture of a person literally climbing over someone else to reach the top, and this is a truism that crosses many different types of hierarchical organizations and relationships. The same is true in the

military when officers destroy the morale of their subordinates to achieve personal advancement. The person who's on the bottom in this scenario gets hurt and loses trust in both leadership and the process.

Man is fallen and the best we will ever do is to weave some level of corruption into everything we touch. If you are not a person of faith, that statement—in fact this entire chapter—may not sit well with your views on life. Scripture tells us that "for all have sinned and fall short of the Glory of God" (Rom. 3:23). We can try our best to be a good leader or help our fellow man, but as human beings we will always fall short. We can certainly attempt and should strive to lead a righteous life, but our nature will always be a hindrance. Galatians 5:17 says, "For the flesh desires what is contrary to the Spirit, and the Spirit what is contrary to the flesh. They are in conflict with each other, so that you are not to do whatever you want." While the subject of fallen humanity exceeds the scope of this book, suffice to say that we will always war with trust issues in relationships that are man-to-man focused. However, we needn't war with the relationship that is man-to-God focused.

Scripture is the love story between a Father and his sons and daughters. It's a dance across time that affirms God's faithfulness—eternally! This view requires a long-term scope. It's impossible to confirm or deny a trust in God based on one single negative experience, or even a handful of situations! We may never understand the reasons we face such hard and difficult things during our natural lives, but when you think about it, nowhere in Scripture are we promised all the answers this side of eternity. Sometimes, we will see a hidden purpose in the pain through the perspective that only comes with hindsight. Abraham experienced highs and lows, good and bad, pain and sorrow, and even died without seeing the total fulfillment of the promises laid up for him (Heb. 11:13). The good news here is that our Heavenly Father promises he will not leave or forsake us (Deut. 31:8). He will not betray our trust, but he does call us to a life of faith and also a life of surrender.

## Trust Leads Us to Faith, Which Points Us to Sovereignty

While the argument certainly can be made that soldiers following orders often do so by an act of faith and that soldiers serve a sovereign state, it's not exactly the correlation I want to explore moving forward with this chapter. Purposely now I want to transition this section into concepts that are more of a religious nature than a temporal one because it moves directly into my personal story and helps to frame an understanding of the ultimate Commander-in-Chief.

Rooted at the core of trust—whether vertical or horizontal—is faith. At the beginning of this chapter, we learned that trust is an assured reliance on the character, ability, strength, or truth of someone or something and it is an attitude that promotes risk-taking. The venture of trust requires faith! John Bishop writes, "The concept of faith is a broad one: at its most general 'faith' means much the same as 'trust.'"[15]

Indeed, part of the Greek meaning for the word faith, *pistis*, means trust![16] In his book, *All of Grace*, Charles Spurgeon writes, "…You have made an advance toward faith; only one more ingredient is needed to complete it, which is trust. Commit yourself to the merciful God; rest your hope on the gracious gospel; trust your soul on the dying and living Savior; wash away your sins in the atoning blood; accept His perfect righteousness, and all is well. Trust is the lifeblood of faith; there is no saving faith without it."[17]

If you think trust is a challenging word, then just wait until you meet sovereignty. Sovereignty is a really big word that can be hard to swallow, especially when you've been raised in a freedom loving, liberal, free-thinking society that values autonomy, self-reliance, and free expression above traditional values and moral restraint! Sovereignty is defined as supreme and ultimate power. Scripture declares that God is sovereign, one of God's attributes which is related to his omnipotence and providence. Here are a few references for your personal study: 1 Chronicles 29:11–12; Proverbs 16:9; Isaiah 46:9–10; Proverbs 19:21; Psalm 103:19; Isaiah 45:7; Ephesians 1:11; 1 Timothy

6:15; Ephesians 2:10. As to the extent of how sovereignty impacts free will and vice versa, I will leave that topic for another author.

A. W. Pink wrote one of the finest works on sovereignty in 1918, simply entitled *The Sovereignty of God.* In the first chapter, Pink writes:

> The Sovereignty of God. What do we mean by this expression? We mean the supremacy of God, the kingship of God, the god-hood of God. To say that God is sovereign is to declare that God is God. To say that God is sovereign is to declare that He is the Most High, doing according to His will in the **army of Heaven** (emphasis added), and among the inhabitants of the earth, so that none can stay His hand or say unto Him what doest Thou? (Dan. 4:35).
>
> To say that God is sovereign is to declare that He is the Almighty, the Possessor of all power in Heaven and earth, so that none can defeat His counsels, thwart His purpose, or resist His will (Ps. 115:3). To say that God is sovereign is to declare that He is "The Governor among the nations" (Ps. 22:28), setting up kingdoms, overthrowing empires, and determining the course of dynasties as pleaseth Him best. To say that God is sovereign is to declare that He is the "Only Potentate, the King of kings, and Lord of lords" (1 Tim. 6:15). Such is the God of the Bible.[18]

Surrendering to the concept of sovereignty was difficult for me. Maybe it was because I had never been told no for anything I really wanted until it came to having a baby. I thought I knew God and his ways, so this battle I had been enlisted in confused me. It scared me. Did I really understand my faith? Why was it out of focus and hard? What was the point of this new season? Just tell me what was needed, and I would get it done; I would accomplish the task and overcome the test. But God wasn't looking for me to perform for him or accomplish some sort of a ritualistic endeavor. Infertility was about building character; childlessness was about building trust; closing my womb was an intentional way to teach me about His nature and

character. I was finding my way along the narrow path, and it all started with longing and suffering.

Somewhere several years into my journey, I found the book of Job and I sat there for a very long time. In one book I had found the solace for my confusion. What in the world? So many denominations and people wrestle over the book of Revelation, but not me. No, I camped out right in Job. I wrestled through the injustice and the (perceived) wrongness of all that happened to Job (Job 1-2). I got lost in accusations and condemnation that came toward a man who had lost everything (Job 4-5). I couldn't see or understand God's purposes behind all that transpired in Job's life (Job 7). I wrestled with the cause-and-effect nature of sin and wondered if I had done something to bring infertility upon me (Job 8, 11, 15). The wisdom seemed upside down and backward; in Job, it felt safe to wrestle out and question the traditional and lighthearted "goodness of God" (Job 9-10).

It's impossible to record the thoughts and prayers that transpired during these desperate years of my life. I can't provide you with a how-to list or ten steps to overcome the particular pain of life you are facing. But I can tell you it's in the night seasons spent wrestling with God that character is molded and changed. Just like in the book of Job, God shows up in the midst of human suffering and reveals his omnipotence. It's that holy place, where the words recorded in Job 38-41 lead to trust and transformation. When God rises up and asks, "Where were you when I laid the earth's foundations? Tell me, if you understand. Who marked off its dimensions? Surely you know! Who stretched a measuring line across it?" (Job 38:4–5), or "Can you bind the chains of the Pleiades? Can you loosen Orion's belt?" (Job 38:31), or "Can you raise your voice to the clouds and cover yourself with a flood of water?" (Job 38:34).

When we (humanity) can accept our smallness and fall into God's greatness, something internally begins to shift. When we can catch a glimpse of who he is, we get a better understanding of who we are. When we are able to honestly say, "I know that you can do all things" and "Surely I spoke of things I did not understand, things too

wonderful for me to know," we—like Job will be able to say, "My ears had heard of you but now my eyes have seen you" (Job 42:2–5).

You may be reading this book and saying to yourself: enough already on the trust and sovereignty topic! This is supposed to be some chick's story about infertility that ends with a happily ever after, let's get on with those details. However, this is where you are wrong. This is not a book about infertility, as noted in the preface at the start of this book. This is a story of transformation to be prepared to run the race I was predestined to run. In order to achieve my destiny, however, I had to know and trust my God; I had to understand his ways; I needed to know his precepts; I had to be able to declare, "He is good"! In my life, this took time, lots of time filled up with tears, trials, and tests because the understanding had to be rooted deeply. Time was needed for trust to grow. I wanted a baby, but God wanted so much more from me. He needed me to be broad, open, passionate, and fearless. He needed to transform me into someone who was not easily content or small, therefore, he—the great and sovereign framer of the Stars chose to take me on a journey of transformation in order to develop trust in him as my leader, and in the end create in me a new heart.

## Getting to Know the Eternal Commander-in-Chief

God has many attributes recorded in Scripture; he also has many names that express the personality and strength of His eternal and multifaceted character. He is called Elohim (strength or power), Adonai (Master or Lord, the Sovereign), and Abba (Father). God is also called Jehovah, which means, "I am who I am." This is because there is none like Jehovah; he stands apart from all others; he is the only almighty, holy being for which there is no equal. He is self-existent, not dependent upon anything or anyone else in the universe.

God also has many compound names that give a deeper understanding of his character and nature. Even in researching this section, I learned more about the variety of names that represent God. I thought I had a handle on the majority of them, but it turns out I was

really wrong! There are many more, a great deal many more ways God is presented to his people in Scripture.

In fact, I found one web page titled 900+ Names and Titles of God! Here's a short list of the more common ones you will encounter in biblical studies:[19]

- Jehovah-Elohim – The Lord God who made the earth and the heavens
- Jehovah-Jireh – The Lord Who Provides
- Jehovah-Rapha – The Lord Who Heals
- Jehovah-Nissi – The Lord our Banner
- Jehovah-Rohi – The Lord is my Shepherd
- Jehovah-Shalom – The Lord is Peace
- Jehovah-Tsidkenu – The Lord our Righteousness
- Jehovah-Shama – Jehovah the Indweller
- Jehovah-Elyon – Most High
- Jehovah-Sabaoth – God of Angel Armies

God is infinitely complex and yet astoundingly simple! He is filled with light and life and worship and holiness and purpose and power and wisdom and might—the adjectives used to describe him are as innumerable as the stars in the sky! The beautiful thing is that he draws near to his creation and gives us illumination to understand his character! He also gives us a pathway into His presence, which can be seen through creation, the Law, Jesus, the church, and the Bible, just to name a few. Psalms 19:7–9 explains, "The *law* of the Lord is perfect, refreshing the soul. The *statutes* of the Lord are trustworthy, making wise the simple. The *precepts* of the Lord are right, giving joy to the heart. The *commands* of the Lord are radiant, giving light to the eyes. The *fear* of the Lord is pure, enduring forever. The *decrees* of the Lord are firm, and all of them are righteous" (emphasis added). Notice how his nature and character are totally fearful and totally beautiful at the same time?

- The law...*is perfect and refreshing.*
- The statutes...*are trustworthy and wise.*
- The precepts...*are right and give joy.*
- The commands...*are radiant and give light.*
- The fear...*is pure and enduring.*
- The decrees...*are firm and righteous.*

## Understanding My Commander: "Jehovah Tricky"

I debated putting this content in the book, primarily because I don't want to bring offense on such a serious topic. While it may not be necessarily true in our generation, history informs us that using and communicating the names of God correctly is very serious religious business and rightly so! The ancient Hebrews didn't even write out the word Jehovah at all because they didn't want to take the Lord's name in vain or dishonor his holiness. His name wasn't even spoken except by the High Priest when he entered the Holy of Holies on the Day of Atonement.

**Personal disclaimer:** I do not intend to weave any form of error into doctrine or literature because someone takes the following section out of context. I also do not mean to literally infer that I have been given any type of visitation by God to reveal a characteristic outside of what has been introduced in Scripture. At the same time, a personal revelation on my Commander-in-Chief is centric to huge parts of my story moving forward. If personal revelation is too strong, let's call it an experiential understanding. I am only expanding on what I've observed about God's character through my years of training through the various trials I have endured for the purpose of a getting a new heart.

I suspect my Many Breasted One can probably handle what I'm about to share. In fact, I know he can because I believe that God is a God of humor. It may not be one of his listed attributes, but I can assure you that humor is part of his nature. Threads of humor and irony run through both the Old and New Testaments. Cautiously then, and at the same time with a little tongue-in-cheek, I have decided to

introduce you to another compound name for God you might never have previously heard: Jehovah Tricky.

I don't remember exactly how it all started, but at some point in my early process of understanding my Commander-in-Chief, I started to lovingly call my Heavenly Father, Jehovah Tricky. Not in a tempter/trickster sort of way, but more of a "you just think you know what I'm about" sort of way! Again, and to clarify yet another way, I'm not talking about the Father of Lies, who sets up humanity with false presuppositions. I'm talking a God who is radical in his approach, relentless in his objective, and fierce about his plans. If he must set up his people to get us on a destiny track, then so be it! Sometimes, the tricky approach is necessary to accomplish his eternal purpose, or at least that's been my experience.

Maybe the word tricky doesn't suit you well; maybe I've finally lost you here. How about we replace the word tricky for confounding? Is that better? Let's consider Jesus's approach during his earthly ministry. Jesus often told parables that on the surface made no sense and seemed like confusing riddles. His disciples often had to pull Jesus aside to gain understanding; in modern rhetoric, the disciples were basically like, "Say what, Jesus?" Time after time, Jesus hopelessly confounded the learned men of his day through this genre. He hid truth in layers, requiring spiritual eyes and revelation to uncover the mysteries of his words.

Parables may not be the same thing to you as tricky, but I say the great "Fisher of Men" will use whatever bait necessary to haul in his catch. Consider the following examples; you'll be hard pressed not to see Jehovah Tricky at work in these stories:

Jacob and Esau – I mean, the ultimate Jehovah Tricky example must be the case of predestination found within the very trick itself! How cool is this example: Jacob tricks his father Isaac, pretending to be the older brother, in order to capture the birthright, which God had already told their mother was Jacob's before the twins were born!

Joseph and his dreams – Who could've guessed all the twists and turns in Joseph's story from the pit to the palace to the prison to the position of potentate! Jehovah Tricky's thumbprint is all over this story of a

young man whose arrogant and spoiled behavior turned his brothers against him, only to be transformed into a leader who would eventually extend a hand of mercy to rescue and restore those same brothers.

Gideon and the 300 – Okay, how about when God kept whittling away Gideon's army? Sure, we know this is a picture of how God can confound the wise by using the simple; how he can do less with more. This story is filled with Jehovah's presence, intervention, counsel, and direction. But, I say, it is filled up with a little bit of that Jehovah Tricky too. Disqualified because you lap like a dog? There's a sure sign Tricky is on the move!

Jonah and the Whale – Seriously? This one actually writes itself. God told Jonah to go preach at Nineveh. Instead of obeying, Jonah hops a ship traveling in the opposite direction. God sends a storm; Jonah gets thrown overboard and swallowed by a fish, and then said fish spits Jonah out at Nineveh. Oh yeah, and the Ninevites just happened to worship a fish god!

God loves us and leads us each in a way that is up-close and personal. For me he may have needed to be Jehovah Tricky and infuse a little holy humor in the process; for you he may just need to be Abba Father. He knows who we are! He created us! Being imminent is another one of his character traits (attributes). God came so close to his creation in the garden that scripture describes Adam's first breath as a kiss from God. Think of it, God literally blew his breath into man. How much closer can you get? Psalms 139 is a beautiful chapter filled with verses of God's perfect knowledge of us. In this psalm David writes,

> You have searched me, Lord, and you know me. You know when I sit and when I rise; you perceive my thoughts from afar. You discern my going out and my lying down; you are familiar with all my ways. Before a word is on my tongue you, Lord, know it completely. You hem me in behind and before, and you lay your hand upon me.
>
> —Psalm 139:1–6

There were many years this verse would've taken my breath away. I only could see the "hem me in behind and before"; I chaffed at the sovereignty of God and his role in my life. I didn't yet have eyes to see the comfort and providence in this aspect of God's nature. In hindsight, it's not hard to see why God felt a need to step in and enlarge me, give me a new identity, and to overlay his purposes onto my narrow worldview—even when he had to trick me to do so.

I have one final comment to make about trust, and that is trust matures. Mature trust is the space where individuality can come back to life. This is because the nature of the Commander-in-Chief is wired back in through an understanding of purpose, not self-expression. Individuality and self-expression have a place, but it is not at the beginning of the trust cycle! Once the true purpose is understood and rooted in deeply, the unwilling recruit becomes a soldier willingly showing up for the battle. General Dwight Eisenhower said, "I would rather try to persuade a man to go along, because once I have persuaded him, he will stick. If I scare him, he will stay just as long as he is scared, and then he is gone." [20]

Here's the thing: God wants us to stick! He wants us to accomplish our race. Our life story is not simply obeying rules to avoid eternal punishment; it's about co-laboring with Christ to manage the earth as kingdom heirs. It's about accomplishing our dominion assignment, not just being comfortable or satisfied while we are alive. R.C. Sproul wrote, "Living under divine sovereignty involves more than a reluctant submission to sheer sovereignty that is motivated out of a fear of punishment. It involves recognizing that there is no higher goal than offering honor to God. Our lives are to be living sacrifices, oblations offered in a spirit of adoration and gratitude." [20]

Although I didn't know it at the time, my purpose was to become an advocate who would be a voice for the voiceless. I didn't know how to be a living sacrifice. It's not that there was anything wrong with wanting (craving) a baby; it's a very natural and legitimate desire. But God was calling me beyond my natural needs, and I didn't even know it. In fact, I wouldn't even begin to grasp that truth wholly for decades.

Thankfully, my Jehovah Tricky knew the path he was leading me down, and he had every step perfectly prepared to accomplish its unique and specific purpose in my life.

How do you create a passionate advocate? You create someone with a heart that isn't easily filled or quick to give up, and that kind of heart doesn't come without a great deal of suffering.

# 6 Tactics & Strategies

## Pivotal Circumstances & Providential Relationships

*If you know your enemies and know yourself, you can win a hundred battles without a single loss. If you know only yourself, but not your opponent, you may win or may lose. If you know neither yourself nor your enemy, you will always endanger yourself.*
*—Sun Tzu*

There comes a point in the progression of a soldier's career when the specialized training and trust building usually leads to some type of engagement. After all, the point of training an army is to prepare the army to defend against the enemy and protect the country. While people long for peace, the sad truth is that humanity has been locked into warfare for all of recorded history. Today, there are many reasons countries are drawn into war: failed states, geopolitical resources, protecting democratic regimes, balancing of powers, religious wars, and outright conquest. The root of all war stems from either security or power. Democracy and liberty have proven no exception to this fact. Did you know that the United States has been at war 93 percent of the time and has only been at peace for twenty-one years since 1776?[1] With numbers like that, it is no surprise that the majority of soldiers in modern times are engaged in active duty at some point, whether that is in full-scale war, some type of regional conflict, or as a peacekeeping force. However, even during peacetime, the US Army

61

"must always be ready to defend the United States and its territories; support national policies and objectives; and defeat adversaries responsible for aggression that endangers the peace and security of the United States and our allies."[2]

Defending national interest effectively always involves carefully crafted strategies and tactics, both of which are essential to warfare. Strategies answer the "what are we trying to do?" while tactics answer the "how are we going to do it?" Military theorist Carl von Clausewitz put it another way. He wrote that tactics is the art of using troops in battle; strategy is the art of using battles to win the war.[3] Each strategy has its own tactics. Many strategies can be put forth to win a war, and several might even run concurrently. Let's consider WWII where the US was really fighting two wars at the same time, one in the Pacific and one in Europe. Although both of the wars were a battle against fascism, the very fact that they were a world apart against different people groups required different strategies and thus different tactics. The war with Japan was, in the beginning, largely a war of containment held mainly at sea with the Pacific fleet, while the war in Europe, which took preeminence, was held on land and in the air.

Sometimes the hardest part of building a plan is differentiating between strategies and tactics, yet this is a critical part of the planning process. A strategy is defined as "the science and art of employing the political, economic, psychological, and military forces of a nation or group of nations to afford the maximum support to adopted policies in peace or war, the science and art of military command exercised to meet the enemy in combat under advantageous conditions."[4] It is the overarching plan to achieve a goal, whether that is in war, in government or in business. Clausewitz says, "At its most basic, strategy is a matter of figuring out what we need to achieve, determining the best way to use the resources at our disposal to achieve it, and then executing the plan,"[5] whereas a tactic is defined as "an action or method that is planned and used to achieve a particular goal."[6] Tactics are the actions and operational parts that drive the strategies.

## Sun Tzu

I want to look at the ancient writings of military strategist, Sun Tzu. Yes, you read that right—we are going to examine concepts from *The Art of War*. Don't worry, this is groundwork I need to lay to properly present the material in this chapter.

Sun Tzu's classic philosophical work, *The Art of War,* is the world's oldest treatise on war. Historians continue to debate the existence of one man named Sun Tzu, but it's undeniable that this surviving piece of literature from the sixth century BC has been studied for over 2,500 years by generals, war theorists, politicians, and diplomats. Today his teachings extend far from the battlefield; business leaders, project managers, and even motivational speakers and self-improvement gurus have used principles from *The Art of War*. Tzu, a Taoist, stressed the importance of planning and strategy when it came to warfare. Historian Samuel Griffith explains, "War, an integral part of the power politics of the age, had become `a matter of vital importance to the state, the province of life and death, the road to survival or ruin.' To be waged successfully, it required a coherent strategic and tactical theory and a practical doctrine governing intelligence, planning, command, operational, and administrative procedures."[7]

Sun Tzu writes about strategies in chapter three and tactics in chapter four, which again confirms the pattern we've already examined that war tactics flow out of war strategies. He says that "it is in war the victories strategist only seeks battle after the victory has been won, whereas he who is destined to defeat first fights and afterwards looks for victory."[8] This treatise on warfare, written in a proverb style, explains why battle plans are of critical importance in the military. Tzu also enlightens how the tides of war are turned by knowing yourself and by knowing the enemy. After reading this book, it's clear why many have referred to *The Art of War* as the bible for military strategy and warfare. There is a lot of truth to be extracted from these famed thirteen chapters.

The part of the material I really want to narrow in on is Tzu's five constant factors in war: Moral Law, Heaven, Earth, The Commander, and Methods.[9] My purpose is not to explain how these factors are

connected to Taoism or the larger worldview of Chinese philosophy. However, I do want to extract truths applicable to the warfare imagery and how these apply to my personal infertility story. After reading several different editors' versions of *The Art of War* (go to Amazon and check out how many versions there are of this book!) and endless blogs about the application of this material, I created a quick reference chart to help us understand Tzu's five constant factors in today's language:

| Constant Factors | Sun Tzu's Meaning | Examples Today |
|---|---|---|
| Moral Law/Way/ The Path | Being in complete accord with the Ruler, so you will follow him; a mutual philosophy and purpose.[10] | A mission statement, doctrine, patriotism, team spirit, shared values. |
| Heaven | Day and night, cold and heat, times and seasons[11]; environmental factors. | Timelines, schedules, environments outside our control. |
| Earth | Distances, great and small; danger and security, life, and death.[12] | Logistics, tools, and resources, environment under your control. |
| The Commander | Virtues and wisdom, sincerity, courage, benevolence; leadership.[13] | Leadership, character, decision-making, ability, and attitude. |
| Method and Discipline | Marshaling of the army and training of officers.[14] | Methods, discipline, commitment, ability to implement strategy. |

What strikes me is this ancient warrior understood and builds his methodology on principles that I've come to understand during my infertility wars, ones I have been attempting to lay out in the last few chapters:

- Man is subject to a hierarchy under a supreme ruler.
- Some things are under our control.
- Some things are outside of our control.
- Strategies and tactics matter to wage war successfully.
- Discipline, virtues, and commitment matter to win.

Here's the craziest thing to me about studying Sun Tzu: I didn't know any of this when I was drafted (chapter one), a new recruit (chapter three), getting specialized training (chapter four), learning about my Commander-in-Chief (chapter five), or starting to implement strategies and tactics (chapter six). I didn't plan to write this book according to the principles as outlined in *The Art of War*. I am dumbfounded to realize that my story, mirrors an ancient military pattern, which was written for me to walk in before the foundations of the earth by a sovereign and eternal King.[15] I mean, come on, right here, right now, LET FAITH ARISE in your personal journey— whether that is infertility, divorce, abandonment, bankruptcy, critical illness, or unfulfilled hopes and dreams.

Here's what I'm getting at: war is part of life! It's part of political life, it's part of business life, and it's part of spiritual life, so why don't we expect war at some point in our lives? The Bible is filled to the brim with the imagery of war, especially in the Old Testament. At the very least, we are assured that tests and trials could be considered a personal form of battle (1 Peter 4:12–13; Ex. 20:20; Ps. 66:8–12, just to name a few). Why did I not see war as a prevailing theme until I started writing this book? The Bible is a love story of family (Father and sons/daughters) set in the context of a battle between good and evil, powers above and powers below, and principalities (Eph. 6:11–20; 2 Cor. 10:3–5; Luke 10:19; John 10:10, again, just a few). I mean for goodness' sake; the stage is set and the battle begins within the first few pages of the book!

It stands to reason that wars in the natural realm are a picture to help us understand wars in the spiritual realm. You don't have to like what I'm saying to know it's true. Hey, I don't like what I'm saying. You should know me enough by now to know that I am the world's

most hesitant warrior ... maybe ever. But I don't like sin and death either, both of which entered the world way back in Genesis and the Garden of Eden. While the eternal effects of the curse were broken when redemption came to man through the obedience of Jesus Christ, we do not yet walk in the total redemption of the earth. I guess we can pretend this isn't the case and just bury our heads in the sand, seek peace and prosperity, and wish upon a star that all of our dreams for happiness and peace will come true. But the truth remains that war is everywhere. War is both ancient and modern; it is a condition of fallen humanity. We may not all be called to spend our entire natural (or even spiritual) "careers" in the armed service, but we all need strategies and tactics to proceed in a state of war!

## Building a Plan

God wired man to take dominion over the earth (Gen 1:28). We are different and set apart from the rest of creation because we are made in his image (Gen. 1:27). He provided us with critical thinking and reasoning skills, strong bodies, and the ability to relate and co-labor with others. These natural skills allow us to build plans, construct strategies, and execute tactics using our own wisdom and understanding. If we are a fully functioning human, we execute this cycle over and over in many different ways throughout our daily lives.

Let's move this story back into the kitchen for a minute. I've heard my mom use this illustration before in her teachings, so I'm going to borrow it from her. (*Thanks, Mom!*) Think for a minute about what it takes to prepare a Thanksgiving dinner. If sitting down to a fully decorated table and hot turkey dinner with all the fixing is the "battle win," then a host needs to think through the strategies and tactics it will take to achieve that "victory" (if you would allow me the liberty of these terms for the purpose of this example).

Depending on the menu and size of the guest list, it's not outside the realm of reason that this could take a week or longer to effectively plan and execute. Remember that our strategies help us achieve the victory, while our tactics are the operational steps to achieve the strategies. As the general in charge of this battle, I would take the

responsibility of building a plan. Normally tactics would be listed under each strategy, neatly separated and organized with numbered lists, bullet points, and exact timelines, but for the sake of space I'm condensing this content a bit:

## OPERATION THANKSGIVING DINNER

*Strategies:* *Invite guests, delight with dazzling décor, serve a scrumptious and hot meal.*

*Tactics:* *identify guest list, send invitations, follow-up on RSVPs, select décor, make centerpieces, prepare table, create menu, order pies, shop for groceries and other supplies, thaw turkey, prep food, build schedule for cooking timeline, etc.*

Planning for a Thanksgiving victory did not require God's input or help. I was able to do this largely on my own, maybe with the help of a spouse or another family member, because of the talents and skills wired into me by the Creator. I am essentially able to manage these earthly duties. There are going to be difficulties in the battles that we are going to have to endure, like long lines at the grocery store at Thanksgiving or a spouse who would rather watch football than help prep the food. Family members might arrive and want to talk about politics, shifting the mood away from giving thanks and moving it toward trash talking the opposite political party. The timer on the turkey may not pop or the oven may break, leaving the host to wonder if the meat is thoroughly cooked or if she will give her guests food poisoning. Not everything will go according to strategy; battles are hard (she writes with tongue in cheek) and complicated.

We can battle alone in our lives. We can build our plans and set about achieving our goals. I mean we really can for many things, but the question is why do we want to? Remember the Commander-in-Chief we discussed in the last chapter? The sovereign? How does he work within our strategies and tactics? Well, I can tell you that he wants to co-labor with us in our earthly assignments (1 Cor. 3:9). He wants us to live and move and have our being in him (Acts 17:28). He cares about our day-to-day lives and he cares about the battles we face (Ps. 121:3; Ps. 23:1; Matt. 6:32). John 14:26 tells us that God gave us the Holy Spirit as a helper and an advocate. The Holy Spirit provides us with *dunamis*[16] power from on high (Acts 1:8; Eph. 3:20). Why don't

we want and seek heaven's help in our daily lives? We are always going to experience the trivial frustrations of living life and the complications and difficulties of living with other people. However, when we open the door to cooperatively living with heaven, we make room for the next two concepts I want to explore.

## Pivotal Circumstances and Providential Relationships

I think we all understand that as adults we must faithfully steward our lives. We build our plans and do our part to fulfill the strategies and tactics to fulfill those plans—as we understand them. But the next part, the really sweet part, happens when we let God be God. This is often where heaven kisses earth and breathes in new life we didn't anticipate or see coming. An unexpected phone call, a stranger's comment, a song on the radio, a job we weren't looking for—something we need to progress forward is injecting into our reality from seemingly nowhere.

A pivotal circumstance is a defining moment, something that propels us forward in our lives and our personal battles. A providential relationship occurs when we hear God through others. In his teaching DVD, *Five Things God Uses to Grow Your Faith*, Andy Stanley identifies pivotal circumstances and providential relationships both as faith catalysts that we cannot initiate or control.[17] These current buzzwords in Christian culture can each stand independently, but I have found they are often inexplicitly connected together.

We can look back in history to see how these concepts even occur in the scope of warfare. In fact, wars are often won on moments that swing change. We could say these moments were a "twist of fate" or "luck," but instead of viewing history through the lens of humanism, let's put on some God-sighting, destiny-driven goggles for a moment:

1. Battle of Saratoga (1777) is known as a turning point (pivotal circumstance) in the Revolutionary War; it was at this pivotal circumstance that France became an ally (providential relationship).

2.  Battle of Gettysburg (1863) was a turning point (pivotal circumstance) in the Civil War; Major General John Buford (providential relationship) arrived in Gettysburg one day before the Confederates army and led his small Yankee cavalry to claim the high ground, which led to crushing defeat of General Lee's southern forces.

3.  The U.S. entering World War I in 1917 was actually considered a turning point in this war; in this case, the US's presence could actually be used as both a pivotal circumstance and a providential relationship.

In looking at Scripture, I can think of no greater example to support this section than the story of Ruth, Naomi, and Boaz. If you don't know the story, go ahead and read through the book of Ruth to find out how a pivotal circumstance led to a providential relationship, which led to another pivotal circumstance, which led to another providential relationship, which eventually led to a king.

Naomi, along with her daughters-in-law Ruth and Orpah, lived in Moab and through the course of life's "battles" ended up together as brokenhearted widows. Deciding to return to her home country of Israel, Naomi released the girls from any commitments they felt to remain with her and encouraged them to stay in their country of Moab. Orpah stayed; Ruth famously said, "Don't urge me to leave you or to turn back from you. Where you go, I will go, and where you stay, I will stay. Your people will be my people and your God my God."[18]

After returning to Israel, the first battle they faced was for food. Ruth, operating with her own reasoning and strength, developed, and put into operation a plan to glean for their food.[19] In this very natural act of working a tactic (gleaning) to achieve a strategy (eating), Ruth encounters Boaz (providential relationship), who instructs his field workers to leave grain purposely for her to glean (pivotal circumstance). Ruth's story doesn't end with filling her stomach. No, in fact, God has a plan in motion to fill her barren arms with an heir. As the story unfolds, Boaz becomes her kinsmen redeemer and not only marries Ruth but restores a son to Naomi in the process.

Isn't it a beautiful thing when we begin to look through the situations (battles) that we face in life and see the story that God is weaving in the midst of our difficulties? This is how we begin to get new eyes, a new heart, and a new walk.

In early 1991 Tim and I were considering buying a piece of land to build our third home. By this time, I was an account representative in the TWA sales office, and Tim was in outside sales for a window manufacturer. We were each advancing in our careers and enjoying endless domestic and international travel experiences thanks to my airline job. I bought a blue, two-seater Mazda Miata convertible, an outward expression meant to quiet my inward desire. On one hand, I was making myself live and adapt to a childless lifestyle. On the other hand, we continued trying the old-fashioned way to have a baby, resulting in an unwilling ride each month on the rollercoaster of infertility that peaks with hope and then crashes with despair. Feeling we had exhausted medical options and shutting the door on adoption, we were just living with empty arms in a weird dualistic approach to our infertility.

Then one spring day in 1991, my mother-in-law came to visit with a book in a small brown paper bag. The book was called *How to Get Pregnant with the New Technology: A World-Renowned Fertility Expert Tells You What Really Works, What Doesn't Work, and Why* written by Dr. Sherman Silber. I remember being overwhelmed with embarrassment as I removed the book from the paper bag and saw the title for the first time. Because even though we all knew the truth of our infertility, it was not commonly discussed—or at least the topic was never brought up by anyone else first.

Tim's mom had heard Dr. Silber on a radio show and was so inspired by his interview that she went out and bought the book for us. Here's the most important detail about this entire moment: Dr. Silber's practice was located in our hometown! Turns out, he was an internationally known pioneer in infertility treatment and the medical director of The Infertility Center of St. Louis at Luke's Hospital in St. Louis, Missouri. Besides running his practice and writing books, he was

a popular guest speaker, appearing many times on *Oprah*, *The Today Show*, *and Good Morning America*. Imagine finding out that a world-renowned infertility specialist was practically living in our own backyard!

If ever there were a pivotal circumstance and providential relationship experience in my treatment story, it was this moment. We had a defining moment that propelled us forward (pivotal circumstance) because we heard God through others (providential relationships). No doctor had ever spoken to us about the possibilities that were emerging through assisted reproductive technologies (ART). *At this stage of my journey, I didn't even know that term!* Of course, I'd read about procedures like in vitro fertilization (IVF), but there was no roadmap to connect me with these possibilities. Remember, we are talking about the days before the internet opened up communication and resources.

Before I even finished the first chapter of Dr. Silber's book, I knew in my heart we'd found our future path. It was almost as if the book had been written directly for me with statements like: "The most common, overused 'diagnosis' for infertility is 'endometriosis'"[20] and "There are many popular 'diagnoses' which may lead to inappropriate surgery that gets an infertile couple no closer to getting pregnant."[21] Like water to a dying man, this book's information and this doctor's experience were exactly what we needed.

Dr. Silber was a vascular surgeon who was pioneering technologies to help couples get pregnant, but more importantly he was an expert in male factor infertility. Ever the type A, driven personality, I was ready to step into the world of high-tech infertility treatment immediately! But as with anything that defines you and molds you in life, there was to be inevitable waiting wrapped up in the process. Apparently, I was not the only infertile woman seeking the answers Dr. Silber was providing. The same book press that drew us to him also drew couples from around the world to his clinic. By the time we called to make an appointment, there was already a six-month waiting list for the first consultation.

Imagine with me please the rising expectations occurring in our lives. We'd listed our home for sale and proceeded to purchase the cul-de-sac land we'd been looking at to build our next home. Planning trips moved to the back burner, as I became obsessed with learning about ART technology, while at the same time began looking at floor plans to build my home. After years of zero forward movement, let alone traction, there was a glimmer of hope on the horizon. Five and a half long years into our battle with infertility and finally, some legitimate hope and solid answers began to surface. Hope started to awaken in the depths of my soul—we just had to wait for that darn appointment!

Finally, the day arrived to meet Dr. Silber! I was so nervous and I tend to have diarrhea when I get nervous. I realize that's borderline TMI, and I apologize, but it's a very real problem that I live with and will play a part in the story I'll be sharing a few chapters from now. In any case, it was finally the day to meet the doctor (and I had diarrhea). He read through our charts, was intrigued by Tim's hypospadias, not surprised by all the hoops other doctors had put us through and told us we were ideal candidates for his practice. Based on the sperm count and vitality, he was doubtful we'd ever get pregnant on our own, despite the fact that I was only twenty-four years old.[22]

Dr. Silber was working with a doctor from Australia, testing out a new in vitro technique called Gamete Intra Fallopian Transfer (GIFT), "to bypass all of the incredible hurdles that sperm and eggs have to go through (even in a fertile couple) to achieve a pregnancy."[23] The process would involve a normal in vitro cycle of egg stimulation, retrieval, and sperm collection, but instead of transferring into the uterus, the eggs and sperm would be transferred directly into the fallopian tubes where normal fertilization takes place. GIFT also bypassed the normal forty-eight hours the sperm and egg sit together in an incubator for purposes of fertilization, so the procedure was all done in one day instead of two. The fees were staggering, the waiting list long, the drug protocol intensive, but there was—at last—hope for a baby. Depending on the condition of my eggs and Tim's sperm on the procedure date, we might have as much as a 45 percent chance of a pregnancy on the first procedure. No thinking required—SIGN US UP!

We were initially told it might be a year before a procedure time slot would be available. I was broken. So close, and yet still so far away from my baby. I knew in my heart this was our pathway, but time continued to stand as the great barrier to my dream. We completed the required paperwork and paid the necessary fees to get on the list, and then like so many others, waited until it was our turn. I saved up every penny and every ounce of hope I could find during the waiting season. I even started taking prenatal vitamins so that my body would be optimized and ready for pregnancy.

By early fall we received a call that we were being included in the GIFT group for March 1992 with my treatment protocols expected to begin in the December before. There aren't words for how I felt when the manila envelope arrived in my mailbox with the step-by-step instructions for our procedure. I wept, I prayed, I shouted, and then I did what I do best—I got my calendar out and started to get organized.

## The Bible, Sun Tzu, and Me

It was becoming clear that my strategy for getting a baby was to use the tactics of assisted reproductive technologies to achieve a pregnancy. But while treatment presented us options we'd never had, it also presented us with several moral dilemmas. Remember Sun Tzu's five constant factors that we examined earlier in this chapter? Factor number one, Moral Law, and factor number five, Method, came into play at this point in my story. I didn't know it at the time, but we were being forced to balance our strategic planning by moral choices related to advance reproduction. How far would we go to have a child?

We had to consider our religious beliefs and determine what choices we believed to be ethical and in keeping with our practice of the Christian faith. Concepts such as "selective reduction," "donor sperm," and "life at conception" were all issues we had to wrestle through with our doctors when we embraced ART solutions. We faced the possibility of "freezing eggs" and even "selling eggs," a seductively tempting option that would have helped offset the cost of the $10,000 procedure. While a GIFT procedure doesn't deal with actual embryos

like an IVF procedure would,[24] we realized the necessity to fully comprehend all of these new options to understand the complexity and weightiness of the issues involved. In the pursuit of making a baby, we found that our faith had to inform our decisions and could not be set aside simply to fill my arms.

This situation is exactly why the Catholic church does not approve of assisted reproductive technologies that artificially create embryos.[25] Not being Catholic and in the absence of a prevailing accepted position in the Christian camp at the time, we believed that creating a baby in a lab that was from our genetic DNA was covered under our marriage covenant. It was the terms of that covenant that prevented us from 1) selling my eggs to pay for our procedures, 2) using donor sperm to increase our chances of fertilization, and 3) agreeing to the terms of selective reduction if we conceived higher order multiples.

We approached this situation with a balanced faith and reasoned approach, not situational ethics (under which I believe this list of three fall). We did embrace scientific advancements to overcome infertility, while wrapping our decision up within the moral and righteous boundaries of our faith. We found our footing in this ethical cliff within the universally held Christian belief that life begins at conception. Understanding that life cannot exist outside the body (yet), we believed that any and all embryos we created would need to be transferred and given the opportunity for God to decide which would implant and develop, and which would not.[26]

I am not intending to suggest that these guidelines should represent the views of the church related to ART solutions. Many, much more learned than I, have and will continue to debate the moral implications of emerging technologies and the challenge advancements in reproduction present to the field of Christian ethics. I am simply telling our story, the issues we faced, and the decisions we made in navigating what appeared to be a moral minefield.

In December of 1991 I started the first drug and took my first official step into the high-tech world of treatment. Although my actual procedure wasn't going to take place until March, my body's natural

cycle needed to be reset in order to be manipulated and scheduled by the doctor. I filled all my scripts and brought home bags of medication and syringes. Soon I would be administering daily shots, making two trips per day to the hospital for blood tests and more shots, and subjecting my body to hormone abuse it had never known before. I scheduled vacation time to spend a week in bed afterward to optimize my chances of pregnancy. I read everything meticulously and prepared myself for the complicated battle that is IVF/GIFT. We paid all of the money, as if anteing up and betting everything on a positive pregnancy test.

I wasn't afraid or filled with fear or really dreading any single aspect of the regimen. If anything, I was almost giddy. I told family, close friends, and a few coworkers, buoyed with a sense of confidence for the future I hadn't known for years. We had broken ground on our new home and were busy with the endless tasks couples face when building a home. All of the big pieces were coming together in early 1992, the year Tim and Dawn would finally become parents. In fact, my mind was thrilled about the prospect of higher order multiples. I was emotionally prepared for the news of triplets, which was a real possibility given my young age.

Roughly fourteen days out from an ART procedure is when the real fun begins with the daily Lupron shots. Lupron shuts down your body's normal hormone production to prepare for the stimulation drugs. This is injected into either the thigh or stomach via a small subcutaneous (sub-Q) needle. I had read the how-to guide many times and knew what to do, but I still struggled the first few times to actually inject the needle into my own body. *It's for my baby, it's for my baby, it's for my baby*, I'd chant repetitively with the needle hovering over my thigh and Tim hovering over me.

About ten days from the target date, you start the real deal, the "let's stimulate your ovaries and make a baby" drugs. My drug was called Pergonal and given my young age, I was only given one ampul a day into my hip via an intramuscular (IM) needle. This drug had to be delivered each night by the nurses from the hospital where my doctor's clinic was located. Additionally, I had to return to the hospital each

morning to have blood drawn so that my estrogen levels could be monitored. By the third day of the stimulation medication, I also had a daily ultrasound to monitor the development of follicles on my ovaries and to measure the lining of the uterus. Oh yeah, I lived about 45 miles on the other side of St. Louis from the hospital and I was also working full time during the stimulation phase. During this period of treatment, my daily schedule looked like this:

Inject Lupron, leave for hospital by 5:30 a.m., sign in to the ER and wait for a nurse to draw daily blood sample, go to the ultrasound lab and wait for my turn, drive to office in rush hour traffic, work full day, call the doctor's office in mid-afternoon to get instructions for next dose and daily test results, drive back to hospital in rush hour traffic, sign in to the ER and wait for a nurse to give you nightly Pergonal injection, drive 45 miles home. Once in a while in here I also had to include checking in on the home we were building.

As your body wearies from the schedule and struggles with the hormones, your mind races while your ovaries start mass producing. It's an absolutely bizarre experience, riddled with complexities. But even in the midst of this head-tripping and body-manipulating pivotal circumstance in my life, I came face-to-face with providential relationships. Here in the waiting rooms of the ER, the labs, and the ultrasound room, I began to forge friendships with others going through the same experiences. We shared our results, talked about our infertility, laughed about the drama, and cried about the pain. We were all on the same battlefield together, fighting in the exact same war. We drew comfort and strength from each other over the month we shared together waiting and hoping, while our ovaries grew follicles and our uterus thickened to prepare for implantation.

Finally, you get the good news that it's time to schedule the follicle aspiration! Mine was scheduled for March 8, 1992. Believe me, you can tell it's time because the bloating from the stimulation drugs is no joke. The final injection, the hCG trigger, occurs exactly thirty-six hours before the procedure. For me, this meant a trip over to the hospital in the middle of the night to get the injection scheduled for 1:30 a.m. It was so exciting, though! My young ovaries had done their job well. I

had close to twenty follicles visible on the last ultrasound, the lining of my uterus was thick, and my estrogen levels were perfect. Sure, I was sore and tired (and poor by now), but everything was looking perfect for our first—and by my estimation—only GIFT transfer.

We arrived at the hospital early on March 8. It was finally Tim's turn to do his only part in this whole process: sperm collection. The staff took him through door A, and I was escorted through door B. Odd to think our baby would be made while we were in separate rooms. I was nervous, and I've already told you what that means. Dr. Silber popped in and gave me an honest and not so cheerful update on the sperm (I believe he called them "miserable swimmers"); I continued to run to the bathroom to deal with my "nerves"; Tim returned from performing his duty; and finally I was prepped for the procedure. I was never so thrilled to have a light sedation as I was on that morning. Finally, the time had come to conceive.

The retrieval went smoothly, and a dozen perfect eggs were harvested. The GIFT transfer was also successful, with four eggs graded at 4+ and a few million sperm properly placed in my fallopian tubes. We were closer than we'd ever been to making a baby. The team gave us a 50 percent chance of having a baby, with a high likelihood of having multiples (at least that's how I remember it). I was sent home on a week's bed rest to incubate.

You go home and wait. You wait for the required fourteen days to click by. You wait for your ovaries to heal. You wait to be sure you don't end up with hyperstimulation. You wait for your baby or babies to implant. You wait to take the test that will determine your future. Meanwhile, you listen to your body. You focus on every feeling, every twinge, and wonder, is this a signal of pregnancy? You cramp endlessly, from the abuse on the ovaries, the invasiveness of the retrieval, and the thickness of the uterus. They tell you cramping is normal and cramping isn't a signal of success or failure. You focus on every cramp and wonder, am I pregnant? or am I starting? A week after my procedure I returned to work.

After fourteen days that were nothing less than actual eternity, we drove back to the hospital for my pregnancy blood test. Although I

was anxious to know, I honestly never for one moment in time considered the procedure would not work. My Commander had sovereignly led us on this pathway through pivotal circumstances and providential relationships. Our house was being built, the foundations established, and the walls going up. It was all a sign for success. My expectations for a positive report were high as the telltale blood was extracted from my arm early on the morning of March 22 of 1992.

In this pre-cell phone era, we returned home to await the good report. It was a Sunday in spring. After the good report came in, we were planning to take a drive up the river road and check out some brick for our new house. Both sets of our parents were home and waiting by their phones, too. Finally, the blue phone on the kitchen wall phone rang around 3:00 in the afternoon:

*Hi Dawn, it's Dr. Silber's office. I'm sorry to tell you that your hCG count was less than two, indicating a negative result. You are not pregnant.*

# 7 Death Days & Memorial Stones

*I wear to this day the physical scars from that attack, never letting me forget that terrible date. But, like the rest of those who survived that day, I have other wounds, ones that can't be covered up with slacks and long-sleeved shirts. Scars on a part of me no one can see.*

*—Seaman First Class Donald Stratton*

*Author's reminder: As we begin this chapter, more so than probably any other part of this book, I want to again remind my readers that I am in no way comparing actual warfare to my personal life story. Bloody battles, mass casualties, and surprise attacks are simply not the same thing as the various forms of warfare individuals face throughout life; please hear my heart that I understand and respect the difference! I've simply found so many truths that are relevant to me expressed so perfectly in militaristic pictures. When I fall short of communicating in accurate terminology or by using extreme comparison, please allow room for interpretations to be categorized poetically.*

———— ❧ ————

Soldiers face death because they face war. Death is inevitable in war. Sometimes death is faced head on by charging into battle, and sometimes death comes by surprise attacks from the enemy. The attack on Pearl Harbor by the Japanese that occurred on December 7, 1941, is one historical example of an enemy's surprise attack. Nearly the entire US Pacific Fleet was docked in Pearl Harbor on that fateful morning. A total of 2,403 people died in the attack, with 1,177 from

the USS Arizona alone.[1] An additional 1,143 people were injured.[2] Many of these were servicemen who returned to active duty after recovering to fight the enemy with a vengeance in WWII. It is the survivors who live to tell the harrowing tales of battle, and it is they who must find the courage to fight another day.

One of the survivors of the USS Arizona, Donald Stratton, has published his memoirs and firsthand account on the Day of Infamy. Here's his powerful description of the death day he lived through and the profound way he was forever changed:

> As I looked back at the harbor billowing furiously with smoke, seeing the Pacific Fleet destroyed where they were moored, staring at the collapsed remains of the *Arizona* engulfed in flames…. the devastating sweep of it was too much.
>
> At that moment, I knew I had lost a part of myself in the ruins of that ship, and a big part of my family in the men who died there. I turned my head.
>
> I had to look away from my ship, from the once-majestic form that had taken my breath away when I first saw her; from my home, filled with so much life less than an hour before.
>
> And I had to turn away from my shipmates, from the future that no longer awaited them….and from a part of myself that now would be forever entombed with them.[3]

I can picture the moment as if it were yesterday: I see myself crying, slumping down onto the floor with the blue phone in my hand and the cord tangled around my body. I was standing in the kitchen of our second home when I received the call on March 22, 1992, that my first ART procedure had failed. It happens like a dream sequence; you hear the words but your mind sort of stalls and wants to reject the incoming

news. The results took my breath away as the negative report was absorbed throughout my body. Tim just covered his face with his hands and stood beside me, knowing completely without hearing the words. I had simply never dreamed that the answer was no—all the shots, all the money, all the hoops—this was our answer! IVF was our answer! Everything had led us down this path. It was as clear as a giant neon billboard and big pointing arrows screaming THIS IS YOUR PATH! There was never a doubt in my mind, not even for a single second during the entire cycle, that I would not get pregnant.

*"I'm so sorry," the nurse said. "Your hCG count is less than two. You are not pregnant."*

All of the oxygen was sucked out of my world in that moment of time. All I heard was heaven saying "no" and I was defeated in my tracks. This battle, our first actual battle, was lost. The day was spent holding vigil on what could've been and what should've been with friends and family who came by our house to grieve with us. The sad story was repeated to everyone who walked in the door or called to check in. "I can't believe it," "I'm so sorry," "you can try again," and "don't give up hope" were the common platitudes being served by well-meaning loved ones who struggled to find the right words to bring relief. It's almost as though you detach from your body a little bit and watch the unfolding events more from the audience perspective, rather than the actors up on the stage. Someone is hugging you, comforting you all the while your brain keeps screaming, *Is this really happening to me?*

Within a day my body confirmed the negative test result with violent cramping and hard bleeding. I was paying the price for this battle, even after loss. Longing for escape and relief from the gut-wrenching and confusing defeat, we needed to run away. The water beckoned and promised relief; responding to its call, within days we were on a plane to my beloved Hawaii to mourn and to heal. If I couldn't have a baby, I would have Hawaii. At least God had given me an airline to fill my aching heart. I drained my tears all over the islands,

especially at the Pearl Harbor Memorial, a fitting place for *kanikau,* the Hawaiian word for lament or mourn.

March 22, 1992, became my first death day. The best way to explain a death day is being caught somewhere between yesterday and tomorrow. It's just a day where you can't go backward or forward; there is no choice but to stand and mourn for what is lost and what will never be—or at least never be as you had always envisioned it. Besides the loss of a great-grandparent, I had never experienced a close tragic death. I had no understanding or pattern for dealing with this level of emotional pain. Infertility had been a heavy burden and disappointing reality, but even six years living as an infertile couple did not prepare us for the loss we were now experiencing.

## Intangible Loss

I've come to realize that an ART failure is an intangible loss. There is no body to bury, no service to prepare, no grave on which to mourn. There is and never was anything except a dream and maybe hope. If empty arms could have a death, that's what this would be. But since empty arms are empty in the first place, it's almost like a nothing death. I found myself jealous of people who miscarried because at least they had some tangible death to mourn. At least at some point they had flesh growing within. I know that statement probably sounds awful and harsh, and I cringe about being that raw here. But it's how I felt. I was so low that I was jealous of someone who miscarried because everyone is allowed to mourn this nature of death.

But I was never pregnant. We lost eggs and sperm and money and a dream, none of which were actually ever living. I had paperwork and needles and pictures of follicles from an ultrasound, meaningless mementos for those empty arms of mine. There is no real period or rituals of mourning for people like me because NOTHING ACTUALLY DIED. In her work, *Grief Unseen,* Laura Seftel writes, "Our modern culture has neglected to provide a framework to manage the disruption in our lives that can ensue following a significant loss."[4] It's not too long before family wants you back to the responsible

firstborn daughter status, and friends want you back to your sanguine self. Meanwhile, I'm over here throwing dirt on a gravesite that only exists within my heart.

Intangible loss, invisible loss, and psychological loss are all words to define a loss like I experienced on that day in March of 1992. Loss is simply a state of being without. While much is written on traumatic loss and loss in general, I've found very little written in books or scholarly articles about intangible or invisible loss. Anything I've found is usually connected to quantifying monetarily an undefined loss for an insurance settlement as related to a divorce case or loss of a job (both of which could be classified as an invisible loss); it's a term usually applied to the loss of an intangible variable associated with termination of a contract. This is a huge red flag to me that in our society we fail to see, recognize, or allow for the invisible realm—as if what you see is what you get is the highest validation of life in the physical realm.

Jerry Sittser in *A Grace Disguised*, writes, "Loss... leads to a confusion of identity—since we understand ourselves in large measure by the roles we play and the relationships we have, we find ourselves in a vertigo when these things are changed or lost."[5] I was indeed in vertigo when every measure I had defined womanhood by failed to be mine and exceeded my grasp. If I couldn't be a mother, what was I? Was I only a daughter and a wife, maybe perceived by others in the workplace as a corporate ladder climbing feminist? These labels either weren't what I wanted or no longer satisfied. My loss had confused my identity and I was beginning a free fall spiral down toward depression.

Desperate to get pregnant, I immediately scheduled my next procedure, one I should mention we could not afford. We were in the middle stages of building our home, no offers had come in on the home we still lived in, and we had just taken an unplanned vacation. This procedure was going to be paid for by Mastercard; I was determined to have my own "priceless experience" to share with the world. The fact that my body would have little recovery time or that we would be paying interest for our second IVF made zero difference to me. My world was in full motion to have my family by this point,

and nothing was going to stop me now. Our next target date was set for early September. I consoled myself with the fact we were only being slightly delayed, and anyway, I could get moved into the house before getting pregnant. Plus, if the last procedure fulfilled our failure percentage, then odds were this procedure was bound to be a success!

During the follow-up appointment, it was determined our next procedure would take a slightly different approach by combining a traditional IVF with a zygote intrafallopian transfer (ZIFT). ZIFT transfers zygotes, whereas GIFT transfers gametes. The process of delivery into the fallopian tubes is the same; it's the stage of development (fertilized eggs vs. unfertilized eggs) that marks the difference between the two procedures. The stimulation and retrieval process would be the same, but the sperm and eggs would incubate together in a petri dish for forty-eight hours to allow for fertilization. Once fertilization occurred, the resulting embryos would be transferred into the fallopian tubes using the ZIFT approach. Always frank, Dr. Silber shared his concerns about the motility of Tim's sperm and their ability to penetrate an egg. These conversations were always so difficult to endure, knowing there was simply nothing either of us could do to change the root cause of our infertility.

It was at this juncture we learned about a new technology specifically designed to address male factor infertility called Intracytoplasmic Sperm Injection, or ICSI. This procedure would allow for the injection of a single sperm into a single egg with the use of special micropipette. High-tech infertility was evolving at a rapid pace with many exciting promises on the horizon. Dr. Silber was working with doctors in Belgium to refine the technique and had hopes to bring the technology to his clinic in St. Louis soon, but unfortunately it was not an option yet. For the time being, IVF with a ZIFT transfer held our next best chance to obtain a pregnancy.

My packet arrived and drug protocols began in early summer, roughly the same time we were preparing to move. After a year on the market, our home was finally under contract to sell in July, about the same time our new house would be ready to move into. We were living in a very stressful period trying to manage all of these big issues

happening concurrently in our lives while both working full time. Evenings and weekends were either spent at the new house painting trim, hanging wallpaper, and painting walls, or at our existing house packing and prepping the house for closing. Of course, you know that delays in real estate transactions are not uncommon, and par for the course we experienced hiccups on both sides. The stress in our lives— to build the perfect lives—was very high given the unrealistic expectations placed on my time, energy, and mental health during these few months between procedures.

By the time August arrived we were finally settled in our beautiful custom-made home on the cul-de-sac. This house was mine top to bottom, and I was in love with every detail from the imported Italian deco tiles, the white cabinets, hardwood floors, Jacuzzi tub, and spare bedrooms for our children. I still remember what it felt like to wake up in our master bedroom after our first night in the house. It was the sweet feeling of fulfillment and the smell of brand new (and the surprising and unexpected sounds of trains in the distance). There was still a lengthy punch list of things to do and buy, but we would have forever to get them done as a family. Dreams were coming true all around us. We were living in our dream home and soon the blond babies we had dreamed of would be in our arms.

The time arrived to begin the daily injections, and not long after, the daily hospital trips. I struggled with intense headaches during this stimulation, every aspect of it seemingly more difficult on my body than the first cycle earlier in the year. My ovaries performed as expected, but they weren't thrilled about taking another hit for the team. Every day the pressure in my abdomen grew, making me feel like I constantly needed to hold my belly up with my hands. The ultrasound techs were always astonished at the number of follicles I produced and how well they were growing. My right ovary was proving itself the overachiever, way outperforming the left ovary for the second stimulation in a row. Now I suddenly knew why this side always hurt more during ovulation; this sucker had an agenda and something to prove!

The friends I made the first time through ART weren't by my side in the waiting room this time around. They had either gotten pregnant at the first cycle or were waiting to try again at a later time. There was nothing in me that wanted to get to know the new people sitting around me in the waiting room this time around. It was obvious who the first timers were in the group because innocent hope radiated from their eyes. It was taking all I could muster to find hope for myself; I couldn't go all in with another group of waiting parents. I didn't want to carry their stories, share in their success, or feel any more pain. The cheerleader was gone.

I also knew how the system worked now, so I did my best to avoid the first timers. I arrived extra early and ran upstairs to ultrasound to be the first name on the list, then down to the ER waiting room to be the first blood draw. I've always been the kind of person who liked to be one step ahead. It's always been part of my personal (yet flawed) belief system, rooted foolishly in that darn first child perfectionist mentality. You can be certain this one-step-ahead mode was in full force to get me pregnant and to self-protect. My twenty-fifth birthday and our seventh anniversary came and went this year, somewhere in the middle of waiting for an ultrasound and a blood draw, in the basement of St. Luke's hospital.

We finally got the news that our retrieval date was being set for September 9 and the transfer date would be on September 11. As before, I was given the exact time to arrive in the ER for the hCG shot exactly thirty-six hours before the follicle aspiration was to occur. This middle of the night run to St. Luke's was more matter of fact than the first time we made the jaunt; it was simply another check on a very long list of to-dos on the IVF checklist.

The morning of the procedure arrived, and once again Tim was escorted one way and I another. My mom was with us this time and kept me company in pre-op. My nerves, as always, flared and provided the comic relief of the morning with endless trips to the bathroom. Dr. Silber and the accompanying OB/GYN (who still on the second procedure didn't know my name so I won't use his) stopped by for the official pre-op patient visit. We chatted about TWA, frequent flyer

miles, and travel—this was becoming our shtick together once he found out what I did for a living. Oh, and of course, we talked about what was about to happen in the OR.

When I came out of anesthesia, Dr. Silber walked us through the next forty-eight hours. As in March, the eggs looked great, the sperm not so much. He explained that the eggs and sperm would be kept in an incubator until early Friday morning when they would be checked for fertilization and the development of embryos. If fertilization occurred, the transfer would occur as scheduled, and I would be sent home on a week of bed rest again with a pregnancy blood test two weeks later. If fertilization did not occur, I would receive a call and would not need to come to the hospital. This time around I would have some form of an answer within forty-eight hours instead of two weeks. This time I walked out of the hospital and left all my effort, hopes, and dreams in the lab, not inside my body.

At 4:00 on the morning of September 11, 1992, the phone rang as we were preparing to leave for the hospital. I was standing by the side of my bed when I answered the call:

> *(Practically a whisper) Dawn, it's Dr. Silber's office. I'm sorry to tell you that there was no fertilization with your eggs. You do not need to come to the hospital this morning.*

## Memorial Stones

The book of Joshua picks up right after Moses's death when the children of Israel are preparing to leave the wilderness and cross over into the promised land. First though, they have to cross the Jordan River, which is not nearly as easy as it may sound. In Joshua 3 we are told that the crossing will occur during harvest season when the waters of the river were at flood stage and overflowing their bank. The people needed another miracle to safely pass through the Jordan, similar to the one they received at the Red Sea while fleeing Egypt forty years earlier. This is Old Testament drama at its finest. Joshua instructs the

priest and the people what to do and what to expect of God (vv. 9-13) and the events play out exactly as he had prophesied (vv. 14-17).

While this is a great story of God's miraculous power, Joshua's leadership, and the end of the Israelites wandering period, it's what happens next in Scripture that draws my focus. Let's take a look at chapter 4 (emphasis added):

> When the whole nation had finished crossing the Jordan, the Lord said to Joshua, "Choose twelve men from among the people, one from each tribe,

> and tell them to take up twelve stones from the middle of the Jordan, from right where the priests are standing, and carry them over with you and put them down at the place where you stay tonight."

> So Joshua called together the twelve men he had appointed from the Israelites, one from each tribe, and said to them, "Go over before the ark of the Lord your God into the middle of the Jordan. Each of you is to *take up a stone* on his shoulder, according to the number of the tribes of the Israelites, *to serve as a sign* among you. In the future, when your children ask you, '*What do these stones mean?*' tell them that the flow of the Jordan was cut off before the ark of the covenant of the Lord. When it crossed the Jordan, the waters of the Jordan were cut off. These *stones are to be a memorial* to the people of Israel forever."

> So the Israelites did as Joshua commanded them. They took twelve stones from the middle of the Jordan, according to the number of the tribes of the Israelites, as the Lord had told Joshua; and they carried them over with them to their camp, where they put them down. Joshua set up the twelve stones that had been in the middle of the Jordan at the spot where the priests who carried the ark of the covenant had stood. And they are there to this day (emphasis added).[6]

There is a lot of symbolism packed in right here, most of which we are just going to acknowledge and pass right through (you see what I did there?). Passing through the Jordan is considered a foreshadowing of baptism.[7] The children of Israel passed through the riverbed into a new life, leaving behind the pathway to their old life. In the middle of the miracle—in the middle of the dying of the old and the resurrection of the new—God was thinking about future generations! He instructs Joshua to pick up memorial stones from the riverbed and to erect them as a memorial to future generations at the place where they will make camp after the crossing is complete.

Imagine if you would, what the raging floodwaters standing up in a heap might look like. I'm guessing that the heap would be growing larger minute by minute during the length of time it would take for the young nation to cross through the riverbed! God doesn't seem to be the least bit concerned with passing time or heaping water though. He's focused on leaving a testament to the generations yet to come. God asks the question in verse six: "What do these stones mean to you?" And gives an answer in verse seven: they are meant to be a memorial to both death (wilderness living) and life (promised land living). Those stones memorialized the truth that God is able to deliver and to save.

Death days and memorial stones are connected, both in the natural world and also in the spiritual world. When a loved one dies, we erect a headstone so that the deceased memory doesn't fade away. Memorials are constructed to remind us of valiant battles fought and lives lost in pursuit of a common purpose. Baptism is a marker in our spiritual life of a death day, too; we identify with Christ in the symbolism of death and resurrection. Building memorials is a timeless tradition from the earliest days of recorded history until now. People need something to hold onto in the midst of mourning so that the person, thing, or dream isn't forgotten. God knows this about his creation; that's why he carefully instructs Joshua to erect a memorial specifically about the Jordan crossing. God understands how we are wired, how we cope, how we recover, and how we remember. He knows how to perfectly integrate all aspects of recovery and loss for our healing, even in the face of death.

———— ❧ ————

Death days feel empty, like you are going through the motions without emotion. It's a space where time stands still, and nothing satisfies the starving soul. Part of me didn't know how to bounce back from this hopeless death place I was being forced to live, and the other part of me refused to even try. I knew I should drag myself to worship, but instead I indulged myself in mourning and refused to leave the gravesite in my heart. My memorial stones became the actual days of loss: March 22 and September 11. The dates were all I had to hold on to. Again, the burden of an invisible, intangible loss is that there is never anything to embrace—even in the memorial.

After my second procedure, I entered a prolonged depression that would take me nearly a year to emerge from. I felt set up and cheated by Jehovah Tricky. Tim began struggling with alcohol, an addiction he had been clean from since turning his life over to Christ as a teenager. We both ran away and tried to anesthetize our pain, whenever and however possible. The Thanksgiving right after the procedure we spent in France, and Christmas we spent in Italy. I didn't even want to make memories in our new home without having a family, so I left my home and the rest of our family.

I had no idea at the time that I was picking up stones from the bottom of my Jordan River. Each place of death that I was drawn to, each one that threatened to hold me under and take my life, was a place where I retrieved a stone. I was building my memorials and living testaments in the middle of my death day, just like the children of Israel did. Even in my grief God was displaying his sovereignty; I just didn't have eyes to see it at the time. I was simply attending to death days. I had no idea that my Father was helping me to construct an altar of remembrance on the other side of the river that would testify to future generations of his ability to save and deliver.

# 8 My Weapons of War

## Worshipping my Way Through Pain

*It is not enough to fight. It is the spirit which we bring to the fight that decides the issue. It is morale that wins the victory.*
—*General George C. Marshall*

Military theory has changed over the years as weaponry has evolved. Obviously, what worked for Thucydides in the Peloponnesian War did not work for Truman in Korea. Javelins, slings and swords, shields and armor, and spears and projectile weapons in the form of catapults characterized the age of infantry. But when the age of cavalry dawned, weaponry and strategies were forced to change. What was true for an army of foot soldiers no longer applied in a day where the army rode on horseback. The same stands true for all subsequent eras from the development of gunpowder to the power of industrialization, and to the speed of technology. In his book, *Warfare in World History*, Michael Neiberg explains, "Militaries must be able to introduce new technologies into their doctrines and employ them on the battlefield in an effective manner."[1] Each era that transformed weaponry required the development of new skill sets and revolutionized training methodologies. When it's time to employ a new weapon, soldiers must learn how to use it. This takes time, training, and patience, but can make all the difference in applying an effective strategy and tactics to win the war.

———— ✖⟋ ————

If my strategy was to get pregnant and my tactics were assisted reproductive technologies, then it stands to reason that my weapons of war were money, medication, and technology. As 1992 closed out, all of my weapons had failed me. I abandoned them on the battlefield as I retreated back to safety. Not only had my emotions taken direct hits, but so had my body. With countless needle marks on my hips and thighs, we'd lost two huge battles and the defeats were unbearable.

Choosing to run away instead of facing the holidays, we spent Christmas and New Year on the Amalfi Coast in Italy. We explored Rome, Sorrento, the isle of Capri, and Pompeii, running as fast as we could each day to escape the internal pain. It was a gorgeous locale to forget about life, a coastal area where lemon groves extend to the rugged cliffs that run into the Mediterranean, and ruins from days gone by tell tales of grandeur. There is also food, all of the delicious Italian food that we could talk about for days… *mozzarella di Buffalla, insalata caprese, Napoli pizza, gelato,* and just about anything made with local lemons. We stayed in the gorgeous Sorrento Palace that was largely empty until New Year's Eve. So empty in fact, that when we went down to the pool area, we had to turn on the lights ourselves. On the exterior, it was the picture-perfect vacation.

The weather was unusually cold for the area and we hadn't taken coats. "Less is more" is the general rule of thumb when you fly standby as an airline employee. Most of the pictures we took together are of us huddling for warmth or wrapped up in giant scarves we bought in the market. Every time we'd inquire about the cold snap, the locals would tell us it would only last "two, three days" (say this, please, with an Italian accent as you wave your hand as if it is nothing important). As anyone who has ever been to Italy can tell you, Italian time is its own thing. We quickly learned that watches didn't matter, hours posted outside a restaurant didn't apply, and transportation would arrive when it arrived. "Two, three days" became a private joke and motto for most of our trip.

Not only was it cold, but on New Year's Eve it was also rainy. We didn't bring coats, but we did bring along clear plastic rain slickers from

Walmart! Bundled in layers and our new Italian scarves, we put on our plastic rain slickers and headed out for the fireworks display we'd heard was happening in the town square. When we arrived around 11:30 p.m., we ran into what I would estimate was most of the population of Sorrento, all dressed to the nines in full-length fur coats. (Please take a moment and picture in your mind exactly how much we stood out in that crowd in our plastic slickers!) Needless to say, the fireworks didn't begin at midnight. In fact, they were just beginning to set up the display when 1993 officially arrived. Somewhere at 2:30 a.m. we watched a small yet hazardous fireworks display that sent sparks flying into the crowd adorned in fur coats. The absurdity of the moment is laughable: facing the possibility of catching on fire in an Italian town square well after midnight while covered in plastic during the middle of running away from our failing lives.

Despite the beauty around us and even with moments of laughter, our hearts were broken in a million pieces. We had basically run away from life, still so blind to the truth that God had provided a means for us to recover through travel as one of his providential blessings during the barren season. When we arrived home, we found our Christmas tree down in the living room with many of our keepsake ornaments broken. The year 1993 rolled in with the realization that running to the other side of the earth didn't ease our unescapable pain. Our lives were still broken and shattered, just like our Christmas ornaments. This new year was filled with some of our darkest days as individuals and as a couple. Depression on my end and alcohol on Tim's end were not a combination for healing. The pain closed in like a darkness that sought to consume all of the light.

# The Purpose of Pain

Nobody likes pain. Pain hurts, and it is almost always something humans try to avoid. I've had enough broken bones in my lifetime to assure you that pain has differing levels of intensity and is a telling factor in diagnosing what might be wrong. Pain can be acute or chronic and can lead to other physical reactions such as nausea, passing out,

screaming, and just plain making you cry. Pain is our signal—an unconscious reflex—that something is very wrong with our body. Let's face it, if pain didn't stop us in our tracks after we broke a limb, we would keep moving forward and not even know we were broken. Pain tells us to stop and pay attention to this matter, something is wrong, and it needs to be fixed—now! Pain hurts, but pain also causes us to know something is wrong and helps us modify harmful behavior.

Pain is a physical experience, but we also suffer pain emotionally. Often the emotional pain is harder to deal with in life. You can't put a band aid over a broken heart and expect it to heal in six to eight weeks. Emotional pain, or soul pain, has its own timeline and healing process. I describe this type of pain as a writhing, unable to get release, curls you up in a ball, unable to breathe, suffocating in its lack of control or ability to be cured or fixed. C.S. Lewis explains this pain much better than I do; he writes, "When I think of pain—of anxiety that gnaws like fire and loneliness that spreads out like a desert, and the heartbreaking routine of monotonous misery, or again of dull aches that blacken our whole landscape or sudden nauseating pains that knock a man's heart out at one blow, of pains that seem already intolerable and then are suddenly increased, of infuriating scorpion-stinging pains that startle into maniacal movement a man who seemed half dead with his previous tortures—it 'quite o'ercrows my spirit.' If I knew any way of escape, I would crawl into sewers to find it."[2]

For all its discomfort though, physical, and mental pain both have a purpose. Pain helps to prepare us and mature us; pain helps us take on our own identity and discover our purpose; pain helps us to heal. We often connect pain with defeat, rejection, or loss, instead of viewing it through the lens of healing, strengthening, or improving. I'm not trying to minimize pain associated with a loss of a loved one or the loss created through infertility. Pain is real and legitimate. It demands recognition. But humans will do just about anything to self-protect from pain's wrath. Pete Wilson writes, "All we can think of is easing our discomfort, leaving the pain behind."[3] We try endless ways to ease our discomfort, instead of trying to understand the purpose for the pain. Instead of sitting in the pain and enduring the healing process, we run away, self-anesthetize through alcohol or drugs, start cutting,

overeat, overspend, fall into depression, or even worse—we blame God.

For some reason Christians tend to carry a false utopian expectation that life will be filled with endless joy and blessings. When something goes wrong, or not according to our plans, it's generally assumed we've either sinned or stepped outside of God's plan. We fail to see that God uses pain as his instrument for transformation. Once again in his profound way, C.S. Lewis better articulates my point. In *The Problem of Pain*, he writes, "God whispers to us in our pleasures, speaks in our conscience, but shouts in our pain: it is His megaphone to rouse a deaf world."[4] Just let God come in and ruffle our nest a little or make us slightly uncomfortable and we practically lose our religion. We don't understand what is going on and why it hurts, so we just run away or shut down everything else entirely. Instead of seeing him right beside us in the fiery furnace (Dan. 3:19–24) or in the middle of the storm (Luke 8:22–25), we often take the view of punishment, rejection, or even questioning God's existence at all. Pastor Paul Purvis says, "God's presence does not equal pain's absence. However, because of God's presence, pain's potency is limited. Difficult times may certainly lead to dark days, but dark days need not mean defeat."[5]

## Misfiring Our Weapons

Dark days may not mean defeat, but they can leave damaging scars. Working through our intangible losses associated with failed IVFs took a toll on our marriage. Tim's solitary drinking escalated and my lonely depression deepened. Year after year after year of reproductive failure took a toll on our intimacy. I don't care what the experts say—those who've never personally endured this type of and length of battle— there is no way to separate the act of baby making from the act of lovemaking. It is simply all connected like a messed-up ball of twine that is impossible to separate no matter how hard you try. It became harder and harder to find comfort in each other's embrace because it always brought us back to the source of our pain. The multilayered private and personal difficulties seemingly know no end. During this

season we became secluded from others and from each other, running hard in opposite directions, trying to ease the pain in our hearts. Our unit was in chaos; our weapons to battle infertility were misfiring on each other; our Commander-in-Chief was silent; we were losing our war with infertility.

I cried. A lot. When I wasn't crying, I was flying somewhere, usually to a beach for a moment of release. I needed a reprieve from the pain in a place I could deeply exhale. If I couldn't have what I wanted, you'd better believe I was going to have what I needed. Travel served that purpose in my life. But even unlimited travel couldn't quiet the depression raging away inside. For me, depression felt like a dark cloak that was easy to slip on. It became comfortable and safe; it became my protection against hope. I refused to hear anything about trying to get pregnant. Depression kept me numb, numb from the highs and lows of life. Alcohol served much the same functions for Tim. We were both lost, hurting, and alone.

Rock bottom came for me one night when I was crying for so long on the floor in our someday nursery that the carpet all around me was wet with tears. Ann Voskamp says that "great grief isn't made to fit inside your body. It's why your heart breaks."[6] I'm not even joking about the buckets of water that had spilled out of my eyes, accompanied by deathlike wailings of lament. It was on this night my soul split wide open, many months after the second procedure failed and we had run away from home during the holidays. Tim walked in the room and said, "I don't know what to do for you anymore. I've called your mom to come over." Then I heard the front door close and his car drive away. Shattered. My emptiness and sorrow had now driven him away.

My mom arrived a short time later to our dark house. I heard the familiar clip-clop of her shoes on the hardwood floor. She was flipping on lights and calling out my name. "Dawn, where are you?" She came up the stairs and found me, by this time a twenty-six-year-old woman, face down on a soaking carpet. She flipped on the bedroom lights, pulled me up off the floor, and led me downstairs for what I will always remember to be my infertility intervention. My mom asked me if I was

willing to lose everything I had: my husband, family, job, friends, and home for the one thing I was being denied. Choking back the tears, I whispered "no." "Well then," she said, "it's time to turn on the lights and worship your way through it."

## Learning a New Weapon: Worship

As I've already shared, my church was birthed in worship. We were first and foremost known as a worshipping congregation with one of the finest praise bands in the area. I was no stranger to contemporary, charismatic services or how to worship my Lord. I sang in the praise team and even played the tambourine when a song required that type of percussion instrument (okay, maybe a song never requires that instrument). I grew up in the middle of the music, so to speak, and was well accustomed to expressing myself in praise. It was a liturgy I understood and regularly practiced my entire life. But now, here, in the middle of my death days, I was empty and lost. I didn't know the way through this dark place, and worship as I knew it wasn't helping.

During this period, it was only legalism that brought me to worship. I came because we were church leaders, Tim was on staff, and my parents expected me to show up. Ever the firstborn, good girl, glasshouse perfectionist, I came because I was supposed to. I literally dragged myself to church and forced myself to stand still in the midst of the service each and every week, months on end, as tears fell down my face and threatened to consume my exterior posture. I constantly fought the internal voice screaming at me to run away and escape. That internal fight or flight self-protection mechanism wanted to drive me home to wrap up in my cloak of depression and prevent hope from entering my soul ever again. I hated all of the trite platitudes like "it will all be okay" and "God has a plan" comments from my church family. I cringed every single time I was compared to Hannah or encouraged to pursue adoption. I felt like a moving target for unsolicited comments from well-meaning acquaintances.

Is it wrong to come to worship through legalism? No, I really don't think so. I'm grateful that when nothing else held me in place, at least

legalism (with a hearty side dish of perfectionism) remained intact. Altar experiences position us for transformation, but first we've got to get to that altar. Everyone falls into legalism at various points on a faith journey. We all start by willing ourselves to learn the Bible, until one day we study the Bible out of a relationship. We might force ourselves to start tithing, and then one day it's never a second thought to give 10 percent of what we've been given back to the Lord. In many areas of developing our spiritual life, we use external forms of motivation. Pain, guilt, legalism, or desire for change are all catalysts that drive our individual brokenness to Christ. He's big enough to take it from there. Faith is a journey!

To followers of Christ, worship means many different things. Merriam-Webster defines worship as "reverence offered a divine being or supernatural power; *also*: an act of expressing such reverence; a form of religious practice with its creed and ritual."[7] There are many Hebrew and Greek words translated for worship in the Bible. In the interest of space, here's a compilation of meanings for worship and praise: to bow down, to confess, praise, give thanksgiving, to kiss the master, lower ourselves, fall or become prostrate, to exalt, to consecrate.[8]

Notice that worship is both an attitude and an action. Worship is expressed many ways, including through music, dance, prayer, serving, hearing the Word, and partaking of the sacraments. It's a concentrated act of participation. Worship involves giving our whole hearts over to a living King who understands our suffering and pain. Through this sacrificial act, we are also transformed! Scripture tells us that worship transforms our mind (Rom. 12:1–2), exposes our sin (Ps. 139:23–24), heals our hearts (Ps. 147:3), builds us up, renews our strength, encourages us, delivers us, quiets our fears, changes our perspective, leads us to surrender, creates a clean heart, and renews a right spirit within us! Eugene Peterson writes, "Every time we worship our minds are informed, our memories refreshed with the judgments of God, we are familiarized with what God says, what he has decided, the ways he is working out our salvation."[9]

There is true worship and there is false worship. Scripture is filled with warnings about false worship, worshipping idols, and

worshipping other gods; in fact, this one is clearly spelled out in God's Top Ten (Ex. 20). As his children, we are mandated to tear down our idols (metaphorical and actual) and worship the living God in spirit and truth (John 4:24). True worship is extended upward; false worship is extended onto others, onto things, and onto creation. It's a perversion of truth to worship the creation over the Creator. My perspective had gotten so distorted that by this point I had turned making a baby into an idol. I deemed the created order and a reproductive life for natural heirs more important and more fulfilling than I did a relationship with my Heavenly Father. All of my passions, dreams, energy, money, and hope were literally spent chasing after my idol.

My mom, Dr. Patti Amsden, writes about worship in her book *Evidence That Calls Us to Dance*: "Man's ability to ascribe worth, to set value, is a core element of worship. Our English word *worship* comes from the Anglo-Saxon word *weorthscipe*. Looking at this word helps us to understand that to worship is to worth-ship. The more highly we worth or prize a thing, the more worth-ship we set upon it. That which is the most highly esteemed by us is the god which we will worship."[10] Not everyone can quote their mama when writing a book, but what can I say, when she's right, she's right!

Worship required me to reconcile God's loud and silencing NO in my life. That's probably why I wanted to run away so badly. I had to face denial each and every time I went to church. Forcing myself to worship felt like forcing myself to understand something I didn't want to understand. But, for whatever motivation that drew me, I came to that altar again and again and again. Each week flooding tears helped me release pain, false expectations, fear, emptiness, and doubt associated with unfulfilled longings. Each week I was drawn to my knees and to the feet of my Savior. I would not lose everything I deemed precious in life for the one thing I was being denied.

My death days were wrestling places with God. Like Jacob in the Old Testament, I spent a night season wrestling with God. Jacob refused to let go until he received a blessing. Miraculously, his life was spared. When the new day broke Jacob was limping, but he had

received a new name reflecting a new nature. No longer was he Jacob, the supplanter (literally heel catcher). Now he would be called Israel because he had wrestled with God. Jacob was changed and he had been given a new name, indicating a significant change in his relationship with God. Simply, time with God changes us. When we gaze upon him and take our eyes off us, something shifts. Our vision gets elevated and our perspective changes.

During this time I had a dream that I've always held close to my heart because it helped to reflect this truth about perspective change. The dream took place behind my parents' house on their small, neighborhood-sized lake. In my dream I was out on the lake in a paddleboat and all around me were shark fins. I was filled with fear about the threat that encircled me. I didn't understand why or how there could be sharks in the lake around me, yet here I was surrounded by certain death. For some reason, I picked up a pair of binoculars by my side to get a closer look. When I focused the lens on the fins, I realized they were not fins at all; instead, they were birds. As I put the binoculars down, I watched all the fins turn into what they really were, birds with wings. One by one the birds took flight, soaring above my head and flying away.

The longer I walked the path of the infertile and dragged myself to worship, the more my vision was being corrected and my perspective changed. Worship was, in fact, a unique and powerful shield God had equipped me with in this war against infertility.

## Rearmament, New Direction, Getting Prepared to Fight Again

Throughout this season of learning my new weapon of worship, nothing changed related to my infertility, but things had started to shift inside me. I began to see—quite possibly for the first time—the other blessings in my life. Instead of seeing sharks surrounding my boat, I began to see the birds that could fly. I learned that running away from family at the holidays was in fact more painful than being home. Running did not resolve my infertility; it just made me lonelier for the

traditions and family I had left behind! I also started to realize that Mother's Day could be in fact about celebrating my mom, grandma, and mother-in-law, and not about the fact that there wasn't anybody to celebrate me. Simple shifts occurred in my thinking to provide new pathways through some of the traditional infertility triggers. Slowly and eventually, the pain started to fade in the presence of my Lord who makes all things new. Worship was awakening me to some real truth and coping tools to live with infertility, instead of running from it.

My soul had split open that night when all of my tears drained out, but ultimately that is how the light was able to get in. In his book, *A Grief Disguised*, Jerry Sittser explains, "The soul is elastic, like a balloon. It can grow larger through suffering."[11] Pain and suffering were indeed causing my soul to grow. Hitting the wall of reality that I really might not have children and learning that I could still breathe, cope, and function was a huge revelation. The pain of the loss was starting to ease, and I was beginning to feel my feet under me again. Depression still beckoned for me to put on its cloak, but gradually and consistently, I began to turn to the garment of praise instead.

In the fall of 1993, a new direction for work began to appear on my horizon. TWA announced plans to move the corporate headquarters from Mt. Kisco, NY to St. Louis, MO. They were looking for St. Louis-based employees who would be willing to commute for a three-month period to take over jobs from New York-based employees who would not be relocating to the Midwest. There was a marketing position that fit my qualifications, so we decided I should lean into this opportunity and see where it might lead. My boss, Barbara Pigford, encouraged me to apply and before long I was making my first trek to Mt. Kisco for an interview. I owe a debt of thanks to Barbara for this promotion. A widower from Connecticut, she had given her life to TWA. She forced me to be the system admin for our computer system. I refused multiple times, but she insisted. It was that experience that opened the door for me as the Supervisor of Automation Marketing, although it really had nothing to do with the job. Barbara wrote my recommendation and pushed for an interview. She was relentless when she wanted something, and I am thankful for her tenacity to push me forward in a time when my personal life was

so lost. She was another example of a providential relationship and a pivotal circumstance in my life story.

One year after we ran away from home at Christmas from the pain of our second failed IVF, we were moving me into a basement apartment in Mt. Kisco, New York. I had accepted the supervisor position that came with a nice raise, a daily per diem amount for every day I lived away from home, and the opportunity for the very first time in my entire life to live alone. We sold my Mazda Miata convertible for a car that was better suited for the snow, rented a basement apartment fairly close to my new office, and moved a carload of items across country to set up a temporary home base for the next twelve weeks. The plan was that either I would fly back to St. Louis or Tim would fly to New York every weekend. Being apart for short-term periods seemed like a small price to pay for this career advancement opportunity. Tim flew back to our home and his job, and on January 3, 1994, I started a job that would open more doors for me than I ever dreamed possible.

However, as things like this go, the timeline for moving the offices across country kept getting pushed back. What was supposed to last twelve weeks stretched out over six months. There were a few weekends where winter storms kept us separated, but for the most part the weekend commutes home worked out okay. Sometimes Tim came my way and when he did, we would take the train into Manhattan to explore the city. A few times we would meet up someplace warm to soak up the sun and feed my need to get toes in the sand. But most of the time I made the trek home to St. Louis on Friday night out and back to New York on Sunday afternoon.

In the middle of the endless northeast winter I was growing, learning, stretching, and getting stronger. I discovered my talent as a project manager and as a department builder, forged new and valuable industry connections, and acquired knowledge about marketing my carrier across multiple airline distribution systems. I stepped into a position that had been vacant for nine months and everything demanded my attention all at once. Suffice to say, it was an intense learning curve in an environment where most of my coworkers were

simply counting down their days. This was a time where I could focus primarily on my career, which was such a welcome reprieve from the front lines of the infertility war.

And yet, when I was finally able to move back home in June 1993, we had saved enough between my per diem and salary increase to cover another procedure. The $10,000 sat in the bank account like a screaming neon sign. A few weeks later a friend of mine called with some news. "Wasn't your doctor's name Silber? I think I just heard him on the radio talking about a new procedure that finally addresses male factory infertility...*blah, blah, blah* ..." by this point the sound of my heart was thumping so hard in my ears, I could no longer absorb her words.

I'm not sure exactly how I summoned the nerve to pick up the phone, but I dialed the phone number forever etched in my memory.

# 9 A Spy in the Camp—Fear

*Those who cannot bravely face danger are the slaves of their attackers.*
*—Aristotle*

I am a huge fan of spy movies and thrillers, especially anything connected to either World War II or the Cold War era. It's intriguing to think about people who have the chutzpah to assume a new identity, new language, and basically give up their entire life to serve a national interest. It's also an equally terrifying concept. I grew up during the Cold War era when Americans were frightened of communism, Soviets, spies, and missile strikes. Decades after McCarthyism's failure, the paranoia of someone being a sleeper agent for the USSR was part of our culture, and even as a kid I knew about these concepts. I remember being in the eighth grade when my entire history class thought our teacher was a spy. In all of our deftness about the situation, one afternoon after school we decorated his room with Soviet flags, Communist banners, and lots of red. The next morning, he was mad, and we were in a heap of trouble. It was highly doubtful a Communist spy would be hiding in the middle of small-town Illinois teaching middle school, but just in case it is happening at your school, the best course of action is to call it out publicly and then show up to class (or, maybe not).

We've all seen the spy movies, those thrillers that catch our hearts in our throats as we enter the world of espionage. From James Bond to Jason Bourne to Jack Ryan, these solitary heroes who rescue our way of life from the bad guys mesmerize us. Although, for all the "shaken but not stirred" hero worship moments in our pop culture spy

films, we shouldn't lose sight of the fact that our suave spies are actually fighting some really terrifying bad guys. Usually, the evil spies win several early battles and take out significant amounts of people before their plans are uncovered and exposed by the good spies. Several plot twists and turns later, we usually leave satisfied that good triumphs and evil fails. If only reality were as neatly wrapped up as the movies.

Enemies who are relentless in the pursuit of their agendas do not only exist in the natural realm, but they also exist in the spiritual realm. Ephesians 6:12 reminds us "for our struggle is not against flesh and blood, but against the rulers, against the authorities, against the powers of this dark world and against the spiritual forces of evil in the heavenly realms." Our spiritual enemies are often cloaked forces of evil that approach our boundaries with an agenda of defeat. It's these hidden figures that penetrate our camps, so to speak, wreaking havoc from inside who are so difficult to fight. Once we can identify them and expose their insidious lying nature, they are often easier to overcome. We must be aware of our surroundings, remain vigilant over our territory, and guard against information sabotage in a time of battle. The last thing we want is to be defeated from the inside out.

## When the Spy's Name Is Fear

Fear is a verb and is defined as "to be afraid of something or someone; to expect or worry about something bad or unpleasant; to be afraid and worried."[1] According to Scripture, fear is also a noun because it is a spirit. 2 Timothy 1:7 tells us that "God has not given us the spirit of fear, but of power and of love and of a sound mind" (NKJV). In my literary comparison of infertility to war, fear would be the equivalent of a spy. Fear is often the hidden enemy who penetrates the camp (or inside your head, as in this example) while manipulatively and strategically destroying you from the inside out. Fear works undercover and nibbles away at the fortitude of the courage. Damage is often done before you even identify fear as the spy.

Infertility is a condition filled with foreboding fear. The fear of never having children was greater than the pain I felt each month that I didn't conceive; it was a crushing and humiliating weigh that I bore. As months turned into years, I became enslaved to the lies that fear shouted into my ear: *you are barren*! I was rarely able to keep my mind in a positive place, and even if I ever began to hope for a different outcome, each month's returning cycle and both IVF failures produced overwhelming evidence that fear was stronger—and more correct—than the hope I tenaciously tried to hold onto. I didn't understand that hope was the function of struggle.[2] I also couldn't identify fear as the lying spy dismantling my courage.

Life forces us all onto unknown paths. None of us can see around the next corner or peer around a bend in the road. We can only move forward into our future one step, one circumstance, one moment at a time. We become targets for fear when we can't see ahead clearly and when we stop trusting in the goodness of God. When we become filled with fear, we are unable to focus on the greater purpose of our lives. We tend to scratch out our earthly existence in a scarcity mentality instead of rightly understanding our position as sons and daughters of the Lord who owns it all. This is a very difficult pivot to make in our transformation process because we accept the evidence we can see, with more weight than any truth we possess out of faith. When fear is encamped in our midst, it gains a stronghold that seems to counter any faith we are able to find. Between the verb function and the noun facility of fear, it appears to be a powerful and formidable foe.

I am not enumerating the powers I've observed of fear to strengthen its grip, but rather to expose the variety of ways it insidiously causes battle fatigue or disrupts our ability to show up on the battle front of the wars we each face in life. I know of no greater enemy of destinies than fear because of the way it seems to target our strength and blind our vision. Fearfulness manifests first in our thoughts and then in our actions. Fear prevents us from achieving breakthroughs and binds us to a life of regrets. Fear links incapacity to inactivity; fear yokes with depression and sorrow; fear attacks our courage; fear of the unknown grips us; fear of the uncontrollable terrifies us; fear of unmet desires causes grief; fear of lack makes us

stingy; fear of unexplainable fears locks us in a holding pattern of defeat.

Fear is failure.

Fear is haunting.

Fear makes us its slave.

*Fear is the polar opposite of a Spirit-driven life*

## How to Fight the Spy Inside

When I was a little girl, my mom was terrorized by fear. So much so in fact, that when my dad was gone for work, she would bring my little brother and me under the bed to hide at times when she couldn't control the panic. My beautiful, young, talented, and incredibly smart mother who studied nursing would drag her two young children under a bed to hide in the middle of the day. She hadn't always been a fearful person. Mom grew up in an idyllic small rural town where she lived with her parents in a totally safe and healthy environment. She never experienced intercity tension or gangs; she had not been abused, abandoned, or neglected; she had not been a victim of violent crime or exposed to a life of poverty. Best she can figure, fear snuck in through scary movies and television. It hid in the background of her life and slowly strengthened its grip until she became its slave. Mom listened to fear's voice in her head until reason evaporated and she responded with an action. Each time she hid out under her bed, she lost rational control of her environment and gave fear power over her life.

Then one day my mom came to know the Lord and learned about the power of his presence in her life. One of her earliest battles as a Christian was against fear. In the process of reading her Bible she ran across 2 Timothy 1:7 and learned that a spirit of fear is not from God. Suddenly, light dawned. Fear still dragged her under the bed, but she started whispering that verse over and over again. Slowly, like a person building endurance and strength in a weight-training program, she began to get stronger and louder. What started as a whisper ended up

as a roar! One day my mom climbed out from under her bed and she was forever free. Fear lost its grip and power over her actions and then eventually over her mind. Since climbing out from under her bed, she's convinced that renewing our minds according to Scripture is the key for a victorious life. My mom is a giant in the kingdom of God today; now holding a doctorate in theology, she is a writer and speaker who unfailingly and tenaciously and tirelessly uncovers biblical truths for the Body of Christ.

Like a spy, fear uses cloak and dagger games to keep us paralyzed and prevent us from moving forward. But here's the amazing thing: fear doesn't necessarily have to win! My mom could've spent her life under the bed, which probably meant I would've ended up doing the same thing. But she fought back and became resilient. I've never battled fear in a crawl-under-your-bed hiding way, probably because at a young age I was inoculated through her resiliency! It's critically important that we have our eyes open to the power afforded to us though Christ. We must learn and apply the truth contained in the Bible if we want to be transformed and walk as conquerors through this life in whatever battles (valleys, trials, circumstances) we face. Scripture is filled with the antidote to fear, which interestingly is often framed through acts of war and through acts of worship.

> "The Lord is my light and my salvation; Whom shall I fear?
> The Lord is the strength of my life; Of whom shall I be
> afraid? Though an army may encamp against me, My heart
> shall not fear; Though war should arise against me, In this I
> will be confident."
> —Psalm 27:1, 3 (NKJV)

> "Have I not commanded you? Be strong and of good
> courage; do not be afraid, not be dismayed, for the Lord your
> God is with you wherever you go."
> —Joshua 1:9 (NKJV)

"In righteousness you shall be established; You shall be far from oppression, for you shall not fear; And from terror, for it shall not come near you."
—Isaiah 54:14 (NKJV)

"Do not be afraid of sudden terror, Nor of trouble from the wicked when it comes; For the Lord will be your confidence, And will keep your foot from being caught."
—Proverbs 3:25–26 (NKJV)

## How Soldiers Overcome Fear

In his first inaugural address, President Franklin Roosevelt famously said, "Let me assert my firm belief that the only thing we have to fear is fear itself—nameless, unreasoning, unjustified terror which paralyzes needed efforts to convert retreat into advance."[3] Our nation's thirty-second incoming president was declaring "war" on the Great Depression. Little could he have known in 1933 that World War II was looming on the horizon and how far-reaching his challenge would be to the American people and our fighting forces. This one line in his speech became the call to a generation to rise up and overcome, despite all the challenges and in the face of all fear.

If the US Military surrenders to fear, they lose battles and ultimately the war. Learning to overcome fear then is an important key to advancing instead of retreating. One way that soldiers overcome fear is through resiliency training. Resiliency training is also referred to as exposure therapy or battle inoculation. In today's modern army this is done through high-tech simulations, similar to how a pilot uses simulation training for learning to fly. Using this methodology, soldiers face every possibility that might occur and learn to deal with the emotions and fear involved. Science is used to make soldiers stronger and is a very effective tool in dealing with fear. In previous eras, resilience training was simply an outcome of surviving battles. J. Glen Gray explains this principle in a personal battle story during World War II: "The gloomy October air is rent by the roar of big guns. They are not frightening after the first startled awakening. But then one hears the whistle and the rending explosion... I am less frightened than most

109

of the others, I know not why. Eventually one becomes more or less used to it all, if not indifferent."[4]

Soldiers must also know themselves and their team. This goes back a bit earlier in the book when we examined how boot camp and job training instill in a recruit the importance of rank and order. Constant practice through drills and maneuvers helps soldiers respond without thinking, leaving little room for fear's destructive influence. Fighting as part of a unit is also another level of protection against fear. Michael Evans explains, "Men do not usually fight as duelists. They bond together in a disciplined formation, because it is in the formation that a man's natural fear and aversion to fighting is counterbalanced by the will of the primary group."[5] This principle underscores the importance of strength in numbers and the need for a team to remained focused on the mission and unit above the individual. Constantly pushing through comfort zones together while maintaining communication and honesty builds strength, trust, and stability in the face of the unknown.

Another dimension to fighting fear is to recognize that it is also a natural defense mechanism toward self-protection. Our bodies are hardwired with a flight or fight protection mechanism. "Fear can prey on the mind to the point where it makes a soldier unfit for combat. Usually it rises just high enough to prevent reason, and with it the detachment of self-consciousness, from governing."[6] Soldiers must fight physical manifestations of fear through breathing techniques and positive self-talk to quiet fear's ugly voice. Breathing helps to keep the heart rate down, which is critical in keeping perspective and remaining in control. The higher the heart rate increases, the more rationalization decreases. The effects of hormonal-induced heart rate rapidly decrease optimal combat performance as fine motor skills begin to deteriorate, visual reaction time decreases, irrational fighting or fleeing takes over, tunnel hearing and vision increases, and cognitive processing deteriorates.[7] Fear can escalate a bad situation to a critical situation, in a heartbeat. At this stage, we don't need an enemy to destroy us. Fear destroys us from within.

Sun Tzu wrote, "If you know the enemy and know yourself, you need not fear the result of a hundred battles. If you know yourself but not the enemy, for every victory gained you will also suffer a defeat. If you know neither the enemy nor yourself, you succumb in every battle."[8] This wisdom helps us understand why we must understand the enemy of fear in order to be successful. In combat, our military face life-threatening situations and fear regularly. Fear must be understood and faced if it is to be defeated.

## Facing Fear: Heading Back into Battle

There was a spy that invaded my camp during the infertility wars and its name was Fear. It gobbled up my confidence on a regular basis by whispering barrenness in my ear. It threatened my peace, commandeered my joy, and stole my hope. I may not have hidden under my bed like my mom, but for too long this spy insidiously destroyed my confidence and tried to steal my battle plans. And then the worst thing I could've possibly imagined happened when we lost two battles back-to-back with the failed IVFs. It was looking like we weren't going to win this war to become parents after all.

Hard, cold, reality hit us squarely in the face forcing us instantly into the valley of the shadow of death. We spent many dark days wandering through that valley. But here's the thing—we didn't die. The valley didn't kill us. In fact, we began to find God again in the valley. We learned how to worship in the valley. We each discovered news skills and value there too. Day by day we got up and moved forward, away from our deepest place of loss. We went through the motions of living at first, but at some point, we did start living again. We were stronger on the other side of this valley, and slowly but steadily, fear's power was starting to lose its grip.

In June of 1994 I moved back to St. Louis from New York stronger mentally, physically, spiritually, and financially. We had enough money saved from my six months of commuting to pay for another IVF, which was interesting timing because our doctor had just started performing the procedure we had actually needed all long. ICSI was

111

available locally for patients of male factor infertility and because we were already patients, there wasn't a long waiting period involved. Dr. Silber called this my first real attempt because the first two cycles weren't exactly the technology we needed. I'm not sure I agree with that thinking, because my body had done the complete drill twice already, but I understood the point he was trying to make. Somewhat numb, we said yes and joined the fall group with a target day for mid-November.

There was quite a bit happening for both of our careers at the time we were signing up for round three. Tim had been working in the home remodeling business for several years now, learning the ins and outs of the industry from various vantage points. He was taking early steps to start his own company but wasn't quite ready yet. Let's just say he was in the positioning phase for launching out on his own and this dream was growing in his heart. He was working on a business plan, looking for a location, considering business models, and researching company names. This part of his life was fulfilling and energizing.

I was busy settling back into working life in St. Louis, living through the cross-country move of our headquarters. It was a time of great transition for TWA as we restructured to an employee-owned company away from the destructive hand of corporate raider and billionaire, Carl Icahn. Some New Yorkers moved to the Midwest to stay with the airline, but there were a lot of new heads filling a lot of recently empty jobs from those who didn't make the big move. Many of the friends I had made throughout my tenure were finding their way to our corporate offices downtown. Commuting to New York had sort of positioned me at "the right place at the right time" in the marketing group, and other possibilities were starting to appear on my professional horizon. This sphere of my life was bright and full of hope.

Hope is a tenuous thing though, up one day and down the next. I'm the kind of person that looks for signs and spends way too much effort trying to figure everything out. It probably stems from my previously explained one-step-ahead thinking and my perfectionist issues. I'm

sure it's also about trying to control my own expectations and keep my heart from getting hurt again, but it makes hope exhausting sometimes. I felt like I had learned so much, come so far, and could see one hundred reasons why the timing was better this time around for success. The testimony of Hannah whispered hope inside of me; yet fear's critical voice still rang louder in my ears: *You're going to spend another $10-12,000 for a 50 percent chance of pregnancy? When is enough, enough? What if it doesn't work this time? What does it mean when you've exhausted the available technology?*

Like new orders arriving to a soldier, my IVF packet arrived in the mail a few months before our target date. I rearmed for warfare, this time with my weapons of worship, pushed fear aside and dared to become brave again. Brené Brown says, "Sometimes the bravest and most important thing you can do is show up."[9] So, I showed up, returning to the battle for my children. Before the summer was over, I turned twenty-seven years old, we celebrated our ninth wedding anniversary, and I started the drug protocols for the third time.

A professional now with ART, I did well with the stimulation cycle, and everything was looking great as our target date approached. I no longer had to report daily for blood work and ultrasound checks; some of the protocols had been relaxed a bit since my early procedures. This was a nice reprieve in the demands of balancing the cycle and my work schedule, which was requiring more and more travel. My ovaries showed no signs of slowing down yet and were still performing like they had something to prove. In due course, the big phone call arrived announcing the point for the injection to trigger the eggs for the final phases of the maturation process. Our target date for retrieval was scheduled for November 17 when the ISCI would be performed. Two days later on November 19, any developing embryos would be graded based on size and viability and then transferred back into my uterus during a second procedure. Both procedures required a twilight level of anesthesia to keep me comfortable, and then I would spend three days on bed rest to give my embryos the best possible chance of implanting.

Ready, aim, fire: it was time for procedure number three or number one, depending on your perspective. On November 17, 1993, we arrived at the hospital at the break of dawn, separated to accomplish each of our special preparatory tasks, and then spent time catching up and joking around with our medical team. We might have been nervous of another negative report, but at least we were finally comfortable with this part of the process. The retrieval and ICSI were both textbook perfect, and we were sent home with the hopes of returning two days later for a transfer, which of course brought us immeasurable worry since fertilization didn't occur on our last IVF. You can only imagine our great relief to get a call the next day from the office saying they had taken the eggs out of the incubator for a quick peek and several of them indicated signs of fertilization. We were given instructions for returning to the hospital for the transfer, a step we took with great joy and celebration! Finally, a positive report!

On November 19 we arrived at the hospital ready and anxious for our transfer. Dr. Silber talked us through the embryo grading process; we discussed how many we would transfer; and then he showed us a video of our microscopic four-celled embryos. They even gave us a videotape of our embryos to take home, which to us was like an early ultrasound photo of our babies. We ran through all the normal conversations about multiple pregnancies, selective reduction, and all of the other moral issues related to this procedure we'd faced in the past. *Yada, yada, yada,* just give me a positive pregnancy report already and we will trust God with all of the "other" possibilities that come next. The transfer "was beautiful," and as soon as the anesthesia wore off, we were sent out to the door holding our videotape like it was recently discovered treasure and with instructions to rest and incubate for the next few days.

We had been hesitant to engage our emotions much with this cycle, but we left the hospital that day with high hopes for a pregnancy. I spent the required time resting and then returned to work. As with the previous procedures, time literally comes to a standstill waiting for the blood test day to arrive. My body was achy, my ovaries screaming from the recent abuse, my uterus crampy from being violated, and my hips sore from the nightly IM progesterone shots. On one hand it felt like

I was going to start my period any minute, but on the other hand we had a videotape! I simply don't have the words to describe the level of torture this step of the process is for a hopeful to be expectant mother.

On December 2, the day before my blood test, my manager called me into her office. She had exciting news to share with me! Because of my commitment to the airline through the time spent commuting and my excellent work over the past year building up the distribution department, I was being nominated for the annual Award of Excellence in the Sales and Marketing group. Not only that, but I was being offered a promotion with increased responsibility and more pay. How did I like the title, Manager—Interline Marketing?

I knew instantly my blood test the next day would be negative and the procedure had failed. I wanted the title of "Mom," but God was giving me something else instead. To say I felt set up by Jehovah Tricky at this moment was an understatement. Fear had certainly lost some hold on me because I had dared to pick up my weapons and try again, but I was still infertile, left with only a videotape of cells as I fell to my knees in brokenness once more.

# 10 The Terms of Surrender

## Infertility—My Enemy & My Ally

*The hope of the world is that wisdom can arrest conflict
between brothers. I believe that war is the deadly harvest of
arrogant and unreasoning minds. And I find grounds for
this belief in the wisdom literature of Proverbs. It says in
effect this: Panic strikes like a storm and calamity comes
like a whirlwind to those who hate knowledge and ignore
their God.*
*—General Dwight D. Eisenhower*

Five long and hard-fought years stood between the bold statement of
independence the Colonies made in 1776 and ultimate surrender of
England in 1781. There were many moments in the war where it
seemed the Patriots' rebellion would be crushed by the world's
hegemonic leader—a large offensive to claim New York City nearly
trapping Washington's army, starving and freezing soldiers during the
winters at Valley Forge and Morristown, the defection of General
Benedict Arnold, a bruising defeat in Charleston—just to name a few.
But, as it often happens, the tides of war began to turn in favor of the
American Patriots who won several pivotal battles in the latter years of
the Revolution leading up to the Battle of Yorktown. With help from
French forces led by Comte de Rochambeau, the Continental army led
by George Washington laid siege around Yorktown, cutting off the
supply line of food and ammunition to the British armies led by

116

General Charles Cornwallis. This siege led General Cornwallis to raise the white flag of surrender at Yorktown on October 19, 1781, which effectively ended the Revolutionary War. Legend has it the British band played the song "The World Turned Upside Down" as the British troops marched out to surrender. Peace negotiations ensued, leading to the signing of the Treaty of Paris on September 3, 1783. After eight years of war, the United States was free and independent.

## A Surrendered Life

I knew our third procedure failed before my blood was even drawn on December 3, 1994. The promotion, the one that fell into my lap the eve before the pregnancy test, answered the question for me. Jehovah Tricky was once again choosing an airline business career for me instead of allowing me to be a mother. I didn't even want to drive over to the hospital on Saturday morning because it just seemed like a huge waste of time and gas. But we did... because I'm a hopeless rule follower. What's one more needle prick? By this point I've literally endured hundreds. A few hours later we suffered the difficult, and yet by now predictable "you are not pregnant" call from the doctor's office.

Weeks before Christmas we experienced our third death day. Sadly, by this point in our war on infertility we were developing a rhythm to these defeats: call friends and family to report the news that would also break their hearts; cry in each other's arms until we felt numb; get out of the house we'd built for our children and see a movie or try to eat food; scream and yell at our God for failing to grant us a baby; more rounds of crying, until the tear wells ran dry; vow to never try again or open ourselves up to this cycle of pain; make the decision to sell everything and move to Hawaii permanently (something we tried to do more than once in our marriage); figure out which flights to what cities had open seats so we could run away; climb in bed to sleep as soon as the sun sets on the day that threatens to never end.

Yes, it stung hard. Of course, I was disappointed. Sure, my body needed yet another season to recover; each procedure was extracting a

greater toll on my system. Indeed, Christmas of 1994 was another painfully hollow event. Certainly, the promotion was bittersweet. But something was also very different in the wake of this loss. I realized that just like I had a routine through the IVF process and the death days, I also had built a pathway to recovery!

For example, depression was an easy cloak I knew how to put on, but oh, how I had grown to hate how that garment made me feel. It was weighty and dark and cumbersome. Depression is sort of like those old fig leaves that Adam & Eve tried to use to hide their nakedness in the garden after they sinned. They attempted to cover their own sin and pain instead of running toward God when he arrived in the garden to fellowship that fateful night when humanity fell. They failed to say, oh Abba, I messed up and tried to fill my own life with what I felt I was missing. They couldn't comprehend that they could eat of EVERYTHING in the garden except that ONE tree. They failed to worship.

After my second failed procedure in 1992, I also responded like Adam & Eve. I tried to cloak myself in depression and hide from my Lord. I was willing to give up everyone and everything I loved for the one thing I was being denied. But now, several years later, I found myself running toward my Commander-in-Chief in worship instead of retreating from his presence in depression. When 1995 arrived, I was actually figuring out how to drop my self-protective armor and clothe myself in worship. Essentially, I was learning how to raise the white flag of surrender.

In a state of war, failure ultimately leads to surrender. Surrender changes the landscape: invading armies depart; winning armies take control; prisoners-of-war are released; armistice is reached; and peace ushers in a new era. As this book has attempted to show, I was in a war for my babies. But let's be honest, I was also in a war with my God. Some (okay, *most*) aspects of my infertility were about my learning how to surrender my control. Is it possible to ever totally "let go and let God" this side of eternity? No, I don't think so. But Scripture promises that we can be continually transformed into the nature and image of God.[1] I was beginning to understand that infertility wasn't a

curse or a punishment; infertility was the tool my Father was using for my transformation and my maturity. Instead of tending to the altars I'd constructed of grief, I started tending to altars of worship and surrender.

Freedom comes through surrender after turning the world upside down. Earthly kings know this. Should we really be surprised that our heavenly King expects the same thing from our lives? We come to him broken, seeking, hurting, and wounded, and he teaches us about the upside-down truths of his eternal kingdom.

## The Upside-down Gospel of Christ

After King Solomon's reign, Israel divides and both kingdoms eventually fall to foreign powers. Messianic prophecies had foretold the coming of a Messiah. Through exile and foreign domination, Israel waited nearly a millennium in anticipation. Take a look at a few of the prophecies recorded in the Old Testament about the Messiah's coming and purpose:

> For to us a child is born, to us a son is given, and the government will be on his shoulders. And he will be called Wonderful Counselor, Mighty God, Everlasting Father, Prince of Peace. Of the greatness of his government and peace there will be no end. He will reign on David's throne and over his kingdom, establishing and upholding it with justice and righteousness from that time on and forever. The zeal of the Lord Almighty will accomplish this.
> —Isaiah 9:6–7

> In my vision at night I looked, and there before me was one like a son of man, coming with the clouds of heaven. He approached the Ancient of Days and was led into his presence. He was given authority, glory and sovereign power; all nations and peoples of every language worshipped him.

His dominion is an everlasting dominion that will not pass away, and his kingdom is one that will never be destroyed.
—Daniel 7:13–14

Rejoice greatly, Daughter Zion! Shout, Daughter Jerusalem! See, your king comes to you, righteous and victorious, lowly and riding on a donkey, on a colt, the foal of a donkey.
—Zechariah 9:9

The expectation for the Messiah to usher in peace and institute a new kingdom was palpable. Suffering in exile and being occupied by foreign powers for centuries, Israel had developed presuppositions about their coming king. But alas, prophecies are rarely understood or interpreted correctly, as they are often a veiled glimpse of what's to come. A babe born in a manger, portraying an utter condition of poverty, was not the king anyone was anticipating. Right from the beginning, Jesus was in the business of turning worldly thinking on its head and shaking up preconceived ideas about his coming kingdom. We know now, with the benefit of hindsight, that Jesus was setting up an eternal kingdom of which there would be no end! He was not here to bring a revolution to the Roman Empire and reestablish the nation of Israel in the traditional sense. Jesus was here to be the sacrificial lamb of the world, assigned with reestablishing the connection with heaven and in doing so, breaking the powers of sin and death over mankind. Jesus's obedience brought the dead to life; released all of creation from the bondage of the curse; opened faith to Jews and Gentiles; and launched his church who would in fact, eventually turn the Roman world upside down.

Jesus was countercultural, and this got him into trouble with religious leaders of his day. He insisted on taking earthly wisdom and turning it upside down, inverting principles of leadership, economics, and status. Take a minute and read through the Beatitudes contained in Jesus's famous Sermon on the Mount in Matthew 5. Talk about your upside-down thinking! Jesus says blessed are the poor in spirit (vs. 3); those who mourn (vs. 4); those who are meek (vs. 5); and those who hunger and thirst (vs. 6). He proclaims it to be a blessing when people

insult you, persecute you, and lie about you (vs. 11). Christ inverts all of these painful human conditions and tells us in verse 12 to "rejoice and be glad, because great is your reward in heaven."

Clearly, he is revealing an eternal mystery to humanity in these passages. He's saying hey people—it's your thinking that's upside down due to the fallen and perverted nature of man. Listen up and invert your thoughts because the last is going to be first in the kingdom.[2] Ann Voskamp, *One Thousand Gifts*, writes, "In the upside-down kingdom of heaven, down is up and up is down, and those who want to ascend higher must descend lower."[3] Not only did Jesus proclaim these things, he also exhibited this paradigm shift during his three-and-a-half-year ministry by breaking bread with harlots and tax collectors, healing on the Sabbath, casting out demons, touching the outcasts, communicating directly with women (including, *gasp*, a foreign woman!), and recruiting simple fisherman to be his disciples.

It is through this lens of upside-down truth then that we understand in the Christian life, surrendering is winning! Jesus himself gives us the very best example of how this is accomplished as the time drew near for him to approach the cross. In the Garden of Gethsemane, Jesus surrenders to his Father even before he surrenders to the Romans: "Abba, Father," he said, "everything is possible for you. Take this cup from me. Yet not what I will, but what you will."[4]

Pastor Rick Warren says, "Genuine surrender says, 'Father, if this problem, pain, sickness, or circumstance is needed to fulfill your purpose and glory in my life or in another's life, please don't take it away!' This level of maturity doesn't come easy. In Jesus's case, he agonized so much over God's plan that he sweated drops of blood. Surrender is hard work. In our case, it requires intense warfare against our self-centered nature."[5]

A new era arrived and was ushered in through the obedient and willing sacrifice of Jesus's death. Discipleship and maturity come in our faith when we are willing to be partakers in Christ's sacrifice and become willing to die to self. I'm not talking about actual martyrdom, although some saints are called to that level of sacrifice. I'm talking about the capitulation of self, the volitional choice to say to Abba, not

my will but thy will be done. Lord, please turn my world upside down so that I may see with your eyes, embrace what you are saying, and go where you are leading.

## Infertility, My Ally

Infertility had been my enemy for so many, many years now that it was hard to remember a time before its presence impacted my life. After I finally came to terms with this war and my conscription, I fought valiantly. I embraced the fight and even returned to the battle after being seriously wounded, several times in fact. The spoils were too precious; retreat was not an option. However, my Commander was showing me that in this spiritual war, unconditional surrender was the pathway to victory. He was ordering my steps. He was leading my training. He was orchestrating each battle. I was now learning how to raise the white flag and fall on bended knees, not in grief but rather in surrendered worship. This was a pivotal time in my training as a soldier. In fact, I believe it was actually a place of promotion in God's army.

In true upside-down kingdom thinking, I was slowly beginning to view infertility as an ally in this war for my children. Not in an "Ooh, I'm totally cool with being barren" sort of way, but more in an "Okay, so this a holy thing in my life that I need to respect, come along side of, and identify with my Lord through suffering" kind of way. This was indeed the pathway my Lord had selected, really for my lifelong transformation. I was also learning that it was a place I could identify with others in their pain, many others actually, who had gotten pregnant and delivered their babies while I was still on the battlefield. Infertility was the first circumstance in my entire life I couldn't bust through or push beyond. It was making me stronger and more compassionate and more resilient. I was learning how to live with hope in the midst of continued disappointment. I'm not saying I was at the point where I enjoyed or celebrated my barrenness. But there was no doubt that my Commander was leading and directing my path, and I began to appreciate His wisdom, His processes, and…well yes, even His sovereignty.

In my heart I knew there would someday be a fourth procedure. We had to give ICSI a 100 percent chance to work. I know it's not statistically accurate to view it this way, but we owed ourselves at least two legitimate 50 percent shots of getting pregnant. The doctors told us not to give up, that one more procedure wasn't a fool's errand. However, as 1995 arrived, I was determined to take some R&R and a real break from treatment. Unlike before, I wasn't being driven to the next attempt to fill my empty arms. I was not running away, but this time I was going to wait on the Lord. We weren't entirely whole, but we weren't entirely broken anymore either.

We decided it was time to live and breathe right in the middle of the unfinished baby conflict and make a few life decisions not based on children! One of those included finally buying living room furniture for a part of our home that had remained empty since we'd moved in many years ago. We were so focused on paying for procedures or running away in pain that we hadn't even taken the time to truly occupy the space we had created! Imagine, stepping inside the foyer to stairs in front of you, hallway to the kitchen and family room on the right, and an enormous great room with a vaulted ceiling completely empty to the left. It felt like a hall you could rent out for parties with hardwood floors and beautiful picture windows on each end. It was a monumental event when we decorated that empty space that greeted us every time we walked in the front door. After all these years, I was embracing the fact that my home was also a dream in my heart that deserved to be decorated and occupied—even if it was just for the two of us.

Another huge step for us was deciding to take an African safari to celebrate our tenth anniversary. This decision was definitely pushing IVF off for quite a while and that was incredibly freeing to my soul. This was the R&R we had needed for so long, a real chance to step away from our battles and refresh! I had a blast planning and prepping for this two-week adventure that included one day in Switzerland on the trip over, ten days exploring Kenya, and three days in London on the way home. We had to get visas and shots and of course, a high-end 35mm camera with a 700mm lens. I'll tell you, things don't really fill a soul, but a nice Canon camera in your hand can go a long way toward

easing the pain! Thanks to airline friends at other carriers, we flew first class both ways and were able to take advantage of a discounted travel industry trip that included a stay at the famed Mt. Kenya Safari Club. We kissed giraffes, slept on an ark, stood on the equator, danced with warriors, ate with monkeys, chased animals across the Masai Mara, laughed with new friends, and closed each day with breathless sunsets over the savanna.

The summer of 1995 we experienced the trip of a lifetime, one that would've never happened if I had become a stay-at-home mom at nineteen. Yes, infertility was an enemy, but it was also an ally in my life story. There were so many experiences that made me uniquely me in this long and lonely process, absolutely none of which wouldn't have happened if Tim Stark hadn't come home in the spring of 1989 and found his carpet all over the front yard. Our private joke, "Dawn, get a job," had opened us to rich mercies in the process and taken us all over the world to change every single thing about our narrow view of life.

## A Fourth and Final Attempt

As 1995 ended, several things had shifted for us professionally. Tim had officially launched his own business. He was busy building his new company, one he had been working toward for years by now. He had a handful of employees and a few subcontractors that were associated with the business. This was an exciting time for him as the business began to get off the ground; it seemed every day there was another new opportunity and growth occurred rapidly. He sold nearly a million dollars in business that first year of being self-employed. The company was occupying our spare bedrooms and running out of our home, but Tim was actively looking for rental space to set up an office location with a storefront for product displays and a location to meet with potential customers.

At the same time, I was promoted to Director of Electronic Distribution in the airline's marketing and sales division. I was the youngest director in the Sales & Marketing Division, which was

remarkable considering I didn't even hold a degree. I was just in the "right place, right time" and worked very hard to gain a thorough understanding of airline distribution (also there was the whole God ordering my steps thing, too, which didn't hurt!). This was an amazing time when the industry was beginning to flirt with the idea of internet technologies, launching me into meetings with Microsoft and other organizations looking to gain entrance into the very large field of travel and tourism through the development of products called Expedia and Travelocity, which are now obviously huge household names. My workload was overwhelming, as was my travel schedule. I was taking the marketing lead on projects such as the airline's first website, electronic ticketing at the airports, self-serve kiosks, and online ticketing. I was also given the budget to hire a team, which meant writing job descriptions, managing budgets, and hiring new staff.

It was an incredibly exciting and challenging time for us both professionally. Given our other volunteer time at church, the weeks and months simply raced by. But every now and then someone would come and whisper "Hannah" again in my ear, or my children would appear in glimpses inside my dreams, or Tim would observe a little blonde girl holding her daddy's hand. There were just nudges, here and there, throughout my world and in my worship. Was it time to try again? We had the money this time, so that wasn't the issue. I was better—we were changing. Did we really want to open that door for a fourth time? God love my mom, the woman who never tires of pulling me into truth. "You can't grow old with regrets," she said. "If you think there is a chance, then you must be vulnerable one last time."

I dialed the familiar number, one that I hadn't used for a very long time but that had never been erased from my mind. The office manager, by now nearly a friend, answered the call. I didn't take the next available cycle because we had already planned a spring vacation to Kauai. I also requested a new OB/GYN for this cycle with Dr. Silber.[6] I could no longer bear working with the doctor who after all of these cycles and office visits still didn't know my name. Oh, how things had changed, as desperation gave way to taking care of myself first! It was obvious I had been promoted from that young and naïve recruit who was thrown into conflict so many years ago. We said yes to our

second ICSI and fourth IVF for August of 1996 and welcomed a new doctor into our lives, Michael DeRosa. We also decided to keep this procedure a secret. I couldn't bear to see the disappointment in the eyes of my friends or family another time; with the exception of our parents and my direct boss nobody knew anything. If this attempt didn't work, we were closing the door to treatment and moving on without regrets. This decision was not made in the hot pain of loss but from a place of wholeness and peace.

It was during this season when I began journaling to my children, pouring out my emotions about the upcoming procedure. The need to write was compelling and new for me. Looking back on these entries, I can see they contained early insights from the Lord about the direction for the book I am writing today, over twenty years later:

> *May 15, 1996: I had a dream about you last night and I can't seem to get my mind off the future. I am sitting on this plane trying to keep the tears from streaming down my face. I really go months and months without shedding a tear anymore. Holidays and births of friends' children do not bring me to a state of depression or grief any longer. I know I have come so far in this journey and God has touched my heart deeply with His love. But there is something deep and moving happening in my heart again, and I just feel as though I should start writing.*

> *June 1, 1996: I want to tell you about my career at TWA: the ups and downs, the fear and the joy, and the blessings and the trials. I know this about life—it is bittersweet. The good is always mixed with the bad, the joy is mixed with the sorrow. I guess you could say that I have found myself in spite of losing all that I hoped for. I only pray I am becoming who God wants me to be and hope all of these years of preparation will serve the kingdom in the future.*

> *June 13, 1996: You see, not everyone makes it through their 'boot camp' experience. Some cannot handle the physical and mental pain that is required to endure the process. However, those who do eventually leave the camp leave changed. They are changed inside and out. I want you to know that I am one of those people. My 'boot camp' has transformed me*

*into someone new, someone who will follow the Lord no matter the cost. Know this my child, my infertility is the process that solidified my salvation and made me discover my God. It is the best thing that has ever happened to me. I will never be the same.*

There was nothing usual about the few months leading up to our procedure. Several things took us by surprise, throwing off all my controls and sense of normal out the window. First off, I had planned a Memorial Day weekend getaway with my parents to Germany. We were going to drive the famed Fairy Tale Road and explore castles, something none of us had ever done before. But when we got to JFK in New York, something had happened that canceled almost all the flights into Europe. Our only options were to travel to Tel Aviv or Paris, and Tel Aviv was too far to go for the weekend. So, off to Paris we went without a single plan in place. And it was the most delightful weekend ever! We followed the crew to the crew hotel, which was amazing—right in the heart of Paris and on the subway line. Paris was also hosting the French Open this weekend, so my dad bought a ticket and attended by himself! Tim ran into Chuck Berry on the streets of Paris, which was on the same level as the French Open was for my dad. And best of all, I discovered I could get all of my medicines for the IVF for a fraction of the cost (like $10 per vial versus $100 in the US) and without a prescription. *Hmm, Jehovah Tricky—what are you up to?* We came home from that trip with memories to last a lifetime and saving enough money on the prescriptions to pay for the trip!

Three days before my retrieval, Tim secured office space and was able to move the business out of our home. It was the perfect location and situation for us, too. It's like it all fell in place like dominos, with people to even help move things out of the house, to renovate the new location, and to clean up our spare bedroom. It was amazing how God caused the pieces to come together in way we weren't even looking for it to happen. We got our home back again and couldn't help but wonder if that was because it was finally time to start our family?

The retrieval for this cycle on August 5 went very well, and this time I got to stay awake during the procedure. I watched Dr. DeRosa aspirate about half of the follicles, and then I asked to have some

medication to take the edge off the discomfort and pressure. I think I slept throughout the rest of the procedure but was so grateful to have a glimpse into what I had always slept through. As was our norm by now, Dr. Silber talked to me about TWA and how I have been around since the dark ages of infertility treatment. He said I could probably write a book about my experiences. I had nineteen eggs when it was all said and done, which was a record for me. Tim said I was muttering something about getting a gold medal for my performance when they brought me back in the room.

We got the call on August 6 that the embryos were developing, and everything was moving forward for our transfer on August 7. It was looking like we would be transferring four embryos this cycle. However, there was to be another change to our normal routine. When we arrived at the hospital the next morning Dr. Silber wanted to do a surgical ZIFT transfer versus a non-surgical IVF transfer to increase our percentages of pregnancy. The ZIFT transfer will require a 1-½ inch incision in my abdomen so that they could transfer our embryos directly into the fallopian tubes. My recovery time would be about a week. Nodding my head in agreement to this unexpected change of plans, I told him this was our last shot, so let's give it all we've got. And with those final words, I was wheeled into the OR away from my hopeful baby daddy for my first mini laparotomy on our fourth and final ART.

# 11 A Peace Treaty

# A Letter to My Unborn

*"Duty, Honor, Country" — those three hallowed words
reverently dictate what you ought to be, what you can be,
what you will be. They are your rallying point to build
courage when courage seems to fail, to regain faith when
there seems to be little cause for faith, to create hope when
hope becomes forlorn.*
—*General of the Army Douglas MacArthur*

*August 20, 1996: Tomorrow we find out the results of the procedure
and tonight I can't seem to stop crying. Yesterday was my twenty-ninth
birthday; I was confident I was pregnant. I had experienced little
sensations and changes that led me to believe something good was
happening. But today is different. I am experiencing the cramping and
feelings that are too familiar to me. I find that I have already assumed
the worst before we even know anything for sure.*

*The transfer went very well but it was more painful that I had expected.
It really kept me down that first week and sitting up at the computer
was not even a thought. I worked a few half days at the end of last week,
but my first full day back was yesterday. It was really last Saturday, one
and a half weeks after the transfer, that I started to feel myself again. It
would take a long time for me to forget that experience, especially if we
receive a negative report.*

*The doctors gave us a 50 percent chance of achieving a pregnancy. That was the best report we had ever received. Somehow tonight, 50 percent just doesn't seem good enough. I know that I have survived this process before, but I can't bear the pressure this evening. I have read that early pregnancy symptoms are very similar to premenstrual symptoms, so I should probably not be worried. However, it is very hard not to let my mind run wild tonight, as my emotions seem to be running at full throttle.*

*I hope to hear that you are on your way. God has given me so many promises that part of me can't believe this is a no. Your dad is so excited about a positive report...*

*Oh, this is too hard tonight. I am afraid that I will never be able to open this door again if we find you are not on your way. I love the idea of you more than I can express, but at some point, I have to close this endless door of grieving. It can be more than my heart can bear. This may be my last entry for a while, or forever. Tomorrow will hold the key to either a new chapter in our lives of parenthood, or a new door in our infertility journey.*

*I will never stop hoping to meet you, my children. God willing, I will find you tomorrow.*

*"Now faith is the substance of things hoped for, the evidence of things not seen" (Hebrews 11:1 NKJV).*

*Goodnight, my loves.*

# 12 The Battle for Our Firstborn—Finally, Pregnant

*I thought I might die. But then I thought, 'Other people*
*have made it through these things before'. I kept my eyes on*
*the lights on shore and kept swimming.*
*—Corporal Clint Eastwood*

In yet another departure from our normal IVF routine, I had an unavoidable trip to Kansas City the day of the blood test. There was a critical development meeting with the IT department, several VPs, directors, my boss, and several other peers. Our corporate offices and hub were in St. Louis, but Kansas City was the location of other admin staff, IT, and the maintenance flight hanger. We often made trips back and forth in a day; in fact, a good portion of the hourly flights between St. Louis and Kansas City were filled with employees! But I had never had to fly the day of the blood test. I couldn't decide if it was a good thing or a disastrous thing, although I was obviously leaning toward disastrous. The situation definitely required a plan to protect me from getting bad news when I was not in the comfort of my own home. I let the doctor's office know that Tim would be calling for the results this time. I was putting the weight of the inevitable "no" on his shoulders. He would hold the news until I got home.

I arrived at the hospital at zero dark thirty for my blood test and then quickly headed to the airport for a 7:00 a.m. flight. Before the days of 9/11 and increased airport security, I could park in the short-term lot and be in my airplane seat thirty minutes later. This was not the ideal time frame, but it was certainly doable if you were just carrying

a briefcase. By the time we took off that morning, my heart was racing faster than the wheels of that plane down the runway. What in the world was I doing on this flight? Except for my boss, I was surrounded by coworkers who knew nothing about my secret. I mustered every ounce of strength and self-control I could find to hold it together. Now was not the time for tears, I told myself there would be enough time for those later. Soon enough the quick up and down of this forty-minute flight was over. We were in the process of the deplaning when it happened: my dress caught on an armrest and ripped all the way up exposing my....um, well...my entire backside.

Now, I am a fan of the critically acclaimed TV series, *The West Wing*. The rapid-fire dialogue and brilliant character development of this political drama that ran from 1999–2006 hooked me right from the beginning. During Season four, Episode six we find President Josiah Bartlett preparing to walk out on stage for his reelection debate. All of the staffers had walked out of the room after offering the president a few final words of encouragement and left him alone with the First Lady, Abigail ("Abbey") Bartlett. Abbey looks at her husband in the eyes and declares, "It's all in the bag now!" They briefly reminisce about their grown daughters waiting in the audience and then about the first presidential debate four years earlier. Jed, a religious yet also surprisingly superstitious man, remembered the tie he wore in that first debate and how one of his staffers had helped him find a tie right before he walked out on stage. Jed was telling Abbey they couldn't find the exact same tie this time, which was clearly stressing him at this moment; Jed says there "was a lot of juice in that tie" and credits the tie for giving him "the energy to get out on stage." Abbey looks at her husband and says, "Tough," pats him on the shoulders, affirms her love, then declares, "Game on, boyfriend!" as she quickly and purposely takes a pair of scissors to cut his tie in half! At this point, Abbey is laughing, the staff is in chaos, and someone throws a tie to President Bartlett as he walks out on stage to face his debate opponent. The unexpected, albeit manufactured, crisis by his wife works! President Bartlett finds his confidence and easily trounces his opponent. He goes on to win a landslide reelection.

To this day, I believe this is what happened as I was getting off that airplane on August 21, 1996, with a heavy and defeated heart:

Jehovah Tricky to the angels: "Hurry boys, we need a preemptive strike to throw her off her game before she falls apart!"

Angels: "Game on!" (scissors in hand!)

Me: Oh my goodness, my skirt just ripped all the way up my backside!

Laughter, chaos, and teamwork ensue in the heavenlies and on the earth. My coworkers cover me with jackets as we dash out of the airport. It just so happened that the employee who picked us up had access to a sewing machine on route to our office and one of my colleagues was a seamstress! We made a quick pit stop, the dress was repaired, and we arrived at our meeting on time. The crisis had successfully diverted my attention for a few hours, and I was able to focus on the meeting at hand.

## Is Forty-One Good?

After the meeting we were hanging out in an office, checking our voicemails and waiting to be driven back to the airport for a return flight to St. Louis. Remember that Tim was supposed to call the doctor's office and sit on the negative report until I got back home that evening. We agreed that I wasn't even going to plug in the car phone to hear the news. In those days a call was about $5 per minute! This phone was truly for road emergencies, which would probably happen if I were sobbing all the way home after hearing a negative report during rush hour. No, no, a thousand times no, he would be waiting at home with the results. You can imagine my surprise then when a call came through in the Kansas City office for me. My voice mail wasn't forwarded to this office, my team was all in the room with me, and Tim didn't have the number where I was going to be for the day. It may be hard to wrap your head around, but in the days before cell phones we weren't accessible to everyone every single moment of our life.

Upon answering the call, I immediately recognized my husband's voice on the other end of the line when he asked me, "Is forty-one good?" Still surprised to hear his voice at all, my response was simply, "Tim, how did you find me?" Again, he asked me, "Is forty-one good?" Then he continued, "I called the doctor and they said the results were forty-one." He didn't need to say anything else. I knew instantly that forty-one was my hCG count and I was pregnant. With every other procedure my hCG was less than two, meaning not pregnant. This time, our fourth time, Tim was told the unbelievable news that my hCG count was at forty-one. However, this is very low, and the doctor was hesitant to confirm a pregnancy quite yet. They explained to Tim that we would need to repeat the blood test in two days and if the hCG doubled, then a pregnancy would indeed be confirmed. He tracked me down to tell me the good news.

Two days later we were sitting in Dr. DeRosa's office together when they gave us the results that my hCG count had nearly tripled and that I was definitely pregnant. Based on the count we knew it was likely only one baby, but we would need to wait a few weeks on an ultrasound to confirm how many babies I was carrying. We fell into each other's arms in joyful tears when we heard the good report. The staff moved us to a private room for a while so that we could process this news that came on our eleventh wedding anniversary. Our sorrows were turned to joy on the foundational day of our marriage! Ten years to the day after we started trying, we found out we were pregnant with our first child. We bounced from tears to giddy laughter—could it really be true that all of our waiting was over? Can you even imagine the impossible beauty of this moment? I could barely answer the nurse's questions while she completed the prenatal form on Baby Stark. There were a lot of tears in the eyes of the staff that afternoon, too, as they learned more about our story. I still struggle to find the words that can capture the essence of this moment that God brought to us on August 23, 1996. One year before we were on the savannas of Africa finally learning to enjoy life again as a couple, and now we were pregnant. We spent the next few weeks in a bubble, with only our immediate family (and my boss!) knowing about our secret miracle.

Our ultrasound confirmed a singleton pregnancy at six weeks and our
due date was set for April 27, 1997.

*Selah.*

## Hannah's Prayer

> I'm bursting with God-news!
>     I'm walking on air.
> I'm laughing at my rivals.
>     I'm dancing my salvation.
> <sup>2-5</sup> Nothing and no one is holy like God,
>     no rock mountain like our God.
> Don't dare talk pretentiously—
>     not a word of boasting, ever!
> For God knows what's going on.
>     He takes the measure of everything that happens.
> The weapons of the strong are smashed to pieces,
>     while the weak are infused with fresh strength.
> The well-fed are out begging in the streets for crusts,
>     while the hungry are getting second helpings.
> The barren woman has a houseful of children,
>     while the mother of many is bereft.
> <sup>6-10</sup> God brings death and God brings life,
>     brings down to the grave and raises up.
> God brings poverty and God brings wealth;
>     he lowers, he also lifts up.
> He puts poor people on their feet again;
>     he rekindles burned-out lives with fresh hope,
> Restoring dignity and respect to their lives—
>     a place in the sun!
> For the very structures of earth are God's;
>     he has laid out his operations on a firm foundation.
> He protectively cares for his faithful friends, step by step,
>     but leaves the wicked to stumble in the dark.
>     No one makes it in this life by sheer muscle!

God's enemies will be blasted out of the sky,
   crashed in a heap and burned.
God will set things right all over the earth,
   he'll give strength to his king,
   he'll set his anointed on top of the world!
—1 Samuel 2:1–10 (MSG)

———— ✋ ————

# Finally, Pregnant

Assuming my warfare days were now behind me, I (metaphorically) took off my soldier's uniform, hung up my dog tags, and tried my best to return to a civilian life. I just wanted to be normal and pregnant like everyone else.

But alas, there was no magic switch that flipped to normalcy once the test was positive. First off, I was recovering from surgery when morning sickness rolled in like the tide. Although always a good sign of a stable pregnancy, being sick and too tired for words 24/7 are never a fun experience for a first-time working mom. Even though I only actually vomited a handful of times (one time in particular after being on a very turbulent prop plane flight), I lost nearly ten pounds that first trimester from not being able to eat or stand the smell of food. Second, my ovaries were starting to complain about the IVF cycles, and I was experiencing symptoms of overstimulation, including lots of pressure and cramping.

During my first trimester I was monitored closely with ultrasounds to make sure everything was progressing as expected, although this was always more of a relief than a burden. The images of our growing "boogie," as we took to calling our wee one, filled my nervous heart with much peace. Oh, how much we loved hearing the swish, swish, swish sound of our growing baby's heart. It's a sound that neither Tim nor I will ever forget—such sweet music to our ears. I was also still receiving daily IM progesterone injections in my hip, as was the normal protocol for IVF pregnancies. Because of this, either Tim or my mom both had to travel on work trips with me just to administer this shot.

These daily injections continued until the end of my eighth week of pregnancy when I was officially taken off high-risk status.

It was with great joy that we began to share the news widely about our miracle baby. For my own self-protection, I had kept the procedure a secret from even my closest friends this time. My friend Heather, who was pregnant with her second child, playfully punched me with a "get out of here, how dare you to keep this from me" gesture as she broke down in tears. We couldn't believe our babies would only be three months apart! My friend Cindy didn't smack me, but she responded with immediate tears as well. I had walked by her side though multiple miscarriages and the birth of her four children. She was overjoyed that God had heard our cry and given us the desire of our heart. I'll never forget sharing the news with our church family either. This is a group of people who had walked the difficult and emotional journey with us over the past decade, holding us up in prayer and encouragement even when we couldn't do it for ourselves. When we finally said the words, "We're pregnant" during the big announcement, everyone jumped from their seats and clapped and clapped and clapped. It was such a sweet time of rejoicing with friends, our church family, and coworkers who were simply thrilled about our new addition.

However, I was surprised to discover that you don't stop feeling like you are infertile just because you are pregnant. Infertility had defined me for so long and become woven into me, which was a surprising and unexpected revelation. I didn't fit into the support groups I had surrounded myself with any longer and yet, I didn't fit in with the other baby mamas wholly either. It was an incredibly strange time for me. Infertile friends, although happy for me, didn't really open up the doors for ongoing relationship after my announcement. Meanwhile, everyone in our circle of friends who already had children were in the process of adding more children to their families. They knew all the ropes about mothering and talked about this pregnancy or the next pregnancy, all of it was easy and taken for granted in some way. For instance, I would be asked if I wanted a boy or a girl "this time." All I could think was that I wanted a baby! The idea of "this time" didn't compute to me at all. I was often dumbfounded about this

question because I felt like saying, "What do you mean *this* time? What exactly have you missed about my journey to *this* baby? This is likely my *only* baby!"

The other dichotomy I kept experiencing was nobody wanted to hear that I was sick or hurting in any way. I would often be asked the very benign question that every expectant mother receives: "how are you feeling?" I learned right away that nobody wanted me to answer that question honestly. When my pale face that was holding back vomit answered that I wasn't feeling great, I would quickly hear, "Oh, but at least you're finally pregnant" or "Well, this is what you always wanted." Ouch, those responses stung so hard. Believe me, the message was received loud and clear! I am only allowed to be grateful. Got it. It's not that I wasn't grateful or overjoyed. I was blissfully happy but also quite early in my pregnancy. I was also extremely hormonal from the drugs associated with my IVF cycle. And the reality of being pregnant is far from any fantasy of the process that I'd imagined for so long. I was sick and so tired. It was scary! The roller coaster of IVF, the hesitant first yes, ruling out higher order multiples, ongoing ultrasounds, daily shots, and maintaining my crazy career with travel and demands sapped all the energy I could muster each week.

I was oddly insecure about several aspects of pregnancy. I couldn't put my finger on it then, but now I can see that I was going through a huge identity shift. Odd, that it was the thing I had always wanted yet when it happened, I didn't know how to be comfortable as a pregnant person in public. Please don't misunderstand. I was in love with my baby on a level that cannot even be imagined. I loved our private, intimate life together—like feeling the early flutters, dreaming about the future, finally getting to plan a nursery, rubbing my stomach, and singing lullabies to our little boogie right from the start. Being pregnant meant no longer living under the heavy weight of denial driven by fear. But the private pregnancy and the public one were very different experiences at first. For instance, it was so much fun to go maternity clothes shopping with my mom. We celebrated my tiny bump! I put on the store's padded tummy pillow so that I could see how the outfits would expand and fit in a few months' time. It was all a dream come true! Yet, when it was time to wear maternity clothes to work or

church, I was so embarrassed. I felt like I didn't deserve it somehow or that it was all a charade; the blending of my fantasy (having a baby) and my reality (infertility) were simply awkward. I'm sure that the ridicule I felt when being candid about my morning sickness prevented me somewhat from honestly integrating these polar opposite realities.

## The Eighteen-Week Ultrasound

As an IVF patient I had enjoyed many ultrasounds during the first trimester, but we had not seen our growing baby the whole six weeks I was considered "normal." We were anxious to see how much our boogie had grown, although we had already decided that we didn't want to know the sex of our baby until delivery. After waiting a decade to get pregnant, we wanted the whole experience! I had devoured the required reading, *What to Expect While You're Expecting*, planned out the nursery, written out my birth plan, and scheduled hospital tours. We were making and revising name lists all the time; the girl's name was settled quickly, while the boy's name was constantly evolving. Yes, the project manager was feeling better and more confident about this whole thing. I was soaking up every possible memory from my one and—likely only—birth experience!

Once the ultrasound started, we learned right away that our little one was transverse and backward. No wonder my hips were hurting so badly; this wee one was growing sideways! We weren't going to learn the sex of our baby today even if we wanted to. But it wasn't long before the friendly chitchat with the ultrasound tech came to an end. She picked up the phone, whispered something in the receiver, and then excused herself from the room. Uh oh. We might have been first-time parents, but we knew this was not a good sign.

Almost immediately my OB walked in and resumed the ultrasound himself. After a few minutes he told us that I had a complete placenta previa. This is a condition where the placenta covers the cervix and can lead to complications later in the pregnancy if it doesn't resolve itself. Most of the time placentas will move upward as the uterus grows, but based on the severity of mine, the doctor was skeptical it would move

enough to avoid a C-section delivery. I was told not to worry yet, our baby looked great, but just to be on the safe side it was time to slow down. No more sex, no more travel, and no heavy lifting. Whew, I was relieved at the no more travel part! Lugging my carry-on and laptop for long day trips with a growing belly had stopped being fun months ago. The doctor might have mentioned a few other things as he was handing me the videotape of our perfect miracle baby, but I'm fairly sure I stopped listening...something about *bedrest, hemorrhaging, hospitalization, premature birth*...blah, blah, blah...

I told myself, most of the time placenta previa corrects itself. I'm not worried. Thanksgiving is tomorrow and I'm finally pregnant. It's going to be just fine.

The woman who left the ultrasound room on a late November day in 1996 seemed a little too reminiscent of that young, naïve recruit drafted many years ago, instead of the battle-hardened warrior she had actually become. That young mother still thought her war was with infertility and that she had been discharged. It wasn't yet clear to her that she had been called to war for her heirs.

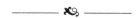

## The Battle for Our Firstborn

I was twenty-six weeks pregnant in January 1997 when I picked up my friend's toddler at church. It was only for a minute; I needed to give him a quick hug. Not long after I was in the bathroom and noticed some spotting. I wondered if this is what my doctor meant by bleeding? Tim took me home and we called the weekend exchange. Within minutes, Dr. DeRosa called me back and ordered a week of bed rest and instructions to check in every day by phone. The problem was that Tim was leaving the next day to take his parents on a trip to Hawaii. When I mentioned the trip, he said to me, "There's a flight home every day, Dawn. It'll be fine." In case I haven't mentioned it before, I was a nervous first-time mother, and my doctor knew it. I asked questions about everything. By this point in our doctor-patient relationship, as he guided me through the IVF and the placenta previa,

Dr. DeRosa knew me pretty well. "Let him go" was code for "chill woman, you are not having your baby this week."

So, my honey left me lying on the couch to take his parents to my favorite place on earth. To this day, he still reminds me he's been to the islands one more time than me (seven for me, eight for him, but who's counting?). I cannot express how slowly this week passed and how lonely I was while he was gone during my first week on bed rest. I'll admit, going from working full time to being down is a bit of a shock to the system. The first day it's like, hey, a week of TV, reading and rest—I can deal with that! But when you're alone and your body aches from too much laying down, the mind tends to go on overdrive as your activity comes to a screeching halt. I was drowning in the projects going on at work and a week off would only put me further behind. I was hiring a team and in mid-launch on several projects. Plus, I was not ready for this baby. The nursery walls were painted, but neither of my showers had happened yet. I only had a few outfits, no diapers and—oh my goodness, my overnight bag wasn't even packed yet. The control freak, firstborn, Type A perfectionist was losing control!

The week passed very slowly. Friends and family came by at regular intervals to drop off food and to make sure I was staying off my feet. Luckily, I still had shower and bathroom privileges! I would shower, come down the stairs in the morning, lay on the couch all day, then make my way back upstairs for bed. When I made it to Friday without another "incident," I was released to work part-time. By part-time work I actually mean hardly any work at all. I was allowed two four-hour days in the office each week, and the rest of the time I worked as much as I could from home through email utilizing a dial-up modem. Back in the day, these were slow and laborious connections. Feeling more and more like a ticking time bomb, so to speak, my priorities shifted to reordering projects and preparing to leave much earlier than originally expected. Every plan now needed a back-up plan.

It was at this point the conversations with my doctor became very frank. The next four to six weeks for my baby were critical for development and a "major bleed" could happen at any point now that

I'd hit the third trimester. I was officially classified high risk. The placenta had not moved at all, and I was instructed to cancel Lamaze and instead schedule a C-section class. It was all very overwhelming and disappointing news to absorb, and yet at the same time all I could think about was getting this long-awaited baby here safely. Placenta previa happens in about one in two hundred pregnancies and I had none of the risk factors for this condition; it also had nothing to do with our infertility or with IVF. It was just this impossibly dangerous thing that happened to my miracle baby and me.

On February 21, I experienced my first major bleed from the placenta previa. I was getting ready for one of my four-hour days at work when bright red blood started pouring out of my body. There was so much blood. I was home alone, upstairs in my bathroom, and in complete shock. Nothing anyone had told me or that I'd read could prepare me for the amount of blood I was losing. I grabbed the phone, paged Tim with a 911, called my mom to come immediately, and called the doctor; thank God we had a plan in place should something happen. I laid on the floor and put a towel between my legs until they both arrived about ten minutes later. I found myself detaching a bit from reality as the crisis played out in a foggy, slow motion. The bomb had finally gone off. How in the world is this happening to us, after all that we've been through to get this baby? Tim got me in the backseat of our car and Mom put a beach towel between my legs, hoping to absorb the heavy bleeding. Tim drove the 30 miles to my doctor as fast as safely possible. They both prayed without ceasing. I had no idea if we were having a baby today or honestly if I would live to the see the hospital. How can you lose that much blood and be okay?

When we arrived at the hospital there was a team of staff waiting outside for me with a wheelchair. It felt like something I'd seen on TV or in the movies. They whisked me past the ER and took me right up to Labor and Delivery. Everyone was concerned and moving quickly. An IV inserted into mama; monitors hooked up for baby. The sound of that little heartbeat swishing away finally broke the tension and my tears. We were both going to be okay. The bleeding had finally stopped, this time. Inhale, exhale—repeat, and repeat again. It was time to slow down and sort through the crisis. I was put on strict hospital

bed rest. Y'all, that is just ugly. It means no showers or toilet privileges. I was given a bedpan. There was to be no weight on my cervix at all. I was given the first in a series of steroid shots to help develop the baby's lungs. Twenty-nine weeks was just too early to have this baby. Ideally, we needed to get to thirty-six weeks, but every day in the womb was considered a success and meant less time in the NICU. I was also started on some anti-contraction medications because the bleeding episode had irritated my uterus and I was starting to experience mild contractions.

My laptop was taken away and shut down on doctor's orders— maternity leave had officially started. We were in a day-by-day battle for our firstborn; this was now trench warfare. I was looking at months on my back and possibly in this hospital bed. Every hope and dream I'd had for pregnancy, preparation, birth, and everything else about becoming a mother evaporated. I wasn't even able to care for myself anymore. I was helpless and vulnerable, reduced to a bedpan. The only thing I could do was wait for the time to pass. There was nothing I could offer this baby right now except possibly another day to grow and prayer, lots and lots of prayer.

After four long and lonely days in the hospital without another incident, I was allowed to come home on the understanding that if there was another bleed I would be admitted for the remainder of my pregnancy. THANK YOU, JESUS! I got to shower and use a toilet, tiny mercies in a really long and hard battle. Work friends rescheduled my baby shower and held it at my house a few days later. I sat in a recliner while friends and family did all the work. It's incredibly humbling to have people who've never been in your home before to come in and take over your space while you sit helplessly on the sidelines. And yet at the same time, it was all filled with such love and honor. These people I had worked alongside, many of them for the better part of a decade, truly cared about me. They gave of their personal time off to come to my home, thirty miles away from the office, to celebrate this pregnancy. It was such a sweet day that even some twenty years later the memories of that afternoon still bring tears to my eyes.

On Sunday afternoon, March 9, I left my house and went to a baby shower hosted by my church family. There were too many people attending this one for it to be held at my house. My friends had set up a recliner for me so I could keep my feet up, so we decided it would probably be okay if I went to this event. By this point, I was spotting a little every day, but it had been a few weeks since my last major bleed. It was a very special time with this group of friends and family, many of whom had waited nearly as long for this baby as we had! Plus, by this point I had not been at church for nearly a month due to the bed rest, so it was really wonderful to catch up with so many faces I love. Although we didn't know the sex of our baby, I was able to announce our name selections: Lydia Jean or Ethan Michael. There was lots of excitement about both names, although most in the room felt we would be having a baby boy. We left the church with carloads of gifts showered on our family. Tim brought them all up to the nursery and my mom brought me to bed.

On Tuesday, March 11 at thirty-three weeks' gestation, I was admitted to the hospital for the remainder of my pregnancy and the scariest week of my life. That day's bleed was worse than the first one. We didn't waste time at home calling the doctor; we knew what needed to be done. Tim got me in the car as my mom pulled in the driveway and raced to the other side of St. Louis with me again in the backseat and another beach towel between my legs. This time, a state trooper pulled us over for speeding. Unlike in the movies, he did not offer an escort. He offered to call an ambulance, but Tim promised to drive the speed limit the rest of the way, so he let us leave quickly. Calling the doctor's office en route, Tim was instructed to take me to a different hospital this time. I didn't want to change hospitals, desperately clinging to any last shred of the delivery plan I had crafted, but my doctor didn't care what I wanted. He wanted me at the hospital with the level 2 NICU. Sobbing, defeated, and in total fear, I lay in the car patting my belly and begging my baby to hold on. Once again, we arrived at the hospital with a team waiting to meet our car. It was the last time I would be outside for fifteen days.

The next week played out in slow motion. I met with the NICU staff to understand what was ahead for an infant delivered between

thirty-three to thirty-four weeks' gestation. My doctor told me he was sleeping "with one foot on the floor." My room was located right next to the operating room. According to hospital staff, complete placenta previa and preeclampsia patients are the cases that scare them the most in obstetrics. I was no longer asking to go home; I didn't even want to leave. It was clear right next to the OR is exactly where I needed to be. My family started donating blood should I need a transfusion. I knew that showers and toilets were a luxury no longer available to me in this critical condition. I was on medication to sleep, medication to stop contractions, and medication to move my bowels. There were small bleeds daily now, and another significant one on Friday. It's an odd experience to be pregnant wearing menstrual pads. As I understood the current plan, the goal was to buy as many days as possible for the baby without putting me at too much risk. I was also told there was a significant chance I might lose my uterus during delivery if the bleeding could not be controlled. To think that women, not too many years ago, would simply bleed to death in my condition was horrifying. There was a lot at stake at this point of my pregnancy. Would we both make it through alive?

## A Promise I Couldn't Hear

The weekend before my baby was born there was a guest minister speaking at our church. My dad, sanguine to his core, brought this man over to the hospital to pray for me. I must tell you that I was clearly annoyed about having a guest I didn't know come for an unexpected visit after six days on hospital bed rest. Now, remember, we didn't know the sex of our baby, but we had definitely decided on names. A daughter would be Lydia Jean and a son would be Ethan Michael. After praying over me, this minister said he felt as through the Lord was going to give us a son and we would name him Michael. I shared with him that we if had a baby boy his name would be Ethan Michael. At this point, the man I did not know said to me, ""No. I believe his first name will be Michael." Getting more annoyed by the second, I said, "No. Michael will be this baby's middle name." Yet a third time he

responded, "I'm quite sure I heard you, you will have a son named Michael." Rolling my eyes internally, while restraining myself to remain polite, I thanked the minister for his prayers and explained to my dad that I wanted to be alone now please.

It wasn't until I started writing this chapter that I remembered this short incident that occurred in my hospital room a few days before my first baby was born under tremendous crisis. At that time, I could only focus on the baby I was carrying and the condition threatening us both. I knew that baby's name would not be Michael, but Ethan. I'm sharing this particular story in chronological order using the perspective of hindsight, something I have avoided to this point in the book, because I feel it's important to show that God was actually giving me a place of hope in the middle of my crisis! This man's prayer and dare I say prophetic word, a man whom I don't even remember his name, was actually speaking to a future son, one that wasn't even on my radar. This encouragement was meant to transcend my present situation. I was only looking at my present circumstances, while the Lord was trying to give me hope for the future as I faced the prospect and the possibility of losing my uterus.

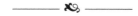

## A Muffin, a Holiday, and a Tiny Green Bow

Dr. DeRosa had been out of town over the weekend and I had been in the care of another doctor from the practice, Dr. Shaner. On Tuesday morning, March 17, Dr. Shaner came to visit me while making the morning rounds. We talked about all the bleeding I had experienced over the weekend and how delivery was likely near. My contractions were increasing, my uterus was irritated, and my baby was exactly thirty-four weeks today and estimated to be five pounds. This was the gestational goal everyone had been hoping to hit. He walked out of the room and I ate my half of a bran muffin while flipping through the morning news shows.

I had no sooner swallowed the last bite of muffin when blood just started pouring out of my body. Screaming, I hit the call button. By this point, blood was running off the bed and onto the floor. You

cannot understand how it feels to painlessly bleed and know there is nothing you can do to stop this flow of life from leaving your body. It's absolutely as terrifying as it sounds! Suddenly, time shifts into slow motion. Just like in the movies, everyone rushed into my room all at once. Dr. Shaner told me to call my husband and have him come right now. He added, "The baby will be here before he arrives." My bed was wheeled out of the room and down the hall toward the ER. It was time for an emergency C-section, not because of my baby, but because of me.

While I was being prepped for surgery, they discovered I had just eaten a muffin. Oh no, big problem! Then, as suddenly as the bleeding started, it stopped again. The team decided to put surgery on hold for now because I had just eaten. There were now more factors to consider on the timing, such as aspiration. At this point, in walks Dr. DeRosa wearing a green St. Patrick's Day tie. Until that moment I hadn't even realized it was St. Patrick's Day. He was back from vacation, stopped by my room to check in, saw the blood on the floor, and came looking for me. After catching up on what was happening, everyone agreed that today was the day. We had bought this baby enough time and made it to thirty-four weeks; now it was time to turn to mama's needs. Provided there was no more bleeding in the meantime, the delivery would happen later in the afternoon after Dr. DeRosa finished up office hours. Only eight more hours to go, we were almost at the finish line after ten years and seven months. I just had to endure one day with all of our family in my hospital room making jokes, engaging in small talk, blowing up medical gloves, and anything they could think of to keep my mind off how slowly the clock was ticking on what could be my last day pregnant forever.

Due to complications of the placenta previa, I was required to have a C-section under general anesthesia. This meant that Tim would not be permitted in the room while our long-awaited baby was being born. There were also concerns about more bleeding, and I faced the real possibility of a hysterectomy as well. There were still a few hurdles ahead for us, but it was all out of our hands now. I made Tim promise to stay with our baby and let my mom take care of me as the night unfolded. The nurses offered to take pictures on our camera from

inside the operating room, so my husband handed off his camera, his wife, and his unborn child to this amazing team of medical professionals. We kissed goodbye and he was left alone in the hallway as they wheeled me away to surgery. Once again, we were both alone facing our individual tasks in the process of making and having a baby. Separate, but together, the hallmark of our reproductive lives.

On March 17, 1997 we won our first battle with infertility. Despite incredible crises and difficulties, our daughter arrived weighing five pounds, two ounces and measuring eighteen inches long at 5:42 p.m. This baby girl that we weren't in the room for when she was conceived or conscious when she arrived, the one we had waited a decade to come into our empty arms, arrived at thirty-four weeks and breathed all on her own. Lydia Jean Stark, our beautiful and resilient miracle, was born on St. Patrick's Day. We were the lucky ones after all it seems. Lydia had a green bow affixed to her tiny head before either her daddy or I got to lay eyes on her preciously perfect little face. I couldn't believe that God had given me a daughter, which is precisely what I wanted but was too afraid to ever admit out loud.

## My Heart Begins to Heal: Lydia Jean

Lydia and I were both released from the hospital nine days later. Although I had lost a lot of blood, I did not lose my uterus. Lydia had some struggles for the first few months of her life common to prematurity, but she caught up quickly and the effects of her rough start did not cause lasting problems. We were both bruised from the battle but nowhere near defeated. I resigned from TWA to be a full-time, stay-at-home mommy to this long-awaited child. Tim and I couldn't have been happier as first-time parents; we enjoyed every minute, every coo, every cry, and yes, even every diaper change. We were, as you can only imagine, head over heels in love and well on our way to becoming classic helicopter parents.

As much as I could easily fill volumes with tales (and photos!) about our beloved and perfect daughter, that's not the purpose at hand with this book. Lydia opened the door to parenting for us. God used her to

help heal our hearts so that we would have the strength and fortitude for the battles ahead. We didn't know that of course, but that is what happened. God, our astoundingly wise Commander-in-Chief, knew that Tim and Dawn needed some time off the battlefield in order to heal, to prepare, and one day begin to war again.

# 13 Rest, Recuperation and Reassignment—Hope is Born

*War is the supreme test of man in which he rises to heights*
*never approached in any other activity.*
—*General George S. Patton*

After Lydia's birth we had a sweet, albeit brief, season of reprieve from battle. I guess you could say we had been wounded in action during the pregnancy and birth of our daughter, so our Commander moved us off the front lines for a period of time to allow for some healing and recuperation. We weren't discharged from service, only sidelined to recover. It took almost a year before my nightmares about the hemorrhaging and crisis surrounding the birth experience faded. It also took eighteen months before Tim would break free from his fight with alcohol; a dependence he had leaned on for too long and too heavily during our infertility. We both needed some therapies, some interventions, and some time to recover from the heavy toll seasons of warfare had extracted.

We might have been wounded in battle, but we were awarded this amazing Medal of Honor named Lydia Jean. Our princess did this beautiful thing of capturing and healing our hearts at the same time by bringing a dose of heaven's love into our lives. We still didn't have the eyes to see where we were headed, but our infertility wars were far from over. There were to be many more battles ahead for our small family. We now understood the great value of being parents and having children in a very real and tangible way. Having a baby was all that we had dreamed—and more! We knew in our hearts our family was not

yet complete. Lydia certainly took her time getting here, but once she arrived, she armed us with hope.

## Armed with Hope

Hope is a critical weapon that the Lord gave into our hands during this season of our infertility wars. Hope is defined as "to expect with confidence, to cherish a desire with anticipation, to trust."[1] First Corinthians 13:13 (NLT) explains that "three things will last forever—faith, hope, and love—and the greatest of these is love." Hope is inseparable from faith! Faith trusts in what you cannot see, while *hope imagines there is something there to trust in!* In their book, *The Hope Habit*, authors Terry Law and Jim Gilbert write, "Faith and hope are symbiotic; i.e., neither can exist without the other. They are also synergistic, working more effectively together than they could separately."[2] A phrase I've read often, but can't find who the credit belongs to, accurately expresses the point I'm trying to make here: Hope redefines what is probable and opens the paths to the impossible. This is exactly what Lydia's arrival did in our lives—she helped us redefine the probable (being parents) and opened paths to the impossible (having a baby).

Proverbs 13:12 tells us that without hope our hearts get sick. Pastor and author Erwin McManus writes that "hope is essential for our souls to thrive" and "if you don't believe you have a future worth living for, your spirit loses all hope, and your soul was not designed to live without hope. In fact, when we lose all hope, we lose all desire to live."[3] That was certainly true for me when depression tried to literally drown me from life. Science even confirms this truth from Proverbs. Hope researcher Shane Lopez says hope is like the oxygen we breathe, that we can't live without it.[4] For instance, Lopez and his colleagues conducted three meta-analyses. Their findings showed that hope leads to everything from better performance in school to more success in the workplace to greater happiness overall. This makes sense! Hope makes it possible to see beyond the challenges.

Hope is an action of the mind that must be actively and intentionally cultivated in our lives. "When we're hopeful, our ideas and feelings about the future work together. Our thoughts look ahead and tell us what we need to do today to get where we want to go. Our feelings lift us up and give us the energy to sustain our effort. Hope is the work of the heart and the head."[5] Returning to the promises in Scripture, we learn that when hope is planted:

- Heartbreak is turned around – Hosea 2:15
- Sickness is turned into life – Proverbs 13:12
- Our bodies can rest securely – Psalm 16: 9
- It anchors our soul – Hebrews 6:19

The hope we gained through the birth of our daughter inoculated us with new courage. Although there were more painful failures ahead on our path, they didn't impact in quite the same way as they had before Lydia arrived in my arms. I didn't mourn the losses or failures quite as deeply because my heart and head had received so much healing. I think the key was that I didn't allow myself to return to the heaviness of depression. I certainly mourned, but it was different from depression. At the same time, there was so much more on the line because now I knew what I was missing. In that way, infertility moved from an intangible to a tangible loss.

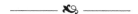

## Moving Forward

To carry us to the next part of the story, I need to quickly explain a few things that occurred in our lives after Lydia's birth. First off, my former boss at TWA approached me with an offer for consultant work about six months after my resignation. The airline needed my help to complete a critical legal project related to my old department and to ensure a smooth transition with my replacement. Although I didn't get to keep my travel privileges, I was able to earn a nice salary while caring for my daughter at home. Virtual workplaces were a fairly new concept in the late nineties; it was not something I was looking for or expecting.

# REST, RECUPERATION, AND REASSIGNMENT

For me, it was the best of both worlds! I would still be with Lydia, but I'd also be able to build up the savings that would be needed for future IVF. This consultant job that lasted for a year was yet another example of a pivotal circumstance from a providential relationship in my life.

Another important development, and one that plays heavily into future parts of our story, is that we sold our custom home in the cul-de-sac and moved into a 150-year-old farmhouse on fifteen acres a few miles outside of town. Ah, the stories and antics from this single life decision could fill up a book all on their own! Comparisons to *Green Acres*, *The Money Pit*, and *Funny Farm* would all be accurate. Lydia had just turned a year old when we found the property, so we put our house on the market in a "let's see what happens" kind of moment. Nobody was as surprised as me when it sold a few weeks later for nearly the full asking price. It was a very bittersweet time for me to leave the home I loved so much, but Tim didn't carry the same affinity as I did for the home we built together. He was ready for a new adventure! I only saw the massive remodel job that this farmhouse would require just to move in; Tim saw a barn filled with animals, chickens laying eggs in the coop, rolling alfalfa fields where a horse might someday live, and all of the other fantasies only an Eagle Scout would have about country living.

In June of 1998 we packed up our lives, moved into my parent's basement, and gutted the old house in the country. We ran central air and electricity into walls and ceilings, updated the kitchen, closed up an upstairs loft to build a third bedroom, updated the bathrooms, drywalled the living room, repainted the entire house, and installed new carpet. It was an eight-week project to prepare the farmhouse for our small family. Tim ran his business during the day, while spending his evenings and weekends on the remodel. I spent as much time as possible there, too, but the level of construction we were doing made the space challenging for me to work in with a toddler in tow.

Looking back on this timeline, it's hard for me to imagine why in the world I felt it was the best time to try and have another baby. I suppose it was because we had saved enough money for the next IVF and were eager to continue building our family, regardless of the other

life events swirling around us. After all, we had waited so long to become parents in the first place! I was head-over-heels in love with my daughter, but after her first birthday my itch to have another baby was stronger than ever. I loved being a mommy! We were already in that mode, so why not? Other than my pregnancy and delivery, it was better than anything I dreamed. We were moving, starting over in many ways, and honestly, I think we just assumed our infertility was behind us. Other people buy homes and have babies at the same time, why couldn't we?

## Trying Again and Again

The target date for my fifth procedure was mid-July, about one month after moving out of our home and starting to remodel Stark Acres, the cheeky nickname we gave the place. Lydia was walking and talking and a non-stop source of pure joy in our lives. As much as I dreaded the shots, runs to the hospital, and the entire process of getting pregnant, I was excited about the possibility of enlarging our family and finally getting our lives back on track from the derailment of infertility. My packet arrived and before I knew it, we had fully jumped back on the high-tech baby-making train.

I was almost thirty-one years old by this point, but my ovaries were still easily stimulated and cooperating very well. Everything about the procedure went like clockwork, and now that my body knew how to be pregnant, my medical team was hopeful for success with this round of embryos. In fact, they looked so good that we transferred four and froze two for a future procedure. It was amazing how fast technology was moving in the world of assisted reproduction! Freezing was in the experimental phases during my last IVF in 1996. I can't tell you the peace of mind it brought me to know that I could possibly have two pregnancies from this one procedure. I'm guessing it's the same feeling a lottery winner feels when suddenly they have more money than they can use! This was probably my easiest procedure yet. I complied with the required bed rest for a few days after the transfer and endured the painfully long wait from procedure to pregnancy testing date. There

was no way I could've prepared for the "NO" that was coming. This one hit me like an upper cut punch to the jaw. On August 13, 1998, the familiar voice on the phone once again uttered the phrase I knew so well: *"I'm sorry Dawn, the hCG count is less than two. You are not pregnant."*

How could this be? I thought we were past all this "NO" nonsense. How are we still adding death days to this list? Why is infertility still part of my narrative after my sorrows were turned to joy? Question after question about God's decision to deny me another pregnancy at this time pounded my emotionally and hormonally charged brain. I scooped up my tiny daughter and sobbed. At only sixteen months old, her little fingers patted my back and wiped away my bitter tears of loss and confusion.

With this loss there was also another emotion that manifested in processing through the pain: guilt. On top of your regular infertility rollercoaster, I had now unknowingly introduced mama guilt into the equation. I felt guilty for wanting more children. Was I somehow not appreciative for the gift I had already been given? I felt guilty for crying and letting Lydia see me in this deep pain. I felt guilty for doing the procedure in the middle of a large remodel. I felt guilty for any way I was communicating to Lydia that she wasn't enough for me. I was simply too young of a mother to identify this emotion from the devastating blow I had just received from my old friend infertility. And I didn't take the time to sort it all out either.

It wasn't lost on me that we still had two frozen embryos and just enough money left to cover that transfer. True to form, almost like replay of 1992, I rushed back in with another back-to-back cycle. The "no" had sent me into spiral mode. I didn't stop to process or worship or ask the Lord how to proceed. The mantra I grew up hearing from my dad—"everybody is moving, nobody is sitting still"—pushed me back onto the battleground as soon as possible. I was moving; there was no time to sit! I was brutalizing my body with chemicals once again, and I didn't even care. I consoled myself that this was not a stimulation cycle, only a transfer cycle. I knew that statistically our chances were less with frozen embryos; the technology had improved, but the success rates with "frozen over fresh" were much lower. But I

was geared up and wanted another baby, and reality had very little to do with my frame of mind running through into this next treatment cycle.

Not surprisingly, on November 18, 1998, our sixth ART procedure came back with a negative pregnancy report. Neither of our two last embryos implanted. If you are keeping track, we had one pregnancy out of six high-tech infertility procedures and over twelve years of trying to get pregnant. Our statistics were abysmal. We were out of money. I was done trying. I decided to focus on and live gratefully for my one beautiful, smart, articulate, and perfect little princess. It was time to let go and move on from our dreams for more children. We had fought very hard for a long time for our miracle, and she was enough.

## The Juxtaposition of Loss and Hope

1999 was a year in our lives when there was a juxtaposition between loss and hope. This is a tough part of my story because there is a lot of loss that happens for our little family. At the same time, there was also a lot of hope starting to arise. As I've mentioned, Tim struggled with a growing dependence (and abuse) of alcohol during our infertility. He was a solitary drinker, not a mean or wildly partying drunk. Alcohol provided him an escape from the pain of infertility and the weight he carried because of the nature of our problems. He was burdened with the fact that we had male factor infertility, yet I was the one who had to endure all the treatment. My pushing through two IVFs in 1998 didn't help the drinking either. Those failures just served to remind my husband that we were infertile and that he was helpless to change that fact. I never blamed him, yet at some level, he blamed himself and at the unconscious level he needed an escape. Alcohol provided him that relief.

However, alcohol is not a friend. It is actually a foe. The problem was that by the time Lydia arrived and we started to heal from the pain of the last decade, drinking had now become an addiction. Tim's coping mechanism was now in control of him. Not all the time and

not every day, but there were times when I wouldn't see or hear from him for a day, or sometimes two. He would simply disappear from us, from his business, and from life. I couldn't believe that after everything that we had been through and all that we'd overcome, I was now losing my best friend to a bottle. I didn't drink; we didn't drink together as a couple; this was not the man I married or the values we shared. How could this possibly be the end of my story?

If you've faced something difficult or challenging in life, chances are you've probably had someone tell you that it's going to be okay because "God works all thing together for our good." As you imagine after reading my story, I've certainly had my fair share of being on the receiving end of this little phrase. The one knee-deep in the crisis usually wants to slug the person who utters this cliché and seemingly out-of-touch-with-reality response. I get it, I really do. Part of me hates that phrase, but another part of me knows it's true. I've seen so many places in my life were God worked together impossible and painful pieces to bring about goodness. The question we need to ask is whether this biblical concept is true all of the time or just some of the time? Is this statement true when we see how all the pieces fit together and untrue when we do not? That can't be right, because that would make God's Word subjective to our interpretation and our desires. Obviously, it's true all the time because God is true all the time. The tough part for humanity is that we don't always know, understand, or see the whole story. We may not like this inconvenient truth, but we can be assured all things do work together for the good because God says it's so.

This little nugget of truth (or frustration, depending on where you are in your own life right now) is found in Romans 8:28, a book I struggle with anyway! I find this one of the toughest books in the Bible; it's literally Greek to me (she writes tongue in cheek). Looking at this verse in context of chapter 8 helps us understand that a Spirit-led life will lead to suffering. Nonetheless, those sufferings are for our future glory and we are promised, "If God is for us, who can be against us?" (vs. 31). And here's the best part for me as I'm reading the chapter with fresh eyes: "in all these things we are more than conquerors through him who loved us" (vs.37). Boom, right back to the warfare

theme of my story! Yes, our lives are going to be hard, filled with "trouble or hardship or persecution or famine or nakedness or danger or sword" (vs. 35). But nothing—not even your husband's alcoholism after a decade of infertility "will be able separate us from the love of God that is in Christ Jesus our Lord" (vs. 39).

In January of 1999, not long after our last failed procedure, Tim went on a binge unlike any other I'd seen. Pushed to my limit, I called his parents to let them know the reality of what I had been living with over the past year. They were heartbroken, for their son and for our family, wishing I had called them sooner. They immediately engaged; my father-in-law and mother-in-law were waiting in the driveway when Tim arrived home that evening. I guess you would call it an intervention. They took the steps to find help for their son and walked him through a complete evaluation at a local facility the next morning. It was the beginning of thousands of steps Tim would take in his sobriety journey. He did an outpatient program for two weeks and started attending AA daily, something he would continue to do for a very long time. January 8, 1999, became a new birthday of sorts for Tim and it is still one we celebrate every year.

As battles go in our lives, this one was fairly short-lived and ended up in a great victory. I didn't share every little detail about Tim's struggle with addiction any more than I divulged into every little story about parenting Lydia or every antic that transpired at our farmhouse for this simple reason: it's not the purpose of this book. However, it's an important detail to know because addiction and recovery play into Tim's future. Was it tough? *For sure!* Did it push me to my limit? *Absolutely.* Did it come close to destroying our marriage? *Yes, the final months of the drinking had me contemplating divorce.* Was I confused and heartbroken? *Beyond words.* Did I question God's goodness, sovereignty, and even love throughout this entire experience? *More than I care to admit.* Why me, why one more weight, why one more battle? *I have no idea.* But here's the bottom line: despite all the pain and heartache it brought, God was able to work Tim's alcoholism for good! I know that sounds crazy but stay with me a little longer in our story.

All of us lead lives that unfold before us in a way we never imagined when we were young. We all face events and circumstances that lead us down unknown paths and directions we would never have found if the hard or painful events hadn't happened in the first place. Sure, some of our stories are more drastic than others, but I believe this is a universal principle of mankind. Because we are not sovereign, our lives are unpredictable! One door shuts, another door opens. It's such a beautiful thing to stand back and say, man that was painful, and I wish it didn't happen to begin with, but I also love this new thing that has occurred as a result of what transpired in my life. It's amazing how God rescues, restores, and redeems his people by repurposing their lives. He alone stands at the juxtaposition between loss and hope.

## A Magna Doodle for God

Do you know how in a soap opera one story line wraps up triumphantly as another plot twist is introduced to keep you hooked? You never get to sit right in the midst of that happy, content, relieved moment for long because that's not how drama works! The next story arc begins to emerge as the previous one resolves because writers know how to keep you tuning in. This is exactly how I feel about most of my life. I've even debated leaving certain parts out of the book because at some point it all becomes more like a fictional story rather than my real-life autobiography. Honestly, I find some of it really embarrassing, except that I can see now how all these pieces needed to fit together. God is a master at storytelling, always getting us right where we need to be at exactly the right moment in time.

I've jokingly called my life a Magna Doodle for God. You know those toys, right? They are a magnetic drawing toy, consisting of a drawing board, a magnetic stylus, and a few magnet shapes. Maybe you are more familiar with the Etch-o-Sketch, which is an earlier generation of this toy. I don't know why exactly, but it seems to me that God often resorts to drawing out his will for me visually. If you think about it, it's not really that far-fetched because Scripture informs us over and over that God writes upon our hearts (Deut. 11:18; Jer. 31:33; Is.

159

49:16). I think if the Lord can write upon my heart, he can certainly communicate his purposes in picture form too. After all, that's what a sign is, right?

The Bible is a book filled with signs and wonders. There can more no better evidence to my point here than the life of the prophet Hosea. God told him to marry a prostitute and have children with her in order to "illustrate how Israel has acted like a prostitute by turning against the Lord and worshipping other gods" (Hos 1:2, NLT). God hasn't changed since Hosea's time; God is eternal and unchanging! He hasn't stopped ruling in the affairs of men or stopped communicating with humanity just because there are no new books of the Bible. I may rarely understand the picture being drawn out in advance, but in hindsight I'm often like—well, sure enough, that couldn't have been any clearer if it had been spelled out in front of me.

For example, let's talk about our business, Remodeling 2000. In the early to midnineties when Tim was launching his business, he came up with this name to communicate innovative building materials and solutions. There was much prayer and time invested into launching this company and stepping into self-employment. At the time, we knew it was Tim's next step, and for many years it was a successful business that not only supplied for our family but several others as well. As it turned out, the name would oddly and very accurately predict when the company would close down. We saw it one way, but in hindsight, we were able to see the writing on the wall had been there the whole time. It doesn't necessarily make processing through the unknowns of life any easier, but it does help to bring comfort and healing when you can see that your Commander was speaking and guiding you throughout the entire journey.

Just as Tim began to step away from his addiction and clear his head, we started to watch our business unravel before us. It wasn't because of his drinking, although that certainly didn't help matters, but rather because we got involved with some remodeling projects that were tied to state development funding. At first these contracts looked so shiny and promising; it was almost like shooting fish in a barrel! We honestly believed it was a huge turning point for our company. And it

was, just not in the direction we had been expecting. The problem was that although it was easy to get the contracts and run the jobs, the government funding was fraught with complications, delays, and frankly corruption. The more freedom Tim got in his soul over addiction, the worse things became with our business. It was an incredibly frustrating time in our life. I was finally getting my husband back from the brink only for our business to be pushed to the brink. What on earth was God doing to us?

At the same time the problems with our business were escalating, we started to get signs of twins in our life. Something I haven't shared yet is that I am allergic to every animal with fur (as well as trees, grass, and pollen) and have been for my entire life. As a child I went through the weekly shot series, but unfortunately, I never did outgrow my allergies. Although many people like to think that allergies are something you can just "get over," anyone who's lived with them chronically knows this is simply not the case. I can walk into a house where a cat lives, and no matter how clean the house is, or if the cat has been moved to another room, I will become symptomatic within minutes. For my allergies at least, there is no such thing as a "hypoallergenic animal."

Now that we had fifteen acres and a barn, we knew that having a dog was finally possible. Even if my interactions with our pets would be limited, we were excited about a chance for Lydia to have a dog and her mommy at the same time! We were considering what breed would be best served by our property and my limitations when some dear friends offered us not one, but two Great Pyrenees puppies on the same day we received negative results on our sixth IVF. It was totally unexpected, but excitedly we said yes knowing confidently this was another mercy in the process. We named them: Zach (the Lord remembers) and Zoey (life). Zach and Zoey were our first set of twins. They were mischievous as all heck, but we loved them deeply anyway.

A few months later Tim decided we needed goats. He was really embracing the country life and wanted to add more animals to Stark Acres "for Lydia's sake." We already had chickens and one incredibly annoying rooster, but apparently goats were the thing we were still

missing. Okay, okay, I relented, clearly not understanding what we were about to step into with these animals. Tim brought home two goats in June of 1999. Within weeks we had five goats. Unbeknownst to us, they were both pregnant. The first one delivered a single spotted kid not long after coming home; the second goat delivered one black and one white kid that we watched being born. It was at this point we started thinking, what is going on here with these sets of twins?

I was having dreams about twins, possibly inspired by our twin animals for sure. But others were having dreams of me having twins too. And the craziest sign of all happened with eggs! I had bought two dozen eggs from our local Farmer's Market and every single egg I cracked in those two cartons had double egg yolks. After cracking a few of the eggs and seeing the double yolks, I got very curious. I remember pulling out a bowl and cracking all twenty-four eggs just to see what was inside. I picked up the phone, called information (back in the day!), and reached out to the farm where the eggs had come from to ask this question, "Do all of your eggs have double yolks?"

I mean, how silly, right? You can imagine the farm's employee hesitant, "What do you mean ma'am?" Of course not, farmers don't have any control over the double yoking of an egg! Yet here I was with twenty-four eggs with two yolks *and a very large omelet for dinner.*

How could it be that God was whispering the promise of twins to us at every turn, and meanwhile our business was failing? We could not get the state to pay us what they owed, and our debt was climbing every day. We were simply too small of a business to sustain bureaucratic delays. There were other employees to consider and a mortgage on the house the business occupied as a tenant. The last thing we had was money for a procedure! How could our Father be this cruel? How was I supposed to hope for something that there was simply no pathway to reach? I didn't have $12,000 and frankly I was done with IVF. In all of our years we had never gotten pregnant on our own. Talk about your hopeless situation. Finally in October 1999, we officially closed our business. A sober, yet heartbroken Tim went looking for a job. I started working two days a week at our church as a project manager and director of our children's ministries. The Magna Doodle drawing

before us was a contrast of our loss (debt to our eyeballs, fighting with the state to release our contracted funding, closing our business) and signs of hope (twins, twins, and more twins). The picture drawn on the canvas of our life made no sense to us whatsoever.

# 14 The Final Battle

# The Double-Portion Blessing Arrives

*If we wish to be free; if we mean to preserve inviolate those
inestimable privileges for which we have been so long
contending; if we mean not basely to abandon the noble
struggle in which we have been so long engaged, and which
we have pledged ourselves never to abandon until the glorious
object of our contest shall be obtained — we must fight! I
repeat it, sir, we must fight! An appeal to arms, and to the
God of hosts, is all that is left us.*
*—Patrick Henry*

Sometimes in life the only thing that makes sense is just taking the next step forward; some days merely taking the next breath is a huge accomplishment. We don't always know where we are headed, but we can be assured the direction is forward—even if that might be at a snail's pace into the future. Erwin McManus says, "Hope pulls us into the future."[1] I'm sure that's why God gave us signs promising twins because we needed some hope in the middle of a really tough season of life. The year 1999 was clearly a time when Tim's redemption story crisscrossed over mine. There were different themes that intermingled (infertility, addiction, financial), but all were for the purposes of our transformation. As we slugged through the process of closing the business and dealing with all that miserable aftermath, Tim was finally figuring out how to handle the stress and pain of life without the crutch

of alcohol. As I faced another difficult process and uncontrollable situation, I was able to focus on Lydia, hope in future promises, and keep depression at bay. It was undeniable that we were growing, changing, and becoming stronger even in the midst of the battles that swirled around us. We couldn't see all the rich promises that were ahead for us, but our Father knew exactly where we were going and cared enough to make sure we were both healed completely from the harmful dependencies we'd both developed through our early war experiences.

## A New Path Emerges

As the calendar turned over to the year 2000, a new man was beginning to emerge from the ashes. Nearly a year into his sobriety, Tim was sensing a call back to ministry as unexpected doors began to open before him to lead a discipleship program for young adults at our church. While attending a conference along with other church leaders running similar programs, Tim once again surrendered to a life of ministry. He experienced a renewal in his faith as powerful as his early conversion to Christianity when he was still a teenager. After returning home and spending the new few months in prayer and research, the decision was made for him to return to church staff and begin to develop this program for launch in the fall of 2000.

I was so excited that after all of these years, we were finally stepping into ministry together serving the next generation. Tim was serving young adults and I was serving the children's ministries. Finally, the new picture was beginning to emerge! I can't explain how this time felt for us, except to say it seemed like a full circle moment and that restoration was finally at hand. Around this same time that Tim was returning to pastoral work I had a dream about saying goodbye to Dr. Silber and switching to a new doctor. I have always been a prolific dreamer, but this dream was so very precise. I woke up unsure exactly if there was a meaning—was I officially done with treatment or was there a change coming ahead? Regardless, it was really a meaningless question, because we existed day-to-day in our finances thanks to the

business loss. We didn't have any savings to pay for a procedure anyway. Like most of my dreams, I reflected on it, jotted it down in my journal, and then went on with my day.

Not long after Tim returned to church staff, we received the benefits booklet from our new health insurance company. Much to my utter shock, there was a provision in this policy that covered IVF. You should probably reread that last sentence. I said, suddenly we had coverage for treatment! Rubbing my eyes in disbelief, I read the policy over and over (and over and over) before calling the insurance company to verify what I was reading. Turns out that our state had recently passed a law requiring group insurance plans to cover ART procedures to address infertility under certain conditions, all of which we qualified for. But here was the catch: I would have to switch doctors because mine didn't accept insurance.

*Okay, God, you've got my attention.*

Tim gets healed, steps back into ministry, and suddenly— impossibly—there is a pathway made for another IVF? And not only another IVF, but one covered 100 percent by insurance? This moment right here was the ultimate juxtaposition between loss and hope in my life. Here at a crossroads that we could only come to because of a difficult loss, stood a place filled with incredible hope. Only God can orchestrate this level of plan perfection, and it brought me to my knees. I knew there would be a seventh IVF in our future, and I held great hope in my heart that it would bring forth our twins.

We said goodbye to Dr. Silber and said hello to another reputable reproductive endocrinologist in St. Louis. Although there were a few preliminary tests this new doctor required before scheduling me for a procedure, the transition to a new office was easier than I anticipated. Not only was my procedure covered at 100 percent, but our medications were also covered at 50 percent. Our seventh IVF would cost us about $700 versus the $12,000 we'd spent for each of our other procedures. Even though we were broke, I had emotionally written off treatment after our sixth one failed. Once again, my Jehovah Tricky new EXACTLY the conditions it would take for me to agree to being

vulnerable again. Throw in a few years of financial hardship pulling treatment completely out of reach and combine it with an essentially free procedure would pretty much assure I would say "yes" to round number seven. Within a few months of Tim stepping into full-time ministry, we were added to the waitlist and told to expect a target date somewhere in the spring of 2001, just about the time Lydia would turn four years old.

## An Unexpected Whisper

One month before the target date, I was standing in my dining room ironing when I heard the name Isabelle whispered in my heart. The word was arrestingly clear: Isabelle. Falling to my knees, I replied, "Lord, am I going to have another daughter?" I wasn't even thinking about the procedure or infertility or babies when this happened; I was in the middle of quilting and quite focused on making sure my pieces were lining up correctly. I immediately went to the bookshelf and pulled out the baby name book to look up Isabelle, a derivative of the name Elizabeth meaning "pledged to God."

I broke into worship. I loved the name Isabelle—it's a name I totally would have picked on my own. It was such a beautiful variation of a classic name with a beautiful meaning, too! Tim's grandmother, the matriarch of the Stark lineage, was named Elizabeth. We would call another baby girl Isabelle Ann, adding the name Ann from Tim's mom's middle name. Just like Lydia who carried the names of two grandmothers on my side of the family, there would be another daughter carrying two names from Tim's side of the family.

I knew right in that moment that my Father was giving me a little insight into the mystery that would soon be unfolding. More hope to fuel my courage that the path I was on would not wash out from underneath me again. I didn't know if there would be multiples, but I was fairly certain that a little lamb named Isabelle—whom we would call Izzy—would enter our lives before the year was out. And this piece of news simply made my heart soar!

## The Double-Portion Blessing Arrives

By now you understand what a procedure entails, the ups, the downs, the diarrhea episodes, the panic attacks, the abdominal pressure, the sore hips, and the hormonally-influenced emotions. Even though I was now thirty-three years old, my ovaries still performed like they were twenty-something. I had loads of follicles, a great retrieval, and five beautiful embryos to transfer on March 23, 2001. It was the most we had ever transferred, but since it was my seventh procedure, the doctor felt comfortable with this unusually large number of embryos. We had none left to freeze. Every possible potential for pregnancy was successfully transferred into my uterus nearly nine years to the day after our first failed GIFT procedure. Death days were never lost on me, but maybe—just maybe—it was time to finally turn March losses around. The day before my blood test, this is what I wrote in my journal:

> *On one hand, everything in my body is different from with a normal failed procedure. I have no signs that I'm going to start any minute. My abdomen is so swollen and I keep feeling these tearing and ripping sensations. I feel three months pregnant, which is crazy. It's like something violent is going on. On the other hand, I can't even imagine taking that phone call and getting good news tomorrow. Tim heard our only yes. I've only ever heard no. Just fourteen hours left before our destiny unfolds."*

At 1:30 on the afternoon of April 3, 2001, the phone rang. Our family and closest friends had come over to be in the room when the call arrived, which was very different from any other time before. I answered the phone and heard the words I had waited a lifetime to hear:

> *Congratulations Dawn, you are pregnant! Your hCG count is 168, indicating a good strong number. We will repeat the blood count in two days to make sure everything is progressing normally.*

The cheering and tears that washed over my soul brought such healing; I'm not sure mere words could ever convey the impact of that moment. Lydia, by this age very eager for a sibling, laid her head on my shoulder and cried. Our tribe openly wept. We lifted up prayers of thanksgiving. We didn't know all of the answers about this miracle, but at that moment, we knew all we needed to know. God was adding to our family after a very long and weary fifteen years of an infertility war.

## The Battle for My Twins

We suspected multiples after initially hearing that first hCG count. Remember, my first hCG count with Lydia was forty-one. This time the initial count was more than tripled! The follow-up count a few days later was three hundred and eighty-three, again way elevated over Lydia's numbers. The pregnancy symptoms started much earlier this time around with tremendous low pressure and nausea right from the start. Also, having some hyperstimulation side effects on my ovaries didn't help this much either. While the doctor's official comment was that hCG levels are not necessarily an indicator of multiple gestations, I was convinced I was carrying two babies or possibly three.

We didn't have to wait long to find out! Just a few weeks later on April 13, we were delighted to see two teeny-tiny sacs growing in my uterus. At five weeks and three days we confirmed a twin pregnancy before there was even a visible heartbeat. While we were ecstatic, our new doctor was sober. He explained there was a 50 percent chance we could still lose both babies at this stage. As medical professionals do, he outlined the hurdles we still had to get through until we had a viable twin pregnancy. We left absorbing the weight of his words and the fact that we were going to have twins! This was the first time it really hit Tim that we were going to add two more babies to our family. He went home and started cutting grass. Four hours later he was still numbly driving around on that riding lawn mower as he processed the news. We still laugh about my coming outside and getting him off that mower on that afternoon—it was a lot to absorb. Meanwhile, I giggled all day long. It was like a dream, but this time, a really sweet and perfect dream.

On April 23, everyone breathed a huge sigh of relief to see two strong heartbeats on the ultrasound. Now given the names Baby A and Baby B, our twin pregnancy was well on its way and I was released to the care of my OB/GYN to manage my pregnancy. It was an exciting day to share with Dr. DeRosa that I was pregnant with twins! The day got even better when he announced I could switch to an oral progesterone and stop taking the daily IM injections. After four months of daily shots of one form or another, you can imagine those words were music to my ears. My ovaries were healing and my babies were growing; I was officially released from high-risk status and allowed to resume normal activities. I felt horribly pregnant and not like doing too much anyway, but after my first experience with pregnancy, normal was a beautiful word to hear.

But alas, normal did not last for long. At nine weeks and two days I started to bleed. Terror ripped through my heart. I could barely get the words out on the phone to the doctor's office, who instructed me to come in right away. Once again, Tim whisked me to the other side of St. Louis at a frantic pace to get checked out. The ultrasound showed both of my babies moving and hearts pounding away. Relief washed over me; they were both fine. The nurse saw more blood in my uterus and told me to expect more bleeding. My doctor came in and said they can't always explain where the bleeding comes from, but not to worry because some women bleed in their first trimester and their pregnancies are fine. He knew my history, so I tried to take comfort in these words. Well, as much comfort as you can have being pregnant and wearing a pad because of constant bleeding. I left the office that day with orders putting me back on bed rest until my twelfth week of pregnancy. Talk about facing your old fears head on!

Tim left town with his students for ten days in mid-May while I was on bed rest, so Lydia and I moved to my parent's house. Lydia really missed her daddy, but my bleeding had virtually stopped so my heart was peaceful again. The night before Tim came home, Lydia and I were sleeping together in one of the spare bedrooms upstairs. To my incredible horror, I woke up at 12:50 a.m. to the all-too-familiar feeling of gushing blood with my daughter lying by my side. I made my way to the top of the stairs and yelled out, "I'm bleeding!" These two little

words sent my family running. My mom helped me get to the toilet as my brother Dallas scooped my sleeping daughter out of the bed. The minute I sat down on the toilet I passed a clot the size of my fist. I remember crying and saying over and over, "Oh no, not my babies," as my mom put a towel between my legs and moved me to the edge of the tub while she retrieved the clot.

All she could say to me was, "Honey, I don't know." The blood was all over the bed, my nightgown, and the floor. I couldn't believe this was happening again. How could I have painlessly lost two babies at eleven weeks and two days? How would I ever tell Tim I lost his babies while he was out of town? What would I say to Lydia?

God love my dad. He took the clot downstairs and looked through it. He came back up to let us know he only saw blood. This should've relieved me, but at this point I was so dazed and confused. I paged my doctor who called back in a matter of minutes. He told me not to panic; this was not uncommon since I had already had some bleeding. My instructions for overnight were to go to the ER if I started filling pads every twenty minutes. Otherwise I was to stay off my feet and come in the office the next morning. Slowly my head cleared as the panic began to recede. There was no way I had lost my babies; there would have been some evidence of that in the blood. Also, I was not cramping or experiencing any of the labor-like symptoms friends report when miscarrying. I rationally told myself that two fully formed fetuses don't painlessly fall from your body. After cleaning everything up, Mom climbed in bed beside me and prayed without ceasing. Uncle Dallas cared for his four-year-old niece in the room next to mine. I had no way of reaching Tim, who was driving through the Rocky Mountains by this point. I watched the clock tick off minute by minute in one of the longest nights of my entire life.

The next morning, I saw my Baby A and Baby B dancing and moving around in beautiful motion set to the sounds of their swishing heartbeat. They were oblivious to the crisis their mama faced last night. The doctor assured me all was well with my babies, but believe it or not, right now we were dealing with a previa issue again. However, this is not the same as what I had gone through with Lydia. At this stage

of a twin pregnancy, the two placentas take up a lot of room, but as the uterus grows, they will move up and the bleeding will (or should) stop. My pregnancy was viable, and my babies were fine. It would take another month by the time this all was stable, but eventually I was able to be pad free, released from bed rest, and able to regain some mobility.

## A Secret Revealed

Finally, I hit the sixteenth week of pregnancy and it was time for our big reveal ultrasound! On the way to the appointment Tim wanted to know my heart's desire on the sexes of our babies. Given our infertility journey, this was a tough one for me to answer. I always felt somewhat guilty about what I wanted related to building our family, knowing what I felt, but also being aware what I should say out loud. But we were alone in the car, without anyone else listening or judging so, I answered, "I'd like to give Lydia one brother and sister."

We had already picked names for our babies. As you will remember, God had whispered a girl's name before my procedure. If we had one baby girl, she would be Isabelle Ann. My father was born Dennis Michael Kincaid, but he was given up for adoption by his birth mother when he was nine months old. His adoptive mother, my grandmother, changed his name to Dennis Wayne. We decided to honor my dad's birth name and call a son Michael Kincaid. We had a second boy's name in place, but not a second girl's name. Turns out we were 100 percent prepared for the results after all! On June 27, 2001, we discovered our Baby A was a little boy and our Baby B was a little girl. With great joy we were able to share with Lydia that she was going to be the big sister to Michael Kincaid and Isabelle Ann. She just giggled and kissed us both, then officially introduced herself as the big sister to "her" babies growing in my tummy.

The last summer with just the three of us was very sweet and filled with some special family moments. I was growing larger by the week but enjoying the short window I had of feeling better to get all of the baby preparations in place. Although things were going well in my multiple pregnancy, I was informed and experienced enough to know

that it could change in a moment. Lydia started preschool in the fall, and I was that mother who couldn't stop crying at the door. I'm sure it was quite the sight to all the other preschool moms, especially because I appeared ready to pop and was well into waddling mode by late August. My doctor did start home monitoring for uterine contractions and blood pressure around this point, but only as a precautionary measure, not because anything was wrong.

I entered the third trimester feeling well, measuring a few weeks early, with blood pressure and everything else normal. I was able to see my babies regularly on ultrasound, which is one plus for having high-risk pregnancies. Unfortunately, I developed gestational diabetes, which occurs more commonly in a multiple pregnancy. I was very disappointed by this news. Even though my glucose results were on the border of normal, I had to attend the mandatory three-hour class and learn the diet control measures. Every day I was required to test my urine, monitor for contractions twice, test my blood sugar levels twice, and monitor my blood pressure. It was all preventive, but managing my pregnancy took up so much of each day. Otherwise, everything was progressing very well as we entered the home stretch.

## A Heart in Crisis

My doctor called me in the afternoon of October 17 to let me know the home monitor reported that I'd had too many contractions that day. What? Outside of being huge and peeing every ten minutes, nothing had felt abnormal to me in particular. Just to be on the safe side though, he wanted me to head to the hospital to get checked out and possibly rehydrated. He asked that I leave within the hour. It was the beginning of my thirty-second week of pregnancy. More irritated by the thought of an entire evening spent at the hospital than concerned that something was wrong, I asked my sister to take me so that Tim and Lydia could follow through with the plans they had already made for the evening. She agreed and soon we were off to the hospital for a quick evaluation. I didn't even think about packing a bag.

Within minutes of arriving, it became apparent that uterine contractions were no longer the main concern. In fact, they hadn't even hooked up the monitor to check my contractions when they discovered that my son's heart rate was beating way too fast. A resident checked me quickly to make sure my cervix was still closed, and then the team brought me straight up to Labor & Delivery to consult with a few specialists. This wasn't my first trauma rodeo; yet I knew there was something happening they weren't telling me because everyone was very unspecific in their answers, and there was a team of doctors surrounding my bed. The staff perinatologist[2] appeared to perform an ultrasound, and I soon learned that we were facing a serious crisis with my son's heart. He had developed a form of arrhythmia known as atrial flutter, where the upper chambers of the heart were beating at an unsustainable rate. It was very rare in unborn babies but a condition that always reverses at birth. The pediatric cardiologist assigned to our case had only handled four cases of this condition in singleton pregnancies. He had never seen this happen to a set of twins. Not only would the treatment approach need to take into consideration my healthy heart rhythm, but also the heart of the other baby currently occupying the same womb.

Here I was in the same hospital once again facing the threat of death in a pregnancy. This time it wasn't for me; this time it was for my son. After thorough testing it was determined Michael's heart wasn't showing signs of failure yet, so the doctors felt this was probably a fairly recent complication. Regardless, a decision for a course of treatment had to be made quickly to avoid heart damage. They didn't necessarily want to deliver the babies as a first step because that would subject them both to a premature birth. There was also no time to begin the series of steroid shots to develop their lungs as we had done with Lydia. Twins born two weeks earlier than my singleton would face a significant stay in the NICU. The tears started to silently fall down my face as the drama played out before me. These babies could possibly be here within hours. Tim was at an event with Lydia and I had been unable to reach him; my mom was ministering in the Pacific Northwest; the nursery was not ready; I was going to miss my baby shower—again. All I could think was no way, this was my do-over,

double-portion blessings. This was the second night of this pregnancy that I watched the clock tick by minute by minute.

The next morning all of the doctors working on my case evaluated the data and formed a plan to keep Michael in utero a while longer while not harming Isabelle or me. They decided to treat his atrial flutter with a low dose of Digoxin that I would take orally. They gave us twenty-four hours for this treatment to work while monitoring his heart rate and us girls. If this medicine didn't work (and they had never seen it work), the next step would be injecting Michael with some medicine via amniocentesis to attempt to convert the heart rate. If that didn't work, our third step would be taking the babies via C-section within the next few days. Even though it was all very overwhelming, I felt better having a plan. They didn't think the Digoxin would completely lower the heart rate, but if they could get it to drop some and Michael didn't enter distress, they would try to hold delivery until thirty-four weeks and begin the steroid shots. Of course, I was worried about my twins, but now I was worried about Lydia because this would mean I would be in the hospital for several weeks. She was a total mama's girl who lived by my side. How in the world would she cope with weeks apart? It was time to get people praying for my babies and me. Our church family was brought up to speed on our condition, and requests for prayer were sent out far and wide. Baby Michael needed a miracle to convert his heart, and he needed it now.

At 5:00 the next morning, I was staring at the monitors when I watched my son's heart rate drop from 225 beats per minute to 160 beats per minute. The rate didn't bounce back and forth; it just went from the high number to the low number and stayed there. I immediately called the nurse's station and asked if they had seen that new number and they said yes, they'd seen it too. The resident came right in, checked the monitor, and said we'd just have to watch it and that the pediatric cardiologist would check on me when he did rounds in a few hours. I knew we'd gotten our miracle and that my son's heart had converted permanently. I was starting to feel the effects of the medicine, so he must have, too.

A little while later the perinatologist came in to check on us. She was thrilled and surprised that the first step on the treatment plan had been successful. She told me her orders for the upcoming weekend already included the delivery of my twins, but now she was thinking there might be a break in her schedule! The conversations throughout the morning began to shift away from an imminent delivery to letting me go home—maybe as early as the next day. I think God heard my prayers, but I really think Lydia's prayers moved him the most. The night before she had been peeled off me by her nana while screaming, "I can't let go, my heart hurts so bad." I found out later that Lydia asked my sister if she could be her mommy now. So yeah, I'm pretty sure God was listening to even the needs of my "Jean Bean" when he sent some healing power into her new baby brother's unborn heart. Once again, hope surged and pulled me out of the moment and into the promise of a tomorrow.

Once my blood work and EKG cleared, and the pediatric cardiologist found all of Michael's heart chambers beating in the proper rhythm for twenty-four hours, we were cleared to go home. They did find all of his heart chambers bigger than Isabelle's, but the doctor didn't feel there would be permanent damage. The medicine was lowered, and I had to return to the neonatal lab for non-stress tests several times per week, but I was going home. Insert all the praise hands right here! I was moving slower than molasses, but at thirty-two weeks and two days I was able to go home and be with Lydia again, grateful that we were able to buy more time for all three of my babies. I spent the next month doing all the home monitoring steps I've already told you about every day, seeing both the perinatologist and Dr. DeRosa each week, while also hitting the neonatal lab twice a week. We wore out the path between my home and the hospital, but it was also extremely reassuring to be so closely monitored at this stage of what was clearly another high-risk pregnancy.

## The Breaking of Waters

By thirty-five weeks I was having regular contractions and pre-labor symptoms. The medical team that just a few weeks ago was talking an emergency C-section had now approved me for a vaginal birth after C-section (VBAC) in the operating room, provided that there were no new complications. This was incredibly exciting and an answer to prayer for me. I was hopeful that with this birth I could actually be awake, and Tim would be allowed in the room! It would be nice to have the whole experience of delivery without crisis—we'd been through enough of that nonsense in our journey to build this family! I was making progress with dilating and effacing normally, and Michael's heart remained steady; our babies were both measuring around six pounds on the ultrasound and could safely be born at any point now. We decided to decorate the house for Christmas in mid-November, thinking we probably wouldn't have time to do that once we brought these little bundles home. This time, for the first time, everything was done and ready before the birth. Then, just like every other pregnant woman feels in the last few weeks of pregnancy, time basically stops while you wait for the big day to finally arrive.

At 2:58 a.m. on November 20, I was awakened by a hard, pinching sensation. I was exactly thirty-seven weeks pregnant. I reached over Lydia, who was sleeping between us, and woke up Tim whispering, "I think my water just broke." Sure enough, when I stood up from bed, water poured down my leg and all over the floor. We both started laughing. This time instead of gushing blood, we had gushing waters! It was such an exciting moment! God seemed to be present in redeeming all the details of birth experience this time around. We called the doctor, the sitter, and the family—it was GO time! Although this trip to the hospital still involved a towel between my legs, there was no need to fear or panic. Today we were having two perfect little babies, and we were over the moon with joy!

As deliveries go, it was a very long and painful day with my first vaginal birth. Our family was close as I labored hard, and Lydia waited at home. Based on my early progress, we expected the babies to arrive in the early afternoon. However, it turns out pushing is really difficult

when one baby is turned sideways, and the other baby is still up under your ribs. My mom held up one leg and my husband the other for the hours I spent pushing once I was finally fully dilated. It was eighteen hours later when we were finally moved to the operating room for their deliveries.

Our Baby A was Michael. It was his water that had broken overnight, and our little man bore the brunt of the long labor. He was born with the help of forceps at 8:22 p.m. Although I was allowed a vaginal birth experience, it wasn't exactly like the natural delivery most women envision. My baby wasn't given to me right away because I still had to deliver his sister and the doctors needed to check his heart. However, from across the room they held him up for me to see and I wept openly. It was a little bit like the *Lion King* moment when baby Simba is held up for the entire kingdom to see (*okay, maybe not exactly like that, but it's how I remember the moment*).

Tim moved across the room to be by our son's side and take photos. My husband is such a good daddy; he knew intuitively where I really wanted him to be. Immediately I could tell Michael was going to be a blondie. We were all talking about his fair coloring when the doctor said, "Dawn, I need your attention right here, right now." Isabelle's heart rate had dropped once her brother was born. They decided to use a vacuum extractor to try and pull our little girl out on the next contraction. After hours of pushing, with seemingly little progress, I was finally down to one more push. I remember one of the nurses practically lying on my stomach to keep Isabelle lower in my abdomen. With the next push out came my Isabelle! Man, oh man, was she mad! Unlike her brother who had experienced an entire day of labor, this little lamb's water was broken, and she was pulled out of the womb a mere seven minutes later at 8:29 p.m. She wasn't thrilled with the environment change, and she wanted us all to know.

Michael Kincaid weighed six pounds, two ounces and Isabelle Ann weighed five pounds, twelve ounces. They were both perfect and healthy. Our entire family was allowed to join us in the recovery room, where doctors and nurses also stopped by to take part in the great celebration. Lydia arrived and oh, the sweetness of the moment when

my babies all got to meet each other. She stood on a bench near my head, holding my hand, talking non-stop to all the family in the room meeting our newborn twins. What a complete reversal from Lydia's birth! What a miracle! What a precious moment! God was so faithful to replace all of the negative memories with sweet ones. My heart was overflowing with love and thankfulness that I was now the mama to three beautiful, healthy, and amazing miracles. All of the pain I suffered in the waiting was swallowed up in the moment they were placed in my arms.

## My Selah Moment

My two-day hospital stay concluded on Thanksgiving Day, and even that was such a confirmation of the abundance of blessings that had been given into our hands. Tim and Lydia were on their way to pick the babies and me up and bring us all home. I will never forget walking into the bathroom to get ready when I saw my face in the bathroom mirror. The minute I saw my own reflection I heard the Holy Spirit say, "Selah." I knew immediately that my days of treatment were over. In that instant, I was thrust into a poignant place of remembering and reflecting on all the Lord had brought to pass for me. It was such a holy place and such a place of clarity for me—right there in the hospital bathroom. It was almost as though I heard the shutting of a door, knowing for certain that I would never be pregnant again. It wasn't painful in the least; the moment was flooded with peace. I was overcome with the double-portion blessing we had received and the merciful way the Lord had redeemed so many barren places in my life. My seventh IVF would be my last IVF.

I considered back over the last fifteen years in my memory and saw a haze arising over the now deserted battleground where our infertility wars were raged. I remembered all of the things from my years in treatment, almost like a photo collage of images: the shots, blood draws, ultrasounds, follicles, surgeries, embryos, hospital runs, hospital stays, expenses, debt, words of encouragement, dreams, tears, loss, worship, depression, travel, addiction, pivotal relationships, high-risk

pregnancies, years spent waiting, and ultimately my surrender to the sovereign. I was not the same person who walked out onto that field fifteen years ago. Infertility had been transformed into a warrior. I was Hannah and my Lord remembered me, guided me, and enabled me every day and every step of the way. He brought me through to this moment, staring at my own reflection, without any sense of loss or pain to this holy place of closure. He brought me through to Selah.

I thought the war was over and now I was just going to be a mom to my three miracles. On that day, I still didn't have the eyes to see beyond me. The transformation of my identity and purpose had not yet been accomplished. I didn't know that there were multiple fronts to this war that was so much bigger than my infertility, my desire, or even my own lineage. The reality was that though the treatment days were over, my war with infertility would push me into new battles I couldn't yet see, for children I couldn't yet picture, for lands I hadn't yet discovered. Lydia, Michael, and Isabelle appeared to be my whole world. Who knew that they were only the beginning?

# III

# ADOPTION WARS

Ask of Me, and I will give You The nations for Your inheritance,
And the ends of the earth for Your possession"

—Psalm 2:8 (NKJV)

# 15 A New War

## The Echo and the Awakening

*I have not yet begun to fight!*
*—Captain John Paul Jones*

"A military institution's concept of war is a composite of its
interpretation of the past, its perception of present threats,
and its prediction of future hostilities. It encompasses tactics,
operational methods, strategy, and all other factors that
influence the preparation for, and conduct of, warfare.
During active hostilities, this vision must be focused on the
here-and-now, on recovering from the last battle and
preparing for the next one. Only after the guns fall silent, ***in
the echo of battle*** (emphasis added), can military
intellectuals refer to the lessons of centuries and contemplate
a variety of futures. They can anticipate the effects of
weapons still on the drawing board, of new tactical schemes,
of radical organizational reforms. They can speculate on
probable enemies and possible battlefields. They may debate
for years the relative merits of annihilation versus attrition,
offensive versus defensive, firepower versus maneuver. And
they can, in theory, develop and cultivate the methods that
will allow them to emerge victorious from the next conflict."[1]

## A NEW WAR

The first year of life with my twin babies, now officially known as Bubby and Sissy (as well as Frick 'n Frack, and so on and so forth as nicknames tend to go), was nothing short of a total blur. Apart from the photos and videos, I have very few actual memories from the year that was 2002. Although I am the type to celebrate and document everything for my babes, when they come in sets, some things—okay, many things—just have to give. Milestones blurred together as months of sleep deprivation took its toll, and suddenly friends appear on your doorstep in February to take your Christmas tree down because they are embarrassed for you that it is still up!

This was also the period in my life where I totally learned to redefine success. What long-term bed rest failed to unwind in my soul, being a mama to wee ones by the handful managed to finish the unraveling. Long gone was the professional airline project manager who wore suits and traveled around the world in first class. During the twins' first few months, a big win for me was taking a daily shower and completing a load of laundry. I remember the grandiose ideas of using cloth diapers on these babies. HA! To be totally honest, that pricey investment didn't even last a week! Soon enough I sent Tim to the store to pick up disposable as time (or sleep, let's be honest) became a commodity more valuable than gold! At two weeks postpartum I also almost gave up breastfeeding. Not because I didn't have enough milk or the babies didn't nurse, but primarily because I couldn't see my way through a few more days of the overwhelming fatigue of nursing every two hours around the clock! Thankfully, my support network helped me through the maze of those early infant days.

I ended up nursing my babies for a full year, which meant I was never farther away than maybe the grocery store. Tim traveled quite a bit that first year with ministry, which left me alone for several weeks at a time with three kids under five years of age. Although there were friends and family who supported us during his absences, I was basically homebound and a full-time caregiver to my children 24/7. I was tired, but I was equally blissfully happy. This was the first year, in basically my entire adult life, where I wasn't wishing to be pregnant or trying to have more children. I was full and completed and so tired (did I mention that already?)

Have you ever stood on a cliff or inside a concert hall and shouted into the void only to have your voice return to you? If so, then you are familiar with how an echo works. Webster's Dictionary explains an echo as a "sound reflected from an opposing surface and repeated to the ear of a listener."[2] Another source explains, "An echo is a repetition of sounds that is repeated after the original sound has ended."[3] Echoes consist of sound waves that bounce back off any obstructing surface, such as a wall or mountain and return to the listener with a delay after the direct sound. Depending on the nature of the acoustics at work, sometimes a single shout will reverberate and fill a space with repeating sounds.

My brother David is a pastor and he preached a message once where he used the phrase "eternal echoes." He explained eternal echoes are sounds that resonate and repeat throughout Scripture, such as worship, the presence of God, family, sacrifice, redemption and so on. Seems to me these "echoes" begin in Genesis, play out through the Old Testament, find resolution in the New Testament, and continue to be heard in our day. Our eternal God emits a sound into the world which continually returns and repeats. The command "Let there be light" is never-ending; it returns every single day. Psalm 29:3 (The Voice) declares, "The voice of the Eternal echoes over the great waters; God's magnificence roars like thunder." The echoes of God reverberate and fill eternity with repeating sounds, can you even imagine?

In her book *Sacred Echoes*, Margaret Feinberg explains that God "often uses the repetitive events and themes in daily life to get my attention and draw me closer to himself."[4] God does this, Feinberg says, because we don't usually hear him the first time.[5] I also wonder if all the noise of modern life is a contributor to us not hearing God the first time, or even possibly the tenth time.

When it comes to hearing God's voice, Bob Goff says, "The sad truth is, I'm often making too much racket to hear Him. He won't try to shout over all the noise in our lives to get our attention."[6] The thing is, we also have to stop talking to hear an echo. In the silence is where

echoes have their power to be heard. If we keep talking, we will miss the subtle and soft sound of the words returning to us. But, when we are not competing or drowning out the sounds with the busyness of life, the phenomenon and power of the echo finally has a chance to be heard.

Just to be sure, did you catch all of that?

Echoes are sounds that **return** and **repeat**—*later when we are silent.*

For me, later seemed to be about two years, as if a switch was flipped once again and suddenly, I was longing for more children. Although I can't explain it, I felt deep in my soul I was missing "others." The old desires of my heart resurrected and without my cognitive permission, took flight. Financially it made no sense for us, already a family of five with a stay-at-home mom on a ministry salary, for the love. But an echo returned and drummed repeatedly in my ears. The dreams of being pregnant started to reoccur again, regularly. My journals are filled with these vibrant dreams. This all started to happen in my life around the time when my twins turned two years old. These two toddlers who filled up my days and sucked all of my energy, also unintentionally brought me another measure of healing, and along with that healing came new hope.

Thinking I was done with IVF from my Selah moment after the twins' birth, and with adoption long ago removed from list of alternatives, I could only assume there would be another miracle—this time a natural conception? Could that even be possible? By this point Tim and I were now seventeen years into this infertility story, and I was in my midthirties. Wasn't a miracle baby conceived in our bed, not a lab, the rightful end to our story? That idea sure made sense to me! On one hand I knew this was totally impossible, but on the other hand, God had continued to show me he was in the business of performing the impossible.

So, we low-key started trying again to have another baby. Even as I type these words it seems utterly absurd that I thought it was possible. But I did. And we tried. Quietly, again, knowing that nobody would understand this unquenchable desire for more children. To be certain, the stinging pain of empty arms had been healed. This time trying to

get pregnant and failing didn't hurt as bad. I knew how to weather the journey by now, how to hold the dream looser, a little less desperate. It was different from the infertility I felt after Lydia and before the twins. I mean, there was still no volition in any of this journey for me. But let's also be honest here, any parent of littles knows some days parenting is intoxicatingly good and other days is an utter failure. The realness of being a mama and the extracting toll it takes helped to balance the all-consuming-ness of my earlier infertility. Also, a measure of my story was already completed, and that completeness helped me find balance in this new unfulfilled longing.

Yet, it's terribly embarrassing to read my journals from this period. To think we started trying again. Years later, even knowing the outcome of my story, I just can't understand my mindset. Was it a fault of my version of faith? Or was this faith? Why was I not satisfied? Where did this relentless pursuit of building a family stem from? Did denial for so long fuel this drive? Which sound kept returning to my ears, pulling me forward, drawing me to hope again? Was this a God echo? Or a Dawn echo?

These questions would take me several more years to wrestle through.

## Repairing the Foundations

We've arrived at the point of this story where it's important that I catch you up on matters concerning our farmhouse. In July of 2004, we finally received word that a lawsuit we had been involved in for over four years regarding the sale of our home and property was successfully resolved. The condensed version of this saga is that the previous owners had taken a lifetime payout on mine subsidence insurance on the property.[7] We stumbled across this fact after living in the house for a year and finding new cracks in our recently remodeled drywall. Turns out this payout occurred after we were the legal owners of the home! (Yeah, I know, unbelievable. Yet another unexpected battle for the Starks).

Obviously, there were some unscrupulous activities involving the seller, their agent, and others connected to the real estate transaction that transpired in order for this payout to even happen. Initially, we were hesitant to pursue a lawsuit in this matter. However, we learned our home would never be able to be sold or be insurable unless these repairs were made to the foundation. This type of repair involved lifting the home up through a hydraulic lift system and laying an entirely new foundation. As you might surmise, this is highly specialized work and the price tag was enormous. We sought counsel from many experts about how to proceed, but in the end, all roads pointed to a lawsuit due to real estate fraud.

Waiting years for this case to settle was arduous, knowing we were essentially stuck in place until the wheels of justice did their thing. Like our infertility, we were in over our head and out of our league to resolve the matter at hand. Homeownership—at this juncture of our lives was just one more place where we had no voice, no volition, and seemingly zero ability to make our own worlds together. Our Commander-in-Chief had something to say about where we lived and what we did with this property. Why it mattered, I had no clue. When He would rescue, I had no idea. Yet again with the waiting... the endless waiting that had become the hallmark of my adult life. You'd think by now I would understand this concept.

Years went by without an update about our case, literal years. Not that we didn't check in with our attorney, but there was never anything of significance for her to report. Tim was busy in ministry; I was busy with babies; we were busy trying to make more babies. Making plans for the future was the purview of others it seemed, not for us. We waited, we prayed, we worshipped, and we waited more—and repeat. The purposes of eternity took its time intersecting with earthy matters regarding the affairs of Stark Acres.

Then suddenly we received a call and learned depositions for the case were scheduled. After four years, it was finally time for the truth to be exposed. Funny thing about truth, once it finally comes out, justice is usually swiftly delivered. Not long after the depositions occurred, we settled out of court with all parties in the lawsuit. Too

many corners cut, too many biases toward the seller, and too many abnormalities within the execution of the transaction set up an ugly scenario of liability for most of the parties involved with our real estate transaction. Once the first domino in the case fell, so to speak, the rest quickly followed suit. The money—our money—was recovered, minus legal fees of course, and reassigned to the legal owners of the property four years later.

Now it became our legal and moral obligation to repair the foundation. And let me tell you, repairing foundations is a long, messy, and expensive proposition. As with so many aspects of our story, God continued to use visual pictures to inform us of his purpose in our lives. Always a living Magna Doodle, this time the restoration of our home was the picture being drawn before us. We hired a family-owned company who had been restoring foundations for three generations to pick up our 150-year-old farmhouse and put it on a new foundation on another parcel of our land. In our thinking, we could then sell that older house once repairs were completed, then build a new house under the old walnut trees where the old house had formerly stood. I mean, if you have to pick up a house and put a new foundation, why not move it across the yard?

We packed up and moved into my parents' fully finished basement across town for what we anticipated to be a two-to-three-month process. We decided to leave most of our furniture and belongings in our home and only took necessities for the next few months. This was more stressful on the kids than me, because every single toy and stuffed animal was considered a "necessity." However, on the exact same day we moved into the basement, we received word our building permit to move the house on our own property was denied. Turns out the parcel we wanted to move our home to, *the parcel miles out in the country connected to where our home currently sat*, was zoned for manufacturing. What in the actual heck? I mean, how is that even possible? Our land was an alfalfa field! The county commissioner told Tim any rezoning of our land would take a minimum of three months. Have I mentioned we had already moved out and the bulldozers were sitting in our driveway ready to begin the work of lifting the house?

DENIED. That should've been the big 'ole fat sign for all that was to follow. But, as usual, God had a different direction than mine. With tears spilling down my face as if a dam had just opened, we sat around the table with my parents trying to sort through this brand-new data. Why is this always my lot? We could either continue waiting and hope the county would eventually approve the zoning change, or we could simply repair the foundation of our farmhouse and reset the house in the exact same spot. What do you think we chose? Yeah, more bittersweet. We finally settled the lawsuit, but instead of building the home I wanted, I was left with the disappointment of staying in this old home for the foreseeable future. What I wanted was the perfect new house, not the older, restored house. What I wanted was a say in the matter, not hear another "no" to my desires. What I wanted was to use my volition and get the house we wanted just like everyone else seemed to be able to do in this life, not be bound to a home and property against my will indefinitely.

Can you hear that echo from my twelve-year-old self?

The words (wants) changed over the years, but the tone was still the same: *No thank you God, I want to be a cheerleader...*

What God wanted was someone to rebuild the waste places and restore the ancient foundations (cue the book of Nehemiah). To him and for our future purposes, learning restoration was more important than building new. Though this might seem like a rabbit trail story to you, this entire event about the house and exactly where it was located on the property plays a significant role in future events that would be critical to enlarging our family. It's also significant because despite all I had learned and how far I had come in my walk with the Lord, I was clearly not yet where I needed to be. Though Tim and I couldn't understand at this time, we were called to restore some ancient foundations. Yet again we were asked to embrace new eyes, a new heart, and a new walk—but I didn't see it... *at first*. When our home was re-lowered upon its brand-new foundation exactly on our nineteenth wedding anniversary, we were starting to realize this was the start of something new entirely.

We expected our remodel to last a maximum of three months. Turns out it would be fifteen months and seven days before we moved back into Stark Acres in the fall of 2005. At last our foundations were restored, thanks to the faithful support of our parents. Although Tim's mom passed away the fall prior to our remodel, Tim had the amazing opportunity to work side-by-side with his dad throughout the entire project. All credit for the completion of our home belongs to Louis Stark, whose engineering background and cautious attention to detail pulled us through many difficult days (okay, months) with this complete bottom-to-top restoration. And my parents housed our family rent free for what turned out to be quite possibly the longest three months ever. When our house was finally complete, we had added on a finished basement, another porch, a fourth upstairs bedroom, and a (small) master bath, not to mention new plumbing, heating/cooling, electrical, and new cabinets. Our home was secure, expanded, and beautifully "farmhouse chic" a decade before that was a thing.

Now, at last, it was time to deal with that unrelenting echo.

## Reenlist or Separate: Responding to the Echo of War

Regardless how you enter the military, there comes a time when every conscripted, voluntarily enlisted, or officer must make a decision about their future in the armed services. There is no set norm here, as length of service throughout the history of the military is dependent on many factors. However, even in the worst of times when drafts were enacted, after serving mandatory time in active duty and very likely even time in the reserves, *eventually* everyone gets the choice to decide whether or not they will continue or separate from military life.

When it comes to the decision of reenlisting, moving to reserves, or transitioning out of military entirely, there are many things to consider. After surveying those who've served, I learned that the benefit packages, lifestyle and community, opportunities to see the world, and a steady income go hand-in-hand with loyalty, duty, honor, and love of country. Some remain in the service because it's part of

their family lineage; many speak of a sense of a calling to this life; and yet others want a chance to experience active duty. One person mentioned to me he stayed in the service to be part of something bigger than himself. Sometimes there are signing bonuses that are too handsome to walk away from. It's part financial, but it's also part communal. There is an ethos in military life, and if that ethos speaks and nourishes your soul, you stay. If it does not, you leave and return to civilian life.

For those who've faced active duty or warfare, there are different reasons to remain in or transition out of the service. For some, the immense sacrifices do not outweigh the benefits. Sometimes, the battles soldiers face and the horrors of war they experience make the decision for them. For these soldiers, the echoes of war are too loud, too vivid, too terrible. Kenneth W. Bagby, 1st Battalion, 7th Calvary of the United States Army found this in the Vietnam War. In a 1965 letter to his parents, he wrote:

> The many men that died, I will never forget. The odor of blood and decayed bodies, I will never forget. I am all right. I will never be the same though, never, never, never. If I have to go into battle again, and I am not killed, I will not come out insane. I cannot see and go through it again. I know I can't. The friends I lost and the many bodies I carried back to the helicopters to be lifted out, I will never forget.[8]

Major Patrick Angier, 1st Battalion, Royal Gloucestershire Regiment in the British Army fought in the Korean War. In a 1950 personal journal entry he wrote:

> I am becoming more and more determined to break free from military life on my return. The more I see of the state of other regular soldiers, some ten years senior, and with very adequate careers, the more I am not impressed that the gamble of soldiering on is worth the sacrifice demanded.[9]

Other times, the chance to fight again, the community and relationships fostered, the job security, and the retirement offered

191

through military life are appealing enough to make the sacrifices and loss of personal volition worthwhile. There is also the sense of duty and honor that defines the military experience for those who choose to remain and make military life a career choice. Many who've served say they are a better person for the experience which comes from proving yourself capable in difficult circumstances. For example, Jack Vohr who served in two wars: WWII and Korea. Vohr, by the way, happened to be a Marine who also served in the Army and the Navy! When asked about his experiences, he wrote:

> Combat showed me a lot about myself, gave me a
> tremendous amount of confidence, and made me more of a
> man.[10]

## A Picture Is Worth a Thousand Words

Remember a few pages back when I told you the story about picking up our home with hydraulic lifts so that a new foundation could be poured? What I didn't explain in detail was all this process entails. While I'll keep this high level and likely a huge oversimplification of the complicated engineering involved, it's important to understand at least some of the process to comprehend how this renovation also was a picture for the future enlargement of our family.

To begin with, a home being lifted or moved must be disconnected from everything that previously supported or was attached to the structure, including infrastructure such as the electrical, plumbing, HVAC ductwork, porches, fences, or landscaping. Next the dirt around the old foundation is excavated and gradually replaced with wood pilings that support the home until new steel beams are placed. The steel facilitates the lifting process. Also, anything left in the house must be secured, such as furniture or wall hangings. Once all of these items are completed, the hydraulic jacks can commence with lifting the home. However, this must be done in increments, slowly as to not crack walls or compromise the home's structure. Think of it more as a bit-by-bit process, versus a "pick 'er up and get it done" type project.

And seriously, that was the easy part of the entire job. Making sure the new foundation lined up exactly and was level so that it could be placed back down on a 150-year-old pre–Civil war home that had gone through two previous room additions was the mammoth process that took months. Kudos to my husband and genius father-in-law who worked tirelessly to "line up the old and the new" so that the structure was stable and secure. The easy part was pouring the new footings, basement walls and basement floors. So many, many times throughout this long process we'd look at each other and comment on how much easier it is to build new.

We only intended to repair the foundations. But my Jehovah Tricky was actually the foreman on our job site, and he was working from blueprints we didn't have access to yet. At two separate times in the fifteen months process, the work came to a screeching halt, and I'm talking about a "nobody returning our calls or showing up to complete what they started" kind of halt. One delay happened over the addition of an upstairs bedroom over the old attic, and the other had to do with adding on a master bathroom. Both times, once we started to expand the house, the work we were waiting on magically resumed as well. It was almost as though the Lord was saying, "Expand here and I'll let you finish up over there." It was the craziest thing to me that size and scope of our home mattered a hill of beans. But it did. For reasons I will never understand this side of eternity, that home on that Illinois farmland mattered greatly to the Lord. Each time we yielded to his plans for that house, our plans moved forward.

## A New War Appears on The Horizon

For a few years now we had tried the old-fashioned way to have another baby, but we did not—nor would we ever—have a miracle conception. Now at thirty-eight years of age, I knew intuitively all of my biological opportunities were coming to their natural end anyway. Lydia was now an unbelievable eight years old and the twins were four years old. Life was moving forward too quickly now, and babies were growing up on this mama who wasn't finished with babies yet. IVF,

pregnancy, and childbirth were starting to fade in the rearview mirror of life. So here at the crossroads of an eternal echo, biological realties, and a new foundation, where was I to go?

Although I cannot tell you the exact moment it happened, something began to shift in my heart toward the end of our remodeling project. I was seeking; God was leading. There was a real miracle happening inside me, after all of these years, but it was not a child growing in my womb. My heart was enlarging and my vision expanding, but not because of anything that I was doing differently. My patient Commander was preparing me for the next battle and leading me gently toward reenlistment for an entirely different war. This time, I was being called up to fight for adoption.

For reasons I cannot explain or understand, I began researching adoption online in December of 2005. I knew everything about infertility, and I knew what I didn't like about adoption based on my dad's personal experience, but I actually knew nothing about the adoption process. It was like dipping my toe into some water, only to look up and discover that body of water was as wide as an ocean. There was domestic—both public and private adoption, foster care, international adoption and hold up now… what is this? Embryo adoptions?

From the minute I learned about Nightlight Adoption Agency's Snowflake Program, the adoption of frozen embryos, I was hooked. Now this, I knew about! This was my wheelhouse! It seemed to be just the answer we were looking for. I was also confident, what with all my newly acquired knowledge on adoption by surfing the web, that by birthing my own adoptive child I was overcoming some of the difficulties my dad went through with adoption. After all, I would be this baby's birth mom. Plus, I could have the entire pregnancy and birth experience all over again, minus the painful stimulation process. Hand me the phone; there was simply nothing more to think about. I called the adoption agency and requested an info packet.

We wasted no time at all filling out the application once the packet arrived in the mail. While we waited to find out if we were approved, I called our reproductive endocrinologist to see if they were familiar

with this program and what type of fees would be involved for an embryo transfer cycle. I was absolutely stunned to learn that the cost would be nearly the same as an entire IVF cycle. Although there wouldn't be an actual stimulation and retrieval, there were still the drug therapies to prepare me for a timed conception, as well as the fees associated with thawing the embryos and the transfer itself. I thought this was our plan—it felt so …. *redemptive*. Yet why would I spend the same amount for a cycle to use someone else's thawed embryos? If we are looking at paying for a full ART procedure, then why wouldn't we try again to make our own baby?

So quickly I reasoned away my Selah moment that occurred after the twins were born, as if God hadn't already closed my womb. But I'm confident he allowed me to traverse this train of thought because it was shifting me, realigning me, opening my heart one crack at a time, and positioning me to see the actual plan. This was just like the adjustments needed when our home was raised and lowered onto a new foundation. My kids had adjustments they needed to make, especially Lydia. When I introduced the idea of adoption to my firstborn, she was adamantly opposed to the idea. "That's weird mommy. I only want another baby from your tummy," she said.

Completely confused and unsure of what was next, I notified the Snowflake program what we had found out about the procedure fees and told them to ignore our application. As I took one last look through the material the agency mailed to our home, I found a DVD from Christian singer/songwriter Steven Curtis Chapman. The video was the story of the Chapman family's journey to international adoption, where they eventually adopted three baby girls from China and how this process turned their family and future in an entirely new direction. Suddenly, miraculously, the scales fell from my eyes. Like a conception, the seed for adoption was firmly planted inside my heart right then and there. I was wrecked. I called Tim upstairs and we watched the video together. Now he was wrecked, too.

I called my sister, Deedra, sobbing from my bed that night and said, "I have a DVD you have to watch right away. I think we are going to adopt a baby girl from China and I feel like you are supposed to adopt

with us." Now she was wrecked. Adoption had always been on my sister's heart, ever since she was a little girl and long before my infertility. This was a journey we were to take together. I didn't know it yet, but I was on a destiny timeline and the clock was ticking.

## Remembering an Old Foundation: Grandma Amsden

I have mentioned my dad's adoptive mother a few times already in this book, but I think it's important now to return to Grandma Amsden's story. Truthfully, I know very little about her early years. She grew up in the little town of Cape Girardeau, MO but somehow made her way to St. Louis where she met and married a man named Ervin, my grandpa. Ervin was a bus mechanic and a volunteer firefighter; Edna was an RN who worked in a city hospital. I know they were unable to have children, and this was the great heartbreak of her life. They would've likely been married in the 1930s, which means they probably came of age during the Great Depression.

My grandma was beautiful when she was younger, but I don't recall ever seeing a photo of my grandpa as a young man. Although they were married over fifty years, I don't particularly think they were happily married; at least I didn't observe love between them like I did my maternal grandparents. I remember that my grandma was very social, she enjoyed organizing events at her church; she loved to travel (Hawaii was her favorite) and was constantly planning her next trip; she always had a poodle, or two, who were always pampered with ribbons and painted nails; she had a green thumb and loved flowers, trees, and gardening; and Edna was the triple threat in the handicrafts department, as she was quite skilled in quilting, knitting, and crocheting! I also recall her quirky habit of bringing her own containers of water from her home in St. Louis when she crossed the Mississippi River to visit us in Illinois, as if she were traveling to a third world country. Grandma Edna was not a fan of my driving, and I was not a fan of sharing a bed with her every Christmas Eve. She spent many years living as a widow, and her final days were confined to a nursing home. Grandma Edna passed away not long after my twins were born.

In any event, most of what I know of my grandma's character and mothering skills comes through my dad's eyes. Edna was never enough for my dad; from his perspective, she never did enough, never loved him enough, was never kind enough, and was never truthful enough. Throughout the years, I've known my dad to call her "Edna" as often as I heard him refer to her as "Mom." The authoritarian parenting style of that era probably didn't help the adoptive relationship. Ervin and Edna were very hard disciplinarians on my dad. He remembers at the age of eighteen when it was time to leave the house, Edna handed him an invoice. In hindsight, it's clear to me now that a major problem in this relationship was that the culture of adoption during this time was not open, transparent, truthful, or trauma informed.

Finding out he was adopted at the tender age of nine from a neighbor kid was devastating to his self-image and likely to any relationship my dad did have with his adoptive parents. It pains my heart to think that the deepest, most important secret about a child was used against him when it came to picking teams for a neighborhood game. His world was forever changed the night when a peer dropped the bomb on the landscape of his young identity. "You're adopted Dennis; nobody wants you; go home." Not knowing what the words even meant, my dad ran to his mom and asked, "What does adoption mean?"

It was from this painful event my dad learned that neither he nor his brother were actually who they grew up believing they were. Grandma Edna told my dad that his mother placed him for adoption, but they loved him so much they took him in as their own son. Without a doubt, this was a defining moment in the souls of the two young Amsden boys. One son, my dad with five kids, ended up a preacher. The other son twice divorced (that I know of), a drug dealer and thief, ended up in jail. In all fairness to my grandma, from that moment forward all my dad ever really wanted was his birth mother. I grew up knowing this truth about his longings, so I'm sure Edna had to know it, too.

But there is more to this story than just my dad's adoption and life experience, and that's where I want to turn this focus. My grandma

was actually a trailblazer in foster care. Long before orphan care was a formalized movement or foster care became mainstream, my grandma—longing for a family of her own—fostered fifteen children, including likely my dad and his brother. What caused a woman in the 1940s to foster? Was it the same drive that fuels my passion—her granddaughter not connected by genetics? Was this an echo inside her, too? Oh, how I wish I would've known to ask her these very important questions about her story before it was too late. In the crushing pain of living my story, I didn't take the time to learn hers.

I've never lost a baby through miscarriage or stillbirth, but I've lost the promise of many embryos and experienced the death of many dreams. I know the blinding panic I feel when my children are hurt, like when Michael broke an elbow, or Isabelle had febrile seizures, or Lydia suffered from night terrors. For goodness' sake, I broke out in a cold sweat just watching my babes get their immunizations. Although it's the subject for another book one day, long-term infertility affected my parenting in that it made me overprotective and child centric. I'm confident this was the case with my grandma, too. She watched many, many children she likely hoped to make her own come and go through her front door. My dad clearly remembers the day the girl he loved so much that they called "Sissy" with blond, curly hair was packed up by "grandparents" and taken away. Who exactly were these grandparents, and when would they bring Sissy back, were questions my dad, who was only five years old, would only be able to answer in time.

Maybe, just maybe, Grandma Edna's ongoing trauma and cumulative losses caused her to engage in an overpowering protection that made my dad—who was suffering from his own primal wound[11]—misread her intentions, resulting in a disconnect versus a healing connection. She finally got her own beautiful baby boy after so many foster babies came through her home; how could she ever be anything less than suffocating? Maybe she hid the truth of his story to protect her own. In an era when adoptions were shrouded in secrecy and anonymity, maybe she could never reach him because the tools society offered to adoptive parents were all wrong.

Clearly adoption is complicated and painful. It is, after all, an experience built wholly out of loss. But adoption is also incredibly beautiful because it is incredibly redemptive. I was beginning to see there was more to the adoption experience than the one picture I'd viewed for my entire life. God is in the business of restoring from the bottom up, as I learned in a very hands-on way through the object lesson of our home renovation. It was now time for the Amsden family to be healed of adoption, by adoption. The next war I was entering was going to involve redemption for my dad too. It was time for a new narrative and a new hope.

## An Ally for the Next War: My Sister

One huge blessing of infertility that I could only see in hindsight was that the decade-long delay in becoming a mom afforded me the opportunity to be a parent at the same time as my sister, Deedra. This was the most beautiful gift, as we were able to develop a bond of friendship that only strengthened the bond of sisters. Now, with six children between us, we stepped into international adoption (IA) together. After watching the Steven Curtis Chapman video, my sister and her husband, Paul, said yes to enlarging their family through IA without blinking. Before the next war even started, God gave me an ally.

I started reading everything I could get my hands on related to adoption and IA in particular. My heart was being broken and being expanded in a steady rhythm those days. Here is my journal entry from April 14, 2006:

> *My heart is beginning to ache for the daughter I want to adopt from China. I think of her often and can even picture her in my mind. I wonder if this is the process of birthing her in my heart instead of growing her in my womb? I've been reading a new book,* The Waiting Child, *and I can't stop crying. We are all going to an adoption seminar in St. Louis on Saturday. I can't imagine how we will pay for it, either. It's like my IVF I waited for on the twins, and then one day we had*

*insurance. I've picked up a redemptive burden and don't know what to do with it. God, please speak to me. I need to have you in this place with me. Show me where to stand and how to war until I hold this new life in my arms.*

After researching a few agencies, we decided to look further into Children's Hope International, a St. Louis-based, Christian adoption agency. We attended an information session to learn more about the process and their programs. We learned two significant things about the China program: 1) according to the Chinese requirements, families with three biological children could only adopt special-needs infants, and 2) there was a minimum family income level to adopt from China. Unfortunately, neither of our families met either qualification as we both already had three biological children and were both at that time single-income families. The other important thing we learned was that Vietnam recently reopened their adoption program and infant boys were available with referral times of under three months. Suddenly we found ourselves shifting from adopting Chinese daughters to adopting Vietnamese sons. Clarity was coming to this vision almost daily now; it was time to start praying for my son.

We also didn't know how we were going to pay for IA, which I should tell you was *at minimum* twice the cost of IVF. While both of our families had big hearts, neither of us had deep pockets. But, funny enough, we did happen to have a two-acre plot of land zoned for manufacturing that we could sell. You don't always get the benefit of understanding why God says "no" to some things and "yes" to others, but in this case, we had a crystal-clear insight on why we were unable to move our house over this two-acre lot a few years earlier. This piece of property had a more important purpose than to be the address where the Stark family lived; this land was going to be used to facilitate the adoption of two children—one for the Starks and one for the Magers. Selling the land would not fund both adoptions completely, but it would get us both a good way forward in the process. All four of us had a profound sense this process was a God initiative we were stepping into; there were so many holy moments we both experienced in that last month that doubt was simply swallowed up. Excitement

and anticipation—yes. Doubt—no. We all found our peace, knowing confidently that God was in the business of redeeming lives and caring for orphans, so he would see to it we had everything needed to complete the assignment.

A few days later, my brother David and sister-in-law Kami bought the land for our full asking price of $40,000. We had given them land a few years before to build their starter home, and they lived right behind us. They weren't clear how they would use two more acres, whether they would build again or sell to someone else, but they had a heart to help their sisters and support the adoptions. For them, it was a quick and simple yes. For us, it was the easiest possible real estate transaction, as my brother already owned the adjoining plot and there would be no complications for the sale. In a little over one month, a life-changing plan affecting the lives of many was given a green light. It was GO time.

The call for missions—the call to GO—that I ran away from as a teenager was understood in a new light. The eternal echo I'd heard for years was finally beginning to make sense! Being commissioned to the nations was never the way I envisioned it to be, of me serving a people group on foreign soil indefinitely. I was impregnated with an all-consuming vision by this point, aware my son was already growing in the womb of another woman I would likely never meet in this life. All I could do was pray and do paperwork, loads, and loads and loads of paperwork. On May 1, 2006, my sister and I, along with our husbands, mailed in our application with a $100 fee designating the Vietnam program for our adoptions. We were approved three short days later.

*May 13, 2006*

*Dear Son,*

*God has planted the dream of you in my heart already, and I find I carry you everywhere. You are not in my womb, but you are as deep in my heart and soul as Lydia, Michael, and Isabelle as they grew in the secret place. It is a comfort to me to know our God watches over and sees you in your secret place, too.*

*You are loved before you are known.*

# CALLED TO WAR

*Mama*

Deedra and I spent the summer of 2006 completing our home studies and applying for permission to adopt orphans from the US Citizenship and Immigration Services (USCIS). Although different in nature, the adoption process is every bit as overwhelming and invasive as infertility ART treatments. Prospective adoptive parents have to open up every single bit of their lives and homes to inspection from a long list of parties who all get to deem you worthy of a child placement. The list of those who get to weigh in on your parenting fitness includes local, state, and federal law enforcement, medical professionals, banking and financial reviews, mental health professionals, social workers, employer evaluations, personal references, not to mention evaluation by foreign government and the State Department. Heck, even your home is subject to scrutiny and inspection. I lost count of the number of times we were fingerprinted and interviewed that summer!

As these things go, there were unavoidable and frustrating delays. At some point, our journey naturally separated a bit from my sister's process. In late September we received word from the agency that our home study was approved and had been forwarded on to USCIS. At this junction, we also learned some very discouraging news that approvals of orphan visas—the coveted 171H approval—were now taking up to nine weeks. In order to be put on the waiting list for a referral, CHI required adoptive parents to have their 171H in hand. This meant that we were likely looking at the end of 2006 before we officially started the wait. But the most devastating news we learned was that in the months we had been completing our home study, the waiting list for Vietnam was now approximately fifteen months long!

We were suddenly looking at three years to bring home a son from Vietnam, and I just had my thirty-ninth birthday. All along, years and years ago, I set the age of forty as a maximum deadline for "having babies." For the sake of my three kids and the son we wanted to adopt, three years away to start all over again with babies was just too far away. In my estimation, we were simply too late for Vietnam. But what did

that mean now that we were "paper pregnant?" How can you be "too late" for a destiny connection? Tim and I started praying for wisdom and direction, again. What were we going to do? Where in the world was our son?

We didn't have to wait long to find out. On October 16, 2006, our adoption took an unexpected turn. I found a waiting child on a website called Rainbow Kids. I was surprised to see waiting infants in Guatemala while we were waiting fifteen months for a referral from Southeast Asia. I didn't know much about IA yet, but I did know switching to another country was complicated. First, our orphan petition and home study were both country specific for Vietnam. Second, and most importantly, there was the matter of my sister. We started this journey together—initially for daughters from China, then for sons from Vietnam. How could I tell her our journey was shifting again, this time to Guatemala?

# 16 Overseas Duty Station

## The Finding and the Waiting

*I am a soldier, I fight where I am told, and I win where I fight.*
—*General George S. Patton*

Everyone in the military understands that getting new orders involving a permanent change of station (PCS) is part of the gig. For many, getting a chance to "see the world" is one of the main advantages of signing up to serve in the first place. A soldier's first duty station right out of boot camp, where you live and the capacity in which you serve, are largely issues that are decided for you. Future assignments usually consider your preferences, although where the military needs you the most, is always the prevailing consideration. There normally comes a time for everyone who is career military to accept an overseas duty station. Depending on the location and the length of time involved, active-duty personnel can often bring their families along for international assignments. For overseas moves, this is known as OCONUS (outside continental United States). Overseas duty station assignments are not to be confused with deployments, which are the movement of troops for military action. However, it is not unheard of for a solider to be deployed away from his family that is OCONUS.

Moving in general is always challenging, but OCONUS moves are especially intimidating. First off, there is the issue of orders. Accuracy in orders matter![1] All the details about location and scope of the transfer must be spelled out correctly. For example, in order to take your family along, everyone in the family must be spelled out on the

orders. How much you can take depends on your rank and number of dependents.[2] Understanding what is covered in the move and what is not (such as your vehicle and pets) needs to understood so that you can adequately prepare and ensure nothing important to your family is left behind.

Planning and preparing and studying about what's coming with an OCONUS is good and necessary. But beware. You might think you know how orders are going to come down, but until they are official and, in your hand, you never really know for sure. Many military families have endured the old last-minute switch in orders when all of their best-laid plans get turned upside down and inside out.

## Our Overseas Duty Station Orders

There is a widely quoted Chinese proverb in adoption circles that says, "An invisible red thread connects those who are destined to meet, regardless of the time, place or circumstance. The thread may stretch or tangle, but it will never break."[3] After a nine-month journey that started with the idea of embryo adoption, which led our hearts to China, then Vietnam, finally ended in early October 2006 when I found a waiting baby boy in Guatemala. Our red thread led us around the world to a baby boy named Dennis who was only a few weeks old. Here was the real clencher to this whole thing: Dennis just happened to be my dad's name! How could it be that a baby boy born in a Latino culture who was up for adoption shared the same name as my dad who was also adopted?

Immediately, we started researching adoptions from Guatemala. After considering Asian programs that involved several weeks of travel away from our three children, it was very appealing to find a program in our hemisphere that only required a few days of travel when the adoption was complete. Another huge blessing for us was that the Guatemalan children were primarily living in foster homes instead of institutions, which contributed to an overall healthier environment for our waiting child. I was reading and learning about IA vivaciously by this point, so I understood how important early child welfare and

bonding was to the long-term development of our child. Being with a foster mama vs. nannies that rotated on a shift was definitely my preference. Additionally, I learned we would be able to visit our child during the adoption process. In fact, I discovered that some adoptive parents (AP) chose to move to Guatemala and foster their own child! I was discovering a significant AP support community in the US and Guatemala, which I immediately began to connect with and learn from the collective wisdom of those further ahead of me in this process. Notwithstanding that I found a waiting child in Guatemala, these reasons were all significant enough for me to consider switching countries.

However, there were serious concerns about adopting from Guatemala. Many adoption professionals and agencies felt the country may be close to shutting down its IA program because of abuses in the system. Charges of child trafficking and reports of birth mothers being coerced to relinquish their children were rising within Guatemala. The country's government was beginning to investigate these irregularities and concerns with their IA program. In fact, our agency, Children's Hope International, had already suspended their adoption program with Guatemala due to these concerns. While adoptions were still being completed on a regular basis, the timelines were being extended as uncertainty of the future crept into the process. Additionally, adoptions in Guatemala were primarily conducted privately. This meant the cost to adopt from Guatemala, versus China where adoptions are facilitated through a central authority system (the government), was much more expensive.

There were also a few matters on the US side of the process that needed to be considered and sorted through. For instance, we would need to navigate this path with our agency. Although we were never officially put on the waiting list or committed funds for Vietnam, we still had to update our home study to reflect the country change. We also needed their help to figure out the steps required to change our orphan visa petition to Guatemala. The next big piece was finding another adoption agency currently taking applications for their Guatemalan adoption program. Then there was my sister and our plans to adopt together. All were daunting matters that required a lot of

research, prayer, and consideration. And yet, there was this precious baby boy…

## A Baby Boy Named Dennis

Dennis was born on September 25, 2006, nine months after we actively, for some unknown reason, suddenly started pursuing adoption. Call me crazy, but I believe that God planted a new seed in my heart the night my son was conceived. The fact that this baby carried my dad's name—the name of the man for whom I avoided adoption for so many years, and yet the same reason pursued it—was too big of a sign for me to ignore. So, Tim and I leaned into Guatemala and one by one watched all the barriers melt away before us in a matter of days. Did you catch that? DAYS. For close to two decades now, very little, if anything, in our infertility war moved quickly. No, agonizingly slow would be a better description of our normal speed in these matters. But, right now, everything moved quickly, which helped confirm to us that Dennis was very likely to be our son. The home study was updated easily and quickly; documentation was sent to USCIS to change our orphan petition from Vietnam to Guatemala without incurring additional cost or delay; we found an agency that was still matching families in Guatemala; and we got the blessing from my sister to go get our boy, which went something like this: "GO!"

On October 16, 2006, we wired $17,000, which was the first half of our country fee, to our new agency and officially took referral of Dennis Leonel, a baby of Mayan descent, who resided in Guatemala City with his foster mama named Karen. We learned his birth mother was a teenager who left her village and came to the city when she learned she was pregnant. I was told that she ate an apple everyday of her pregnancy to give her baby proper nutrition. Dennis went home with Mama Karen the night he was born. His foster mama had three children of her own and agreed to care for baby Dennis. Dennis would be growing up in a home where he was the youngest of three siblings, exactly like the home he would be transplanted into when his adoption was complete. Of course, my heart was fractured in half thinking about

how he went into Mama Karen's arms after his birth, instead of those of his biological mother. I wanted to know a hundred details of the events of that night, details he would one day want to know, details neither of us might ever know this side of eternity.

In an unbelievable act of grace, our new agency was going to let us visit Dennis prior to receiving our 171H approval from USCIS. Tim and I got approval to travel to Guatemala just a few weeks later, meaning I would have my new son in my arms when he was only six weeks old. But there was no time to sit around and revel in the unfolding mystery; there was too much work to be done! I had less than two weeks to compile our dossier so that I could carry it into Guatemala with me on November 2. Not only did I have to quickly compile, translate, and authenticate every piece of documentation for our adoption, but I also had to take along everything I would need to care for a newborn during the four days we would share together at the hotel, not to mention preparing our children for their first real separation from Mommy. I was living outside of all of my controls, with my stomach in knots, and panic gnawing in my heart. Turns out, birthing is never easy—whether that baby is born from your womb or your heart.

On November 2, 2006, Tim and I left our three miracle babies in Illinois and headed toward everything unknown in Guatemala. In this moment, we were pilgrims on an unknown road. It was the very first time we'd ever left home at the same time since our children were born. It was also the first time I had been out of the country since becoming a mother. Lydia was now nine years old and the twins were days away from their fifth birthday. While everyone was excited about their new brother, having Mommy and Daddy both gone at the same time made everything about this first trip away a little more difficult. Lydia cried for hours the night before we left; Michael, ever my articulate one, said "What, are we your old babies or something?" and Isabelle wouldn't let me put her down for days. But as all mamas do, when it's time to give birth, you trust someone else with your children and switch your focus to the important job ahead. For us, this meant a journey to Central America to the country of Guatemala.

The first thing you notice when descending into Guatemala is the volcanoes, followed by the lush green landscape. The vistas are dramatic, but that is not why I was crying as the plane landed. I was overcome by the thought that out of the whole wide world, my son was here in this land. What miracle happened in my heart to bring me here, and why did it take so long for me to get new eyes? I prayed for the country, for my son's mama, for the adoption process, for my new son, for my children back home, and for all of the impossibilities that had been made possible only through God.

We made our way to the hotel, which was to be our hospital birthing room for baby number four. Our instructions were to wait in our room until our adoption facilitator called to let us know that our foster mom and our son had arrived. We checked in, got settled, and like every hospital visit requires, waited impatiently for news. While the ticking clock moved forward slowly, Tim and I nested in our room, set up a baby changing station, unpacked Dennis's tiny clothes, and prepared for the next few days getting to know our son. Eventually, the phone rang. It only needed to ring once before that receiver was in my hand. Dennis was here. We were invited to come down and meet our little man.

In my mind this moment plays out in slow motion. We ran to the lobby where two ladies were standing near the couches, and in the arms of one of the women was a swaddled babe. With urgency, and yet timidity, unsure of how this was supposed to work, we greeted the women while our eyes remained fixed on a tiny head with the largest puff of dark black hair you've ever seen. Tears quietly flowed down my cheek while my arms extended out in sweet anticipation of holding my newest bundle of joy.

Then a miracle happened. Immediately upon being laid in my arm, Dennis started to coo. In that moment, our red thread connection was complete! Heaven's purposes intersected with earth and the response was simply worship. We had found each other by God's grace, and this six-week-old infant knew it, too. I spoke love to him, in English mind you, and he responded back to me, with eyes and heart wide open. It was simply one of the most intense encounters of my life. Any single

doubt I ever had about being a mother to a child I did not birth melted away inside this holy moment.

Tim and I spent the next four days bonding with our son. Seasoned parents by now, we fell right back into the rhythm of baby care together. Our little family of three did very little outside of our hotel room on this first trip. Primarily because it was not wise to be sightseeing with a baby was who not fully ours yet, especially in a country where international adoptions were beginning to be closely scrutinized, and also because our sole purpose for this trip was building a family connection. We bathed him (did he ever hate that!), took turns feeding him, dressed him in tiny baby boy clothes, and snuggled him day and night. I brought along a play list of Spanish worship music, which we left on repeat in the hotel room. We took pictures and videos and did everything we could to fill his tiny little soul with love and words of affirmation in these limited moments we'd been given.

Soon enough, all too soon, it was time to place this precious little boy back into the care of his foster mama, Karen. I tried so hard to keep grief out of our goodbye. But that proved to be harder than I imagined. Although Karen spoke no English, our eyes and hugs spoke volumes. I left her with new clothes, diapers, toys, formula, and a small scrapbook filled with photos of our family and descriptions translated into Spanish. Through a communication filled only with hand signals, I showed her the book and asked her to please read it to Dennis for me. Nodding her understanding, also with tears in her eyes, she covered up my son's face and departed with my baby and his belongings tucked under her arm.

Now my grief came in torrents. Still covered in the scent of my infant son, we made our way to the airport. My arms, empty again, were aching. Tim was silent and also in great pain. We'd only been given a small deposit on a large inheritance not yet ours. I just wanted to get home to my children and hold them until the tears stopped flowing. But this grief was too much to lay on their young hearts. God, always the perfect Father who cares for each of us, prevented me from getting home at all that day. Neither Lydia, Michael, or Isabelle could fill this space, nor should they be asked to. Our flight leaving

Guatemala was so delayed that by the time we reached Houston, there were no more connecting flights to St. Louis. All four of my kids went to bed that night crushed, while I was stuck in a Houston airport hotel reduced to puddles.

Our family was now required to learn the difficult task of learning to live with our heart in two different countries. We expected this process to last for about six months until Dennis would be home and our family finally complete. Who could've imagined the journey we just embarked on would last nearly two years and that another baby was still to be added to our tribe?

## A Christian Perspective on Adoption

The Christian faith addresses adoption from both a spiritual and natural perspective. Spiritual adoption creates a pictorial image of the way mankind can be reconnected to God despite being born under the curse of Adam's fallen nature (Gen. 3). Jesus makes adoption a redemptive act because he provided a pathway for men back into the fellowship of the Father (Gal.4:5). In a spiritual application, adoption through Jesus is the ultimate rescue narrative for mankind. In that same redemptive manner, man can make a pathway—through adoption— for children without parents to once again to have fellowship with a family. The Bible, in both the Old and New Testaments, contains abundant instructions to the people of God to care for orphans. Isaiah 1:17 says, "Learn to do right; seek justice. Defend the oppressed. Take up the cause of the fatherless." It is interesting that this verse draws an analogy between the oppressor and the fatherless, as if to say that the people of God should expect difficulties in defending the fatherless.

In the New Testament, James 1:27 says that caring for orphans is a true service to God. James declares it to be an example of "pure religion" which releases a godly compassion (Is. 61:1–3). Jesus is often portrayed in Scripture as being moved by a "spirit of compassion," and when this occurs, miracles follow (Matt. 9:36; Mark 8:2). Based on this pattern, it could be suggested that opening redemptive pathways through adoption might activate a godly compassion for releasing

aspects of the miraculous on the earth. For people of faith, adoption must be evaluated through the perspective of a biblical worldview, which understands that the family unit, as well as the care for orphans, are both of biblical design.

Professor Paulo Barrozo, Assistant Professor at Boston College Law School, asserts that every child has the right to a family; he writes that "not growing up in good families constitutes potentially one of the most serious breaches of [children's] human rights because of its possible, if not probable, far-reaching effects."[4] Professor Barrozo's comment is actually rooted in a biblical pattern for family. In fact, the actual concept of a family environment was God's original design for the placement of children. The metanarrative of Scripture is essentially the story of family; all of human history records an eternal Father's redemptive love for his sons and daughters. The Bible provides instructions for parents on raising children, indicating that the care of children is a covenantal responsibility to be managed by family government and not by state government (Deut.6:4–7; Eph. 6:4). This principle is also mirrored in spiritual development, as Christians dwell under the care and supervision a Heavenly Father (Matt. 6:25–34; Luke 11:13).

## Strategies, Tactics, and Weapons for a New War

Linn writes, "It is a common criticism, even a cliché, that peacetime soldiers prepare to refight the last war. Yet few ask the obvious question: what version of the last war are they preparing to fight?"[5] While my development as a solider and my understanding of my Commander-in-Chief were both well-established by this point in my story, IA was a different war entirely from the first one I walked through. New strategies, tactics, and an understanding of different weaponry was necessary to survive in a war that was going to occur in two separate countries.

Something I quickly understood was that adoption, particularly IA, was going to be a paper war. This war was fought with documentation and protocols and legal proceedings all separated by immense periods

of wasted time, time that separated a waiting child from a waiting family. That in and of itself is injustice within the very wheels of justice. Details mattered—i's dotted and t's crossed, and in blue ink, mind you! Any little thing not transcribed or translated correctly could cost you months of delay, not to mention the cost of getting new documents translated, authenticated, and delivered to Guatemala. The other challenge here was that we weren't only penalized by our own documentation mistakes, but also by the mistakes of the paid professionals in which we placed our trust!

In ART, we had to think our way through various moral decisions and how our faith informed those decisions. As you might recall, we had to consider our response to issues such as using donor sperm, selling my eggs, and permitting selective reduction if higher order multiples were conceived. In IA, we had to have discernment and wisdom to navigate multiple situations that were corrupted by deception and loads of confusion. In our first war, we didn't have the need for intelligence gathering, but it was clear almost from the start in Guatemala that this was going to be very important to our success. We needed eyes on the inside, and that assignment was going to prove difficult. While my body was no longer directly taking the direct hits with adoption, I was now required to live impossibly with my heart in two separate places.

There was also the matter of funding this war. War always lasts longer and costs more than is ever anticipated at the onset. It didn't take us long to realize that $20,000 was nowhere near enough to complete our adoption of Dennis. Once again, our funding source would be that farmland that we bought nearly a decade earlier. Thanks to the clever idea of my husband, we were able to separate a ten-acre plot of property, leaving us with three acres on which our remodeled farmhouse sat. We sold this parcel of land within two days, giving us more than enough money to fund Dennis's adoption completely.

The other big change in this war was that I was more inclined to let my Sovereign lead most of the battles. As a seasoned warrior, I now realized that not everything was dependent on me. Some battles required prayer, and others required immense amounts of patience

(still not my strongest suit). Everything I learned during my infertility war was needed once again during Dennis's adoption. I sat on my porch swing every morning and prayed for him, for Guatemala, and for his release from that land. I refused to listen to the enemy of fear who tried to whisper in my ear about Dennis's failure to thrive, the possibilities of infectious disease, unknown abuse, or our ability to bond once the adoption was complete. And I worshipped, endlessly and constantly, which filled me with hope and resiliency for the long battles ahead. I wasn't perfect by any means, but I definitely wasn't the same person who first walked out of boot camp over twenty years ago either.

## International Adoption: History and Current Status

International adoption and intercountry adoption are interchangeable terms that represent a family formed across national, and often racial boundaries. An orphan is technically defined as a child who has lost one or more parents.[6] To further clarify this definition, UNICEF and The World Health Organization explain there are 150 million children who have lost one parent (single orphan), and 17.6 million children who have lost both parents (double orphan)[7]. The Hague Convention (frequently referred to as Hague) is a global initiative for child welfare and protection meant to prevent abuses in adoption practices.[8] The "Convention on the Rights of a Child" was ratified in 1990 to offer a "vision of the child as an individual *and* as a member of a family and community, with rights and responsibilities appropriate to his or her age and stage of development."[9]

Adoptions can be traced throughout history, but it was not until the twentieth century that the practice of international adoption became commonplace and a publicly accepted practice. International adoptions really found their origins during the 1940s, as Americans reached out to the world's orphans who were left in the devastating wake of World War II. Kate O'Keeffe, who published her research on the effects of the Hague Convention, points to periods of economic upheaval or catastrophic events that often contribute to the orphan

crisis and subsequent adoptions.[10] This can be seen in the rise of adoptions following the wars of the past century, most notably WWII, Korea and Vietnam, the fall of communism, the Asian tsunami, and nations affected by economic crisis, such as Guatemala and other Latin states.

Americans have historically led the world in intercountry adoptions, bringing more children home each year than any other nation.[11] However, international adoptions have been in a free fall since reaching their height of nearly 23,000 in 2004. Recent figures from the US State Department indicate a little over 4,000 orphan visas were issued in 2018[12], a reduction of roughly 82 percent since the peak of 2004. This drastic decline in the number of completed intercountry adoptions is caused by several factors, including: the imposing influence of UNICEF, implementation of the Hague Convention, the failure on the part of the DOS to work effectively with adoptive parents and other nations facilitating international adoptions, and the increase of in-country solutions which address the needs of orphan and vulnerable children (OVC).

There are significant barriers to international adoption, including nationalistic ideologies and bureaucratic policies. Corruption has also tainted the process and necessitated the development of international standards and practices, which are currently facilitated by the Hague Convention of 1993. Other criticisms are that international adoption strips children of their ethnic identity and causes cultural confusion. To be certain, international adoption represents a loss of many things for a child: the loss of birth parents, a loss of kinship, a loss of language, and a loss of ethnic affiliation. These concerns are not to be dismissed, minimized, or taken lightly. All efforts should be made to achieve permanency through kinship arrangements or domestic adoption before a child is adopted intercountry and interracially.

However, denying international adoption to those children for whom in-country solutions do not exist is like saying their lives simply do not matter. Institutional life does not provide a child with a cultural heritage; rather, this environment strips children of their humanity in unthinkable and unrecoverable ways. International adoption offers a

permanent solution for children facing a life filled with less-than-ideal circumstances, including a life of trafficking, drug addiction, prison, and likely premature death. All adopted children face lifelong challenges of acceptance and belonging, but adoption is a redemptive and biblical pattern that helps ensure adoptees do not have to face these lifelong challenges alone.

There are many complex and emotional issues associated with the goal of achieving permanency for children through IA today. The line between those who support adoption and those who oppose adoption is about as wide and heated as any other highly contested partisan issue, such as abortion rights, gun ownership, or immigration. I recognize that both sides of the debate have some legitimate points and acknowledge that the practice of international adoption is full of complexities, many of which are based on intrinsic beliefs, cultural values, and historical practices. After years of personal involvement and research in this field, today I see IA as one solution along a continuum of care for OVC. I align with the values and best practice standards of many respected child welfare professionals and organizations, such as Christian Alliance for Orphans (CAFO), in upholding holistic, in-country solutions that works toward family preservation, reunification, and other permanency solutions that are in the best interest of the child and the family unit.

## Process Update on Dennis

We were warned to expect delays in Guatemala with new policies and procedures being implemented to protect everyone in the adoption triad: the child, the birth mother, and the AP. Gone were the six-month timelines from referral to pickup trip. One of these new procedures was a second DNA test with the child and the birth mother right before the embassy pick up appointment as a double-check verification that the person giving up the child was in fact the child's mother.

However, something I did not realize before getting involved with IA was that the process timelines in the United States are not always

that much more efficient than those in third world countries. I'm not sure if it was because we changed our country on the petition or if there was another situation causing delays with approvals, but after I had gotten my hands on that baby boy, I was all about getting things moving on the US side of the process. Nothing in Guatemala could move forward until this piece was in place. We ended up needing the help of our congressman, Rep. John Shimkus, to get our 171H approval from DOS. On December 18, eleven weeks after our application was submitted, we finally had approval from the US Government to adopt from Guatemala. Sadly, by the time this was in our hands, Guatemala had shut down for the holidays.

I returned to Guatemala City in early January for another visit with my son. This time I took Lydia along to meet Dennis. A little resistant to change, the jury was still out for her on whether adopting a brother from another country was the right move. Thankfully, her bonding was instantaneous when she saw his big dark eyes, touched his wild black hair, and wrapped her fingers around his tiny hands. Right there on the spot, in the lobby of the Grand Tikal, Lydia gave her heart away a few months before her tenth birthday.

We spent a few days soaking up the bonding time and taking in a few of the local sites so Lydia could do a little bit outside the hotel on her first international trip. We went swimming in the hotel's tropical pool, enjoyed delicious Guatemalan food, and shopped for some handicrafts in the local market. Unfortunately, my girl got very sick with a gastrointestinal bug. This turn of events resulted in a visit to Dennis's pediatrician for Lydia and led to us giving the baby back to Mama Karen a day early. There were some pretty helpless tears flowing down my face that day somewhere in Guatemala City when I handed back my sleeping son while cradling my daughter who by this point was too weak to stand on her own. Honestly, I barely remember how we made it back home.

The next few months I lived for those monthly emails with updated photos and physicals of my baby. He was growing and changing so much, and all I could do during this time was hold him through my prayers. By March, Tim and I had to start repeating physicals and

fingerprints because these particular pieces of our dossier were only good for a year. On one hand it seemed hard to believe we had started the entire process almost a year ago, and on the other hand it seemed like time had actually stopped while I was separated from my son.

Dennis's case progressed through family court easily, followed by the first DNA test. This meant that for a little bit on some random day I would never know of exactly, Dennis would be back in his birth mother's arms. During this time, I learned so much about trusting God with my children. Most of what was happening was outside of knowledge and far from my reach. He was too little to know cognitively what was happening, but I knew his soul knew and that broke my heart. All I could do was fall to my knees, a place where so much of this war was destined to be fought.

*February 8, 2007*

*Oh, my sweet baby boy,*

*There is no end in sight with our journey to each other and tonight I am hopeless. I wonder, how is your heart? I want to see you so badly, but the older you get the more I'm afraid it would hurt you instead of helping. Here we await DNA, the day you'll see your birth mother again. It's one step closer to me and one step further from her. I'm so sorry little one. I ache for you. The God who is sustaining me is sustaining you. We'll learn that together on this journey. I saw your four-month photos today, and oh my, you are so handsome. My tears can't seem to stop falling for you.*

*Love,*

*Mama Dawn*

After receiving news of a DNA match in early March, our file was then on its way over to the US Embassy to get preapproval (PA) of

the adoption. Normally this step takes about six weeks; then once a file receives PA it is forwarded to the Procuraduría General de la Nación (PGN) where the dossier and prospective APs are thoroughly examined by the government of Guatemala. PGN was notoriously known as the black hole of the adoption process. A file could earn a previo, which kicks the file back to the attorney representing the AP, for any number of reasons—a missing document, a typo, or even the wrong color ink. Everyone expects at least one previo, but each time your file is kicked out, it adds a minimum of six more weeks to the process.

For whatever reason, our attorney felt it best to submit our file to PGN before getting the PA, even though he knew that would be an automatic previo. I loosely followed the logic but also hated the idea of any unnecessary time lost in the adoption process. Exactly what I was concerned about happened; we got the PA from the US Embassy on May 3 and then lost a full month waiting for PGN to kick out our file. It was a devastating blow. My son was growing up and hitting milestones without me; meanwhile I lost another month because someone took a gamble on a procedural step.

During this time period I visited Dennis for the third time, although on this trip I brought along his nana too. There was starting to be a rhythm to my trips now: staying at the Grand Tikal; waiting for the call from the lobby that he arrived; and the *oohs* and *aahs* of seeing how much he'd grown in our separation. I got to take him swimming for the first time during this visit. I also took him to buy shoes and a walker, because I didn't think he had the lower body strength he should've had by this stage of development. Honestly, what I observed was probably due to being carried around in a sling more than a physical condition, but these were small things I could do to participate in parenting my little boy.

After returning home, I was informed that on June 7 we finally received the previo from PGN. We were told that the attorney updated the file with the PA and resubmitted our file to PGN on June 11. Oh, and by the way, the only reason Dennis's file received the previo was due to the missing PA. In my mind, it stood to reason that if we had

done this all the right way, we would be likely be exiting PGN now instead going back into the dark hole for another undefined period.

By this point, I began to have reasons to be suspect of the information we were given by our facilitator. This woman was our "boots on the ground" in Guatemala; she would be the number one reason our case would proceed or languish. Little things had started to concern me about how our case was being handled and some of the information we were being fed. I learned from other APs that I could contact PGN myself at a certain time each week to check on my case. Luckily, I had a close friend and colleague who was fluent in Spanish. When she called PGN on my behalf on June 25, I discovered Dennis's file had yet to be resubmitted for review! Not only that, but our file received the previo on May 14, less than two weeks after the original submission date. It was crushing to discover that nothing had happened on our case since I left Guatemala. Another month of that crucial first year simply lost.

Everything in me wanted to confront our facilitator and fire her. Gosh darn it, but my American "let's do this thing" mentality was pushed to the brink. I wanted to kick some butt and take names, as they say. But Tim is always my balancer—what I am to fast, he is to slow. My one-step-ahead mentality combined with his "I'll get around to it" approach have always been a source of frustration in our marriage. However, though we both hate to admit it, this tension also brings balance to our lives. We didn't want to jeopardize Dennis's process any further by demanding another facilitator at this stage of the game. Also, another chapter was about to begin in our larger story and the timing for a return to Guatemala or making changes to our team was simply out of my hands.

———— ✖️ ————

## The Daughter We Didn't See Coming

I had a vivid dream one night of a baby girl falling down a flight of stairs and landing in my arms. Tim and the twins were with me in this dream. We were all waiting for an elevator when I saw the baby falling. At the top of the staircase, I noticed a door, so I took the baby back

up the stairs and went through the door trying to find her parents. On the other side of the door was an office. I asked a woman working in the office if she knew the baby; she replied yes, but that the baby didn't have parents anymore. In this dream, we were with a family friend who'd also faced long-term infertility. This was significant because this friend and his wife had a baby girl given to them through adoption later in life when they weren't even seeking to have a child anymore. The dream ended with me looking at Tim and saying, "What should we do?" to which he replied, "Well, we are already approved for adoption."

The dream unsettled me. We only ever intended to adopt one baby and he wasn't even home yet. I had already been through jumping from one baby to three when the twins came and wasn't so sure I was interested in jumping again from three to five children quickly, or at all. Also, there were the growing rumors about the Guatemalan program closing down. Time was certainly a pressing factor; once this door closed, it would be closed indefinitely. We talked about how Dennis would one day feel about being the only adoptive child and Latino in our family. Didn't it make sense to adopt a second child so that he wasn't alone? I mean, while I was caring for one baby, what was one more? The sale of the ten acres provided enough for us to adopt again, so if money wasn't the barrier, wasn't the answer obvious?

We decided to look into the matter and see if a second adoption was even possible. Turns out that our 171H orphan visa could be amended for two children at no extra expense. I had no idea it was as simple as making the request to USCIS. That discovery caused us to lean in closer toward a second adoption. The other thing we learned was that we only needed to collect a handful of new documents for a second adoption; otherwise, everything we'd already gathered, translated, and authenticated could be used again. However, we would need an updated home study with approval to adopt a second child. The only condition that our social worker required was that the second child be at least nine months younger than Dennis. Based on this restriction, we would need to wait for a baby whose birthday was after June 25, 2007. This meant that the baby girl we would adopt was still

hidden in her mother's womb, growing in the secret place, completely unaware that we were already beginning to prepare for her arrival.

I don't think there was a particular moment when we said "yes" to a second adoption. We simply leaned that direction long enough that when no real barriers appeared, this became our obvious path. Soon enough we found ourselves waiting for the required date to come when we could accept another referral. Although we decided to stay with the same agency, I let the owner and US staff know I wanted a new team in Guatemala for the adoption of the second child. I did not trust my current facilitator and did not want her involved with this next case. Somehow, this information needed to be kept from her as to not disrupt Dennis's process.

We had high hopes of a much quicker process for our second adoption. With Dennis, we lost time right from the start because our 171H was not approved when we took his referral. This time, our USCIS approval was already in hand. Additionally, our dossier was completed, translated, and waiting in the country. Basically, our waiting in this adoption was for a referral. Once the baby was born, we would need to get a new power of attorney dispatched to Guatemala to begin the process and get into family court as soon as possible. Our agency provided us with a different in-country facilitator, as requested. Quicker than I anticipated, everything was lined up for baby girl Stark to arrive!

We planned to name this daughter Amelia Marie. I wanted to call her "Mimi Marie." We had communicated this desire with the agency and our papers in Guatemala reflected the name we wanted to give our little girl. Traditionally, the birth mother names their child, which is reflected on the original birth certificate. However, many adoptive parents select other names and prefer that the foster moms immediately begin using the name the child will carry after the adoption is complete. We chose to keep Dennis's name exactly how his mama named him, obviously because of the significance this name held to us as well. But this time we were waiting on a baby girl; she was not waiting on us. We wanted to have some say into this child's name, and we wanted her to be our Amelia.

However, as with all of other children, God had something to say about this naming manner. On July 10 I woke up with the Bible story of Abraham sending his servant to find a wife for Isaac heavy on my heart. As I read through the passages in Genesis 24, I realized we had gotten our baby's name wrong. I felt quite strongly she was to be named Rebekah. Furthermore, her middle name was going to be Dawn so that this baby carried a family name just like all of our other children. Tim and I contacted our agency with the name change, and they let the team in Guatemala know our wishes. The Stark baby was to be named and called: Rebekah Dawn.

On July 18, while Tim was out of town on a work trip, I received the call that a baby girl had been born a few days before on July 15 and she was ours if we wanted her. Her birth mother agreed to use part of the name we selected for the original Guatemala birth certificate. We were overjoyed at this news! Our baby had arrived, and she was healthy, albeit small at only five pounds. We had to wait a few more days to get photos and the medical reports, but oh my word, did she steal our hearts immediately. I just stared at my computer screen giggling; how was this for real? There was simply nothing to think about, no hesitation at all. After twenty-two years of an unfolding mystery of heaven, the final member of our tribe was now revealed in a tiny little bundle of pink.

## The Call to Come… *Now*!

Not long after we accepted Rebekah's referral, we learned on August 8 that Dennis's case was out of PGN. What an incredible few weeks this had been for our family! At this point, we were expecting to bring him home in the next four to six weeks. All that was needed was a new birth certificate with his new last name of Stark and the issuance of his Guatemalan passport. Once those documents were completed, our file would be resubmitted to the US Embassy for the issuance of the highly anticipated "Pink" slip, meaning the completed file has been reviewed by the US Embassy and the case has been approved for scheduling the pickup appointment. Tim and I were so looking forward to visiting

Rebekah during Dennis's pickup trip, not to mention getting him home before his first birthday at the end of September.

However, on August 18, the day before my fortieth birthday, I received a phone call from our facilitator in Guatemala who abruptly said, "Dennis is dying. He is severely malnourished. You need to come now and foster him for the remainder of his adoption process." This startling pronouncement drastically changed the course of our lives for the next few weeks. We were expecting a phone call that it was time to prepare for our pickup trip, not a call to move to Guatemala for the next month or so.

Obviously, I immediately set the wheels in motion to go. My twins were about to start kindergarten and Lydia was starting fourth grade. I met with their teachers, gathered materials to start homeschooling, researched houses to rent in Antigua where many other adoptive mamas were fostering, bought airline tickets, and quickly arranged our lives in Illinois to be put on hold indefinitely while we moved to Guatemala for the remainder of our adoption process with Dennis. The plan was that Tim would get me settled in a rental house and then fly back and forth so he could work and take care of our home. Thankfully, we all had passports and also had some extra funds in our adoption account due to the recent sale of our land, so we could respond quickly to this urgent plea.

After moving heaven and earth to make this all happen in a few days, you can imagine my shock to have a healthy, robust, and happy Dennis placed in my arms when we arrived in Guatemala City a few days later. His hair had grown, his belly filled out, and his legs were much stronger than the last time I had visited in May. I was perplexed. We were still in the lobby introducing our youngest son to the rest of his siblings when the actual reason we were brought to Guatemala manifested itself. Our lawyer, facilitator, and agency owner arrived in the hotel and spent the next two hours arguing, in Spanish of course. Like a movie scene playing out in front of me, I started putting the pieces together: we had been called to Guatemala for a power play that was bigger than our adoption, our family, and our son. We were simply pawns in their battle. Money that had been reserved to complete

Rebekah's adoption was being siphoned away in a manipulative game by people who didn't have our best interests at heart. I was speechless, stunned, and heartbroken.

It was in this context that we met Rebekah for the first time. The twins were out of their element and equally clingy and crabby; Dennis was wound up by all the attention and crawling everywhere like a mad man; Lydia had a little problem with a rogue showerhead, leading to a water mess; meanwhile Tim and I were trying to figure out what was happening and why we were even here in Guatemala. Add a timid newborn to that double hotel room and well, what should have been such a special moment for our family played out quite differently than I imagined.

Having a fifth baby is nothing like the intimacy of the first baby anyway but meeting your fifth baby in a hotel room when all four of your other kids are there is just insanity. It was nothing like the experience we had meeting Dennis. Rebekah, by this point barely six weeks old, was obviously tense and overwhelmed by what was happening in that hotel room, and who could blame her? I was forty years old and was overwhelmed in that environment! Not only was our family there, but so were the new foster mom and the agency owner. Trying to keep peace in a small room filled with a myriad of emotions and people and hoping to bond with our new baby at the same time was laughable. We took a few pictures, passed Rebekah around so everyone could get a quick snuggle, and prayed over her before saying our goodbyes. I had no emotions toward her when she left, and while that concerned me, there were bigger issues at hand demanding our attention.

The next day we packed everyone up, left our comfortable digs at the Grand Tikal hotel, and headed toward Antigua. The plan was to look at a few rental home options that I had already lined up, and then Tim would have a few days to get us settled us in before he returned home. I had made a connection with a local foster mom who would put us up for a night or two until we arranged for our own housing. When we arrived in the seventeenth century city located an hour from Guatemala City, the cobblestone streets, open-air homes, lack of heat,

and the fact that everyone spoke Spanish overwhelmed me. Of course, I knew that everyone spoke Spanish, but it was so much more real to me on this day in 2007 than it had been on any other trip to this country—or any other international trip that I've ever taken previously. I was aware that I was simply not strong enough to accomplish this task. First off, we didn't have warm enough clothes. How in the world was I going to push a side-by-side stroller on the narrow cobblestone streets? Homeschooling three children and bonding with a new baby? What in the actual heck had I been thinking? Reality hit me like a brick to the head.

So, like any other overwhelmed mother stuck in a foreign country would do, I started crying. Actually, non-stop crying. All I could see in the entire situation were impossibilities. I was paralyzed with doubt. I had been lied to, betrayed, and somewhat abandoned in our adoption process. I might have been a seasoned traveler and adventurer, but I immediately hated Antigua.[13] To me, the city was old, ugly, uncomfortable, and impossible. I have never felt so much culture shock in my entire life. I wanted to go home. But, going home meant leaving Dennis behind…again. Talk about your blocked and conflicted goals.

After lot of prayer and a little quiet time, it became clear to me that the reason we decided to foster Dennis in the first place was he was "dying." I mean that's what we were told anyway, which in fact was nowhere near the truth. Our son was totally fine and only six weeks away from coming home. We made the decision to return Dennis to his foster mom until the end of the adoption and then we would pick up him once the embassy appointment was approved—just like we had always planned. I didn't ask; I simply informed our facilitator of our decision. In fact, by this time I had Mama Karen's phone number and made the arrangements with her directly. We had a long and honest meeting with the agency owner who was also in the country at the same time. She backed our decision and made this happen, while promising to personally oversee that Dennis's final steps remained on track.

I knew many women fostering in Antigua until their adoptions were complete, but I had three young children and their educations to consider as well. Frankly, it was also an expense that we couldn't support, especially given the adoption for our daughter was just beginning. Using the money reserved for her adoption to stay in Guatemala for a baby boy who was comfortable and safe with his foster mama just didn't make sense. Lydia, Michael, and Isabelle were very upset that we were "giving Dennis back," but I was resolute that this was the best plan for all of us, Dennis included. Once the decision was made and plans were in place, we decided to make the rest of the trip more like a family vacation. We explored and made many wonderful memories in Guatemala together before saying our final, tearful goodbyes to Dennis.

I will never be able to know how important it was that our whole family was in Guatemala during this time, for both Dennis and Rebekah. It could've been to expose corruption, it could've been to pray, or it could've been for a million other God reasons I will never understand. All I know is that we weren't even back home a week when Dennis's new birth certificate and Guatemalan passport were issued. Something had shifted while we were in the country, of that I was certain.

Although we were not able to bring him home before his first birthday, Mama Karen celebrated him with a cake and a party. I called on September 25 to wish him feliz cumpleaños! While it's doubtful he understood what was happening or who I was on that call, it was still important to me to be part of that special day in his life. I reconciled in my heart that God must have wanted his first year to be completed in Guatemala, because the very next day we got word that his case was finally pink!

Dennis was finally coming home!

# 17 Returning Home

# The Changing, the Blending

*The art of war is simple enough. Find out where your enemy*
*is. Get at him as soon as you can. Strike him as hard as*
*you can, and keep moving on.*
*—Ulysses S. Grant*

Two-front wars date back to antiquity. They are not unique to the modern era. A two-front war is one when fighting occurs in separate geographic areas. During World War II the United States was engaged in a two-front war. In the European theater we fought against Hitler and his Nazi regime, and in the Pacific theater we fought against the Empire of Japan. While each war had its own unique challenges, they were similar in that the nature of the fight was against fascism. Each war was fought differently as well, using different weapons as well as different alliances. For instance, the war in Europe occurred in urban areas and was a large land and air battle, while the war in the Pacific occurred in largely remote areas and was mostly a naval battle. Each of the wars also ended at separate times. Germany surrendered in May 1945, but Japan didn't surrender until September 1945.

For our family, Guatemala was a two-front war. Operation Liberating Dennis was complete and fighting at one front of the war was finished. But our adoption war was far from over. The battle on the other front was just beginning. As the borders began to shut down around us, and our allies abandoned us midfight, we faced an uphill battle to bring home our baby girl.

228

## Returning from War: Dennis's Homecoming

On October 9, 2007, just six weeks after our family left Guatemala, Tim and I returned for Dennis's embassy appointment and to bring him home. This was a victory trip, one filled with blessings and the sweet providence of God. Finally, it was time to take Dennis from Mama Karen's arms for the last time. We brought gifts for Karen and her children, but honestly, how can one communicate thankfulness for a debt that can never be repaid when a language barrier stands in between? Karen served my son and our family well for the past thirteen months; she was another miracle in the process—another providential relationship. Her sweet smile, kind eyes, and servant's heart left a deep impression in my soul. There were many tears, on both sides, when we made our final goodbyes.

The next morning, the Stark family along with a dozen other families, lined up at the US Embassy for our final step in the very long adoption process. Tim, Dennis, and I had an appointment with a consular officer who would adjudicate our visa petition. One final review of documents, one final set of questions, then Dennis was forever ours! This day held significance for our family, but it also shifted our son's citizenship. Nerves were definitely on edge when our name was called and the three of us were escorted back for our interview, which was conducted through a pane of security glass. Thankfully, everything went as expected and our case was approved. We were given instructions to return the following day to pick up Dennis's American passport complete with his IR3 visa, which allowed him to emigrate to the US and to his new family waiting in Illinois.

During this trip we were finally able to have some bonding time with Rebekah who was now almost three months old. We spent the afternoon together after Dennis's embassy appointment. It was perfect because our son was exhausted from the morning and willingly took a nice long nap, finally giving Tim and me time to be alone with our baby girl. As I had noticed in those first few chaotic moments we shared in August, Rebekah was a delicate little thing. Not only was she very

small, but she was also very skittish. Reading her body language, we just tried to comfort her and pray protection over her for the season ahead until she was ours.

After picking up Dennis's US passport the next morning, we returned to the hotel for a celebration breakfast with our little man. While we were eating, the agency owner called my Guatemalan cell phone to let me know that Rebekah's case had progressed to the DNA test. This was amazing news! Always while my feet were in Guatemala, our case somehow managed to shift forward. But the even bigger news was that Rebekah and her birth mom were heading over to the laboratory right this very minute. The agency owner asked, "Dawn, do you want me to watch Dennis so that you and Tim can go to the lab and meet Rebekah's birth mom?"

As much as we hated to leave Dennis now that we finally had him in our arms, this was an opportunity we could simply not pass up! Within a few minutes of taking that call, Dennis was placed in the caring hands of our agency staff, and we were in a cab racing to the lab. Hands held and eyes closed, we prayed the entire cab trip across town. We had no idea what to expect from this encounter but were both confident this was a destiny moment in our journey to Rebekah.

When we arrived, we found Rebekah, her foster mom, and a young woman we presumed to be her mother all waiting for the test to be performed. Since there is really no established protocol for meeting the birth mother of your baby in a DNA lab, I defaulted to just being a mom and also, an extrovert. I gently hugged her when we were introduced, while Tim patted her arm and kept nodding his head in affirmation to her role in this complicated space. This might have been too American of a greeting, but my heart was leading, not my head. I warmly greeted our foster mom and asked for permission to hold Rebekah by extending my arms. I was aware this baby must be in deep distress in this moment, and I wanted to wrap her in my arms while praying constantly under my breath for her to have peace.

Through the help of a translator, we were given the gift of information that most international adoptive parents never obtain. Since this part of the story is primarily Rebekah's story, I don't intend

to share the details of what we learned that afternoon from our conversation with the birth mother. Suffice to say, we gathered information that Rebekah may find important later in her life. We also took the opportunity to talk to her about Jesus and let her know that her daughter would be raised in a home of faith. She allowed us to pray over her and take a few pictures together, both moments we are grateful to have shared with her, even if it was all rather stiff and took place in a lab.

Once Rebekah's birth mother finished her part of the test and left, we spent a few more minutes alone with Rebekah before placing her back in the arms of her foster mom and returning to the hotel to Dennis. At this moment, I had no idea when we would see our daughter again. Guatemala was becoming a place of hellos and goodbyes; both greetings filled with their own unique and overwhelming emotions.

Early the next morning we boarded a plane to the United States with Dennis in our arms. It was not lost on me that our son had no voice or volition on the changes being imposed upon him. He was leaving his homeland, his language, and all connections to his family and being carried to someplace new and entirely foreign. He was coming into the country as a citizen and a son, but he was also an immigrant. And, he was also a baby, which always makes for fun travel. When he needed a diaper change inflight, Daddy stepped up for the job. It still makes me laugh to think about how long those boys spent in that lavatory getting this task completed. When they emerged, Dennis was in a new outfit and Tim was covered in sweat. Levity, accompanied by a hefty dose of reality, help to balance overwhelming moments.

The homecoming was the stuff of movies. Our family, my siblings, grandparents, and friends all showed up with balloons and cameras and so much love for our newest addition. This is not always a good thing for a vulnerable child, but the wait was so long to bring us to this day that we couldn't say no to the big airport greeting. Dennis soaked up the faces and the love and responded very well to his siblings, which he obviously remembered from our last visit. He was always such a

people person, even as a little baby. The moment when my dad, Dennis, held his grandson, Dennis, for the first time still overwhelms me with such emotion. Seriously, how cool is our God? Who could've scripted this story to be so perfect?

Our early weeks together passed easily. Dennis's transition into our family was just so seamless. His second night home he experienced a few hours of grief where I could not hold him or bring him comfort at all. I just lay by him on the nursery floor as his soul sought to catch up with the major life upheavals he was experiencing. We had been training for this night for a long time now; we knew it was coming and we knew our little man had to process through these stages—alone. Grief has to find a way out of the body, or it will make you sick. As hard as it was to watch these waves of sorrow wrack our baby, I knew it was better for him in the long run.

But, as international adoptee integration stories go, Dennis's was short and simple. We bonded very quickly. Within days he was calling me Mama Dawn, and the "Dawn" part eventually disappeared from his vocabulary. This baby, who only understood Spanish when we brought him home, completely understood everything I said within three short weeks. I figured out he was a visual learner; I believe aided his reception to and understanding of English. Dennis loved to play with toys and learned to walk within a few weeks of being home, too. Sleeping, however, was an issue we would deal with for many, many (many) years to come. But otherwise, it was hard to believe how quickly he transitioned into his new home and family.

Isabelle had been my "baby" for six years by the time Dennis came home, although she only held this title by a whopping seven minutes. She struggled a bit more than the other two kids when we arrived back from Guatemala with a new baby. Izzy took to wearing giant jingle bells around her neck for days until I gently removed them from her body (and hid them somewhere deep in the house). I assured her that she didn't need to wear bells for me to know where she was and that no other baby or person could ever take her place in my heart. Apart from the noisy jingle bell incident, and all the typical dysregulation involved with both parents being gone for an international trip, our

transition into a family of six happened pretty smoothly and naturally. At long last, one front of our adoption war was now behind us.

## Meanwhile, Back in Guatemala

With Rebekah's DNA test behind us, we had high hopes that her adoption would be completed fairly quickly. When we left Guatemala with Dennis in October, we expected her case to be submitted to PGN as soon as the DNA results were complete. While it was doubtful we'd have her home by the holidays, a pickup trip at the beginning of the year was highly probable. In any case, she would be home well before her first birthday. Because of this expectation, we did not plan another visit. Money was becoming a concern as well, thanks to the unplanned international family "vacation" we took in late August, and we wanted to be sure to have enough funds set aside to complete the adoption.

Also, the more I was learning about OVC and best practices, it dawned on me that visiting my children before their adoptions were finalized was likely doing harm to their tiny souls. At their stage of cognitive development, forming a secure relationship with a primary caregiver was more critical than any temporary involvement I could play in their lives. Although it was not intentional and I didn't initially know any better, it was nonetheless a heartbreaking revelation to grasp that some of my choices were serving me more than benefiting my children. As in my ART treatments, my Heavenly Father's focus in most of my trials was first and foremost about my transformation. The adoption process was a continuation of the lessons on patience, trust and worship, but also in the awakening revelation that being a mother was actually not about me at all.

There were two major events that occurred in Rebekah's adoption process that were different from Dennis's case. First of all, Guatemala was finally shutting down their international adoption program. No longer a rumor, this was now a present and timely reality with a hard date of December 31, 2007. For those of us in process, it was a terrifying time. Months went by without our file being submitted to PGN—which, I might add, would have protected us from new laws

going into effect at the start of 2008. However, our agency and attorneys were too busy referring new cases in those final months instead of working the cases that were on their books. In all honesty, this last-ditch money grab by those who should've been an advocate for our family was abhorrent. In nothing less than greed to pad their own pockets, they risked our daughter in the process, while at the same time validating the global communities' concerns about international adoption in the first place! We received no replies to emails or answers to phone calls. We were totally and utterly helpless in how this all played out.

Needless to say, our case missed the December 31 filing deadline. This meant we were now subject to the new adoption laws which required Rebekah to be registered with the new central authority (CA), which by the way, was just being created. Our daughter, who should've been exiting PGN now and coming home to her forever family, was stuck in a pipeline of waiting children and waiting families. It was a heartbreaking and incredibly unjust situation for which all we could do was pray and trust the Lord. I held tightly to the fact that we named this child and were the only option she had for a family. God promises to set the lonely in families (Ps. 68:6) and though I didn't see how, I knew he would not abandon us at this stage of our battle.

The drama that unfolded during the next six weeks in Guatemala was unlike anything we'd yet to experience in either of our adoptions. The new CA registration certificate was required for a case to be submitted to PGN. First, we were told Rebekah was registered, then in the chaos of a system being built from the ground up, it was announced all 2800 cases must be reregistered again during a four-day window. If cases were not registered in time, the case was not grandfathered in under the old rules and you would lose your referral. Although we never heard from our attorney or facilitators during this time, I learned from other APs that attorneys were standing in lines overnight with files several feet thick. In the absence of information, we prayed without ceasing for a miracle. Then, after weeks of deafening silence, we get news on February 11, our daughter was registered and officially had a CA number so that our case could proceed.

*Exhale. Worship. Repeat.*

On March 3, I received word that our daughter's case had finally been submitted to PGN, a fact which by now I knew to confirm directly with PGN myself. Although from previous experience I knew this step carried its own difficulties, it was still a relief to have our case advancing forward. We'd already come too close to losing our daughter once, so every step forward was worthy of celebration—no matter how short-lived. On March 28, I learned we had a previo on the file because the PGN attorneys did not like how our home study was written regarding the adoption of a second child. They required an addendum clarifying our approval. This was documentation that would take us weeks of time to accomplish and hundreds of dollars to get drafted, translated, authenticated at the state of Illinois capitol and expedited to Guatemala.

Not only was I working on this addendum, but it had been brought to our attention that our USCIS 171H approval to adopt internationally was expiring in June. It turned out this approval is only good for eighteen months. This piece required a new home study, new medicals, new fingerprints, and of course time and money—the great commodities that are all things adoption. I quickly moved back into the paper production mode to get all of this documentation prepared for both the Guatemalan and United States governments so that one tiny thirteen-pound girl could obtain her basic human right of a family.

On April 14 the home study addendum requested by PGN arrived in Guatemala. But it didn't really seem to matter to those on the ground representing us, as April passed by without our file being resubmitted. Phone calls and emails were not returned as another month passed by in silence. On May 5 Guatemala announced a suspension on all adoptions until all birth mothers can be reinterviewed by PGN. This was shocking news that rocked the adoption community, as this had never been a role of PGN in the past; those interviews were previously conducted by family court, a step in the process long since behind us in this case. Of course, what any of this meant to us personally was never known or communicated.

Barrier after barrier kept rising against us in our journey to Rebekah. And it was about to get worse, as our second major barrier toward our daughter finally presented itself. Our adoption agency should've been our defense and advocate throughout this entire process. However, unbeknownst to us at the time, the agency owner was facing mounting legal investigations for adoption fraud, not to mention a cash flow crisis now that the program in Guatemala was closed. Suddenly, in the midst of all of the insanity in Guatemala, our agency went out of business. One random afternoon we got a short and apologetic phone call with this information. Along with this news from a now debunked agency was the promise that our facilitator in Guatemala—the one who never returned our calls or emails—would help us complete our adoption.

Suddenly, we were alone and stuck between two governments to bring our daughter home. This was no longer just a paper war. Helmet on. It was time to fight.

## A Cousin Born in Ethiopia

I need to step away from my story to provide a brief update on my sister's adoption process. Although they did not follow us to Guatemala, my sister and brother-in-law continued to pursue international adoption. After considerable prayer and research, their journey led them to Ethiopia through our original agency. Their African program was just opening and the referrals to pickup trips were happening fairly quickly and smoothly. The Mager family proceeded with updating their home study and switching their USCIS orphan petition to Ethiopia.

Between the journey to bring home my two babies, there was a baby born in Ethiopia who also needed a forever home. My sister and brother-in-law received a referral on Christmas Day 2007 for a little boy who was born in September. On Dennis's first Christmas at home, the promise of another son and another race was being added to our extended family. Less than two months later, Deedra and Paul journeyed to Addis Abba, Ethiopia to meet, adopt, and bring home

their fourth child, Ashenafi. Who knew that little Ashu, the nickname that developed soon after his homecoming, was destined to become Dennis's best friend? Cousins, from separate corners of the world with different skin colors, were being drawn together by the hand of the Almighty.

## Recon Mission: Freeing Rebekah

Do you remember how I called adoption our paper war? Well, largely up until this point, paperwork was almost entirely the type of "fighting" we had to do. After the requested documents arrived back in Guatemala in mid-April, we called the attorney and facilitator week after week inquiring about the status of our case. Each time we were promised that our file was scheduled to be resubmitted "this week," yet the next Monday would arrive and there was still no PGN submission number. Friends, I need you to understand this involved walking a piece of paper across the street from the attorney's office to PGN—literally, across the street.

Tired to the bone of this nonsense, it was time to take a defensive posture with our tactics. Tim and I decided that if on Monday, May 19 our file was still not submitted, I would fly to Guatemala City on Tuesday and settle the matter myself. It was time to cross the battle lines, get boots on the ground, and engage in a recon mission to free Rebekah. Sure enough, we called on Monday and found the file was still not submitted. I told my attorney that I would be in his office tomorrow to sort this out, a threat I'm quite sure was simply dismissed. Using my frequent flyer points, I booked my only free ticket for early the next morning. I reserved a room at the Grand Tikal and reached out to someone we had used a few times as a driver and a translator while in the country. I kissed my babies goodbye again and set out on my solo mission, repeating over and over to myself, "If God be for me, who can be against me?"[1]

I arrived in my attorney's office by 10:00 the next morning with my translator in tow. It turned out the receptionist was there alone, obviously not expecting anyone. She picked up the phone and placed

a call, which was quickly handed to me. Through a very tense conversation, occurring through a translator, I was told to leave the office immediately. How dare I bring a strange man into the office! How dare I show up unannounced! I was instructed to return to my hotel room, and they would arrange my baby to come for a visit. I shot back, "I'm not here to see my baby. I'm here to see you and get my paper walked across the street and filed with PGN." I was shaking, but I was fierce. In defiance to the commands being thrown to me, I took a seat in the waiting room.

Magically, in no less than forty-five minutes, I received a brief call from my attorney and was given a PGN submission number. I was in shock; I wholly expected to sit there all day. I was geared up and ready for the engagement. Yet, not even needing to confront anyone but a receptionist, my battle was won. I recorded the PGN number, told my attorney that I was walking over to verify this information myself with PGN. Then I boldly said, "If this information is true and the file is submitted, I would like to see my baby. You can arrange for her to be brought to the Grand Tikal." As I walked out with my translator, my knees were shaking but I felt ten feet tall. We crossed the street, I put feet on PGN property, and verified with the front window clerk the validity of the number I had been given. Sure enough, less than an hour ago, Rebekah's file was back in PGN.

*Exhale. Worship. Repeat.*

Although I hadn't come expecting a visit with Rebekah, I was thrilled to have a few days alone with her now. Our reunion was precious; I couldn't believe how much older she seemed. Sitting tall on her foster mama's lap, she locked eyes on mine the minute we saw each other. I noticed pierced ears, something I had expressly asked the foster mom not to get done without me. I explained in an earlier visit I wanted to make this memory with my daughter. The foster mom immediately covered her eyes in shame, not looking at me as she uttered apologies in Spanish. Choosing to not let the foster mother's decision or manipulations impact our reunion, I ignored the ear piercing and only focused on my daughter. I extended my hands tenderly and she came right to me, interested in my necklace and earrings.

238

With the day's legal battle behind us, it was time to care and focus on this little princesa, a nickname our family had starting using for Rebekah. At ten months old she was only fifteen pounds. An experienced mother by now, I felt she was just too small for her age. I decided to have her checked out by an American doctor while we had a few days together. An adoptive mom friend referred me to someone who could see us the following day. After the physical, the doctor was concerned about my daughter's head circumference which didn't correspond with proper development on either the US or Guatemalan growth charts. He arranged for an MRI and sent us to a pediatric neurologist to make sure everything was normal.

It was time to endure another stressful event on my own this trip. I stood close watching Rebekah get strapped on a board and go through an MRI machine without making a sound. I couldn't believe how perfectly still and quiet she was, abnormally so for a child her age. I remember thinking she seemed to detach emotionally and that concerned me. I had yet to comprehend or understand the far-reaching effects of trauma. Thankfully, the reports all came back normal. Our baby was tiny, but she was perfectly fine. Nutrition was a concern though, so I bought months of baby food and formula to give to the foster mom myself. I was not confident that the money we sent each month for her care was making its way to my daughter's stomach.

Painfully, after a few days together, I handed Rebekah back into the arms of her foster mother. Within an hour of giving Rebekah back, I got very sick. Gastrointestinal illness hit me like a ton of bricks. I called home and asked for my family to pray because I didn't know how I was going to make the trip back the next morning. After being up all night with constant diarrhea and vomiting, I somehow managed to get myself to the airport. All I could think about was getting home to my family; I didn't want to be alone in Guatemala any longer. However, the check-in line for the flight was almost an hour long and I just couldn't stand during the waiting. As pitiful as it sounds, I sat down on the ground and pushed my luggage with my feet as the line progressed forward.

In another unbelievable mark of providence, a group of flying doctors were waiting to board the same flight. They saw my condition and came to check on me, right there in the airport. Although I wouldn't normally suggest taking meds from strangers, I trusted their credentials and took the medications they offered to quiet my system down and help me get back home. These doctors helped get me through check in, security, and to my seat on the plane. Then I fell asleep. The next thing I knew it was time to deplane, clear customs, and make it to my connection in Dallas, TX.

Somehow, I had enough strength to get where I needed to be. When I got to my gate, the waiting area was empty as it was still several hours before my connecting flight departed for St. Louis. I lay down on the floor because I was past the point of even being able to sit up in a chair. I put my luggage at my head, my purse and laptop under my arm, and fell fast asleep. I woke up to the noise of activity and the pre-boarding of my flight. Sitting up and gathering my things, I was stunned to find two US Military personnel right by me. One was sitting at my head and the other was stationed at my feet—one on each side of me, as if standing guard. The significance of this moment was stunning to me, as this book was already being unfolded in my heart. These two soldiers explained they saw me sleeping and wanted to watch over me and my belongings. I just kept saying, "Thank you, thank you," completely unable to articulate any more meaningful words of gratitude.

Were they angels in disguise sent to protect me? Possible, although I will never know. However, I know that when I am weak, Christ makes me strong,[2] even if he has to order military personnel to flank my right and left side after being poured out in battle.

## The Final Battles

I arrived back home to find a major problem on the home front related to the extension of our approval to adopt an orphan from USCIS. In April we had already submitted the new FBI prints and updated home study, so I honestly was just waiting to get news that our extension had

been approved. But for some nearly unexplainable internal confusion we ran into with the Illinois Department of Children and Family Services (DCFS)[3] regarding our home study, we were in serious jeopardy of missing the USCIS deadline.

Plain and simple: if we lost our 171H, we lost Rebekah. Instead of being caught between the US and Guatemala, now we were stuck between Chicago and Springfield right here at home in Illinois. The situation that dragged on through June and July was so incredibly stressful; how in the world with all we had battled through in Guatemala could we lose our child here at home? I burned up phone lines and sent letters to our senators, including then Senator and presidential hopeful, Barak Obama. However, once again it was our local Congressman Shimkus who intervened and saved our adoption, with only days to spare.

Meanwhile, back in Guatemala there was more drama at PGN as our file earned another previo. I only found out because of my weekly calls to PGN directly; I could understand "previo" without the help of an interpreter. There was of course, no communication from our "team" in Guatemala, and no agency left to intervene. All I knew was our file was out of PGN, and we were also battling here in the US to hold on to Rebekah. Our red string connection to our daughter was literally fraying at both ends.

July 15 arrived, and brokenheartedly, we missed the first birthday of another child. As we had done with Dennis, we called Rebekah's foster mom to wish our princesa a happy first birthday. Through the help of a translator, we were told she had a lovely day; she got to ride in little cars on a merry-go-round type ride, and they gave her a new dress. I sobbed when they put our baby on the phone as she babbled back into the receiver. So many milestones passing us by, for so many avoidable reasons.

Just as with Dennis's case, after Rebekah's first birthday passed, we finally started to see some forward movement in her case. First, we learned that the previo was only for a small correction and her file was resubmitted to PGN within two days. Then, miraculously on July 29 we learned we were finally out of PGN! We'd been at this stage in our

adoption process since February 22. And not only did we learn our file was out of PGN, on this very same day we heard from our congressman that our 171H extension from USCIS was approved. Two different countries, separately, came into agreement on the exact same day. God don't play, people: one door released and another opened. David Platt says, "This is how God works. He puts his people in positions where they are desperate for his power, and then he shows his provision in ways that display his greatness."[4]

At last, the pathway was made open for Rebekah to be ours.

*Exhale. Worship. Repeat.*

Although we still spent the next two months dealing with irritating delays and incompetency, our case continued to slowly progress forward. This was still concerning because we heard strong rumors that the country was shutting down completely at the end of the year and adoptions halted, regardless of where you were in the process. I needed to get her out of the country as soon as possible! In my opinion of course, every day she was in Guatemala was now one day too long. Eventually we learned her new birth certificate with the Stark name and new Guatemalan passport were issued. In early September the second DNA test was ordered. And finally, on September 23 we got word from the US Embassy that our daughter's case was now the magic color of PINK.

We made the tough decision that Tim was needed more at home for Dennis's sake than with me in Guatemala. I invited my mom, who had never met Rebekah, to accompany me on the pickup trip. Without help from our legal counsel, who never even bothered to confirm my arrival back in the country, Tim and I researched and prepared the necessary power of attorney for me to complete the embassy appointment and bring Rebekah back to the United States without him.

I arrived back in Guatemala on September 29 still struggling to get details from our facilitator about the embassy appointment the next morning or find out when Rebekah would be given to me. To say that communication sucked right up to the very end is the biggest

understatement ever. My mom and I checked into the hotel by noon and waited until evening for Rebekah to finally arrive. Her foster mom was not prepared to gracefully pass over this baby girl to me. She was sobbing uncontrollably and wailing in the lobby, and though I was sympathetic for her sadness, I was more concerned about how Rebekah was interpreting this transition. Needless to say, our facilitator was zero support. Nothing about this moment was like what we had experienced with Dennis. I was ripping Rebekah out of Guatemala, and I had to be okay with this closure.

The next morning, we took Rebekah to the US Embassy for the exit interview and to get final approval for her visa. The appointment went like clockwork, and we returned the next day to pick up my daughter's US passport. It all felt like I was floating through a dream; the day that would never arrive, finally arrived! Rebekah enjoyed time in the hotel with her new mommy and nana. She seemed to accept all of these changes being thrust upon her and was very curious about her new toys and clothes. It was wonderful to have a few peaceful days together to bond apart from all of my other children. My daughter was on the verge of walking, but I wouldn't let Nana encourage this activity yet. Her daddy needed, no, her daddy deserved to be a witness to this milestone in his daughter's life.

Early in the morning of October 2, 2008, with very little fanfare, our Princesa left her homeland of Guatemala and journeyed to her forever family waiting with open arms at Lambert Field in St. Louis, MO. Both of our flights arrived on time, and the immigration interview on Rebekah's IR3 visa went quickly as well. After everything we had been through in the journey to this child, those mercies were well received and appreciated. As we made our way down the terminal toward baggage claim, I could see my four babies waiting to greet their newest sister. My heart pounded out of my chest; I couldn't get to them soon enough. Our giant reunion hug was so sweet! The way all of my babies and I huddled together in the airport was imprinted on my soul in such a powerful and lasting way. Then I turned around to see my husband standing there waiting to meet his last baby. I simply could not contain my joy as I placed Rebekah in her daddy's waiting and

extended arms. Impossible, yet true, the childless couple were now parents to a tribe.

## After the Troops Come Home

Once the war is over, soldiers finally get to come home. The homecoming is usually highly anticipated and dreamed about throughout the deployment. Both the active-duty personnel and the waiting family count down the days until their loved one is off the battlefield and safely back home. In picture-perfect moments with flags waving high, soldiers arrive home to emotional reunions, celebrations with family and friends, and sometimes even parades. Whether arriving back by land, sea, or air, homecomings are usually a sweet mixture of joy and relief.

There is a spectrum of emotions experienced upon reentry to normal life. There is usually a honeymoon phase upon reentry, but it doesn't last. Honeymoons never do. Combat veterans often need to work through complex emotions and need time to find the pace and routine of life again. Returning to "normal life" can be a real challenge for many after the all-encompassing and adrenaline pumping life they've lived on the battlefield. Heaps of patience, lowered expectations, and loads of support can make a huge difference in the early days of transitioning back to home. A new normal must be sought, as the family unit has likely been forever changed by this experience.

Injuries, whether physical or emotional, also need to be addressed. Sometimes, effects of engagement show up after the homecoming in the form of post-traumatic stress disorder (PTSD). According to the American Psychiatric Association, PTSD is defined as "a psychiatric disorder that can occur in people who have experienced or witnessed a traumatic event such as a natural disaster, a serious accident, a terrorist act, war/combat, rape, or other violent personal assault."[5] Without a cognitive awareness of what is happening, loud noises or accidental touches may trigger flashbacks to the traumatic event. The US Department of Veteran Affairs estimates that as many as 30

percent of Vietnam vets have suffered from PTSD throughout their lifetime, and 12 percent of Gulf War vets have PTSD in any given year.[6]

There is hope and there is help for veterans, but for some, life after warfare continues to be a challenge.

## Post-Adoption Trauma and Healing

Honestly, I'm not sure we really ever had a honeymoon phase after Rebekah's homecoming. She did not adapt well or quickly to life in our home. Dennis came from a foster family unit exactly like the sibling hierarchy he stepped into with his forever family. He didn't miss a beat transitioning to life as the fourth child because that's exactly how his home life had always been shaped. Rebekah did not have that same experience. Her foster mom, someone whose name we were never given, was an older woman with adult children. Our daughter was simply overwhelmed and frightened by her siblings for several weeks, especially Dennis who at two years old desperately wanted to care for "his baby."

Within days of being home, Rebekah got very ill. As I've already shared, she was very tiny for her age. She barely ate food or took formula to begin with, so days of diarrhea were extremely concerning. We had kept our pediatrician up to date on Rebekah's medical reports as we received them from her pediatrician in Guatemala, so all of her information was already on file at the doctor's office when we brought her home. This included the embassy's final medical exam by an American doctor and the notes from the neurologist we visited in May. This was valuable information that helped us make some quick and accurate assessments of her physical condition. Malnutrition was definitely at play, as well as new germs and viruses in her new home that her little system was simply not prepared for. Our doctor ran several labs to make sure there were not any other underlying conditions, and we focused on fever reduction and increasing fluids until she turned the corner. Luckily, we avoided any hospitalizations as

that would've introduced even more trauma into this very difficult adjustment.

Rebekah was also clearly hampered by the language barrier in the transition from Spanish to English. I don't know if this is because she was a few months older than Dennis when she arrived home, or if it was more rooted in her personality and individual learning style. In any event, what took him three weeks to work through took her several months. She was disconnected, distant, and seemed to look right through us when we talked to her. Unlike Dennis, she did not learn visually or enjoy playing with toys. She seemed to be lost, and I didn't know how to reach her.

She was also not initially a fan of her daddy, like at all. He would walk in the room and she would start crying. I wasn't sure if maybe there had been some trauma we were not aware of, or if it was simply that the only significant bond she had developed was with a woman. But Tim was persistent and focused on winning her over. He played with her and let Rebekah set the pace for their relationship. Within six weeks, Rebekah decided she liked her daddy. A lot, in fact. She became a daddy's girl, first and foremost. So much so, that she transferred all of her love and focus to Daddy over Mommy.

Rebekah wouldn't take in food without me pushing it in her mouth; she cried and whimpered all the time; bedtime was always traumatic; and she didn't want me or find comfort in my arms. We were not bonding, or at least, not the way I had known bonding with my other children. I did my duty and cared for her, but my heart was struggling to engage with this baby who only ever wanted her daddy. I told myself to be grateful and thankful for all I'd been given, and all God had done, but everything was just off this time around. Dawn Davenport explains, "After all we've been through to adopt our child, we expect bliss. We deserved bliss. And sometimes we get bliss. But sometimes instead of the euphoric feeling of accomplishment and love, we feel let down, exhausted, unprepared and sad."[7]

I wouldn't call what I experienced post-traumatic stress disorder, although it's highly likely that Rebekah suffered silently from PTSD. However, it was becoming clear that I was going through post-

adoption depression, and not bonding with my fifth child didn't help matters. I already had a history with depression, but because the triggers were different this time around, I didn't make the connection right away. I was slugging through the role of being the mama to five, which coincidentally seemed to be the number where I met my match. I was also stepping off the battlefield after a twenty-two-year journey with infertility and adoption. The overarching story line of my marriage and adult life was finally completed, and though I was relieved, I was also a little lost. Okay, I was a lot lost. Now that the war was over, I didn't know how to reintegrate into normal after everything I'd seen and experienced.

This is painful material for me to write. I've uncovered a lot of my soul in sharing my story. You've walked through my fears, my doubt, my unbelief, and my heartbreak. But this is different. This time period was ugly for me and for my identity as a mother. I felt like such a failure. Through book knowledge I knew that bonding with an adoptive child isn't always natural or easy, but I couldn't accept this would happen to me.[8] All of my children were mama's kids. They always chose me first and were inconsolable when I left. I was a stay-at-home mom who dedicated her life to her children, for goodness' sake. But not Bekah. Nope. She was 100 percent a daddy's girl with zero percentage left over to give to me. I didn't know how to compete with that, and quite frankly, most days I didn't even try. I read her mistrust of me as a rejection, and that hurt deeply.

As a lifelong Christian and a seasoned mother, you'd like to believe that when asked to give love away selflessly you would rise to the call. But, when the time comes to do so, it's not always as cut and dried in practice as it is in principle. Sometimes you are so buried by the responsibility and day-to-day weight of life, you miss the opportunity to love without condition or reciprocation. Please don't think for a minute I neglected Rebekah. I tried to make a connection with this daughter and always responded to her needs immediately but parenting her was simply not how I envisioned or practiced motherhood.

Sadly, and yet mercifully, Rebekah did not fill me. And that right there my friends, was the root of the problem for my side of this story.

It turned out that it took this daughter's distance to me as a mother to figure out that parenting was actually, not about me at all. I desperately needed some adjustments to my philosophy and to my identity if I needed a child to validate my role. This tiny little girl taught me something that none of my other children could. This awareness came gradually, but when it did come it led me to repentance. Parenting was about giving your heart away, not having your heart filled up. Once again, I spent needed time bathing in the waters of repentance and worship in order to properly move forward into my future with wholeness.

Slowly over that first-year post adoption, Rebekah got healthier, started embracing her family, found her smile, and started to bloom. Over that time I began to build a healthy connection with my daughter, find a normal pace of life for a mama of five, and stabilize after years of emotional trauma. Together, Rebekah and I were healing and building something new. In his mercy, God was showing us both how to make beauty from ashes and how to rebuild the waste places of our old lives.

## One Final Step: Readoption in Illinois

Both of our children came home on IR3 visas, which meant they were citizens immediately upon arrival in the US. This is because both Tim and I were able to visit them prior to their pickup trips. After all we had been through, it was nice to have one step of the citizenry process simplified. We only had to pay for their Certificate of Citizenship (COC) from USCIS, then apply for social security numbers and a birth certificate from the state in which we resided. As paperwork goes, this was the easy part.

However, we did discover that it might be best for the long-term interest of our children to also readopt them in the United States. It had something to do with social security benefits should Tim or I die unexpectedly and would also give them a more versatile and acceptable US birth certificate. Plus, we needed to make an official name change for our daughter to correct the spelling of Rebekah and add "Dawn"

to her middle name. All we would need was $904 to pay for the family law attorney, two guardian ad litems, and court fees. Plus, $304 to reissue the very important COC reflecting Rebekah's name change. Just $1208 more dollars, then finally we would be finished with two very costly international adoptions that when all was said and done would exceed $70,000.

On September 3, 2009, we readopted Dennis and Rebekah in the state of Illinois. When this special event occurred, Rebekah was only two years old and had been home from Guatemala for a little less than a year; Dennis was almost three years old and had been home with our family almost two years. This was a huge day for our family as it marked the finish point of what ended up being a twenty-three-year infertility journey. Through a simple ceremony, we all raised our hands together and swore to a judge to be family for each other. Thereafter, the judge issued the order and made the final decree of adoption. While just a formality, it was nonetheless an incredibly powerful experience. Officially and forever, family.

After we left the courthouse, we decided to eat lunch at Olive Garden because it was a place all the kids liked and felt comfortable. When we arrived and the staff learned about the nature of our special occasion, they sat us in the middle of the restaurant and showered us with so much love, attention, and honor. Honestly, it was so overwhelming and beautiful that I could barely eat. Surprisingly, even my introverted children soaked up the experience. Everyone on the staff stopped to congratulate our family, take pictures, and make all of our children feel special. They sang to us and brought out two celebration cakes—one for each baby. Then the manager whispered to Tim and me that the meal was on the house. When we—amid flowing tears—asked why, he said, "Because when you are here, you are family."

Ever since that once-in-a-lifetime day, Rebekah still picks Olive Garden for her birthday. If you would ask her why, Rebekah would simply tell you it's because Olive Garden is her favorite restaurant. But it's much deeper than that, of course. It's because Olive Garden is the place where we finally and completely became a forever family.

# PART IV

# ADVOCACY WARS

Be strong and courageous! Do not be afraid or discouraged. For the
Lord your God is with you where you go.

—Joshua 1:9 (NLT)

# 18 Special Forces

## Learning to Fight for Someone Else

*Military power wins battles, but spiritual power wins wars.*
—*General George C. Marshall*

Lydia, Michael, Isabelle, Dennis, and Rebekah—all mysteries finally revealed. I've loved them all with my whole heart before any of them were mine, and even more so since they were placed in my arms. I could entertain you for hours with the stories and antics of my children and have written many a blog post about these events that I now view through the lens of preciousness and sweet memories. I've wiped all the tears, cared for all the sickness, sat in all the grief, laughed with all the silliness, endured all the heartache, soaked up all the hugs, celebrated all the moments, photographed all the memories, cheered along all the victories, and encouraged all the dreams. I've done all of the things you can imagine—and even some you probably can't—in raising my tribe.

Finally, our family was complete, and we knew that completely! My days and nights were consumed with being a mom to my five miracles. They might have been miracles, but they were children just like yours. They were real, living, breathing children with non-stop needs, distinctive personalities, and unique challenges. Long gone were the days of empty arms. Now I lived life with my hands very full, something I was often told by well-meaning strangers who felt a need to comment on the size of our family. By the time Rebekah came

252

home, Lydia was in sixth grade and the twins were in first grade. These new babies of mine were hauled from here to there as my three older children were by now in school and extracurriculars, as well as involved in church life. Our van was as full as our arms and our days, and we were always on the move.

It might seem as though my story should've stopped at the end of the last chapter. After all, I've got my kids now, right? Well, sure, if this story was only about infertility or adoption, then yes, this book should be finished. However, this book is actually about transformation and how the very thing you run from is the very thing you embrace because a journey with God changes your eyes, your heart, and your walk. While the warfare to build our family was now behind us, my days of fighting were far from over. There was a deep realization that everything I had been through was not only for me and mine. I was forever changed by all I had experienced and seen. Now it was time to be a voice for the voiceless and to willingly accept the call to missions I had resisted when I was teenager.

## Special Forces

Special forces or special operations personnel are highly trained and seasoned professionals who serve the US Military on land, air, and sea. Here are some of the more well-known monikers for these warriors: Army Green Berets, Navy SEALs, and the Marine Corps Raiders. Although special forces have played a role in the nation's defense since before America even fought for independence, it wasn't until 1987 when Congress created the Special Operations Command (SOCOM). This new division finally tied together all branches of the military's special forces under a single unified command to standardize training practices and to coordinate cooperation between special ops units when on mission.[1]

Members of these units are unconventional warfare specialists who are tough both mentally and physically. Whether they be SEALs or Green Berets, they are equipped with unique survival skills and live prepared for rapid deployment. They are required to gain cultural and

language training to enhance understanding of where they will serve. They are also trained in ethics, irregular warfare, leadership, and resistance, just to name a few of their specialties. Often called the "quiet professionals," special ops teams work in the shadows and behind enemy lines.[2] Much of what they do is classified and the public never knows about it.

Generally, members of these elite fighting forces have already served some other sector of the military. These soldiers are not new recruits, although you can request special ops service when you enlist or become an officer.[3] Experience matters significantly in this role though, so three years of honorable service are usually required before qualifying.[4] Members of special ops teams are usually older, more mature, married with on average two children, and are working on advanced degrees.[5] Education is so important to these units that SOCOM even has its own university in Tampa, FL appropriately named the Joint Special Operations University.[6]

## Getting Qualified

Everything I observed during my international adoption process concerned me. The system was so broken, both in Guatemala and here in the US. Redundancies, inefficiencies, lack of communication, and the sheer cost of the process created inevitable barriers between waiting children and their adoptive parents. On every level and in every capacity, all I saw were flaws. The more flaws I saw, the more my heart broke.

Whether it was my mama's heart or a ministry calling, I sensed a need to help and make a difference. I realize those ideals can be so vague and lofty. I also realized my limitations and station in life. My very first step into the role of advocacy was meeting the need for foster mamas in Guatemala. I came up with this idea to fill suitcases with supplies that adoptive mamas could carry in the country with them during visit or pickup trips. I called this new program Clothe-a-Child and got busy finding sources to donate gently used suitcases, recruiting churches and community groups to donate supplies, and raising funds

to ship the suitcases to traveling adoptive parents to take along the extra bag on their trips.

In reality, apart from the donations I took along on each trip, I only really accomplished sending a handful of other bags into Guatemala. This effort barely got off the ground for several complicated reasons. But I was moved to compassion and tried to find a way to make a tangible difference in the lives of those who were hurting and vulnerable. I really wanted to help the injustice I saw in the world, but I just didn't know how to find the path forward at that time. Clothe-a-Child was short-lived and quickly forgotten, but in my life, it was seed for a future day I couldn't even imagine.

One day after Dennis came home, I had a new thought: I needed to get qualified. It was just one of those moments where I really thought God whispered this direction into my ear. It was similar to the day I heard the whisper, "Isabelle," and I knew immediately another daughter was coming into my arms. But this time, what I heard was a compelling direction to "get qualified." I understood this immediately to mean go back to school and finish what I had started so long ago. I also knew this meant facing another fear, math.

The idea of going back to school awakened something inside of me that was different from just being a mom. It wasn't so much looking for a new direction or a new life goal; no, that wasn't it at all. I was busy enough with mothering the four at home, working to get the last one home from Guatemala, and fulfilling my role as children's ministry director at our church. There was a nice balance to my life and my commitments. I was content and not looking for a new chapter; going back to school was not in response to some mid-life crisis. It was also, I might add, a step I took before working through the post-adoption depression I experienced after Rebekah came home.

But if I'm being honest, the fact that I had never pressed in to complete my degree when I was younger was a life regret. I was insecure about my lack of formal education, which took a backseat to my rapid advancement in the airline industry and in becoming a mother. Yet here I stood at the age of forty with this feeling in my heart that there was a day ahead I couldn't yet visualize and a

prompting to get ready. I signed up for one history class the spring of 2008, refusing to look at the very long road ahead of me toward accomplishing a degree at the pace my life's circumstances would require. I decided to take a step forward even though I didn't actually know where I was going and in doing so, I took my first step in responding to a ministry call the Lord was soon to place on my life.

## Surrendering to a Call

In the final few weeks of my first semester of school, which I was loving by the way, I found myself back in Guatemala. Remember that time when I flew down to get a piece of paper, a very critical piece of paper, simply walked across the street? Yes, that's the trip! I was on my recon mission to free Rebekah and when that was finished—a whopping forty-five minutes later—I had a few days free to spend with my daughter.

One evening after Rebekah had fallen asleep for the day, I opened my laptop to access Joy FM's website. My favorite contemporary Christian music station had recently started streaming online and after days in Latin America alone, I was ready for some sounds of home. However, instead of hearing music I tuned in right as the DJs were sharing a tragic announcement about the family of singer/songwriter Steven Curtis Chapman. The Chapman's adopted daughter Maria had been tragically killed when her older brother accidently ran over her in the driveway.

I immediately fell to the floor in a mix of tears and intercession for the Chapman family. My heart was broken for them. This family and their testimony of adoption awakened my heart for a purpose bigger than me just a few years earlier. I would never have been sitting in that hotel room in Guatemala had it not been for their faithfulness to step out and speak up. As I watched my baby sleep in my room, they were preparing for a burial. It was unthinkable and impossible—an utterly un-rectifiable situation. I cried for them and prayed for them on this May night in Guatemala City, a complete stranger who could only carry

their burdens in prayer for a debt I could never repay this side of eternity.

Right in this place of brokenness and intercession for someone else something happened inside my heart. In only the way the Lord can accomplish, there was a profound unraveling of my story that led back to being in Mexico when I was twelve years old. In a moment of time the journey of decades suddenly fell into order and made sense to me. A miracle happened: God gave me new eyes. All of these years, in every heartbreak and in every dream realized, God had been working in the background of my awareness to create the heart of a missionary. A surrendered one. A called one. A sent one. My twelve-year-old "No" simply never deterred him away from my created purpose. He never gave up on me.

Craig Barnes writes, "Every time the Bible depicts a conversion experience, it brings with it a discovery of God and ends with a discovery of mission."[7] This is wholly what happened in my life on a May night in 2008. Once again with my feet standing on foreign soil, I surrendered to the call I had run from since I was a child. I didn't understand what it meant and I had no idea where I was headed, but before my head lifted from the hotel floor that night, I knew enough to declare that I was to spend the rest of my life being a voice for the voiceless.

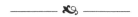

## He Makes Our Hands to War

Sometimes when you get clarity on a future direction, we as people want to roll up our proverbial sleeves, jump right in, and immediately get started. The problem with this approach though is that we tend to view solutions through what we already know, which can limit our long-term effectiveness. Just because we have a seed in our hand doesn't mean we have a clue what kind of plant will one day emerge from that seed. Thankfully, our Heavenly Father knows where we are headed and has the full picture of what he's called us to. If we are willing to let him lead, he will train our hands to war.

Psalm 144:1–2 says, "Praise the Lord, who is my rock. He trains my hands to war and gives my fingers skill for battle. He is my loving ally and my fortress, my tower of safety, my rescuer. He is my shield, and I take refuge in him. He makes the nations submit to me" (NLT). I particularly like *The Message* translation on verse one, which puts this idea in today's vernacular: "Blessed be God, my mountain, who trains me to fight fair and well." The description of this training here is really incredible. Our hands are our strength and tools that help our bodies function endlessly, the list of which is simply too long to mention. But our fingers are instruments of detail, imprinted on each end with our unique and individualistic identity. Think on this promise a minute, God teaches our strengths and our distinctiveness how to battle! He wants our very fingerprints to fight well and fight fair!

This Psalm was written by David, the shepherd boy who became a warrior king. David gives credit to God for his training, even down to the skills in his fingers. David was called to war, but he had to be trained how to fight. This training started while he was a young boy out tending sheep, long before he had any idea that a throne awaited him. He learned how to use his hands to catch and kill lions and bears when taking care of his father's sheep (1 Sam. 17:34–35). He also was an expert marksman because this shepherd boy brought down the giant Goliath with only a sling and a few smooth stones (1 Sam. 17:48–50). His fingers even knew how to use a harp as a weapon, as whenever David played this instrument for King Saul tormenting spirits would flee (1 Sam. 16:23).

Biblical principles are both natural and spiritual in nature. Throughout David's example we see this is true. He is both a man of war and a man after God's own heart (1 Sam. 13:14). David was also progressively trained and grew into his assignments over time. In his commentary on the *Treasury of David*, Charles Spurgeon wrote, "Untrained force is often an injury to the man who possesses it, and it even becomes a danger to those who are round about him; and therefore the psalmist blesses the Lord as much for teaching as for strength."[8] We know this to be true in David's life, because the Psalms record for us that the king learned as much in his failures as he did through his successes.

There was a lot of training involved in David's life, and much of that was done alone and some of the training was even done in the dark. David was catapulted into rock star level fame in Israel when he vanquished Goliath, which led to King Saul's obsessive jealousy with the handsome, young warrior. This dangerous situation put David on the run for his life. David hid in fields, hid in caves, and hid in cities throughout the land of Israel while Saul pursued him with evil intent. During this time, David was accompanied by a few valiant soldiers and confidants who came to be known as his mighty men. They might have dwelled in caves and moved in the dark, but their exploits in battle were renowned (2 Sam. 23:8–39; 1 Chron. 11:10–37). In my humble opinion, David and his mighty men were to Israel what special forces are to the modern military.

## Back to School and Back to Work

I came home from Guatemala in May 2008 knowing that Rebekah's case was finally moving forward again and that I was moving forward in my journey to advocacy—whatever that meant. I also knew that part of qualifying myself meant facing math, which was a big reason I stopped taking classes back in the day anyway. Based on a bad teacher experience in high school geometry, I convinced myself math was a giant I couldn't conquer. Funny thing about giants though, sometimes you just need the right weapon and the right stone.

So many math skills had left my mind by the time I was forty years old that I would now need a total of five math classes in order to get through college statistics. Yikes! Even with counting summer classes, that's a long season of problem-solving. But thanks to these two new toddlers in my home, I had a few years of diapering, nap times, and potty-training ahead of me again. Saying yes to God meant saying yes to getting qualified, which meant saying yes to math. And so humbly, I figured out how to swing two days a week on campus to relearn this core competency.

An odd thing that happened during those five semesters, I discovered a love for math! I had to practice a lot; don't get me wrong.

I'd sit on the pool deck while my kids were swimming or at the table after dinner while they were watching TV and faithfully do my daily homework. This thing I'd avoided for decades, I not only enjoyed, but was quite good at! There was a sureness and confidence that came by applying a formula correctly and getting a right and testable answer. I think that is why I enjoyed the pleasure of solving a math problem because it was so much simpler than other problems life had thrown my way.

When it was all said and done, I completed statistics with an A the same semester I wrapped up all of my other general education requirements at the community college in the spring of 2010. I was accepted into Regent University's online Government/International Relations program which I would begin in the fall. It was a slow train forward, but I was making progress and enjoying being a student again.

During this time period however, it was becoming clear I might need to return to work earlier than we had ever planned. Tim was still in ministry at our church, but we were losing healthcare coverage due to the rising cost of insurance. Plus, we needed more income to support our large family and to pay off adoption debt. With birthdays only nine months apart, our babies were going to be in the same grade at school. In the fall of 2010, both of my littles were scheduled to begin four-year-old preschool. Though I really hoped to have a year at home after all my kids were in school, life circumstances pressed this timeline and forced me back in the work force after thirteen years as a stay-at-home mom.

As you might imagine, this was a painfully difficult decision for all of us. My twins were heading into third grade and Lydia was starting eighth grade. My kids had only ever known a stay-at-home mom. Not only that, but I was also very active in their school, running the parent organization and publishing the school yearbook. The kids all attended the K-12 Christian school at our church, where both mommy and daddy had offices. Going back to work meant walking away from all of these norms and connections in our life. When I say this was a hard decision, I'm telling you it was gut-wrenching.

The other challenge was that I had no success finding a job in adoption advocacy. I couldn't even find a place to volunteer. I was so confused because I had accepted and surrendered to the call, and by now had spent a few years working on my degree, but found no place to give my life in this new field. I couldn't go back to my airline, which had been sold to another airline a decade before. After months of searching, it became clear I couldn't go back to where I'd been or go forward to where I wanted to be. One day I had a thought to see what other travel industry positions I could find in the St. Louis area. To my surprise, I learned that both Drury Hotels and Enterprise Rental Cars had corporate offices in the city. I applied for both and within two days I was offered interviews with both. Not long after, I accepted the position at Drury Hotels and with a heavy heart started back to work in August of 2010 in a new aspect of the industry I had said goodbye to thirteen years earlier.

## Growing in the Dark

My first year back at work was impossibly hard and there were so many, many times I wanted to give up and run back home. All of us, including Tim who was shouldering more of my daily burden with the kids, faced some type of mourning about this change. Once again, I found myself commuting from my home on the east side of the Mississippi to the opposite side of the city. I was back to the daily St. Louis traffic, returned to corporate life with all that entailed, and gone from family for about twelve hours per day. I did enjoy the camaraderie of new friendships and learning about a different side of the travel industry, and our kids enjoyed those special discounted hotel nights we tried to schedule on a regular basis as a reward for this new life. However, I found myself living for the weekends when I could step back into the role I loved the most: full-time mommy.

One day right around my first anniversary with Drury, I woke up and heard the phrase "night auditor" rolling over and over inside my heart. This was a new thought for me, so I was quite sure it was a God thought. I went to work that day and asked my boss what being a night

auditor entailed and if there were any openings. She wasn't sure the position was a good fit for me overall as it would mean working alone on a property at night, wearing a uniform, along with demotion and most likely, a pay cut. I thought about her input overnight, but the next day asked for permission to officially apply and pursue a night auditor position. I'd learned enough in my walk with the Lord to know that following his ideas for my next steps was the best direction forward.

Now let me tell you a few things, I am not a night person. My name, Dawn, was not a mistake. I am a day person through and through. I am also a social person. The idea of staying up all night, working alone, and moving my career even further backward after staying home for thirteen years were not appealing on any level. But the truth is that I loved my family more than any of these issues. There was a Drury property five miles from my house with an opening for night auditor. I would be able to work three ten-hour shifts per week, leave home each night after my kids went to bed, and be back each morning before they left for school. Although I took a pay cut, I also cut gas, meals out, and dress clothes out of our budget. And most importantly, I kept our family's health insurance. I easily said yes, the transfer was made, and a few weeks later I started my new position.

I'm not going to lie, the two and a half years I spent working midnights were tough and long. How hard, you ask? These years were lose-most-of-your-eyelashes hard. My body clock simply never turned from day to night. Even with four days off per week, I struggled to get enough sleep. I also faced several scary situations alone on that property, sometimes circumstances where I needed to involve the police. Oh, the stories I could tell you about the craziness that happens in a hotel at night! For the most part though, the work itself was boring and routine. It was also largely unsatisfying, not aligning with either my previous professional experience or my future aspirations.

But some unique things happened because I said yes to this position. Turns out, God carved time in my life for me to finish my degree while still getting to be a hands-on mama to my miracles. Any night auditor will tell you there is usually some downtime in the job. On the nights that flowed like clockwork, I would have several free

hours each night to work on my schoolwork. Coffee became my faithful companion, always helping me focus on Aristotle and Plato's political philosophy during those wee hours of the morning. I wrote more papers and discussion board posts dressed in my work uniform than you can possibly imagine. The other thing that was happening is that I was getting stronger against fear and learning to not be so easily shaken by circumstances.

This night season in my life actually occurred during a night season. God continues to crack me up at how he can literally and figuratively communicate truths to our lives. Like the roots of a tree, I was growing and getting stronger in the dark. I've come to realize that it is only during the nighttime where you are able to straddle two different days: the one that is ending and one that is beginning. For me, these two different days represented closing out my career in the travel industry and beginning my career in advocacy.

During my final few classes toward my bachelor's degree, and after a few years of waiting and growing in the dark, I volunteered for a nonprofit dedicated to protecting international adoption. This organization was in the middle of a nationwide tour of a feature film called *STUCK* to raise awareness and promote the idea that children belonged in families, not institutions. I should mention the fact that I was also able to complete some of my volunteerism while on the job as well, because it turns out that the tour needed help booking hotels for the team traveling across country with the film. As 2013 ended, I found myself resigning from Drury Hotels. My volunteerism led to a paid position on the team, which I excitedly accepted beginning January 2014 to run faith-based initiatives for the Both Ends Burning Campaign.

Four months later, at the age of forty-six years old, I walked across the stage at Regent University in Virginia Beach, VA and accepted my BA in government, with an emphasis in international relations and foreign policy. Finally, the new day emerged, and the training was complete, six years after my surrender in Guatemala City.

## Looking Back

Looking back on these years, I see some comparison with special operations forces. Once again in this book I'm humbly asking you allow me to extrapolate a comparison from Scripture and the military, without in any way comparing my story to that of King David's Mighty Men or US Special Ops. Clearly, I'm not trying to compare any physical endurance or prowess here. Though I used to be able to tumble across a gym floor with enough handsprings to spell out T-R-O-J-A-N-S, none of my adult careers prepared me for extended periods underwater for rescue missions or the ability to march for days in camo for a covert mission. Also, I've never spent years living in a cave, running from a king, or preparing to be a king!

But there are definitely some literary comparisons that stand up here. First off, as we explored early in this chapter, members of special forces have battlefield experience, have special training, generally are married with children, and are typically older. By this point in my story, I was the veteran of two prolonged wars, had completed special training, and at forty-six was definitely more mature than new recruits. Special ops personnel often speak several languages and have traveled extensively. Again, applying these concepts conceptually, I too had widely traveled and spoke several languages from the travel industry to church culture, to infertility culture, as well as the adoption culture. In fact, it was my ability to speak "travel," "church," and "adoption" that initially opened the door for me to volunteer and work in the field of adoption advocacy. And while I don't have marksman expertise or even know how to handle a gun, I have learned quite a bit about spiritual warfare, including an unshakable trust in my Commander and his promises. Finally, members of a special ops team are fearless and relentless. While these characteristics will always be a work in progress, my adoption journey and time working night audit both worked to prepare me to be a fearless and relentless voice for the voiceless.

# 19 Finally, A Missionary

## New Eyes, New Heart, and a New Walk

*A man must know his destiny. If he does not recognize it,
then he is lost. By this I mean, once, twice, or at the very
most, three times, fate will reach out and tap a man on the
shoulder. If he has the imagination, he will turn around and
fate will point out to him what fork in the road he should
take, if he has the guts, he will take it.*
—General George S. Patton

I first heard Dr. Curt Thompson speak about neuroplasticity and the brain's ability to grow and transform at a conference a few years ago.[1] Dr. Thompson shared that neuroplasticity at its simplest form means that our brains continue to grow and change. It used to be thought our brains were only able to grow throughout adolescence; however new research is proving otherwise. To be certain, plasticity in children and teens is more flexible, but those of us beyond this age demographic should be encouraged to learn that emerging research suggests that change is possible throughout life. Dr. Thompson explains, "The notion of neuroplasticity—the notion that we can reconnect, that neurons can be connected to one another in ways that we didn't think they ever could be before—leads to the reality that our minds can change."[2]

This idea arrested me for many reasons. First off, raising a few vulnerable children from hard places, it was hopeful to hear that our

brains can heal in some measure from trauma that occurs at an early age. Also, as someone in the middle of life, it's reassuring to think that growth and change is still possible. But most significantly, this understanding validates principles in Scripture that instruct us about the importance of renewing our minds (Rom. 12:2; Eph. 4). Not that we need science's stamp of approval on biblical concepts to make them true, but it is pretty cool when that happens!

Listen, God knows what it takes to change us! As our Creator, he knows exactly how many times we need neurons to fire in a certain way to expand our understanding and create a new pathway in our minds so that our souls and bodies can respond accordingly. The Bible tells us, after all, that God is the author and finisher of our faith—meaning he remains at work in our lives until the end of our story.[3] Sometimes these changes happen quickly, but most of the time getting new eyes, a new heart, and a new walk happen because of a long obedience in the same direction.[4]

By this point in my story, I have been on a journey with God for many decades. The more I walked with him, the more he changed me. My Commander transformed the way I viewed issues and situations because he was changing my vision and my hearing. He was giving me a heart for his issues, and in doing so was changing my future walk. He was positioning me for ministry away from the life I had known up to this point. There was a new commissioning on the horizon, and this time—nearly forty years after I first heard the call—this time my answer to follow would simply be, "Yes."

## The Uprooting Season

Life is always in a constant state of change and progression. Whether we like it or not, unrelenting time constantly propels us forward into the next moment, the next day, and the next season. Our babies inevitably grow up, even long-awaited babies. While some changes are exciting and anticipated, life also brings you changes beyond your control. That is the commonality we all share and one that bonds us together as humans: none of us know for sure what tomorrow holds.

# FINALLY, A MISSIONARY

Over the course of a twelve-month period from June 2014 to June 2015, we found ourselves being slowly uprooted from the only life we had ever known. Tim's time in ministry ended and he returned to a career in the building materials supply industry. Lydia was graduating from high school and making plans to attend college about an hour away from home. Our children's Christian school was closing its doors after more than thirty years and we had decisions to make about a new school in the fall. Then, a few days before leaving on our annual Florida vacation in May 2015, I received a call that the nonprofit I had been working for full time for eighteen months now was radically changing directions and my position was no longer needed.

Tim and I were in shock. What was happening? After everything we'd been through and all we'd pushed through, why were our lives falling apart? Did we miss God in everything? Why did our lives seem to be continually hard? While we celebrated Lydia's growth and next steps, the other changes in our jobs, our church and ministry, and our kids' school were somewhat unexpected and difficult to absorb. As a couple, we'd been through more than our fair share of challenging life events, but this period of time was so challenging because there were monumental shifts in every area of normalcy on which we had built our lives. On the brink of our thirtieth anniversary, we were watching something transpire that we did not comprehend. We did not see that all of this uprooting was necessary because we were about to be transplanted someplace new entirely.

Reeling from the sudden and completely unexpected loss of my job, I jumped into exploring open options for a position in the adoption advocacy space that was either remote in nature or based in the St. Louis area. The night before leaving on vacation I found an open position in Florida that intrigued me. I'll never forget yelling up to Tim from my basement office, "I found an interesting prospect for a job, but it's in Florida."

He replied, "You should go ahead and apply, just for kicks." In a total what-do-I-have-to-lose mentality, I applied for the Orphan Care Coordinator position at the Florida Baptist Children's Homes (FBCH).

I whimsically noted in the cover letter that I would be in Florida for the next two weeks should they desire to interview me in person.

Three days later while wading through a saltwater slough, making my way to a beach on Marco Island in Southwest Florida with my five children in tow carrying all manner of sand toys and beach paraphernalia, my cell phone rang. Thinking it was Tim who drove us to Florida but had to fly back to St. Louis for a few days, I answered with a, "Yeah" without looking at the caller ID. "Hello, this is Florida Baptist Children's Homes; we are calling about the application you submitted for a new position on our team. Do you have a few minutes to talk now?"

And with all the professionalism I could muster, I just started to laugh.

## Leaning into Something New

Living in Florida had been a dream of mine since the first time I saw the ocean when I was eleven years old. For every year since, with either my parents or my husband, I have spent several weeks in Florida. Although moving to the Sunshine State one day had always been our dream, we just assumed it would happen later in life once our children were grown. The majority of our family and all of our roots were on the Illinois side in the St. Louis Metro East area. The idea of moving away always seemed more of a fantasy than a reality, as our lives were securely tied down to this area. Until suddenly, they weren't so tied down anymore.

Normally we spent time each summer in Orlando or one of the beach communities on the Atlantic side of the state. Thanksgivings were often spent in the Panhandle. But in June 2015 we decided to vacation on Marco Island, someplace we had never been before on the Gulf side of the state. We were welcomed to this region by rainbows and starfish, sand dollars and handfuls of perfectly formed Florida conch shells. Even before the call from FBCH came in, we were delighted by the switch and all of the unexpected blessings we were finding in Southwest Florida.

268

# FINALLY, A MISSIONARY

During our week on Marco, I completed two phone interviews with FBCH and was scheduled for an in-person interview at the agency's headquarters in Lakeland the next week while we were vacationing with my parents in Orlando. I learned that this open position was based in Sarasota, another city in Southwest Florida that I had never visited before. As our family bounced in the warm, gently rolling Gulf waters together each night looking up at what seemed to be a sky filled with endless rainbows, we marveled at the great mystery beginning to unfold for our family. Was this really happening?

On the day we made the trek from Marco Island to Orlando, the Lord dropped the story of Joshua in my heart, specifically the events of Joshua 1. On the cusp of a new day and the fulfillment of abundant promises, the Lord spoke to Joshua and promised him that "wherever you set foot, you will be on land I have given you" (vs. 3, NLT). After the death of Moses and forty years of wilderness wandering, Joshua is instructed by the Commander of Heaven's Armies to be strong and courageous in this venture and to boldly go in and take the Promised Land.

Clinging to this story and taking a small step of faith, we decided to take a little detour on our route to Orlando to drive through Sarasota and check out this potential "promised land" for our family. The kids were unsure what to think, and while somewhat excited about the idea of living near the beach, they were also aware that every step I took forward down this path meant one step away from the only lives they had ever known. We drove and talked, prayed and laughed, and "spied out" the new land. Could this unknown, flat beach community ever be home? They doubted, but I did not. Too much had changed in me for too long now, and I sensed a holy commissioning about this moment. I didn't understand how, but I did know that through God the impossible was somehow possible.

My interview in Lakeland went very well and I felt a strong and immediate connection with my prospective employer. I could see myself working on her team, though my work would move me away from adoption advocacy and more into other child welfare related causes including foster care and anti-trafficking. I learned they decided

to interview me while I was in the area, although it would be about six weeks before they were ready to select a candidate. As I drove back to Orlando after the interview simultaneously weeping and worshipping, I just kept repeating what was soon to become my new life verse: "Be strong and courageous. Do not be afraid or discouraged. For the Lord your God is with you wherever you go" (Joshua 1:9, NLT).

## The Cost to Follow

After my interview with FBCH, we all agreed to lean into this new direction and quietly wait on the Lord. Although, based on everything that happened on our vacation, Tim and I had a strong sense that relocating to Florida was very likely going to be our next step. Everything about the Orphan Care Coordinator position had my name on it; in fact, as friends and family read the job description the comment was always the same: "It's like this job was made just for you. "But there were several obstacles ahead of us, or figuratively speaking, there were many "giants" ahead of us in this prospective "promised land."

Foremost there was the matter of our precious Lydia who was scheduled to leave for college in mid-August. She had selected a school about an hour away from home so that she could have an away experience but also remain connected at home. As everyone knows, college decisions are long and complicated. Her scholarships were all in place and by the time we'd have any job offer in hand, it would be too late to switch her plans and follow us. This meant that saying yes to Florida meant leaving my beloved firstborn in the Midwest. The idea of transplanting without her was a bit more than my heart knew how to handle. We had many long and honest conversations together about these new developments and how we could each navigate life apart. I honestly wanted to know her thoughts on our move and valued her input. In the end, she simply said to me, "Mama, if they call, you go."

There were my parents and Tim's dad, important relationships we needed to factor into the decision. We wanted their blessings, which

270

was freely given though we all knew this move would bring significant changes from adult lives we'd built together with our parents. I was also saying goodbye to my siblings and a dozen or so nieces and nephews, young ones I'd loved since the days of their births, several of which were constant fixtures in my home and best friends with my children. Moving across the country would inevitably change our daily interactions with each other and also the traditions we'd built together for holidays and birthdays and all of life's other special celebrations.

We also had to consider Tim's relatively new job with a national building material supply chain. He was happy and settled, after experiencing a big employment change not quite a year before. Tim knew that his company had branches throughout Southwest Florida, but he had no assurance of a transfer and didn't want to inquire about the possibility until there was an offer in my hand. Finally, there was the matter of our refurbished farm home that would need to be sold or rented, neither of which we were prepared for.

Yes, there were indeed many giants that stood between us and Florida. But giants were never meant to keep the people of God out of their promised land. While we waited to get a job offer in hand, we dealt with each giant one by one, leaning into the direction of leaving, quietly and relatively quickly, setting our worlds in order to go. I actually set a calendar for moving, one that, incidentally, turned out 100 percent to be on point and accurate down to the day we pulled into Sarasota. We held a giant yard sale, researched schools, and next steps for the rest of the kids, prepared to list our home for sale, and started to look for places to rent as we waited for July to pass. I also started to educate myself on foster care, the community problems this position was being established to address and learned more about the history and work of FBCH.

The phone call came in at the end of July and I was officially offered the position in Sarasota. I was given a few days to make this life-changing decision, although I was pretty sure I already knew the answer. After we stopped shaking, laughing and crying that this was really happening, it was time to pull the trigger on Tim talking to his boss about a transfer and putting our home of seventeen years on the

market. We spent the week in prayer with family and our closest friends, as we considered everything that had transpired over the past six weeks to lead us to this moment.

When Friday arrived, Tim still did not know if a transfer with his company would come through. Although his boss was supportive of his decision to relocate, we needed a manager in Florida to pick up another salesperson. We would simply not have the decision about his job before I had to give the answer on my offer, which was nuts because my salary package was a lot less than his. It made absolutely no sense to say yes. And yet, if there is one thing my God has proven to me over and over in this life, it's that he is in business of accomplishing the impossible.

I called Tim that Friday at work and said, "Well, it's decision day. What do you want me to do?" He paused and then told me a story about famed motorcycle daredevil and stunt performer, Evel Knievel. "Dawn, after planning his route, checking his bike, and practicing his plan, there comes a time when all that's left to do is jump. It's time for wheels up. Call and accept the job." Moving ahead on my husband's modern-day parable, with huge details still unresolved about the viability of moving our family to Sarasota, I accepted the position of Orphan Care Coordinator for FBCH.

## Immediately

> As He walked by the Sea of Galilee, He saw Simon and Andrew his brother casting a net into the sea; for they were fishermen. Then Jesus said to them, "Follow Me, and I will make you become fishers of men." They immediately left their nets and followed Him.
>
> —Mark 1:16–18 (NKJV)

As I've already explained, we came home from vacation in June and spent the next six weeks cleaning closets, downsizing, and quietly getting prepared...*just in case.* In doing so, this scripture began to take

on a new meaning for me. I've been struck by how **not** ready I was to drop my "nets" and follow immediately if the time came to respond to the call.

When FBCH did offer me the position at the end of July, I spent another week pondering the call and the next three weeks packing, selling, downsizing more, and messing around with all of our "nets." Finally, we schlepped our stuff eleven hundred miles in a twenty-six-foot moving truck and then spent the next three weeks unpacking, downsizing even more, and getting settled into our new home. By my count, I spent three months of my full-time energy pondering the possibility and dealing with my stuff in order to "follow immediately." And this troubles me.

This experience helps me frame Mark 10:17–27 in a different light now. It's not that the rich young ruler didn't love the Lord and want to follow him. Rather, it's just really hard when you are loaded down with earthly treasures. I don't mean to oversimplify this passage because I know there is more going on here regarding salvation, but let's focus on verse 24 and 25 a minute: "Children, how hard is it for those who *trust in riches* to enter the kingdom of God. It is easier for a camel to go through the eye of a needle than for a rich man to enter the kingdom of God." (NKJV, emphasis added). This verse isn't some riddle about a camel going through the actual eye of needle; it is referring to the city gate camels needed to pass through, and when they were loaded down with "stuff" it became impossible to enter.

The point I'm making here is that our "stuff," our earthly treasures, the accumulations of trinkets from living in a post-modern consumerist culture (ouch!) often makes it really hard to follow immediately. It's not that we are rich by today's standards, but we are burdened down by the stuff of life. After rounds of downsizing I still needed a twenty-six-foot moving truck to follow my call, which I'm pretty sure wouldn't even fit on the back of a camel much less pass through the eye of the needle gate! I believe this is the timeless truth Jesus is making here: We so easily get burdened down by the cares of this world (Heb.12:1), and sadly too often measure our treasure by

things (Matt. 6:19), that sometimes we miss the invitation to follow when it finally does come.

I'm certainly not saying we can't have possessions; not everyone is called to live on a mission field. I believe putting down roots and getting established in a community is critical to the kingdom mandate to transform the earth. Certainly, that has been the call on my family for the last generation regarding the city of Collinsville, IL. But we are all called to walk away from the cares of our life and follow Jesus. To follow immediately begs us to be ready. What does your call look like? Are you ready?

## Transplanted to Florida

Do I record the funny, light moments of our journey to a new home in Florida, or do I delve into the deep emotional undercurrents of the transition? These two extremes exist in a constant tug of war in this paradox we lived through in August of 2015. Either is appropriate; neither alone seems quite fair. The "I'll be seeing you" coincides with the "we've been praying for you" in every single situation.

I keep returning to the word bittersweet. Bitter and sweet mixed together in a singular sensation that cannot be separated from each other. Every part of this journey holds the highest of highs and the lowest of lows, sometimes at exactly the same moment. We've endured such monumental shifts on so many fronts in our world that I don't even recognize the landscape anymore. There is no more normal. Even in that truth I find relief and anxiety, both sides equal as I set about to build a new home eleven hundred miles away from the only home I've really ever known.

Yet, I hold to the promises before us in the new land. The promise that has been whispered in my heart since this journey began to crack open only a few weeks before our cross-country move was "wherever you set foot, you will be on land I have given you" (Joshua 1:3, NLT). Interestingly, three times after this promise is given in Joshua, God tells his people to "be very strong and courageous, do not be afraid or dismayed." I guess God knew that being afraid and dismayed were

easier than being strong and courageous. There may not be actual giants in Sarasota, but we faced plenty of giant circumstances to get there.

But oh, how amazing is this new land we've been called to occupy! The promises before us are so rich, the area so beautiful, the work so promising, the staff so welcoming. Although my heart aches for my daughter, our family, and our friends, I believe the bitterness will fade and only the taste of the sweet will prevail. The glorious unveiling of a new (and unexpected) assignment and the lifetime fulfillment of our heart's desire to live by the beach are both very sweet and very precious.

Finally, a missionary, a sent one, and in a true full circle moment, back to my early foundations in a Baptist organization no less. Called to raise my voice for those without a voice, to find parents for children who desperately need them, to speak out against injustice and raising awareness about the needs of the fatherless. This process—my entire story—is simply the miracle of transformation and redemption that only comes through repentance and surrender. I am called to war. Where my Commander leads, I will follow. To his call, I will always say, "Yes."

Eyes ahead and not behind, hearts filled with courage and not fear—hold on friends, it's time for a new chapter in our life story. I'm calling this one *Begin Again*.

# 20 Closing Thoughts

## Expect the Victory

*Victory at all costs, victory in spite of all terror, victory however long and hard the road may be; for without victory, there is no survival.*
*—Winston Churchill*

You have taken a very long, difficult, yet redemptive journey with me. What played out over a twenty-three-year timeline in my life, you've likely taken in a matter of hours, or a few days. Having my life story consumed in this way is a difficult concept because you might judge how we walked, the decisions we made, or the faith we embraced. However, this book was not written for you. It was written because it burned on my heart, for decades. The outline for this story was drafted before most of my family took breath and took root for many years shoved in a drawer while my miracles grew up. Ultimately, this book was written for my children and their children. *Called to War* is my memorial stone from many death days and battles fought, but more importantly it is my testimony to the unstoppable and transformable power of resurrected life.

However, if you are reading this book and you are not one of my kin, I wanted you to know a few things. First off, I have prayed without ceasing for all who might read this material as I was drafting every page. There were many, many times I was simply the scribe for what the Lord wanted to say. If at any point you think I am speaking to you, please know that in the infinite mysteries of our King and of his kingdom, I believe this to be highly probable. You may not fight the

same battles I have fought in my life, but the concepts and ideals of transformation are not unique to my journey. Whatever path you are traversing, whatever has been denied or wherever you are in pain, I know confidently God has a purpose and even more importantly, that He is right there by your side. You are not alone. Trust him to lead you, guide you, and direct you as you discover the truth about your unique purpose and his exquisite plan for your life. In one of my favorite quotes of all times, Frederick Buechner writes, "Our calling is found where your deep gladness and the world's deepest hunger meet."[1] I pray that your situation leads you to find this deep gladness in your life.

Though it may feel like it, I don't tell all of the stories or detail every event that took place during any specific section of this book. There are so many more stories I couldn't add but they colored in everything we were living at each stage of our process. There were the stories about several amazing young women who lived with us, each of them having a specific purpose to open our hearts to the next step in building our family. Or the one about the baby girl we said no to before accepting Rebekah's referral because of health complications, and my repentance over this years later the more God corrected my vision and my heart. Then there was the unbelievable timing of Tim growing critically ill with undiagnosed Graves' Disease after Rebekah's homecoming and how my children came so close to losing their dad. How about the miracle of me finally getting a dog I could live with, despite a lifetime of allergies and confirmed medical tests that continue to show the highest possible allergic reaction to canine. Oh, there are so many stories, so much processing in becoming, such endless grace and mercy in our journey through this life.

Where the stories of others overlapped mine, I chose to minimize content in areas; this includes my husband and all of our children. *Called to War* is my story told from my perspective. Where my story intersected others, I tried my best to protect primary details that were not mine to share. I also tried not to foreshadow outcomes and to tell the story as it unfolded chronologically in our lives.

My wars are not over. Each of our children has their own story, their own battles and now we are called to fight alongside them too. Many days the words and emotions poured into *Called to War* were birthed out of the struggles they face, the pains they experience, the fear that threaten, and the understanding that everyone must have their own recruit experience. My children are the impetuses and the continuation of each revelation I have received throughout the course of writing this book, although I never used them as examples as to not foreshadow or disrupt the natural progression of my testimony.

I'm learning that raising five babies is one thing, while launching five people is another matter entirely. As I finish this part of the book, five years have transpired since we made our cross-country move to Florida. Lydia has graduated from college and is in her second year serving in Guatemala as a missionary. Michael and Isabelle are just stepping out of the house into each of their own separate and individual chapters—his in Seattle and hers in Miami. My youngest, Dennis and Rebekah, are days away from starting eighth grade and their last year in middle school. After thirty-four years of longing to be a mom and being a mom, I am trying to find my footing in all of these normal, yet challenging, life transitions as our children leave the nest.

Life continues to be as colorful, the journey with God never-ending, the Magna-doodle-led life is who I am. I am now on the brink of birthday number fifty-three. Tim and I were also set to celebrate our thirty-fifth anniversary next month back in Hawaii, but COVID-19 has postponed that trip. In a few days I will begin my final year of graduate school at Southeastern University, completing a Master of Arts Degree in International Community Development. We still own the farmhouse in IL, though the Lord has kept it rented all of these years since we moved to Florida. Miraculously, I have a Siberian Husky named Ky. Funny to think about the fact that I waited longer to have a dog than I did my children!

In May 2019, the Lord quickly and unexpectedly moved me from FBCH to work for Operation Blessing, the humanitarian arm of CBN that provides strategic relief for the poor and suffering in thirty-nine countries. The work we are doing for children everywhere through

clean water, medical care, hunger relief, and disaster relief was an opportunity I could not pass up. This role has also afforded me the benefit of working from home, which was a huge blessing for our family. We just never know what our good and perfect Father has in store for us until we surrender our desires and pick up his heart.

On one of my final days of drafting, I heard a whisper, "Expect the victory." What a powerful thought—and a new one for me! I don't think I've ever looked at my situation from that perspective before! Oh, how grateful I am that my perfect and patient Heavenly Father continues to help me see things from his perspective and that he never, ever gives up on changing what I see, the condition of my heart, and where I walk.

Selah.

# ADDITIONAL RESOURCES

Now that the book is finished, there are a few points I'd like to circle back to and expand on briefly related to the major themes in the material:

## INFERTILITY

Over nineteen years after my seventh IVF and four household moves later, I can't bring myself to get rid of my IVF paperwork. I still have the daily instructions for every cycle, pictures of all of my embryos, and summary charts on each procedure. It's also still hard to reduce this part of my testimony into a few sentences, as it always seems shallow and a disservice to the twenty-three-year process to even try and sum it all up. I mean, clearly, as you now know the story can fill a book!

Early into my infertility journey I read a statement that really disturbed me: "My infertility resides in my heart as an old friend. I do not hear from it for weeks at a time, and then, a moment, a thought, a baby announcement or some such thing, and I will feel the tug— maybe even be sad or shed a few tears. And I think, 'There's my old friend.' It will always be a part of me."[1] At the time, I rejected this idea entirely. Today, I totally get what the author of this quote meant. From my viewpoint now, infertility is both my enemy and my friend. The truth of this statement is why I can't simply discard my IVF paperwork. Although Tim and I now have a "quiver full" of children, we remain infertile. It has never really gone away; it's grown with me and become part of who I am.

If you are struggling with infertility, please know that you are not alone. According to RESOLVE, the National Infertility Association, one in eight couples face infertility today.[2] That is a staggering number and one that just keeps growing. When we first saw a doctor for help, that number was more like one in ten couples. There are many reasons why people have difficultly conceiving. My understanding is that roughly 30 percent of the time infertility is caused by female factors, 30 percent of the time it's male factors, and 30 percent there are problems on both sides, or the infertility is unexplained. Regardless of

the reason, it's a lonely diagnosis and one many couples decide to carry in silence. For me, it became important to associate with others who understood how I felt and the pain I carried. I encourage you to get involved in online discussion groups for emotional support. In addition to the support offered by RESOLVE, there are many wonderful faith-based support groups on Facebook and other online forums. I've listed a few recommendations on my website at www.DawnAmsdenStark.com.

Facing the truth is also very important. It may be tempting to ignore the problem thinking it will go away and you will "get pregnant next month." However, according to the American Society for Reproductive Medicine, you should seek medical assistance if you are unable to achieve pregnancy after twelve months of unprotected intercourse and the woman is under the age of thirty-five, or six months if the woman is more than thirty-five years of age. You should also seek medical care if you have had more than one miscarriage.[3]

Speaking of medical advice, I have two words I only wish someone had shared with me: **Reproductive Endocrinologist.** Please, please, please do not waste your time, money, and emotions on discussions and treatment plans for infertility with an OB/GYN. I don't care how much you love them or how much they assure you they can help. I wasted so much time with doctors who are not specialists in this area. Seriously, if your doctor offers you a round of Clomid to help you conceive, run the other way. A reproductive endocrinologist will evaluate both partners to determine the exact nature of the problem and then present a targeted treatment plan. I cannot tell you how amazing it was to finally connect with a team of professionals who truly understood and could treat our problem. Understanding there is not always a solution and that carrying a baby to term might not be possible, there is still tremendous peace of mind that comes from finally getting to the truth and understanding your options.

For us, treatment meant in vitro, specifically ICSI, but that is not always the case for everyone. As you've learned in my story, we were in the unique position of being ahead of the technology curve and had to wait on the refinement of the procedure we needed. There are

several other levels of medical intervention that are not as expensive or intrusive.

## INTERNATIONAL ADOPTION

For the time frame in which we adopted from Guatemala, our cases went through relatively normally. Nearly everyone trying to get their children out of the country before the shutdown experienced some sort of delay or misinformation; too many of us experienced some level of fraud. We were by no means unique in our experience. The challenges we faced, on top of more than twenty years of infertility, are why I share my story, especially the fact that our agency went out of business and we were left alone to complete this complicated journey.

There were about five hundred children stuck in Guatemala when the shutdown finally arrived on December 31, 2008. Families struggled for years, with their hearts and finances spread across two countries, to try and complete their adoptions under the new rules. Sadly, even as of the writing of this section there are still a few left that may never be completed. One brave and relentless mama I know personally lives in Guatemala to spend time with her son who is growing up in an institution. She is the only mama this now teenager will ever know. She never gave up.

Intercountry adoptions from Guatemala remain closed today, and it's highly unlikely the program will ever resume. Foster care is being established in the country, although it has miles to go before it becomes a widespread, sustainable solution in child welfare. Many non-governmental organizations (NGO) now also have a presence in Guatemala to strengthen and support vulnerable children and families through sponsorship programs and orphanages, neither of which are the most ideal or sustainable long-term solutions for children or the economy, but they are sufficient to meet the needs for children without parents in the current environment.

I'm still of the firm belief that children should never be institutionalized. Children deserve families, and national borders should never stand in the way of providing a child with loving parents. That said, time has shown the manner and the methods in which IA was conducted many times created a business of adoption which was

actually detrimental to family systems and vulnerable children in the long run. The orphan care movement as a whole, led by the excellent work and research of CAFO and other respected child welfare advocates, is leading the way in taking an honest look at past behaviors and systems to implement best practices to protect children and strengthen families. The general consensus today is that in-country solutions should always be developed and prioritized over intercountry alternatives.

Adoption was a new sound in my ears, but we were not the only ones hearing it. There was a spirit of adoption flowing over the earth and many were answering the call. Tens of thousands of families opened their hearts and homes to children from foreign lands at the height of the international adoption movement. Many, like us, genuinely felt called to IA. I do not doubt in any way that Dennis and Rebekah were meant to be my children. However, IA—even done carefully by removing economics from the equation—will simply never be a broad enough solution to solve the global orphan crisis. The solutions we are beginning to see implemented in many countries today through NGOs using best practices for community development are simply broader and more transformative to culture than any solution IA ever offered children.

From my limited perspective, experience, and education, I believe that God used IA to open the eyes and the hearts of many people to see the true plight of vulnerable children around the world. The hidden suffering of tens of millions was exposed, and those without a voice for so long found their stories being told. This awareness led to a handful of children being adopted over a few decades by families like mine. However, I propose that IA was just the starting point of global transformation and justice for children. Many, including me, made the mistake for a while by believing IA was the answer. Maybe, just maybe, IA was actually the seed planted through the redeeming act of love deeply into the hearts of tens of thousands, that once matured would become part of something new entirely giving way to long-term, sustainable solutions for children everywhere. Please visit my website at www.DawnAmsdenStark.com for more adoption resources.

## FOSTER CARE

I know some of you are thinking, "Hey Dawn, I appreciate your story, but don't you think we should care for our kids here in the US first instead of you promoting international adoption?" I've heard this comment a lot over the years. But friends, we have a global orphan problem. I am of the firm conviction that when it comes to responding to the world's deepest need we must embrace "both/and" solutions. Also, please remember that given my story—prolonged infertility and in the shadow of my dad's adoption pain—international adoption whereby I felt the birth mother narrative was resolved (which of course, it is not), felt like a safer option for me. Just to clarify, I don't necessarily promote international adoption anymore. In fact, when people ask me, I generally suggest foster care or supporting international community development which promotes sustainable solutions to keep families together versus programs that promote familial disruptions.

Although my personal story is about infertility and international adoption, my role as an advocate has led me to become passionate about foster care. With over 400,000 children in the foster care system in our country, there is a tremendous and urgent need for foster parents everywhere.[4] Over 100,000 of these children are available for immediate adoption. Ranging in age from infants to eighteen years old, these are children who have experienced abuse, abandonment, and neglect. They are children who are suffering, through no fault of their own, and desperately need families to provide love, stability, and support. Simply, foster children need foster parents to give them normalcy and to give them hope.

Many people turn to fostering as a pathway to adoption, but this is a largely misunderstood concept. Foster care and adoption are not the same thing; there is officially no such thing as "fostering to adopt." Foster care is actually a pathway for ministry! Foster parents are agents of reconciliation in a child's life, as well in the child's parent's life. *The goal of foster care should always be family reunification!* While children are in foster care, their families are working to overcome the problems that caused the children to be removed from the home in

the first place. The foster parent's role is to provide stability and support to the children during this difficult season in their lives.

I believe the ideal foster parents are either couples who decide to foster before trying to build their own family, or the family whose children have one step out the door. Grandparents in good health also make excellent foster parents. However, as a woman who has endured a twenty-three-year infertility journey, I would not recommend foster care as a pathway for infertile couples. Children who come into foster care are hurting and broken; they need unconditional love and they need professional parents who are wholeheartedly assisting the reunification process. Empty arms can make for a heavy burden, and while that is a legitimate hurt and pain for the parent, it's not a burden that foster children should have to carry. They need advocates who are fighting for them to be reunited with their birth parents, not advocates trying to build their own families. Foster care may lead to adoption, but it should not be the primary reason that foster parents step into the role.

If you feel called to foster care and would like to learn more about this ministry, the best place to begin is with your local DCF office. They should be able to provide you with a list of licensing agents in your area that can help with your training and foster parent licensing. There are often faith-based groups, such as Baptist and Methodist Children's Homes that can license and support foster families, so be sure to check around before you begin classes held by DCF.

I also recommend connecting with your local foster care community and letting your church know you plan to begin fostering. Fostering is tough and foster parents need the wraparound support of prayer, respite, and resources. There are many wonderful support networks, continuing education programs, and community resources available to foster parents that can make all the difference to being successful in this hands-on ministry. Please visit my website at www.DawnAmsdenStark.com for more foster care resources.

# WITH GRATITUDE

Thank you to my church families, work colleagues, and network of friends. There are simply too many to name who cared for Tim and me during our long seasons of war. Your faithful support (emotional, spiritual, and financial) and love are woven deep in the pages of this story. Though I often felt alone, I was never alone. I am forever thankful to everyone who courageously offered me words of hope when my heart was broken, who wept along with me in my despair, who prayed each one of my miracles into my arms, and who always generously celebrated my victories.

Thank you to all the military personnel I interviewed, to all whose stories I gathered, to all who completed surveys, and to all who read early drafts to make sure that my use of terminology was appropriate and respectful. You helped me make sure my voice was truthful in application, and honoring of your profession.

Thank you to all my beta readers and proofreaders who helped to refine and prepare this story for publication. Your feedback was invaluable. I am grateful to each of you who took the time to support this first-time author and help breathe clarity into this manuscript.

Thank you to my editor, Leanne Wickham from Red Pencil Proofreading & Editing. I'm still in awe of how God connected a woman from New Zealand with such a similar background to a new author in the United States. My story of transformation was transformed by your touch and expertise. Your professionalism, timeliness, and support for this project were invaluable.

Thank you to my typesetter, Sally Hanan from Inksnatcher. I'm grateful for your patience and support to guide me through the layout design of this manuscript. It was such a relief to find someone with experience that I could trust to lead me through the maze of self-publishing. I'm grateful for all the ways you've stamped this book with your style and creativity.

Thank you to my artists, Isabelle Stark and Jessica Salas with Alas Creative. Izzy, God has given you fingers that are called to war. The

gifts and talents you hold blow my mind, and I'm not just saying that because I am your mama. I adore the pieces you created for this book and how you were able—when no one else could—to articulate the unique visuals for *Called to War*. Jessica, I am grateful for your vision and talents to take Izzy's art and produce a stunning cover for this manuscript. Thank you for your patience, dedication, and creativity to help us wrap this story in a beautiful and professional design.

Thank you to my publishing coach, Megan Hall, and my entire launch team for helping me to present this book to the world. You all helped me to overcome my fears and insecurities about releasing this book. I am grateful for your watchful eyes, your caring words, and your prayerful support. I could not have launched this book without each of you.

Thank you to my tribe: Heather Galloway, Megan Hall, and my sister, Deedra Mager. You are the people I've given birth with, ugly cried with, laughed till we cried with, and prayed through the night with. This book would not have been born without each of you. Period. You all are my safe space and my threshing floor. Thank you for encouraging me on, always.

Thank you to my in-laws, Louis and Fannie Stark. Although Fannie never knew about my adoption or advocacy wars, she played such an important role in us becoming parents. I am grateful she had the courage to bring us a book from a doctor she learned about on the radio. That book changed our lives. Louis has been such an incredible support and guiding hand throughout all our wars. Our home and children are forever marked by his caring influence and guiding wisdom.

Thank you to my siblings, Denny, Deedra, David, and Dallas. You were all my first babies, and I love you each fiercely. You all helped define family, and apparently family size as well. As the oldest of five siblings, you made it seem only natural to mother five. Your humor, perspectives, and talents have added great joy to my life. Thank you for all the endless ways you each supported me through the infertility, adoption, and advocacy wars.

Thank you to my parents, Dennis and Patti Amsden. You both laid the vital foundations for faith and family in my life. Thank you for leading me to Jesus when I was a child and for standing by my side when Jesus led me away from home. Not only are you witnesses to my entire life story, but you are also both my greatest cheerleaders. Mom, thank you for encouraging me to not live with regrets and for teaching me to "worship my way through it." Dad, thank you for teaching me how to worship and for being willing to continue your adoption story through your grandchildren.

Thank you to my children, Lydia, Michael, Isabelle, Dennis, and Rebekah. I've loved you each endlessly before you even drew that first breath. You are all my treasures on earth. I wrote this book for you because I wanted you to know that God is a rewarder for all who diligently seek Him (Heb. 6:11). I pray you each have the courage in your life to hold fast to your eternal promises and to seek first the kingdom. No matter what difficulties you will face, you serve a faithful Commander who will guide you through your wars. Thank you for loving me and encouraging me to persevere in finishing this book.

Thank you to my husband, Tim. This is as much your story as mine, I hope the memory of our journey together encourages your heart and brings you joy. You've pushed me at times, and I've pushed you at times, but somehow we've made it through to the other side. Thank you for loving me well; thank you for loving our children well. I look forward to enjoying all the future fruits of our past difficulties together as we, by the grace of God, hold many grandchildren in our arms.

Finally, thank you to my God, the one who made himself known to me as Commander-in-Chief. The God of Angel Armies never gave up on me. He alone is the author of my story; I am but his scribe.

# ACRONYMS, TERMS & DEFINITIONS

ART: Assisted reproductive technologies

AP: Adoptive parents

CAFO: Christian Alliance for Orphans

CHI: Children's Hope International

COC: Certificate of Citizenship

DOS: US Department of State

FBCH: Florida Baptist Children's Homes

GIFT: Gamete intrafallopian transfer

hCG: Human chorionic gonadotropin

IA: International Adoption

ICSI: Intracytoplasmic sperm injection

IVF: In vitro fertilization

L&D: Labor & Delivery

NGO: Non-governmental organization

OCONUS: military term for moving outside of the continental United States

OVC: orphan and vulnerable children

PGN: Procuraduría General de la Nación - Attorney General of Guatemala

Perinatologist: an obstetrician with special training in high-risk pregnancy care; also called a maternal-fetal medicine specialist

Pink: or pink slip, a term that means your completed file has been reviewed by the US Embassy and the case has been approved for scheduling the pickup appointment.

PTSD: Post-traumatic stress disorder

USCIS: US Citizenship and Immigration Services

ZIFT: Zygote intrafallopian transfer

# NOTES

## CHAPTER 3 NOTES

1. "Hypospadias refers to a urethral meatus ("pee-hole") which is located along the underside, rather than at the tip of the penis. In minor, or distal hypospadias, the meatus may be located on the underside of the penis, in the glans. In more pronounced hypospadias, the urethra may be open from mid-shaft out to the glans, or the urethra may even be entirely absent, with the urine exiting the bladder behind the penis." ISNA, "Hypospadias: Parent's Guide to Surgery" http://www.isna.org/node/81 (accessed October 22, 2014).

2. Alex Owens, US Navy, personal friend interviewed on January 12, 2015.

3. Jon Davis. "Why are military boot camps so intense?" *Slate*. March 5, 2013, http://www.slate.com/blogs/quora/2013/03/05/why_is_boot_camp_so_intense. html (accessed October 20, 2014).

4. Merriam-Webster dictionary: "disorient"https://www.merriam-webster.com/dictionary/disorient(accessed May 11, 2015).

5. Dictionary.com: "deny" http (accessed April 10, 2015).

6. Tibi Puiu. "How caterpillars gruesomely transform into butterflies" *ZME Science*. January 22, 2018. https://www.zmescience.com/ecology/animals-ecology/how-caterpillar-turn-butterfly-0534534/(accessed August 25, 2020).

7. Merriam-Webster dictionary: "control" https://www.merriam-webster.com/dictionary/control (accessed January 23, 2016).

8. Bible Study Tools: "adversary" from the Hebrew word *Tsarah*; Strong's Concordance Number 06869 http://www.biblestudytools.com/lexicons/hebrew/kjv/tsarah.html (accessed January 23, 2016).

9. The phrase "when empty arms become a heavy burden" is taken from one of the early books I read on infertility. The credit to this phrase goes to Sandra Glahn and William Cutrer for their book written in 1997 with the same title:

Sandra Glahn and William Cutrer, *When Empty Arms Become a Heavy Burden* (Nashville: Broadman & Holman Publishers, 1997).

10. Although there are several different grief cycles applied in today's counseling models, these five steps are generally accepted as the standard. Refer to http://grief.com/the-five-stages-of-grief/ for more information about this cycle. (accessed January 26, 2016).

# CHAPTER 4 NOTES

1. USMC Life, "Your Boot Camp FAQs," section: What's after Boot Camp,https://usmclife.com/marine-corps-boot-camp/boot-camp-faqs/(accessed February 28, 2016).

2. Rick Warren, "What on Earth am I Here For," 2014, *Bible.com*, https://www.bible.com/reading-plans/936-what-on-earth-am-i-here-for/day/16 (accessed August 26, 2020).

# CHAPTER 5 NOTES

1. Mission Command US Army White Paper, "Building Mutual Trust Between Soldiers and Leaders," 2015, p. 10, https://usacac.army.mil/sites/default/files/publications/HDCDTF_White%20Pa per_Building%20Mutual%20Trust%20Between%20Soldiers%20and%20Leaders_F inal_2015_01_09_0.pdf (accessed March 20, 2016).

2. Merriam-Webster dictionary: "trust," https://www.merriam-webster.com/dictionary/trust (accessed March 19, 2016).

3. Katarzyna Krot and Dagmara Lweicka, "The Importance of Trust in Manager-Employee Relationships," *International Journal of Electronic Business Management,"* Vol. 10, No. 3, pp. 224-233, 2012, p. 224, http://ijebm.ie.nthu.edu.tw/ijebm_web/ijebm_static/Paper-V10_N3/A06.pdf(accessed March 19, 2016).

4. Daniel Eek and Bo Rothstein, "Exploring a Casual Relationship between Vertical and Horizontal Trust," *The QOG Institute*, 2005, p. 4, https://www.gu.se/sites/default/files/2020-05/2005_4_Eek_Rothstein.pdf(accessed November 12, 2020).

5. Ibid., p. 6.

6. Ibid., p. 4.

7. Ibid., p. 6.

8. Mission Command US Army White Paper, p. 2.

9. Hebrews 4:14–16

10. Psalms 32:8

11. Mission Command US Army White Paper, p. 4.

12. Maria Fors Brandebo, "Military Leaders and Trust," Karlstads University, 2015, p. 52, http://kau.diva-portal.org/smash/get/diva2:844239/FULLTEXT01.pdf (accessed April 12, 2016).

13. Genesis 22:1–19

14. Christopher M Barnes and Lt. Col. Joseph Doty, "What Does Contemporary Science Say About Ethical Leadership," *The Army Ethic, Military Review,* 2010, p.90, https://www.armyupress.army.mil/Portals/7/military-review/Archives/English/MilitaryReview_20100930ER_art015.pdf(accessed August 28, 2020).

15. John Bishop, "Faith," *The Stanford Encyclopedia of Philosophy* (Summer 2016 Edition), Edward N. Zalta (ed.), http://plato.stanford.edu/archives/sum2016/entries/faith/ (accessed April 16, 2016).

16. Bible Hub: "faith" from the Greek word *pistis*; Strong's Concordance Number 4102, https://biblehub.com/greek/strongs_4102.htm (accessed April 16, 2016).

17. Charles H Spurgeon, *All of Grace*, online version, Chapter: Faith what is it? http://www.ccel.org/ccel/spurgeon/grace.ix.html (accessed April 16, 2016).

18. A.W. Pink, *The Sovereignty of God*, online version, Chapter: God's sovereignty defined, https://reformed.org/books/pink/(accessed March 20, 2016).

19. Blue Letter Bible: "The Names of God in the Old Testament," https://www.blueletterbible.org/study/misc/name_god.cfm (accessed March 20, 2016).

20. R.C. Sproul, "What does "coram Deo" Mean?", Ligonier Ministries, November 13, 2017, https://www.ligonier.org/blog/what-does-coram-deo-mean/ (accessed August 26, 2020).

# CHAPTER 6 NOTES

1. GlobalResearch, "America has been at war 93% of the time," https://www.globalresearch.ca/america-has-been-at-war-93-of-the-time-222-out-of-239-years-since-1776/5565946 (accessed September 18, 2021).

2. Military Spot, "What Does the Army do?," http://www.militaryspot.com/enlist/what-does-the-u-s-army-do, (accessed November 4, 2016).

3. Carl Von Clausewitz, *On War*, ed. Anatol Rapoport and Col. J.J. Graham (New York: Dorset Press, 1991), p.173.

4. Merriam-Webster dictionary: "strategy," https://www.merriam-webster.com/dictionary/strategy?utm_campaign=sd&utm_medium=serp&utm_source=jsonldb (accessed January 21, 2017).

5. Clausewitz.com, "Strategy," US Marine Corps, http://www.clausewitz.com/readings/mcdp1_1.pdf (accessed January 21, 2017), p.9.

6. Merriam-Webster dictionary: "tactics," https://www.merriam-webster.com/dictionary/tactic (accessed January 21, 2017).

7. Samuel B. Griffith, *The Illustrated Art of War by Sun Tzu* (New York: Oxford University Press, 2005), p.44.

8. Sun Tzu, *The Art of War*, ed. Nigel Cawthorne (London: Arcturus Publishing, 2014), p.36.

9. Ibid., p.14.

10. Ibid., p.14.

11. Ibid., p.16.

12. Ibid., p.16.

13. Ibid., p.16.

14. Ibid., p.16.

15. Psalm 139:16.

16. Bible Hub: "power" from the Greek word *dunamis*; Strong's Concordance Number 1411, https://biblehub.com/greek/1411.htm (accessed January 28, 2017).

17. Andy Stanley, *Five Things God Uses to Grow Your Faith*, DVD, Northport Ministries, (Grand Rapids: Zondervan, 2009).

18. Ruth 1:16 NIV.

19. For more on "gleaning", refer to Old Testament laws designed to benefit the poor in Leviticus 23:22.

20. Sherman J. Silber MD, *How to Get Pregnant with the New Technology* (New York: Warner Books, 1991), p.6.

21. Ibid., p.7.

22. ART solutions are typically not used on someone so young, but given our complex problem was really our only shot for ever having a baby.

23. Silber, 1991, p.4.

24. GIFT is different from a traditional IVF where the goal is for the sperm and egg to actually fertilize and become an embryo within the 48-hour incubation process.

25. Catechism of the Catholic Church #2376.

26. Although genetic testing of eggs/ embryos did not exist at this time, the same thinking would've held true and we would not have engaged in any genetic testing.

# CHAPTER 7 NOTES

1. Pearl Harbor Visitors Bureau, "How many people died at Pearl Harbor during the attack?" https://visitpearlharbor.org/faqs/how-many-people-died-at-pearl-harbor-during-the-attack/(accessed February 11, 2016).

2. Ibid.

3. Donald Stratton with Ken Gire, *All the Gallant Men, The First Memoir by a USS Arizona Survivor* (New York: HarperCollins, 2016), p.105.

4. Laura Seftel, *Grief Unseen* (London: Jessica Kingsley Publishers, 2006), p.16.

5. Jerry Sittser, *A Grace Disguised* (Grand Rapids: Zondervan, 2004), p. 8.

6. Although I didn't head this direction in the material, I'd like to point out if you keep reading Joshua 4 that 40,000 crossed over prepared to do war on the plains of Jericho. Even in the midst of the miracle, they were preparing to do battle. I'm asking myself again why I've lived my life seeking peace, ease, and comfort above all else when we are so clearly called to a life of (spiritual) war.

7. As with many theological issues, I do not have the time in this book to lay out the case to support the claim. However, it is largely accepted by biblical scholars that both the Red Sea and Jordan crossings were a type and shadow of the New Testament baptism. If this is a new concept for you, I highly recommend you study the topic on your own.

# CHAPTER 8 NOTES

1. Michael Neiberg, *Warfare in World History* (London: Routledge, 2001). *eBook Collection (EBSCOhost)*, p.5, (accessed February 25, 2017).

2. C.S. Lewis, *The Problem of Pain* (New York: Harper One, 1940), p.105.

3. Pete Wilson, *Plan B: What Do You Do When God Doesn't Show Up the Way You Thought He Would?* (Nashville: Thomas Nelson, 2009), Kindle Edition, p.20.

4. C.S. Lewis, p. 90.

5. Paul Purvis, "May 29, A call to the Lord for Salvation," *God's Wisdom for Today, My Daily Scripture Devotional* (Nashville: Thomas Nelson, 2013), p.150.

6. Ann Voskamp, *The Broken Way* (Grand Rapids: Zondervan, 2016), p.16.

7. Merriam-Webster dictionary: "worship," https://www.merriam-webster.com/dictionary/worship (accessed February 28, 2017).

8. Compilation from the following Hebrew and Greek words based on Scripture research in Strong's Concordance: *Shachah, Towdah, Yadah, Ruwm, Proskuneo*.

9. Eugene H. Peterson, *A Long Obedience in the Same Direction*, Revised & Expanded Edition (Downers Grove: IVP Books, 2000), p.55.

10. Patti Amsden, *Evidence That Calls Us to Dance* (Kirkwood: Impact Christian Books, Inc,1998), p.58.

11. Jerry Sittser, *A Grace Disguised* (Grand Rapids: Zondervan, 2004), p.48.

# CHAPTER 9 NOTES

1. Merriam-Webster dictionary: "fear," https://www.merriam-webster.com/dictionary/fear (accessed September 16, 2014).

2. Brené Brown, *Daring Greatly* (New York: Gotham Books, 2012), p.239.

3. Franklin D. Roosevelt, Inaugural Address, March 4, 1933, as published in Samuel Rosenman, ed., *The Public Papers of Franklin D. Roosevelt, Volume Two: The Year of Crisis, 1933* (New York: Random House, 1938), 11-16. http://historymatters.gmu.edu/d/5057/ (accessed August 30, 2020).

4. J. Glenn Gray, *The Warriors: Reflections on Men in Battle* (Lincoln: University of Nebraska Press,1959), Kindle Edition, p.99.

5. Michael Evans and Alan Ryan, *The Human Face of Warfare: Killing, Fear and Chaos in Battle* (NSW: Allen & Unwin, 2000), eBook Collection, EBSCOhost, p.41 (accessed March 24, 2017)

6. J. Glenn Gray, p.105.

7. Michael Evans and Alan Ryan, p.14.

8. Sun Tzu, p.31.

9. Brené Brown, p.243.

# CHAPTER 10 NOTES

1. Colossians 3:10.

2. Matthew 19:30 (paraphrased).

3. Ann Voskamp, *One Thousand Gifts: A Dare to Life Fully Right Where You Are* (Grand Rapids: Zondervan, 2010), p.170.

4. Mark 14:36–38.

5. Rick Warren, *The Purpose Driven Life* (Grand Rapids: Zondervan, 2002), p.81.

6. Dr. Silber is a vascular surgery who pioneered infertility treatments, but he always works with an OB/GYN for the female case management.

# CHAPTER 12 NOTES

1. Merriam-Webster dictionary: "hope," https://www.merriam-webster.com/dictionary/hope (accessed July 22, 2017).

2. Terry Law and Jim Gilbert, *The Hope Habit, Finding God's Goodness when Life is Hard* (Lake Mary: Charisma House, 2010), p.27.

3. Erwin McManus, *Soul Cravings* (Nashville: Thomas Nelson, 2006), Entry #8.

4. Shane J. Lopez, *Making Hope Happen: Create the Future You Want for Yourself and Others* (New York: Atria Books, 2013), Kindle version, p.10.

5. Ibid., p.22.

# CHAPTER 13 NOTES

1. Erwin McManus, Entry #9

2. A perinatologist is also known as a Maternal-Fetal Medicine specialist or a high-risk obstetrician skilled in ultrasounds, prenatal diagnosis and the care of complicated pregnancies.

# CHAPTER 15 NOTES

1. Brian McAllister Linn, *The Echo of Battle, The Army's Way of War* (Cambridge: Harvard University Press, 2007), p.233.

2. Bible Hub, Webster's Revised Unabridged Dictionary, "echo," https://biblehub.com/topical/e/echo.htm#web (accessed August 20, 2020).

3. Your Dictionary, "echo"

https://www.yourdictionary.com/echo#0zJuFEheh5bKT8A4.99 (accessed August 20, 2020).

4. Margaret Feinberg, *The Sacred Echo, Hearing God's Voice in Every Area of Your Life* (Grand Rapids: Zondervan, 2008), p.23.

5. Ibid., p.34.

6. Bob Goff, *Everybody Always* (Nashville: Nelson Books, 2018), p.136.

7. In the state of Illinois, and particularly in our region of southern Illinois, many communities are built over abandoned mines that sink during the passage of time causing foundation problems and wall cracks. "The Illinois Mine Subsidence Insurance Fund is a taxable enterprise created by Statute to operate as a

private solution to a public problem. The purpose of the Fund is to assure financial resources are available to owners of property damaged by mine subsidence." https://www.imsif.com (accessed August 20, 2020).

8. Jon E Lewis (ed.) *The Mammoth Book of War Diaries & Letters, Life on the Battlefield in the Words of the Ordinary Solider* (New York: Carroll & Graf Publishers, 1998), p. 459.

9. Ibid., p.444.

10. James Brady, *Why Marines Fight* (New York: Thomas Dunne Books, 2007), p.271.

11. In her book, *Primal Wound,* author Nancy Newton Verrier posits: "bonding does not begin at birth, but is a continuum of physiological, psychological, and spiritual event which being in utero and continue throughout the postnatal bonding period. When this natural evolution is interrupted by a postnatal separation from the biological mother, the resultant experience of abandonment and loss is indelibly imprinted upon the unconscious minds of these children causing that which I call the 'primal wound.'"

Nancy Newton Verrier, *Primal Wound* (Baltimore: Gateway Press, 1991), p.1.

# CHAPTER 16 NOTES

1. US Department of Defense, "What to Expect with an OCONUS (Overseas) Move," https://move.mil/moving-guide/oconus (accessed July 2, 2020).

2. Military One Source, "PCS: The Basics About Permanent Change of Station," https://www.militaryonesource.mil/moving-housing/moving/planning-your-move/pcs-the-basics-about-permanent-change-of-station (accessed July 2, 2020).

3. Chinese Proverb, author unknown.

4. Paulo Barrozo, "Finding Home in the World: A Deontological Theory of the Right to be Adopted." *New York Law School Law Review* 55, no. 3: p.704. 2011. *Academic Search Complete*, EBSCO*host* (accessed April 15, 2014).

5. Brian McAllister Linn, p.234.

6. Merriam-Webster dictionary: "orphan," https://www.merriam-webster.com/dictionary/orphan (accessed September 18, 2021).

7. Christian Alliance for Orphans White Paper, "On Understanding Orphan Statistics," https://cafo.org/wp-content/uploads/2015/10/Orphan-Statistics-Web-9-2015.pdf (accessed September 18, 2021).

8. HCCH Hague Conference on Private International Law 1993, "Convention on Protection of Children and Co-operation in Respect of Intercountry Adoption,"

1993, http://www.hcch.net/upload/conventions/txt33en.pdf (accessed July 6, 2020)

9. UNICEF, Convention on the Rights of the Child, "Protecting and realizing children's rights," http://www.unicef.org/crc/index_protecting.html (accessed July 6, 2020).

10. Kate O'Keeffe, "The Intercountry Adoption Act of 2000: The United States' Ratification of the Hague Convention on the Protection of Children, and its Meager Effect on International Adoption." *Vanderbilt Journal of Transnational Law* 40.5. p. 1615-1618. 2007, *Academic Search Complete*. EBSCO. (accessed March 26, 2014).

11. Jo Daughtery Bailey, "Expectations of the Consequences of New International Adoption Policy in the US" *Journal of Sociology & Social Welfare* 36.2: p.170. 2009, *Academic Search Complete*. EBSCO. Web. (accessed March 25, 2014).

12. US Department of State, "Adoption Statistics," 2020, https://travel.state.gov/content/travel/en/Intercountry-Adoption/adopt_ref/adoption-statistics-esri.html?wcmmode=disabled (accessed July 6, 2020).

13. I'm happy to report that I've visited Antigua several times again since these difficult days in 2007 and absolutely adore this colonial city!

# CHAPTER 17 NOTES

1. Romans 8:31.

2. 2 Corinthians 12:10.

3. At this time, the state of Illinois required all adoptive families - international or domestic - to be approved for foster care, even though foster care was never our intent. When DCFS received our updated home study and FBI prints for the renewal, they claimed to have never given us approval in the first place. Our social worker was involved, and she requested USCIS grant an extension on the 171H, but they said no, which is why our local representatives' involvement was so vital in facilitating approval between Chicago and Springfield.

4. David Platt, *Radical* (Colorado Springs: Multnomah Books), p. 48.

5. American Psychiatric Association, "What Is Post-traumatic Stress Disorder?," https://www.psychiatry.org/patients-families/ptsd/what-is-ptsd (accessed July 18, 2020).

6. U.S. Department of Veterans Affairs, PTSD: National Center for PTSD, "How Common is PTSD in Veterans?" https://www.ptsd.va.gov/understand/common/common_veterans.asp

(accessed July 18, 2020).

7. Dawn Davinport, "Post Adoption Depression, The Elusive Happily Ever After." *Fostering Families Today Adoption Today* magazine – special edition 2017, p. 10-11.

8. Biological moms also experience bonding challenges; this is not necessarily unique to being an adoptive mom.

# CHAPTER 18 NOTES

1. Samuel A. Southworth and Stephen Tanner, *US Special Forces: A Guide to America's Special Operations Units -The World's Most Elite Fighting Force* (Cambridge: Da Capo Press, 2002), p. 27.

2. SOFREP, Steve Balestrieri, "Life in Special Operations is in the Shadows, not the Limelight," August 30, 2018, https://sofrep.com/specialoperations/life-in-special-operations-is-in-the-shadows-not-the-limelight/ (accessed July 23, 2020).

3. Military One Source, "A Look into Joining the Military's Elite Forces in the Army, Marine Corps, Navy and Air Force," June 11, 2020, https://www.militaryonesource.mil/military-life-cycle/new-to-the-military/military-career/joining-the-military-elite-forces (accessed July 23, 2020).

4. Ibid.

5. SOFREP, Steve Balestrieri.

6. Joint Special Operations University, https://www.socom.mil/JSOU/Pages/default.aspx (accessed July 23, 2020).

7. M. Craig Barnes, *Sacred Thirst, Meeting God in the Desert of our Longings* (Grand Rapids: Zondervan, 2001), p.143.

8. Charles H. Spurgeon's Treasury of David, "Psalm 144", https://www.christianity.com/bible/commentary.php?com=spur&b=19&c=144 (accessed July 25, 2020).

# CHAPTER 19 NOTES

1. For more from Dr. Thompson, I highly recommend his book, *Anatomy of the Soul*.

2. Jessica Honegger Podcast, "Episode 30 - Create Compassionate Spaces with Curt Thompon", September 12, 2018, https://jessicahonegger.com/podcast/episode-30-create-compassionate-spaces-with-curt-thompson/ (accessed August 20, 2020).

3. Hebrews 12:2.

4. Many believe the phrase, "a long obedience in the same direction" originated by Eugene Peterson. Actually, the credit for this quote belongs to Friedrich Nietzsche.

# CHAPTER 20 NOTES

1. Frederick Buechner, *Wishful Thinking, A Theological ABC* (New York, Harper One, 1993), p.118.

# ADDITIONAL RESOURCES NOTES

1. Barbara Eck Menning, *Infertility: A Guide for the Childless Couple* (New York: Prentice-Hall, Inc., 1988), p.177.

2. Resolve, The National Infertility Association, "What Is Infertility?", https://resolve.org/infertility-101/what-is-infertility/fast-facts/ (accessed July 20, 2021).

3. American Society for Reproductive Medicine, "Frequently Asked Questions About Infertility," https://www.reproductivefacts.org/faqs/frequently-asked-questions-about-infertility/q03-how-is-infertility-diagnosed/ (accessed July 20, 2021).

4. Adopt US Kids, "About the Children", https://www.adoptuskids.org/meet-the-children/children-in-foster-care/about-the-children(accessed August 30, 2020).

# ABOUT THE AUTHOR

Dawn Amsden Stark is a change agent, a storyteller, a promise seeker, and a beach lover. Professionally, she is a development manager for Operation Blessing, where she matches the philanthropic goals and interests of partners to the needs of the most vulnerable worldwide. Purposely, she is the founder of {Re}Purposed Lives, a social business that supports at-risk children and families while reducing textile waste through recycling unwanted stuffed animals and plush toys.

Dawn holds a BA in government and international relations from Regent University and an MA in international community development from Southeastern University.

She lives in Sarasota, Florida, with her husband of thirty-six years, five children, and their Siberian Husky puppy. *Called to War* is her debut release.

In dedication of Dawn's calling to be a voice for the voiceless, 20 percent of the proceeds from *Called to War* will be donated to reputable organizations serving at-risk children and families—both here in the US and around the world. For more details on the organizations benefiting from sales of this book, please visit RepurposedLives.com.

## Follow Dawn

DAWNAMSDENSTARK.COM

   AuthorDawnAmsdenStark

   DawnAmsdenStark

Made in the USA
Monee, IL
26 November 2021

83111683R10174